150 Best New Bathroom Ideas

150 Best New Bathroom Ideas

Francesc Zamora Mola

HARPER
DESIGN
An Imprint of HarperCollinsPublishers

150 BEST NEW BATHROOM IDEAS
Copyright © 2015 by LOFT Publications

HarperCollins books may be purchased for educational, business, or sales promotional use.
For information, please e-mail the Special Markets Department, at SPsales@harpercollins.com.

First published in 2015 by:
Harper Design
An Imprint of HarperCollins*Publishers*
195 Broadway
New York, NY 10007
Tel.: (212) 207-7000
Fax: (855) 746-6023
harperdesign@harpercollins.com
www.hc.com

Distributed throughout the world by:
HarperCollins*Publishers*
195 Broadway
New York, NY 10007

Editorial coordinator: Claudia Martínez Alonso
Art director: Mireia Casanovas Soley
Editor and texts: Francesc Zamora Mola
Layout: Yasuko Fujioka

ISBN 978-0-06-239614-3

Library of Congress Control Number: 2015932549

Printed in China
First printing, 2015

747.78

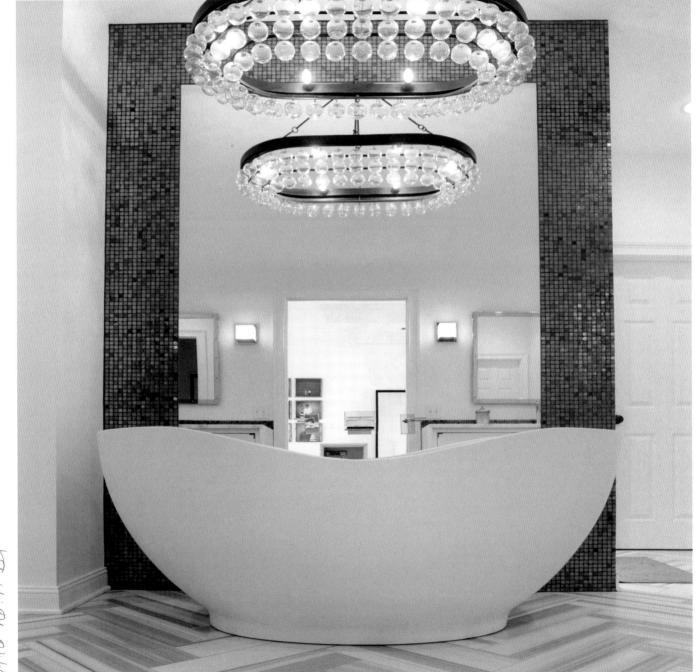

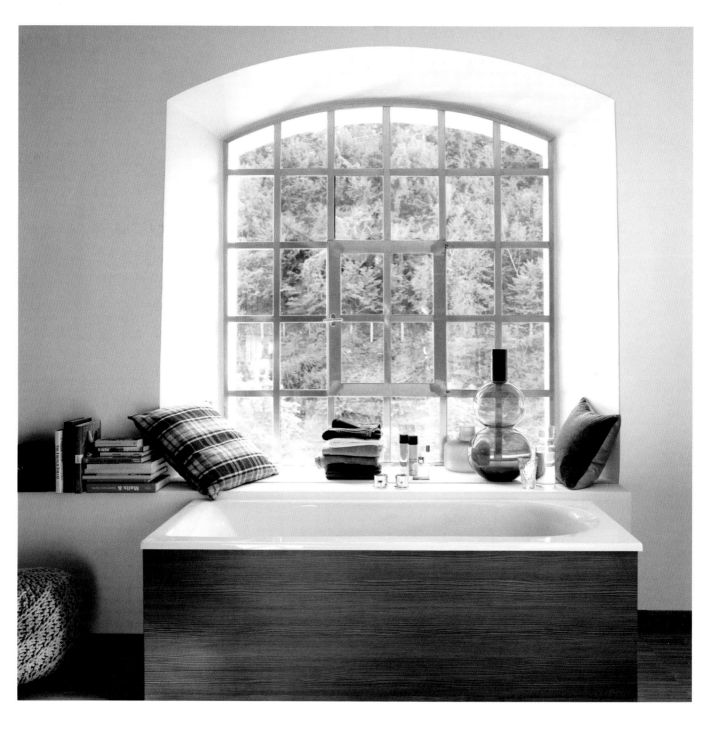

Contents

8 INTRODUCTION

10 BATHROOMS
12 Spa Bath Retreat
18 Refined Elegance
22 Glass Bathroom Walls
26 Classic Appeal
30 Mosaic Feature Wall
34 Bubbly Waters
38 Spa-like Bathrooms
44 Bright and Airy
48 Soothing Symmetry
52 Industrial Charm
56 Fogscape/Cloudscape
60 Portsea
64 Bay Harbor
68 Craftsman Modern
74 Sea Foam
78 Jewel-Box
82 St. Pancras
86 Warren Mews
92 Vivid Eco Wellness

96 Adams Morgan
102 Bathroom on a Stream
106 Ozone Bathroom
110 Stealthy Skin
114 Silvery Gray
120 Glen Rising Bathrooms
126 Pop-up
132 Timber and Sheer
136 Hamstead Bathroom
142 Kenwood Bathroom
146 Visual Illusion
152 Opened to the Forest
156 Bathroom with Views
160 Minimalist Bathrooms
164 Station Blü
168 Tresarca
172 Bathroom for a Studio
176 Attic Bathroom

182 INSPIRATIONS

478 DIRECTORY

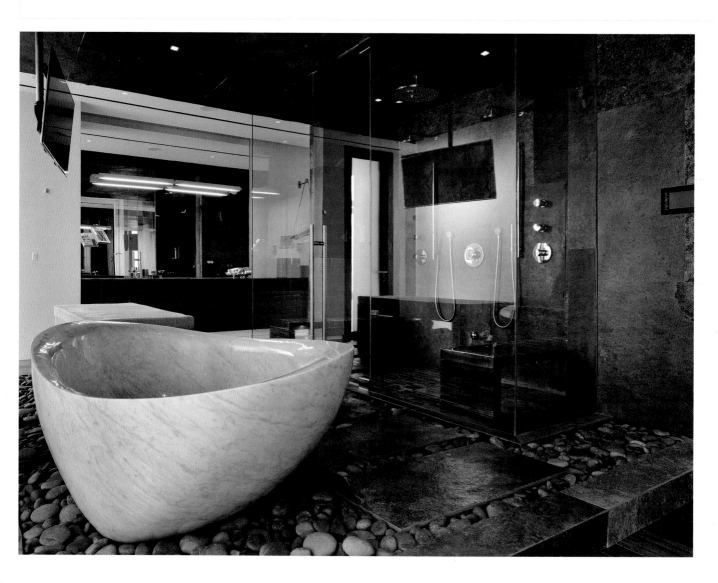

Introduction

Bathrooms have experienced a progressive transformation over time because of lifestyle changes that have elevated the bathroom to a place of importance in our homes. Attitude changes toward privacy have also contributed to this transformation. Nowadays, bathrooms are far more than merely functional rooms tucked away in a gloomy corner of the house. They are bright spaces as stylish as they are utilitarian, opening up to adjacent bedrooms and dressing rooms.

Style and technology pair with the daily rituals of bathing and grooming to create a relaxing atmosphere. Bathrooms are getaways that have the power of revitalizing and soothing body and soul. Also, like any other room in the house, the bathroom reflects personality and lifestyle.

Vintage bathroom fittings are a popular trend. The appeal might have to do with glamour and nostalgia. Pedestal sinks, Venetian mirrors and enameled cast-iron tubs take center stage in renovated early twentieth-century spaces. The more contemporary bathroom style features streamlined fittings carved in stone and marble, made of ceramic, and fabricated in high-quality recycled plastic and translucent resin.

Fittings are important elements in a bathroom, generally setting the style of the room and creating focal points. They are displayed as pieces of contemporary art in rooms that are increasingly larger to accommodate spa-like amenities challenging the notion of privacy.

Privacy is a value that has also changed over the years. It's not so much a matter of hiding ourselves from others, but about shielding ourselves from the outside frenzy. On the other hand, it is not surprising to find a tub right by a floor-to-ceiling window. It seems as if there is a growing interest in having in the bathroom what we have always wanted in the living room: views. New bathrooms often include large windows offering expansive views over a natural landscape or over a city's skyline—way high up in a tower—only to expose occupants to lots of natural light and maybe to birds.

all the life that travels past and over head, how it died, did it kill a turnife, washed slowly to the shore and want really picked up
occasionally the refuse of the sea would actually the waves the sand that
turtle walk is up a new bit of beach the stones each piece has so many stories
sures are to be found in a range of that the refuse shops and terms made by trade and occasionly man
away the surfaces, revealing changes that only the
es to tell us all

Shells from the beaches of lumiq Samuel Blanqueline

© Andrew Wuttke

BATHROOMS

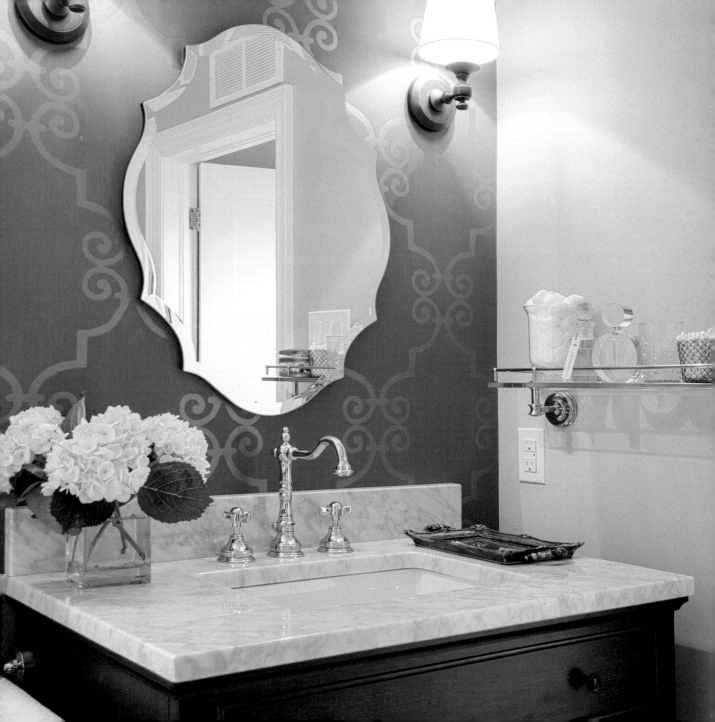

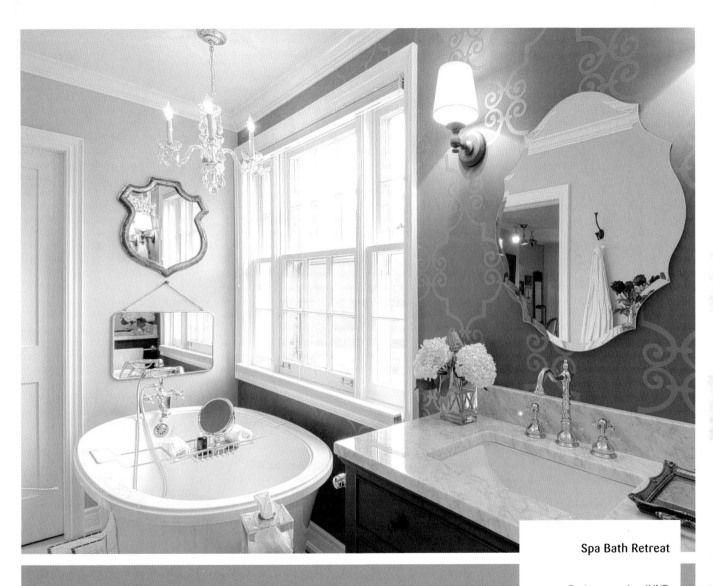

The design concept for the renovation of a master en suite bathroom is one of elegant form and fine detailing. With an eye toward maximizing the existing area, this renovation optimizes underutilized adjoining spaces. This master en suite incorporates classic and timeless elements with today's approach to the ultimate retreat, including all the amenities of a luxury spa.

Spa Bath Retreat

Designer: marinaniLIND
Location: Toronto, Ontario, Canada
Photographer: © Andrea Simone

Semi-precious octagon white Calacatta marble mosaics, framed with St. Laurent Brown Marble Mosaic, Carrara Brick Marble and polished chrome fittings are set amid a sculptural architectural envelope of wall covering, crown molding and millwork.

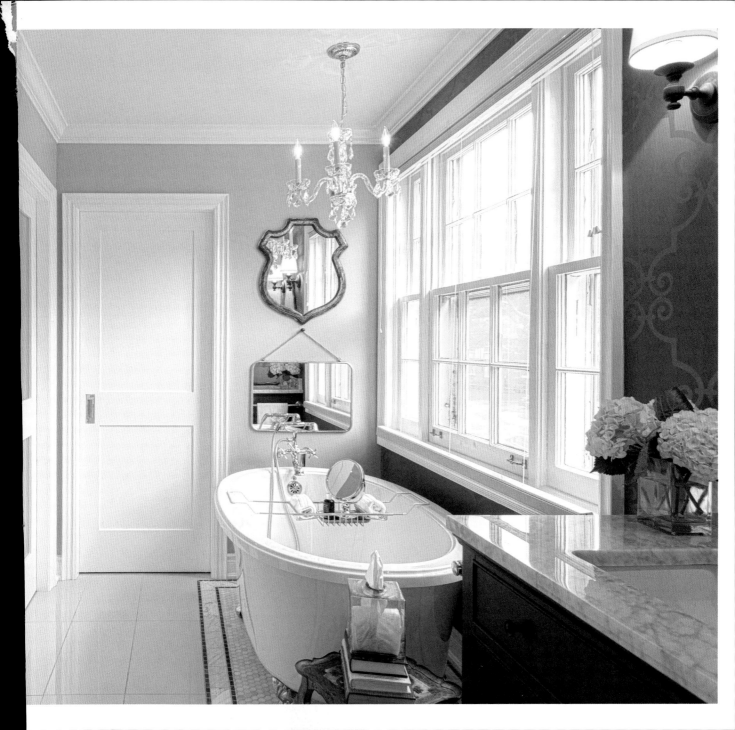

No sacrifices here since this bath is complete with simple yet elegant detailing and unique material combinations.

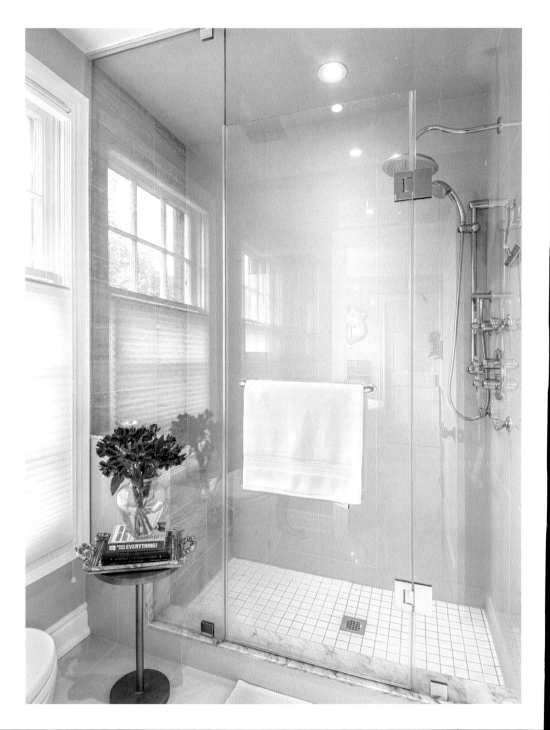

OPEN

Elevations at shower

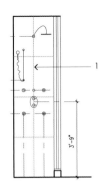

3'-9"

1. 12" x 24" Regal
 polished shell
 white, Olimpia Tile

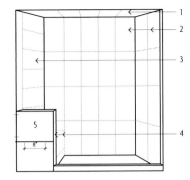

1
2
3
5
8"
4

1. 12" x 24" Regal polished
 shell white, Olimpia Tile
2. 12" x 24" Regal polished
 shell white, installed
 vertically, Olimpia Tile
3. 12" x 24" Luxury
 Daino Dol, installed
 horizontally, Tiles &
 Stone
4. 12" x 24" Luxury
 Daino Dol, installed
 horizontally, bench and
 half wall, Tiles & Stone
5. Niche at shower side

Perspective at shower

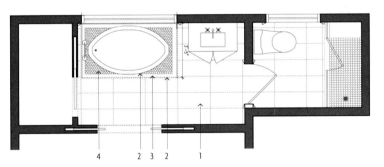

3'-5"

4 2 3 2 1

Floor plan

1. 12" x 24" Regal polished
 shell white, Olimpia Tile
2. 1 row of St. Laurent mini
 brick (12" x 12" mesh,
 brown marble mosaic
 1/2" x 1" approx.),
 Tiles & Stone
3. 3" x 6" Carrara brick tile,
 Tiles & Stone
4. 12" x 12" Octagon white
 marble tile, Tiles & Stone

001

Partitions offer privacy between
the toilet area, the vanity and
the shower. Partitions can also
add architectural interest and
improve the proportions of an
awkwardly long and narrow
bathroom.

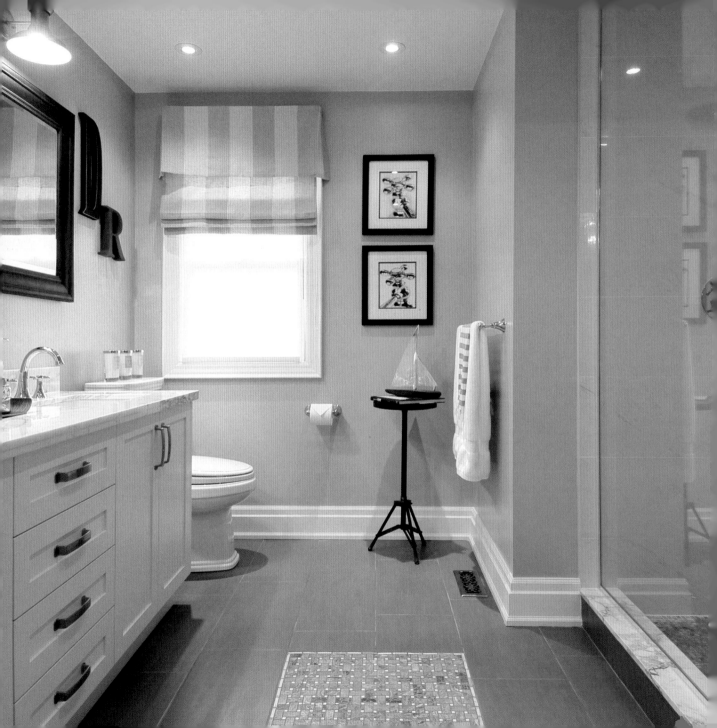

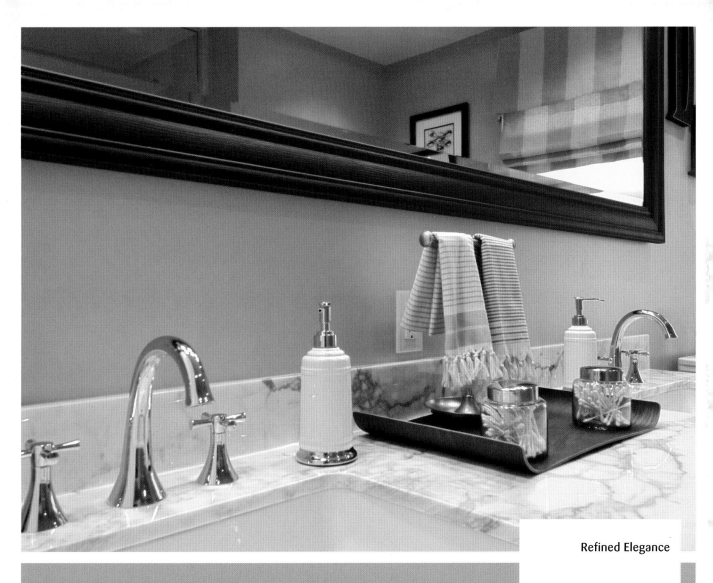

Refined Elegance

This bathroom renovation started out with a color scheme. It's not always that simple, even though we all wish it would be. The design team combined a few other basic elements, which ultimately set the tone for a bathroom of sophisticated elegance and simplistic flair. The long mirror over the vanity and the chrome plumbing fixtures add brightness for a final touch.

Designer: marianiLIND
Location: Toronto, Ontario, Canada
Photographer: © Andrea Simone

Elevation at vanity

Elevation at window

Elevation at shower

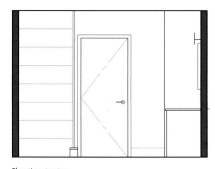

Elevation at entry

002

Sometimes it is as simple as finding the perfect light fixture or hardware to come up with a design concept. Once you have a clear picture in mind, you are ready to start.

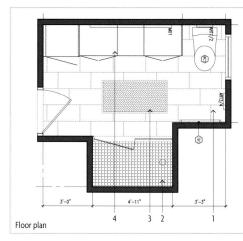

Floor plan

1. 12" x 24" Koshi tile, Ciot
2. 12" x 12" Mud stone mosaic tile, Ciot
3. 12" x 12" Basketweave oyster gray, Moscone Tile & Marble
4. New millwork from Nima

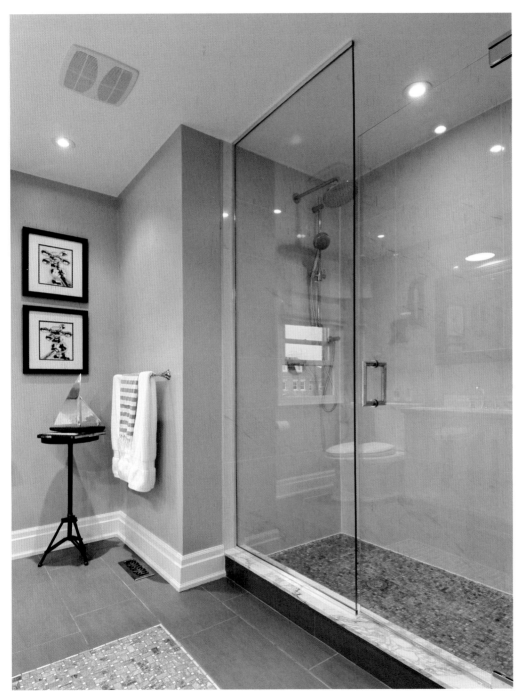

A marble mosaic rug in gray tones is the focal point of this bathroom. The selection of natural stone was critical to carry the design to the walls and to the Calacatta countertop.

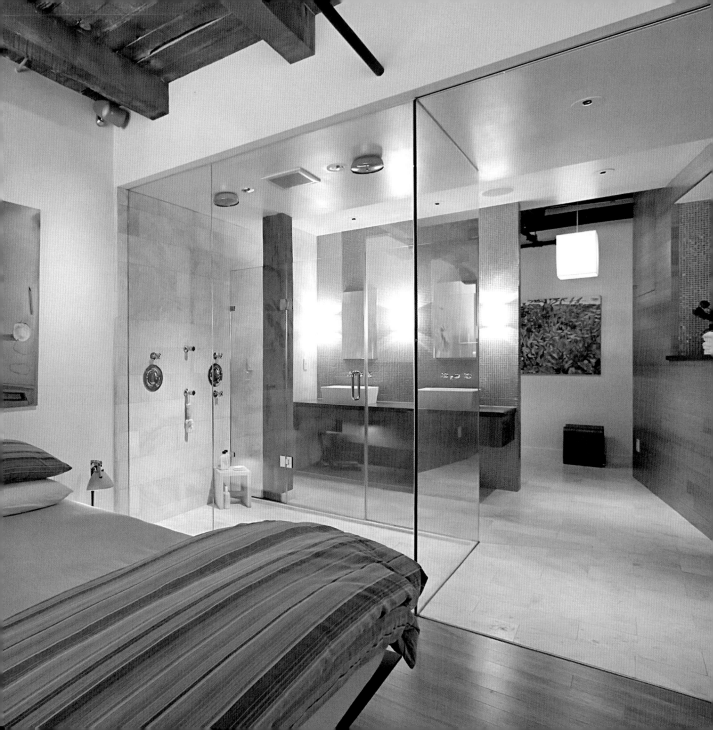

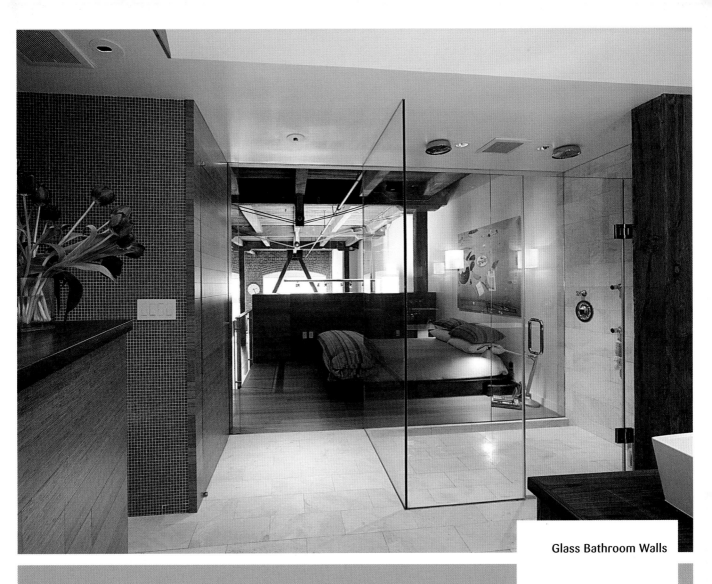

Architect: **Studio G+S Architects**

Location: **San Francisco, California, USA**

Photographer: © **Cleber DeAlencar**

This project comprises a complete renovation of an existing apartment unit. The plan was to create an open and light-filled space. By making much more efficient use of the space (for example, by eliminating the extra flight of stairs that existed originally and reduced circulation space), the architects are able to accommodate the entire plan by making the spaces wider, more open and ample feeling.

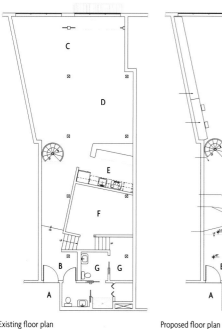

Existing floor plan

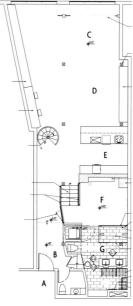

Proposed floor plan

A. Corridor
B. Entry
C. Living area
D. Dining area
E. Kitchen
F. Sleeping loft
G. Master bathroom
H. Closet
I. Half bathroom

Master bathroom floor plan

1. Storage access
2. 14" deep shelves
3. Built in shelves
4. 1/2" Thick glass wall on tiled curb
5. Shower drain at each end of trough
6. 2" deep x 4" wide drain trough
7. 1/8: 12 slope min. at shower
8. 1/2" elevation change
9. Pole
10. Shelf
11. Mirror
12. Shoe rack

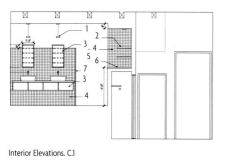

Interior Elevations. C.1

C.2

C.3

1. Pendant
2. Wood shelves
3. Custom cabinet
4. Tile
5. Closet beyond
6. Wood top
7. Wood trim
8. 1/2" tempered glass
9. Shower
10. Mirror
11. Glass mosaic tile
12. Bamboo paneling
13. Paneling this face
14. Tile this face
15. Laundry pocket door
16. Magnetic latch
17. Tempered glass pocket door
18. Guide set flush with finished floor

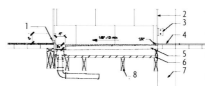

Shower floor and drain detail

1. Tempered glass
2. "Frameless" shower enclosure
3. Shower door hinge
4. Stone tile
5. Sloped mortar bed
6. 3/4" plywood subfloor
7. Existing column
8. New framing

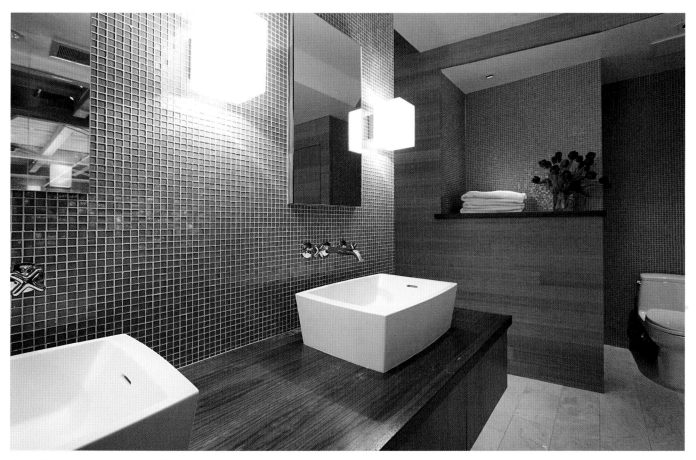

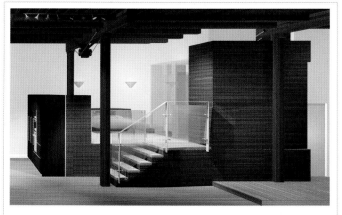

Computer generated rendering

Partitions of transparent or opaque glass help create airy light-filled bathrooms that feel spacious. For instance, Bryant Street Loft has a glass wall between the bath and the sleeping area.

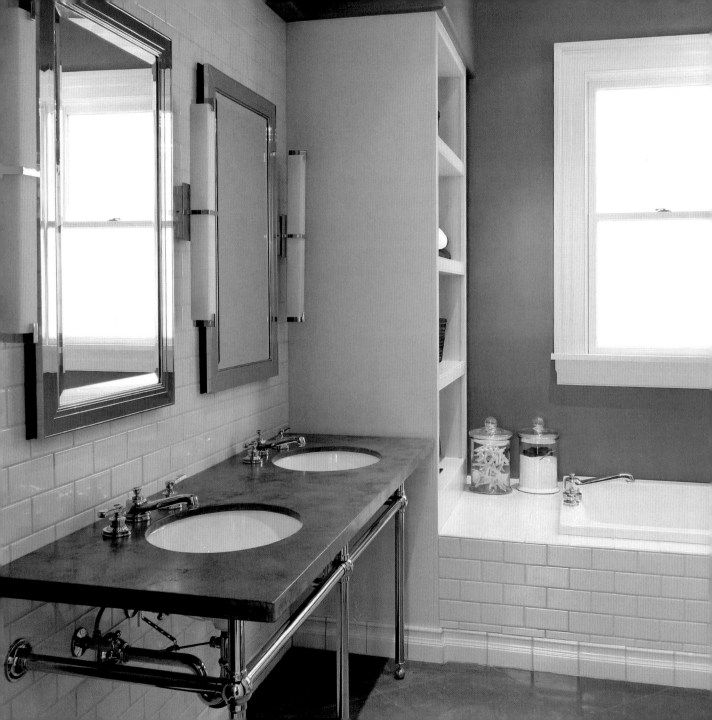

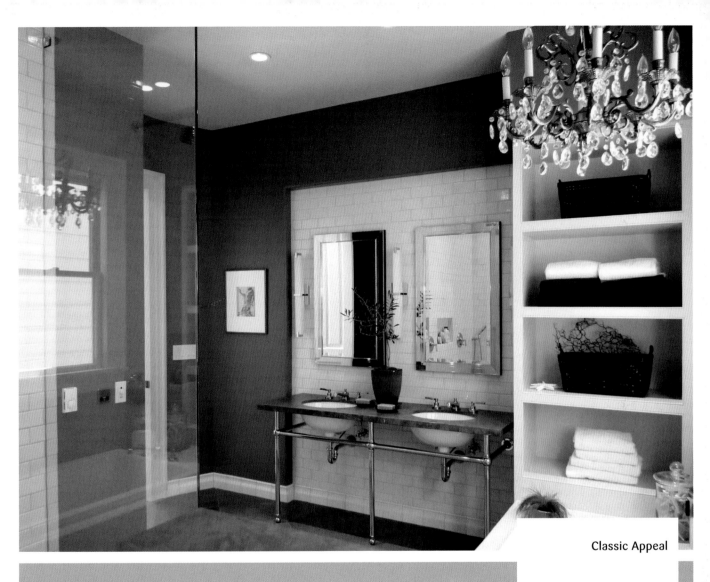

This unusual two-thirds master bath is without a toilet, those facilities being just down the hall. Understated classic fittings, finishes and decorative motifs —like the beautiful mosaic tile carpet in the shower— are arranged in a modernist and minimalist manner, with clean planes, recessed lighting, and a minimum of fuss.

Classic Appeal

Architect: **Studio G+S Architects**

Location: **San Francisco, California, USA**

Photographer: © **Sunny Grewal**

Classic Appeal **27**

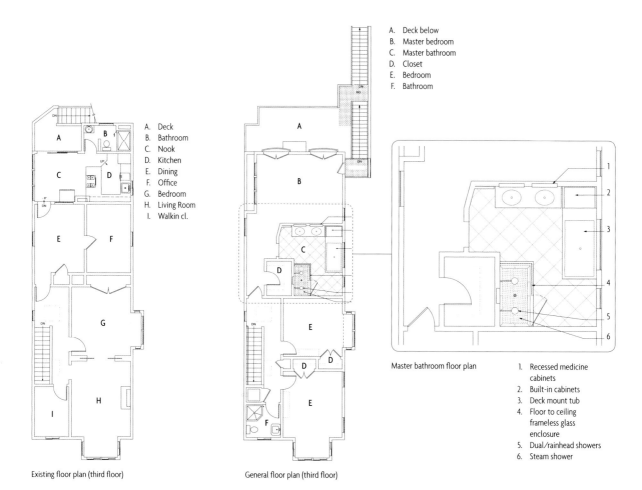

A. Deck
B. Bathroom
C. Nook
D. Kitchen
E. Dining
F. Office
G. Bedroom
H. Living Room
I. Walkin cl.

A. Deck below
B. Master bedroom
C. Master bathroom
D. Closet
E. Bedroom
F. Bathroom

Existing floor plan (third floor)

General floor plan (third floor)

Master bathroom floor plan

1. Recessed medicine cabinets
2. Built-in cabinets
3. Deck mount tub
4. Floor to ceiling frameless glass enclosure
5. Dual/rainhead showers
6. Steam shower

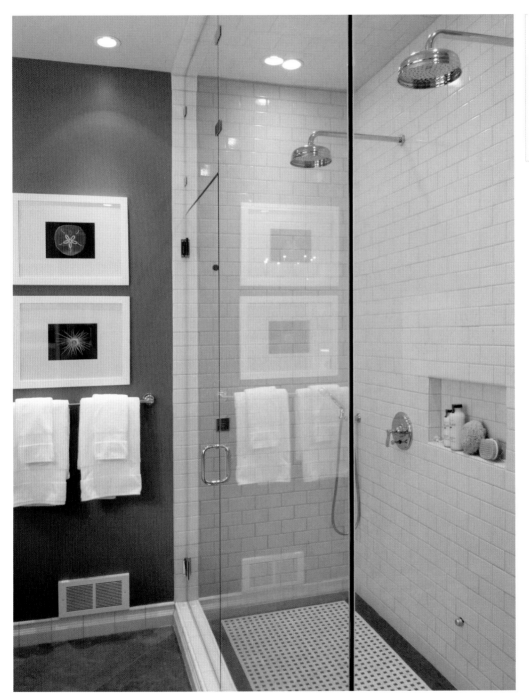

Combining classic fittings
and finishes with modern,
clean, open spaces makes a
comfortable, functional and
beautiful bathroom.

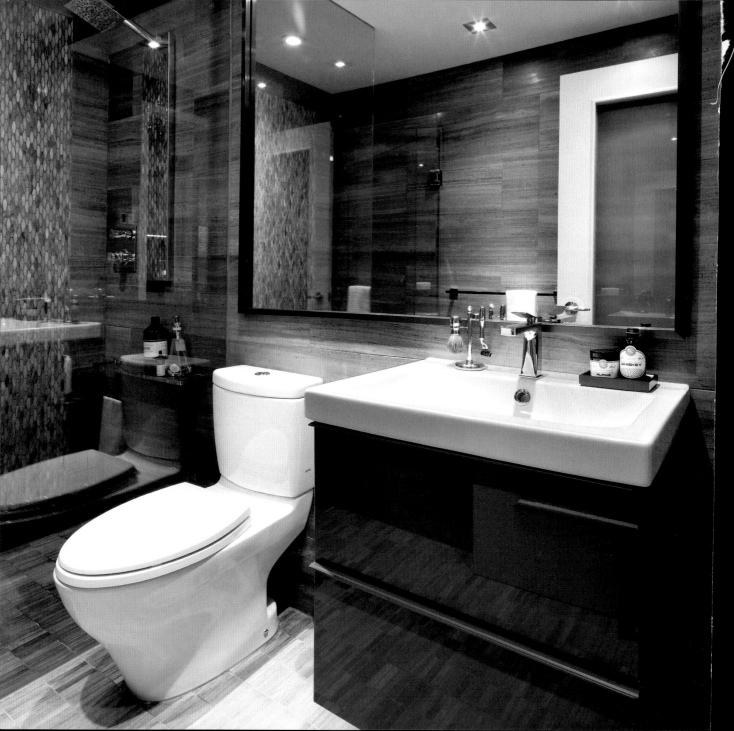

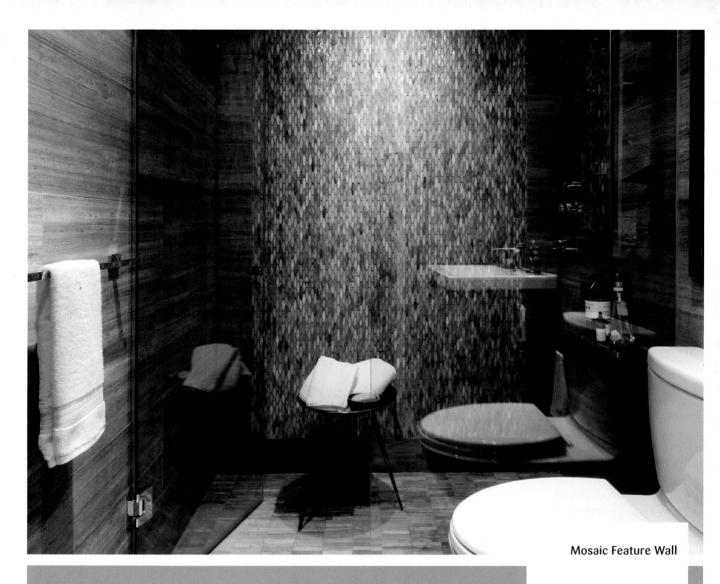

Mosaic Feature Wall

A crisp and contemporary style is achieved through the use of clean lines and sleek finishes. Limestone mosaic floor and wall tile, fish-scale mosaic feature wall and high-gloss gray vanity combine with chrome fittings. The fish-scale mosaic feature wall in the shower area draws the eye to connect all of the colors in the space for a harmonious and serene atmosphere.

Designer: Toronto Interior Design Group
Location: Toronto, Ontario, Canada
Photographer: © Brandon Barre

Floor plan

Elevation at washstand

Elevation at shower

005

A frameless shower enclosure
and a wall-hung vanity are good
ideas to keep in mind when
dealing with small bathrooms.
These details will help create
an airy feeling.

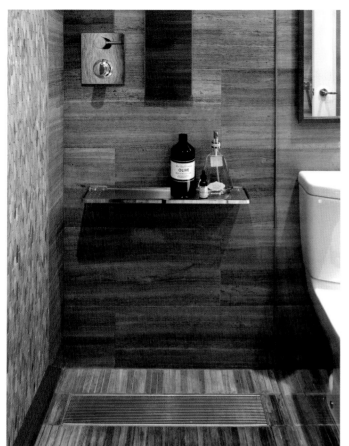

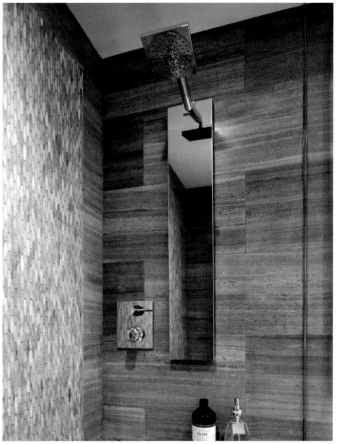

006

To keep an airy feeling amid dark finishes, the walls are wrapped in the same tile treatment except for the feature wall in the shower, which makes an instant focal point.

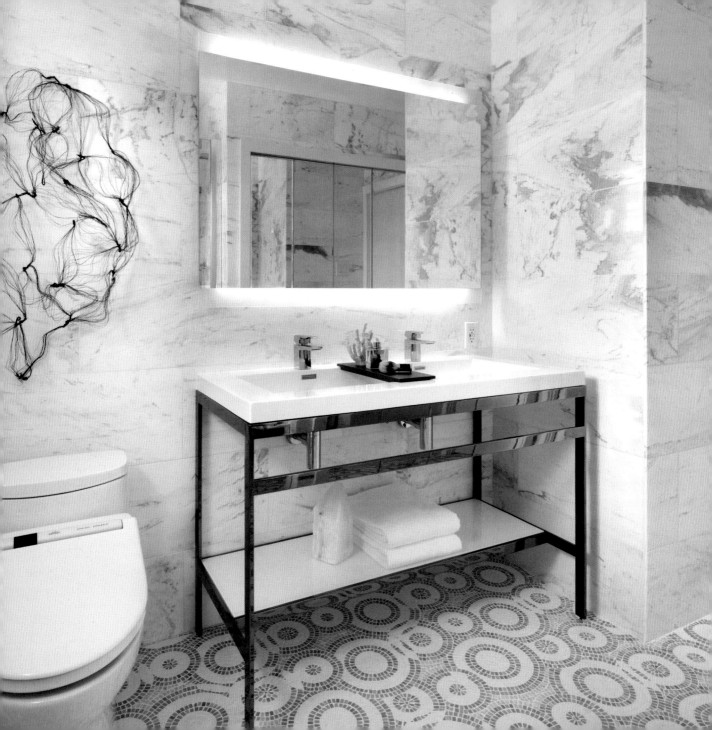

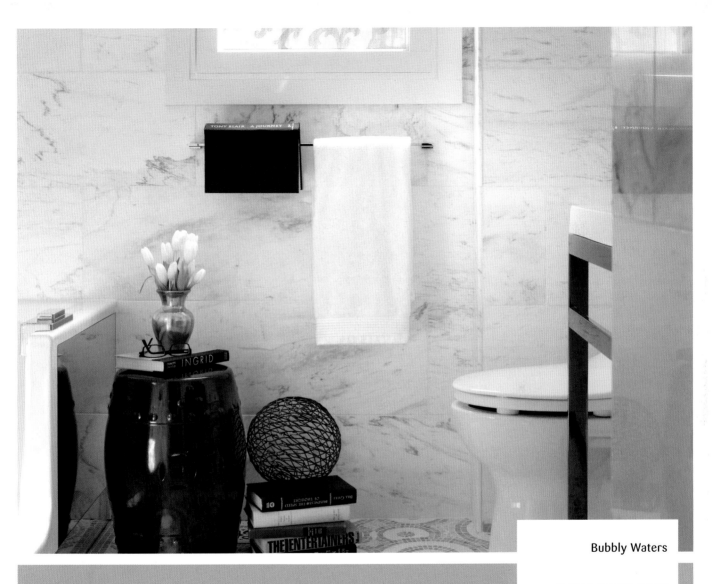

Timeless neutral tones of gray are the focus in this bathroom, with attention to detail through pattern and texture. These elements are layered to create a sense of depth. Natural-stone wall tiles with wavy patterns and mosaic tiles featuring circular designs that resemble bubbly waters provide a spa-like atmosphere. Natural and artificial lighting combine to complete this relaxing setting.

Bubbly Waters

Designer: **Toronto Interior Design Group**

Location: **Toronto, Ontario, Canada**

Photographer: © Brandon Barre

Floor plan

Elevation at shower

007

You don't need to give up on
the idea of having a tub in
your small bathroom. A combo
shower/tub unit provides the
benefits of both in a compact
footprint.

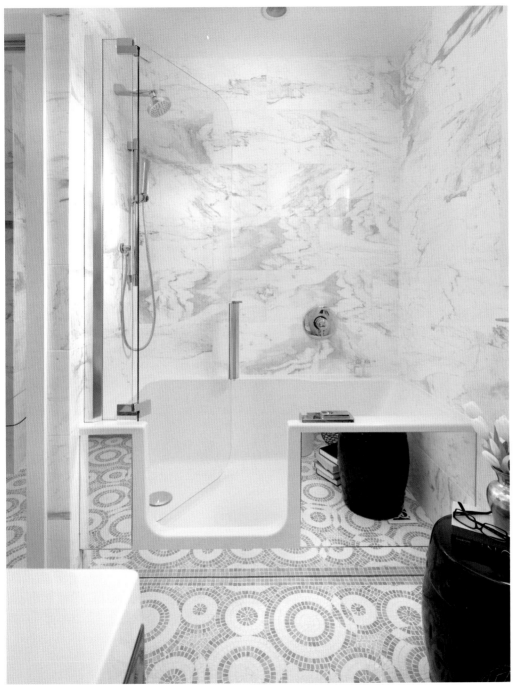

Ambient lighting is provided through the use of reflection with a mirrored skirt tub with a door as well as a backlit mirror over the vanity.

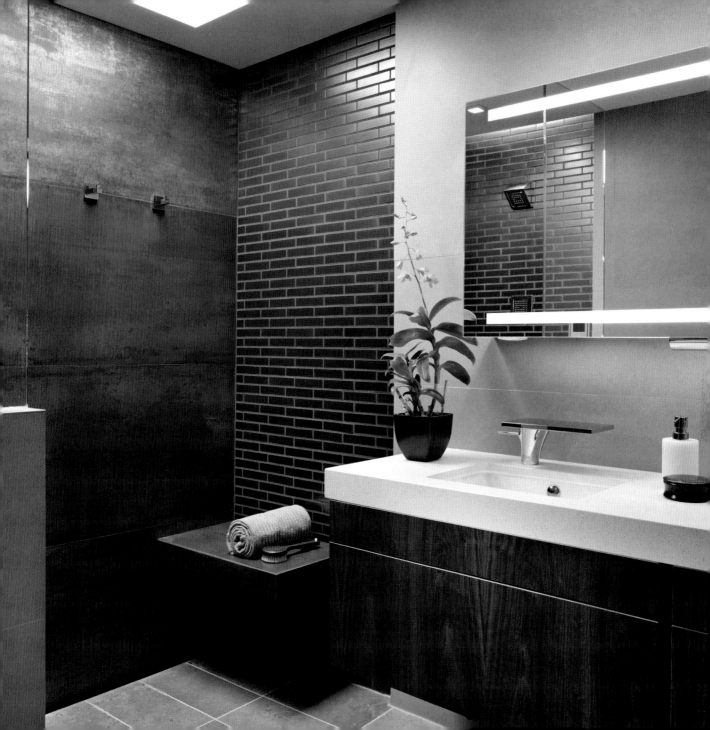

Spa-like Bathrooms

Architect: k YODER design

Location: Philadelphia, Pennsylvania, USA

Photographer: © Jeffrey Totaro

A period restoration of a mid-century house occupied by a young family was not the desired look. Instead, it was reconfigured to suit the family's lifestyle and fitted out with contemporary furnishings and finishes. The conversion of the third floor into a master suite highlights an original ribbon window with walnut wainscoting and a walk-through dressing room.

008

Color and light enhance a
design highlighting materials and
textures. Moreover, light coves
visually create the illusion of
larger spaces as shown in these
photographs.

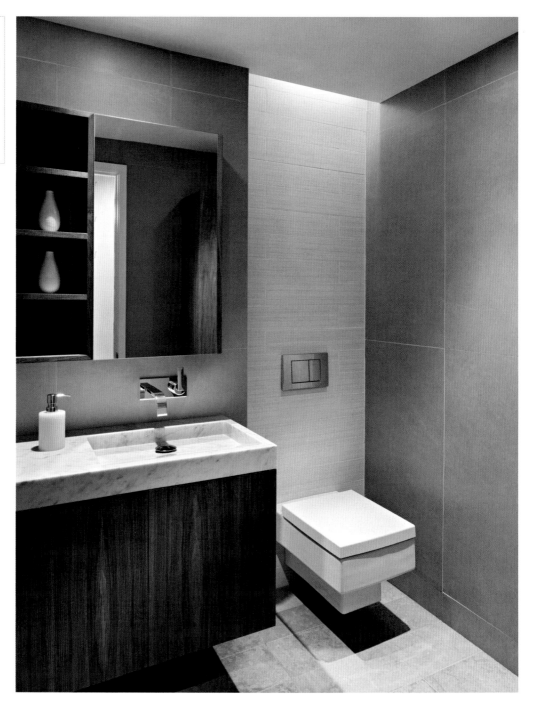

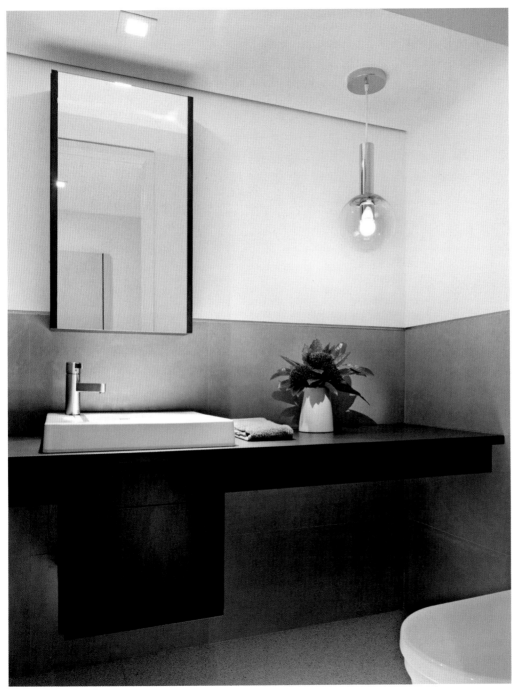

The powder rooms located on the second floor (left page) and on the ground floor (right page) feature floating vanities and natural stone in line with the materials used in the master bathroom on the third floor.

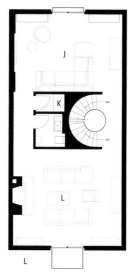

Second floor plan

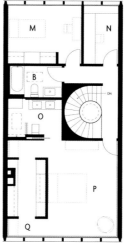

Third floor plan

A. Play room
B. Bathroom
C. Storage
D. Washer and dryer
E. Work room
F. Dining room
G. Kitchen
H. Breakfast room
I. Powder room
J. Family room
K. A/V room
L. Living room
M. Bedroom
N. Office
O. Master bathroom
P. Master suite
Q. Dressing room

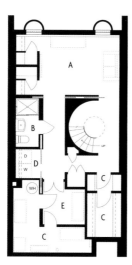

Basement floor plan

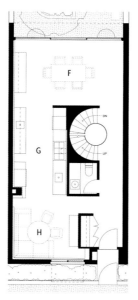

Ground floor plan

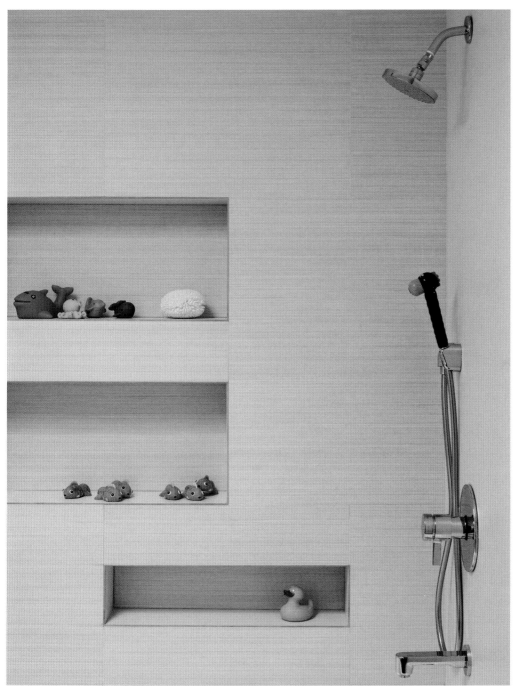

A second bathroom on the third floor is for a young family member. It has its own playful style featuring deep nooks above the tub and colorful details such as the shower handset.

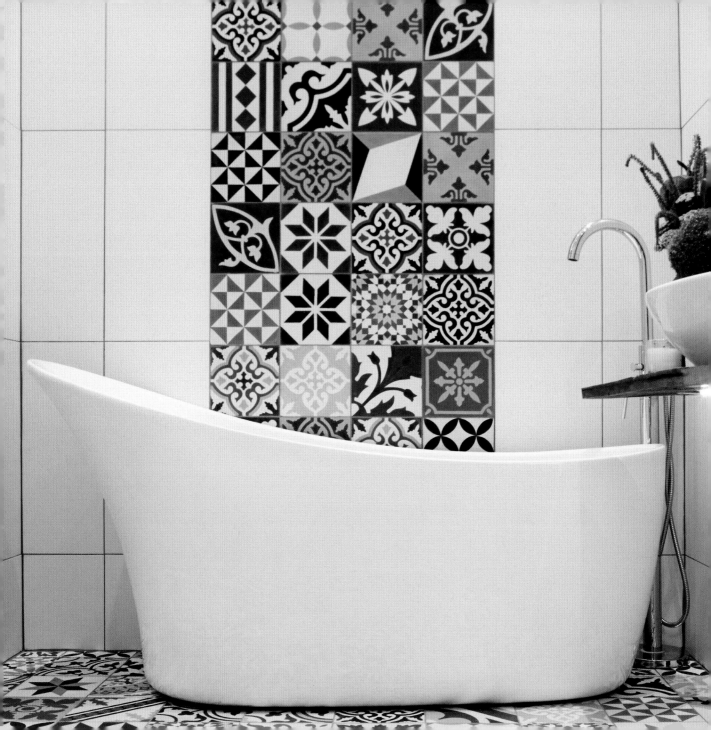

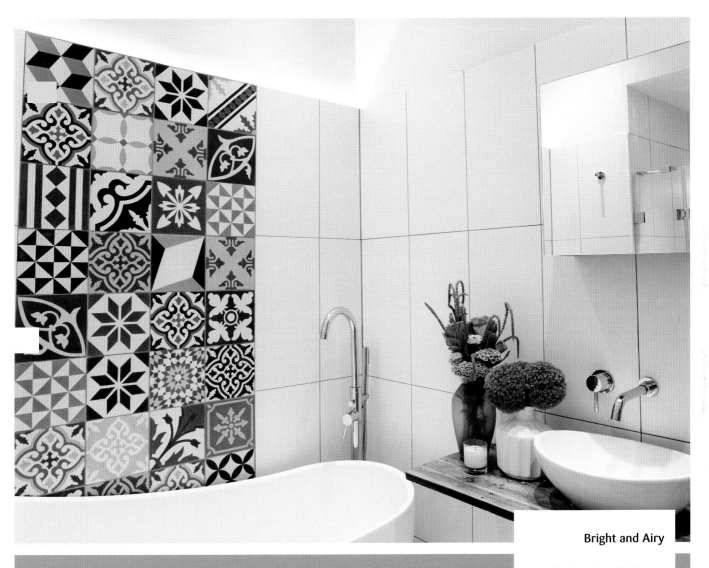

Bright and Airy

Designer: **Cassidy Hugues interior design & styling**

Location: **London, United Kingdom**

Photographer: **© Morgan Hill-Murphy**

Colorful tile, wall to wall across the floor of this bathroom and shower, is all the decoration needed, tying the whole space together. Another splash of color in a band of the tile up the wall sets off the sculptural tub. Classic cement tile comes in a multitude of designs, whether modern reproductions or salvaged originals.

Watercolor rendering

Floor plan

A. Entry
B. Laundry
C. Bathroom
D. Living area
E. Kitchen and
 dining área
F. Bedroom

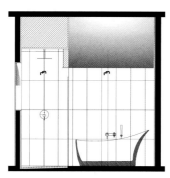
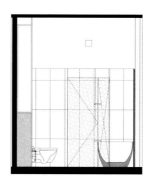

Bathroom interior elevations

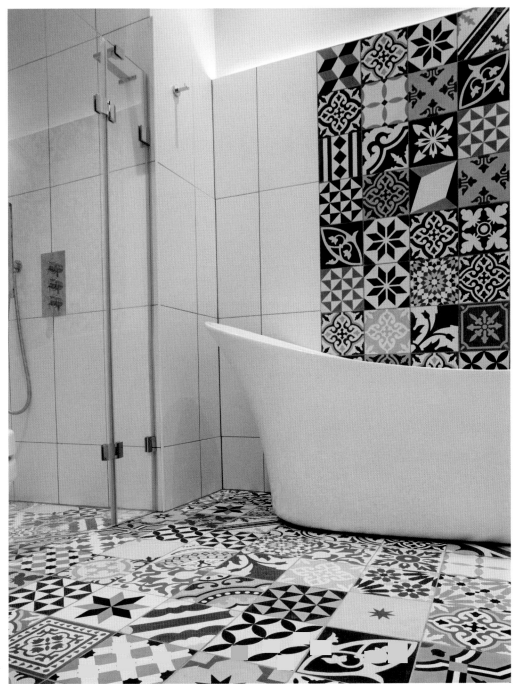

Late nineteenth-/early twentieth-century cement tile was made in a plethora of colorful designs, but often in a uniform size, allowing mixing and matching.

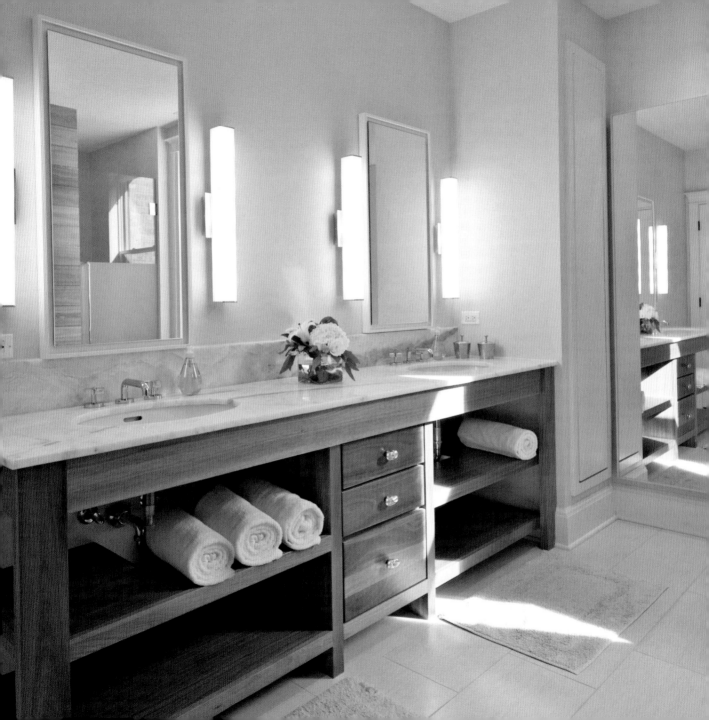

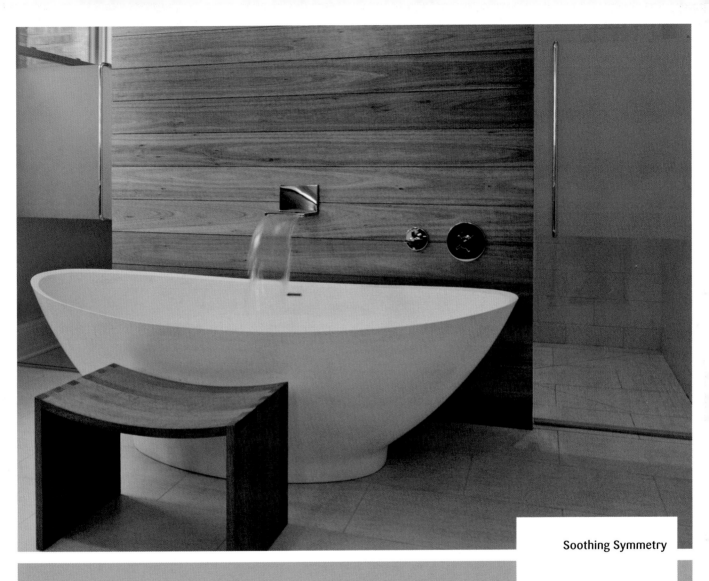

Soothing Symmetry

Architect: Besch Design
Location: Chicago, Illinois, USA
Photographer: © Peter Nilson Photography

Very symmetrical and simple—the tub of this master bathroom sits centered in front of a cedar-planked wall framed on each side by matching frosted-glass doors, with the toilet compartment on one side and the shower on the other. A custom-made vanity with open shelves and a natural stone countertop stands opposite the wall, creating a balanced composition for a calming atmosphere.

Natural wood elements tie the design of the bathroom together. The simple design emphasizes the spaciousness and makes the most of natural light.

Floor plan

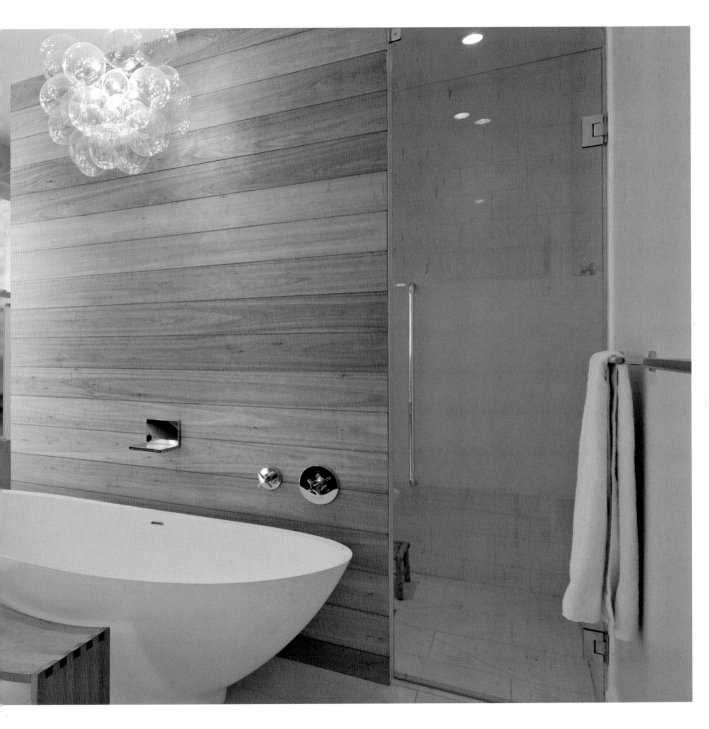

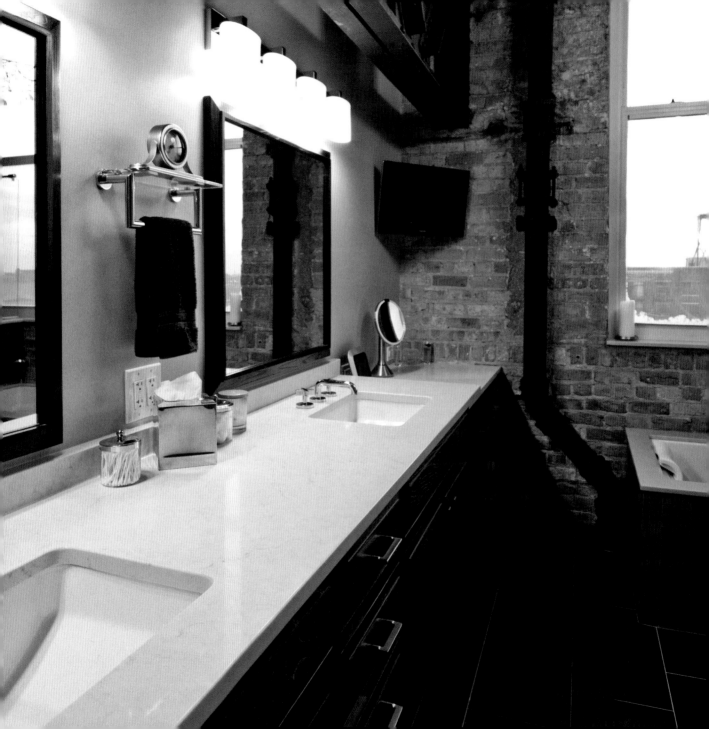

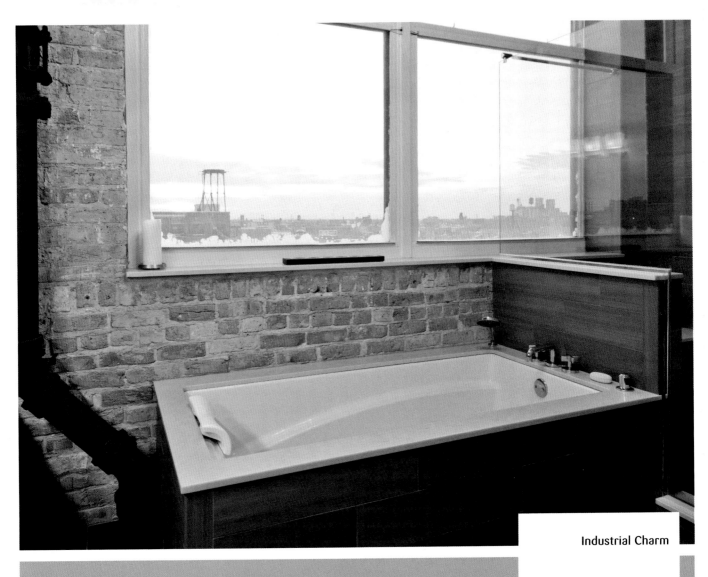

Industrial Charm

Architect: Besch Design
Location: Chicago, Illinois, USA
Photographer: © Peter Nilson
Photography

The rough brick-and-steel trusses of this old industrial building are left exposed, along with hefty pipes, providing contrast to the smooth new finishes of tile, porcelain and polished stone. The heavily grained wood of the cabinets and mirrors hearkens back to the rough industrial character of the original building, tying the space together.

Master bedroom upper level floor plan

Midlevel floor plan

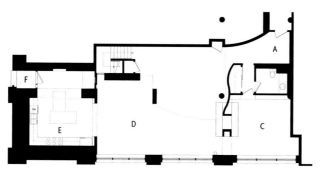

Entry level floor plan

A. Foyer
B. Powder room
C. Den
D. Living/Dining area
E. Kitchen
F. Terrace
G. Open to below
H. Bathroom
I. Laundry room
J. Bedroom
K. Exercise area
L. Master closet
M. Master bathroom
N. Master bedroom

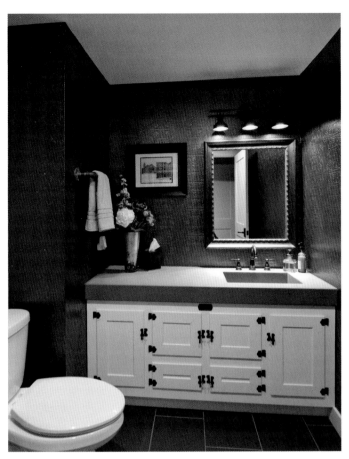

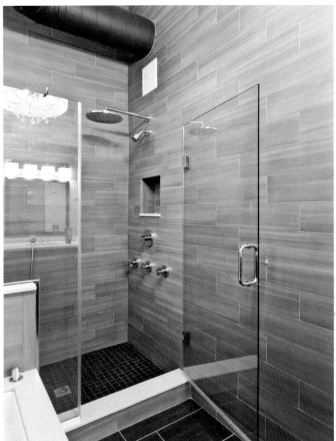

009

The use of varied materials can feel busy or cluttered. But keeping them in a limited color range, as shown in the powder room at the entry level (left) and in the master bathroom at the upper level (right), can bring it all together.

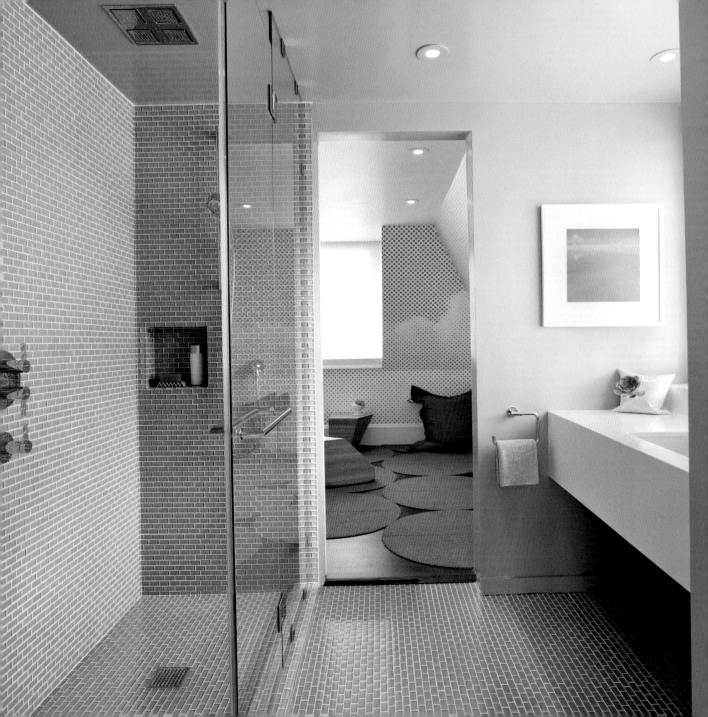

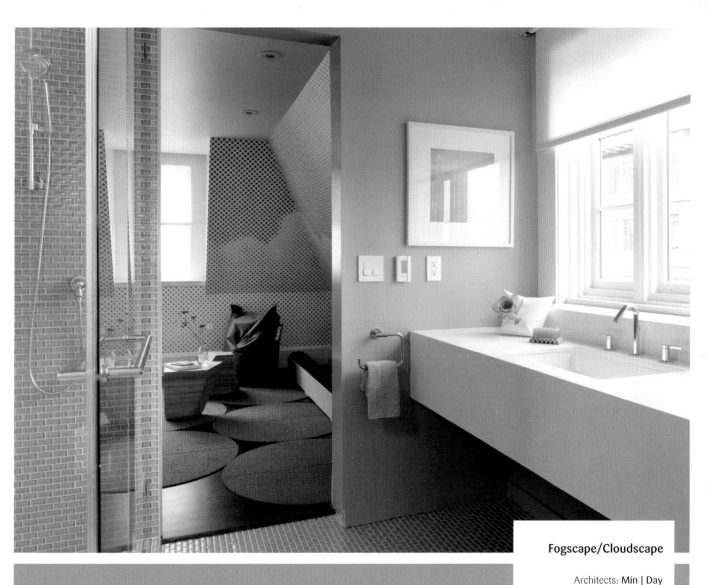

Fogscape/Cloudscape

Architects: **Min | Day**

Location: **San Francisco, California, USA**

Photographer: **Bruce Damonte, Matthew Millman**

Asked to design a "Jack & Jill" bedroom with bathroom connector on the top floor of a large San Francisco home, the architects began with the notion of the rooms as dream-like abstracted landscape. They called the rooms "Fogscape" and "Cloudscape" based on the inspiration taken from the fog that rolls into San Francisco.

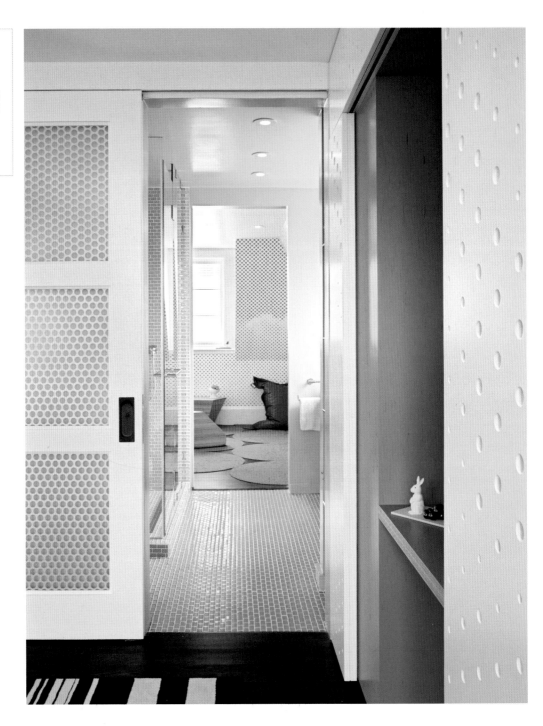

010

Adjacent rooms can be provided with their individual identity without compromising the homogeneity of the overall design.

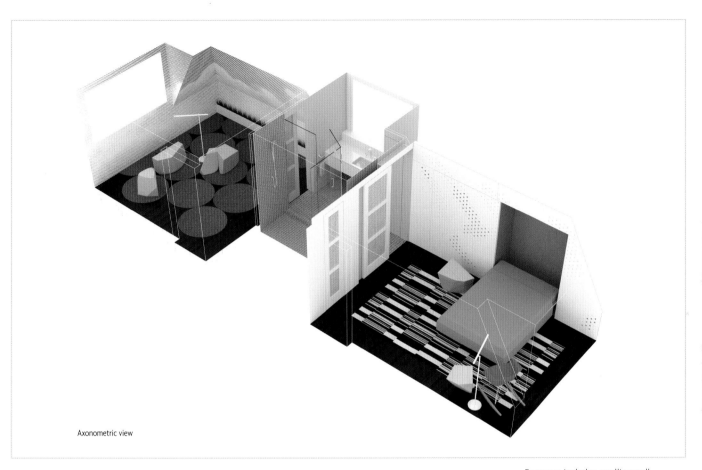

Axonometric view

Fogscape includes a rolling wall revealing either a desk or Murphy bed and Cloudscape features the architects' own designs: Stones Table© and custom Clouds wallpaper.

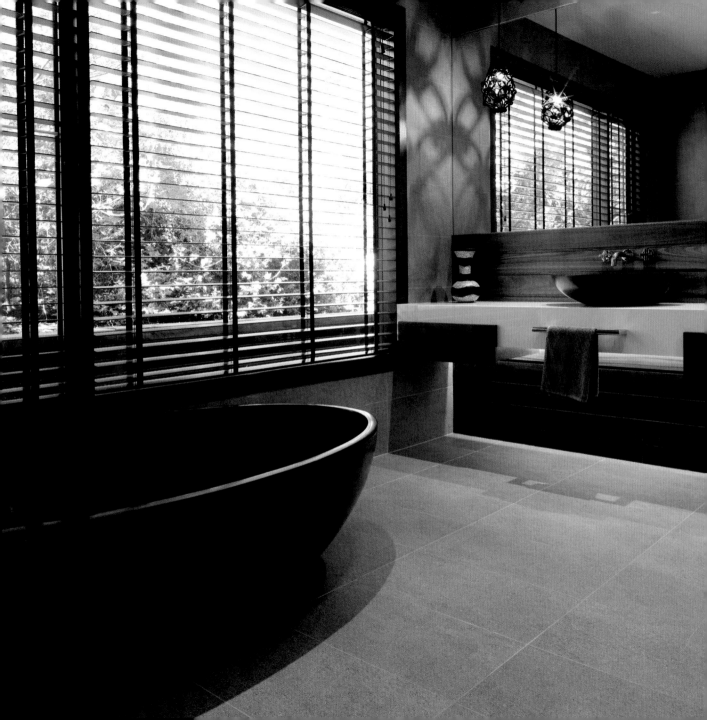

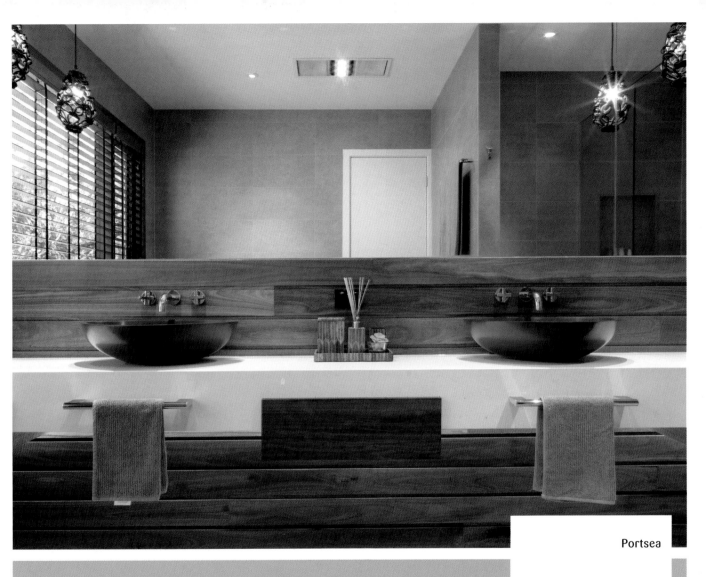

A luxury bathroom is finished in a cool slate gray with warm, natural wood details. A large window makes the space naturally bright, while recessed lighting and pendants round off the design of this bathroom. These pendants cast wallpaper-like shadows on the walls, adding visual interest. Undercounter lighting highlights the wood wall and makes the vanity look like it floats.

Designer: **MR. MITCHELL**
Location: **Portsea, Victoria, Australia**
Photographer: © **Andrew Wuttke**

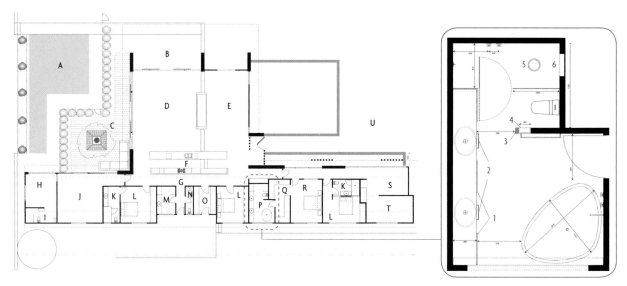

General floor plan

A. Pool
B. Outdoor dining
C. Entertaining terrace
D. Lounge area
E. Dining area
F. Kitchen
G. Service corridor

H. Gym
I. Gym bathroom
J. TV room
K. Guest bathroom
L. Guest bedroom
M. Main bathroom
N. Powder room

O. Laundry room
P. Master bathroom
Q. Walk-in closet
R. Master bedroom
S. Recreation room
T. Game room
U. Future carport

Proposed master bathroom

1. 20 mm thick spotted gum drawer fronts
2. Hand towel rails
3. Tiled timber stud
4. New floor to ceiling cabinet
5. Ceiling mounted shower head
6. Recessed shower shelf 450 mm wide x 600 mm high

011

In frame walls, the depth of the wall can be utilized for shallow built-in storage or shelves. These shelves are finished to match the vanity.

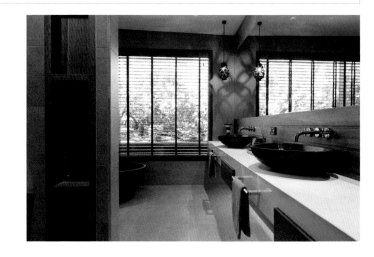

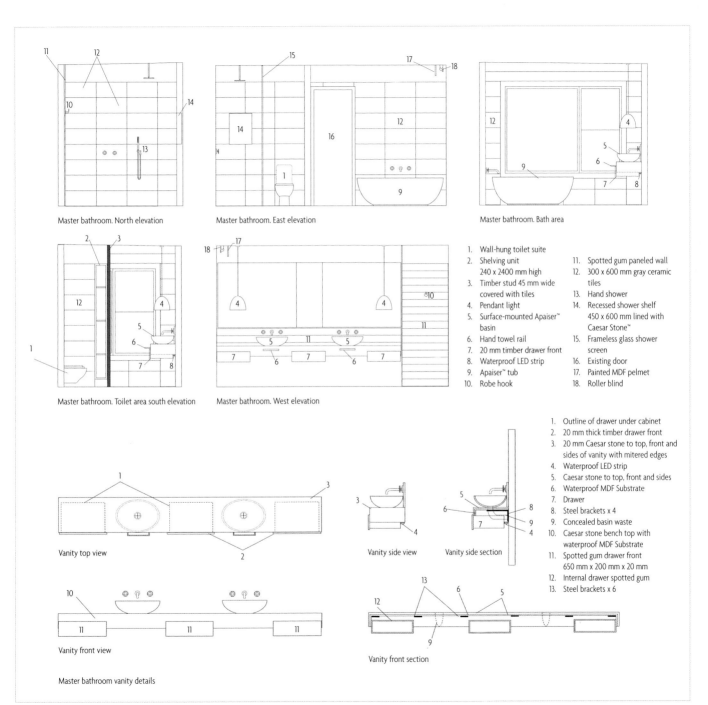

Master bathroom. North elevation

Master bathroom. East elevation

Master bathroom. Bath area

Master bathroom. Toilet area south elevation

Master bathroom. West elevation

1. Wall-hung toilet suite
2. Shelving unit
 240 x 2400 mm high
3. Timber stud 45 mm wide
 covered with tiles
4. Pendant light
5. Surface-mounted Apaiser™ basin
6. Hand towel rail
7. 20 mm timber drawer front
8. Waterproof LED strip
9. Apaiser™ tub
10. Robe hook
11. Spotted gum paneled wall
12. 300 x 600 mm gray ceramic tiles
13. Hand shower
14. Recessed shower shelf
 450 x 600 mm lined with Caesar Stone™
15. Frameless glass shower screen
16. Existing door
17. Painted MDF pelmet
18. Roller blind

Vanity top view

Vanity side view

Vanity side section

Vanity front view

Vanity front section

Master bathroom vanity details

1. Outline of drawer under cabinet
2. 20 mm thick timber drawer front
3. 20 mm Caesar stone to top, front and sides of vanity with mitered edges
4. Waterproof LED strip
5. Caesar stone to top, front and sides
6. Waterproof MDF Substrate
7. Drawer
8. Steel brackets x 4
9. Concealed basin waste
10. Caesar stone bench top with waterproof MDF Substrate
11. Spotted gum drawer front 650 mm x 200 mm x 20 mm
12. Internal drawer spotted gum
13. Steel brackets x 6

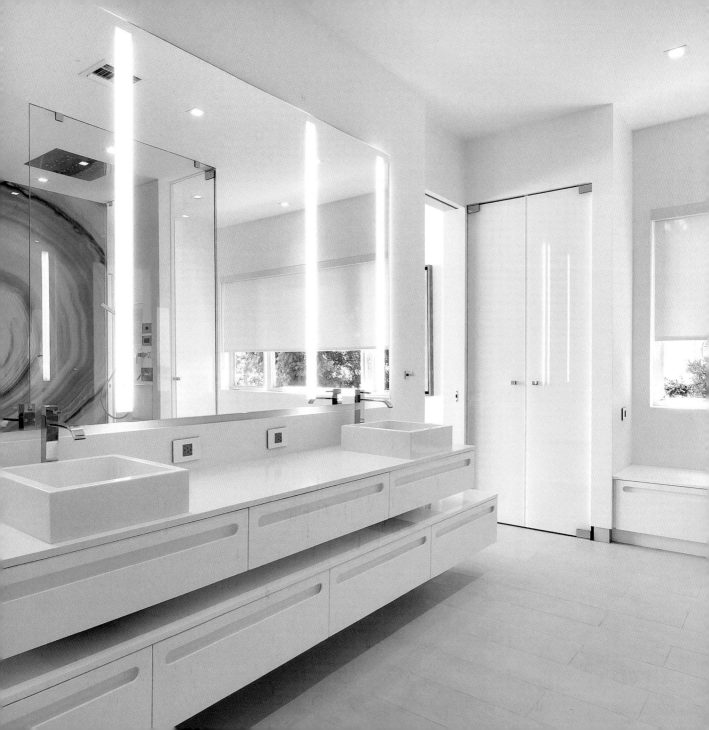

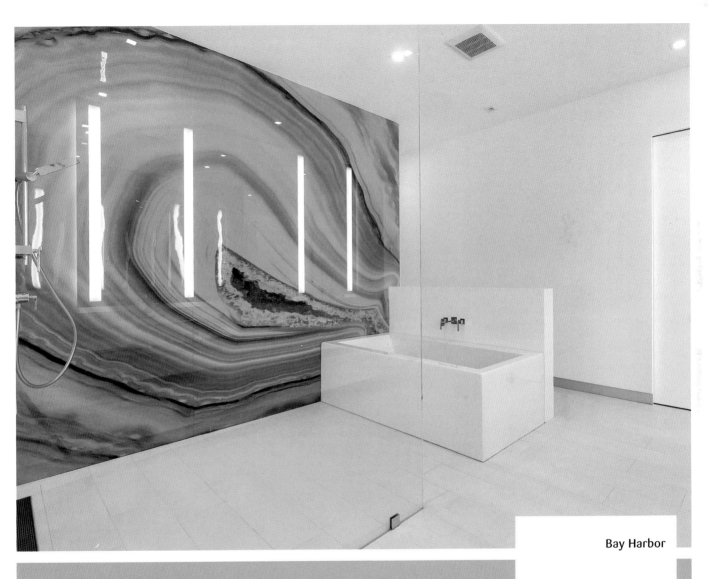

The yin is a big, shiny, liquid blue agate wall that backstops the "wet" areas of shower and bath. On its backside, in the adjacent space, is its yang: a textured woven-looking wall of wood. A clever detail is the cantilevered white boxes that form the vanity when set in two rows, or a long low cabinet/window seat when set in just one row. Glass, transparency and openness are this bath's theme.

Bay Harbor

Architect: one d+b architecture
Location: Miami, Florida, USA
Photographer: © one d+b architecture

The space on one side of the wall is cool and aqueous. On the other side, the space is warm and earthy. It's all in the selection of colors and materials.

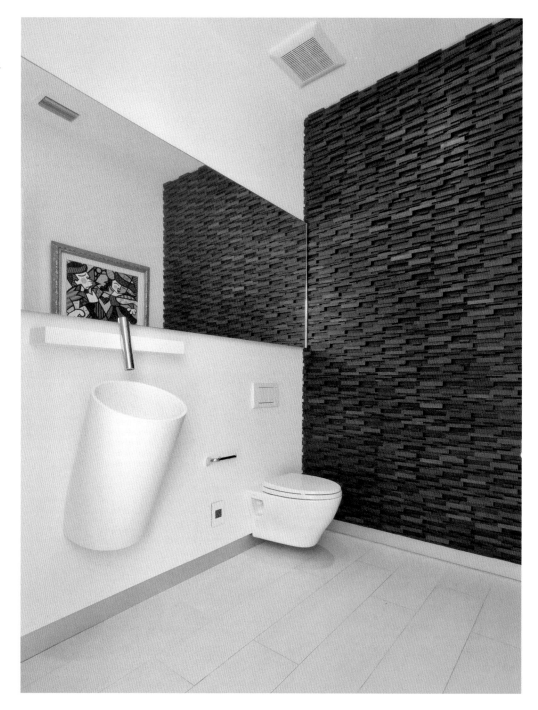

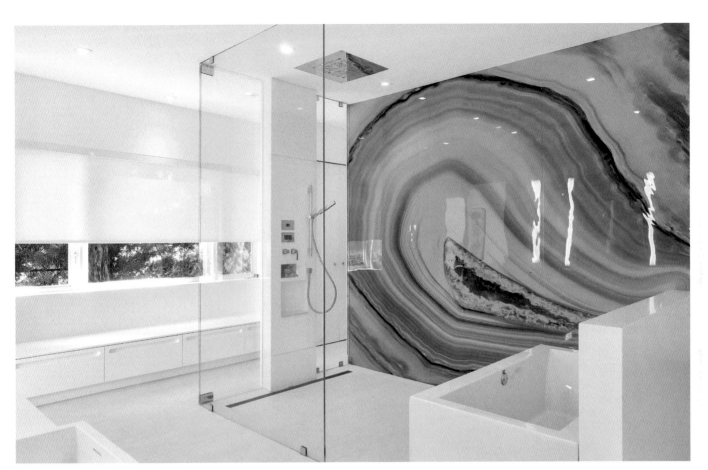

012

One side of the shower can be left open, dispensing with the need of a door if there is enough space for a little splashing before water reaches permeable surfaces.

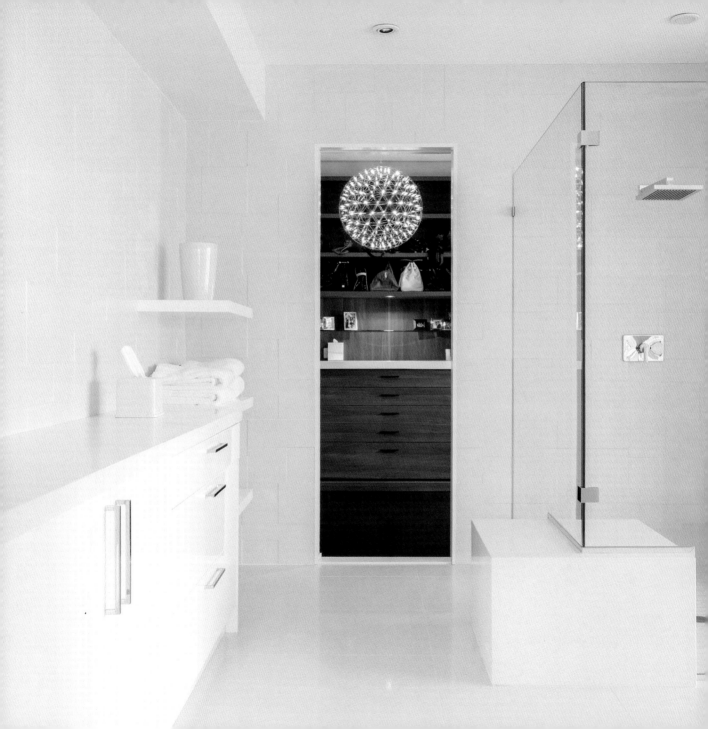

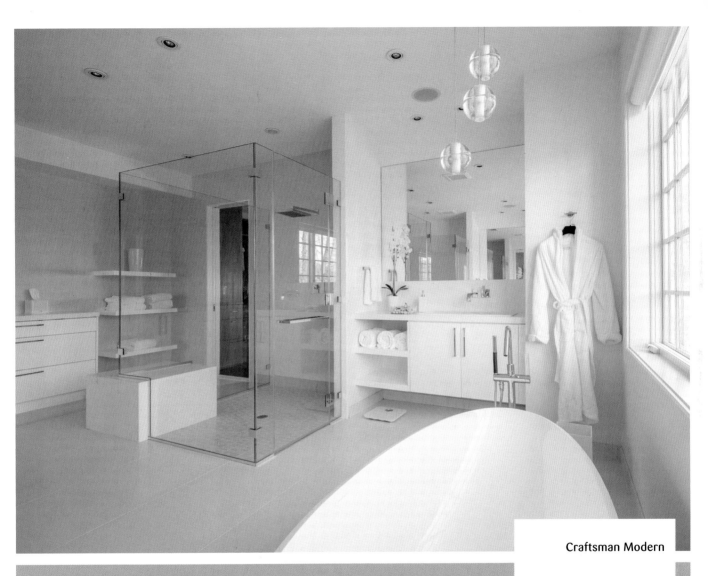

Craftsman Modern

Designer: **FORMA Design**

Location: **North Arlington, Virginia, USA**

Photographer: © **Goeffrey Hodgdon**

This bathroom is centered on a wide window, with the tub dead-center beneath its sill and the vanities flanking each side. The shower and toilet-stalls form bookend glass cubes between which one must pass to approach the window. The only off-center element is a tiled cube bench intersected by the glass shower partition. Lots of storage is offered in the vanities and at the back wall.

Third floor plan

Second floor plan

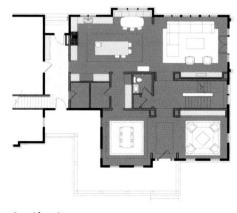

Ground floor plan

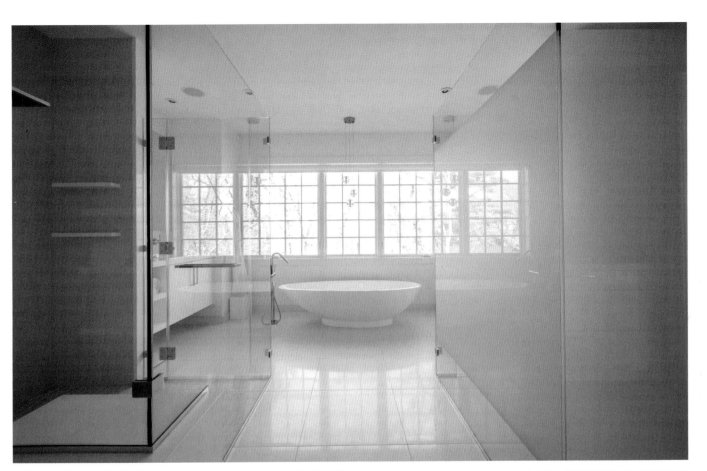

013

Night and day views between the glass enclosed shower and toilet stalls to the garden window can be enjoyed. Frosting of the glass provides a little privacy at the shower stall.

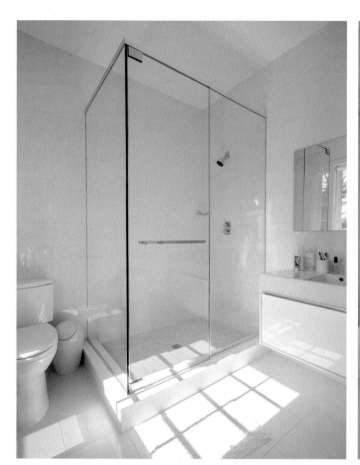
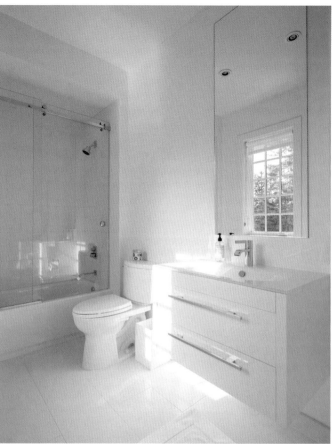

There are two other bathrooms in
this house, which are more utilitarian,
but they borrow some of the glamour
of the master bath by repeating
its finishes and details.

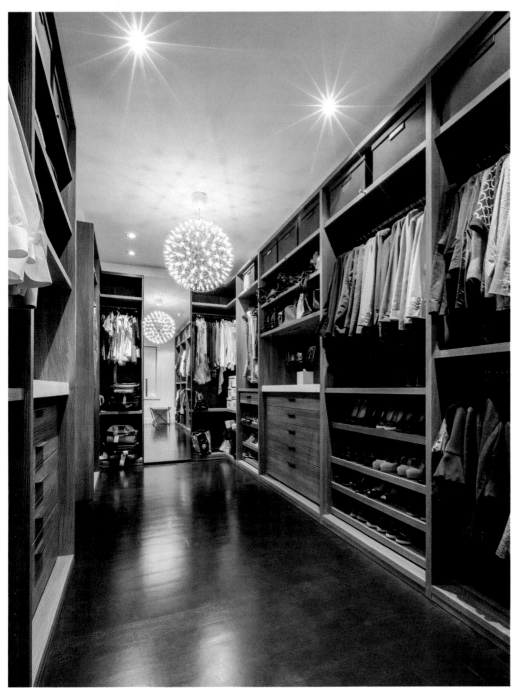

This dressing room attached to the bathroom is a contrast to the light-filled bathroom. The chandelier marks the crossing of the axis of the closet and the entry from the bathroom.

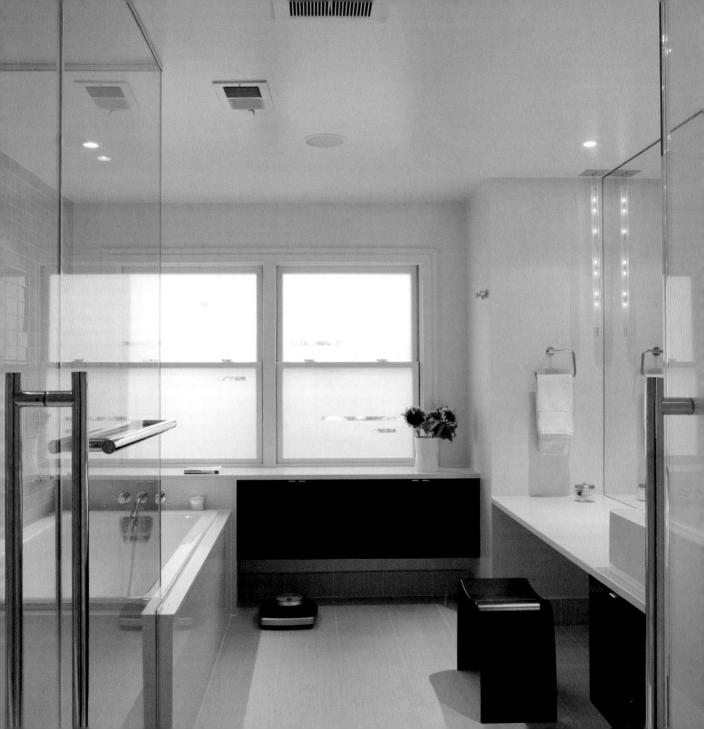

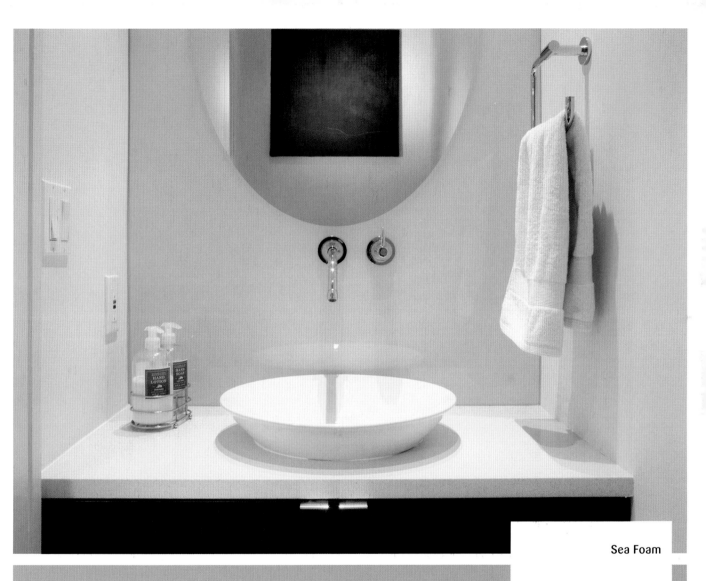

Sea Foam

Designer: **FORMA Design**

Location: **Rosslyn, Virginia, USA**

Photographer: © **Goeffrey Hodgdon**

As you enter this master bathroom you pass between walls of glass enclosing the shower and toilet compartments. Glass is again the finish in the form of a floor-to-ceiling mirror along one entire wall—frameless like the partitions. The powder room is a variation on the same theme. The walls, painted in sofa white or lined in a sea foam green tile work, echo the green glass of all the partitions and mirrors.

014

The use of horizontal alignment of the vanity counter and the wide windowsill cabinet help bring visual order to the space.

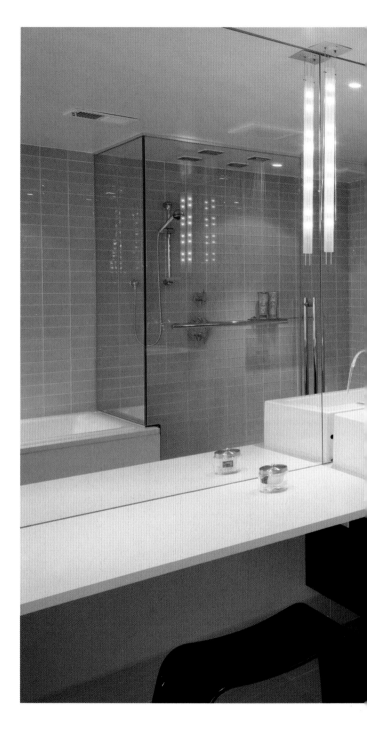

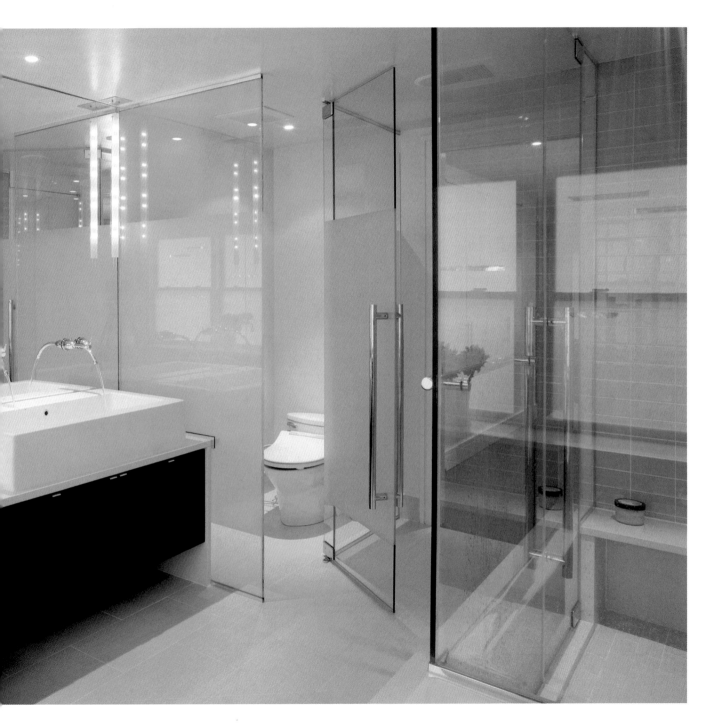

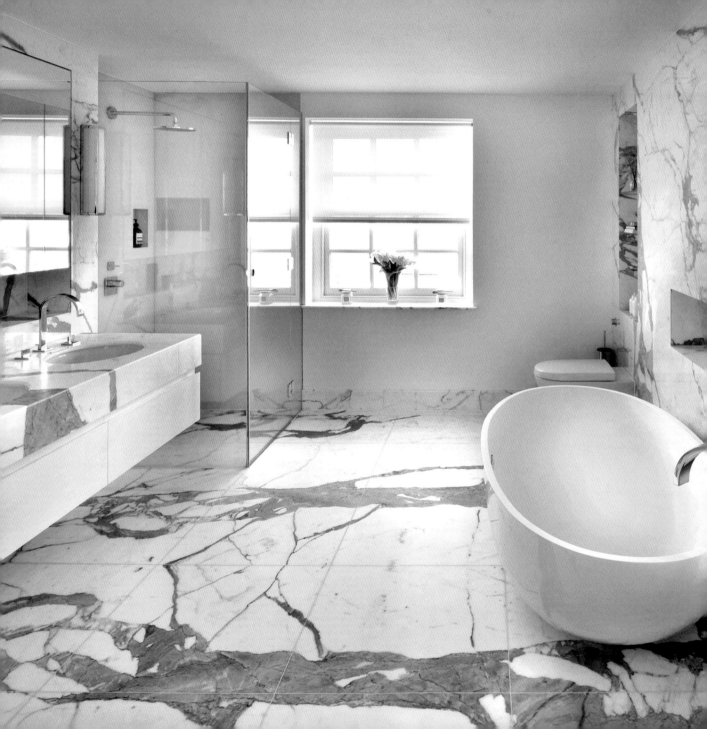

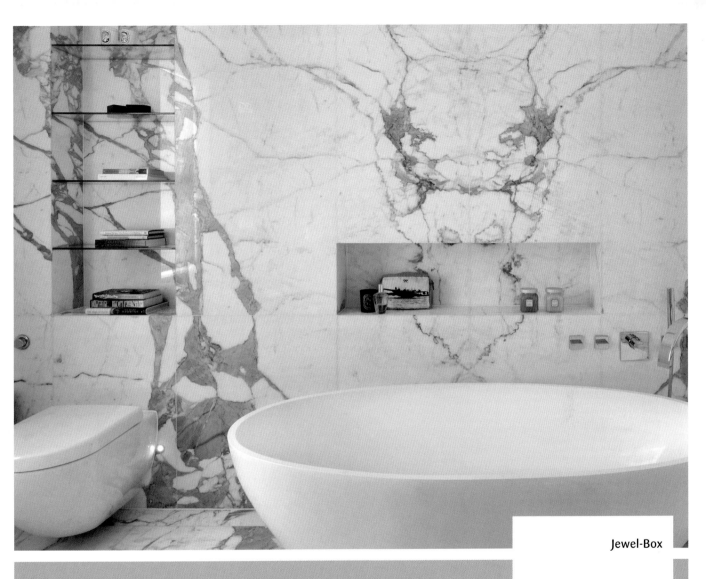

Designer: TG Studio

Location: London,
United Kingdom

Photographer: © Philip Vile

In this jewel-box of a bathroom, the designer has used some very strikingly veined statuary marble and laid it out so that the entire room, floors and walls, is one giant book-matched pattern. The pattern is centered on both the vanity and the tub. Deeply recessed ledges at the tub, vanity, toilet and shower set up another pattern, which breaks the marble veining.

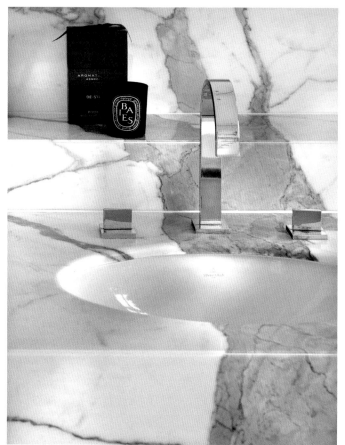

015

Whenever you use large slabs of patterned stone you must always carefully select the location of each piece of stone according to its pattern and color.

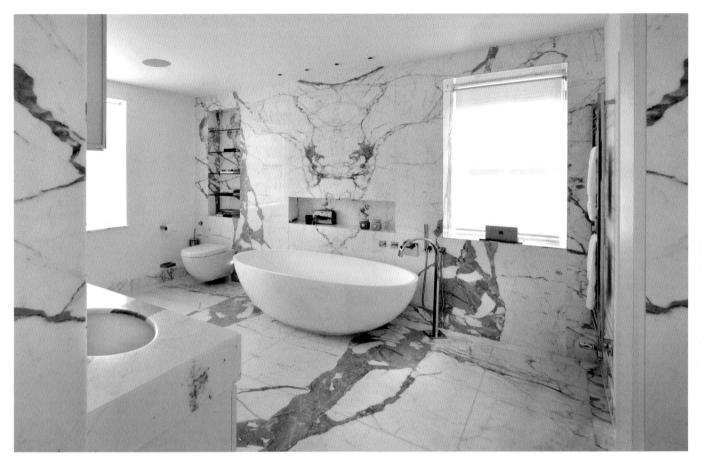

016

The designer recommends that you "ask for an anti-slip finish to be applied on a polished marble floor as it can be very slippery when wet."

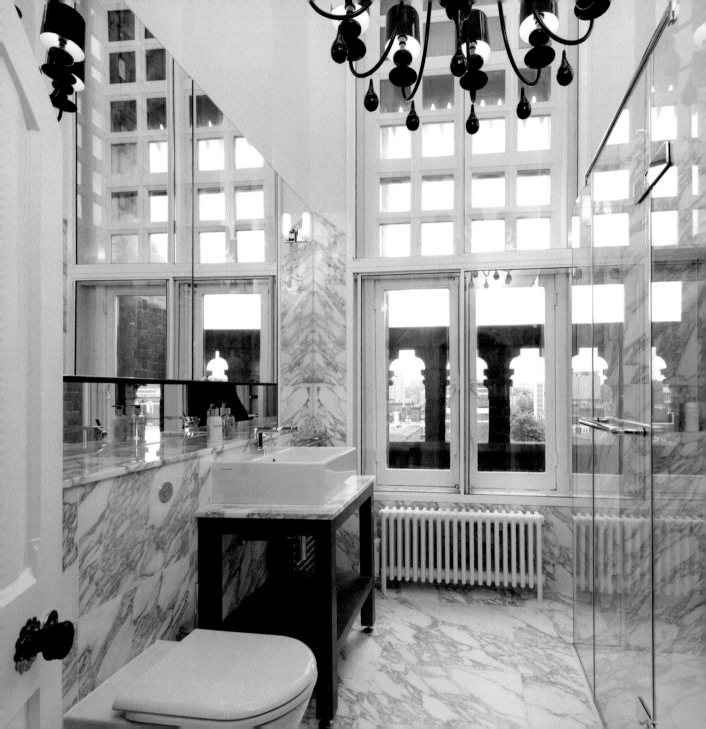

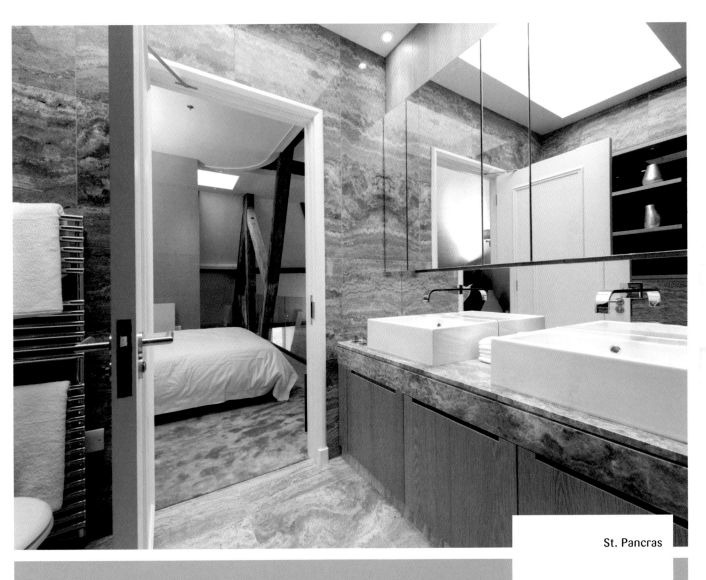

St. Pancras

These two marble-clad bathrooms are on the lower floor and top of a grand, three-story urban apartment. The richly veined marble covers both the walls and floor and is reflected and refracted—multiplied—in planes of reflective glass and frameless mirrors, making it by far the dominant element. Large mirror-door upper cabinets in both bathrooms provide ample storage.

Designer: TG Studio
Location: London,
United Kingdom
Photographer: © Philip Vile

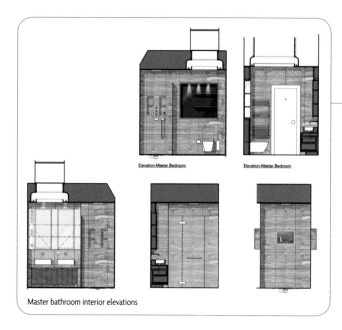

Elevation-Master Bedroom Elevation-Master Bedroom

Master bathroom interior elevations

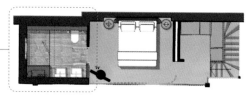

Upper floor plan

Mezzanine floor plan

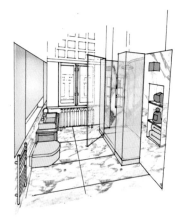

Perspective view

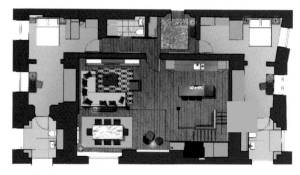

Lower floor plan

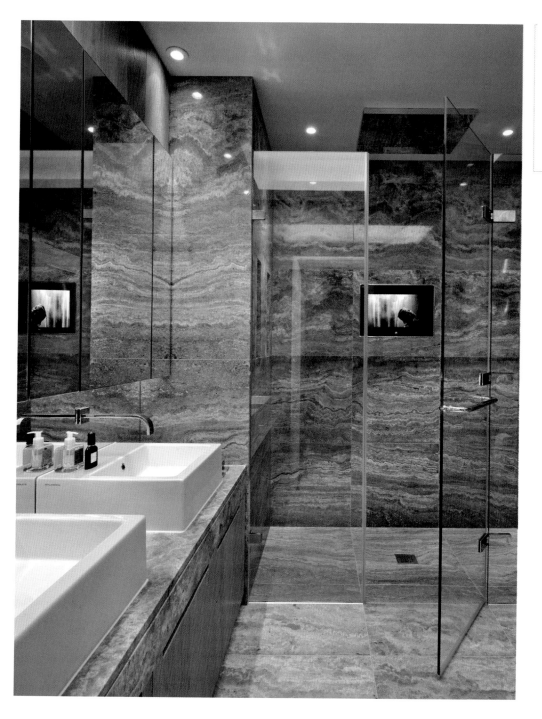

A limited palette of materials will assure a unified look. Here we have only stone, glass/mirror, wood, white porcelain fixtures and chrome fittings.

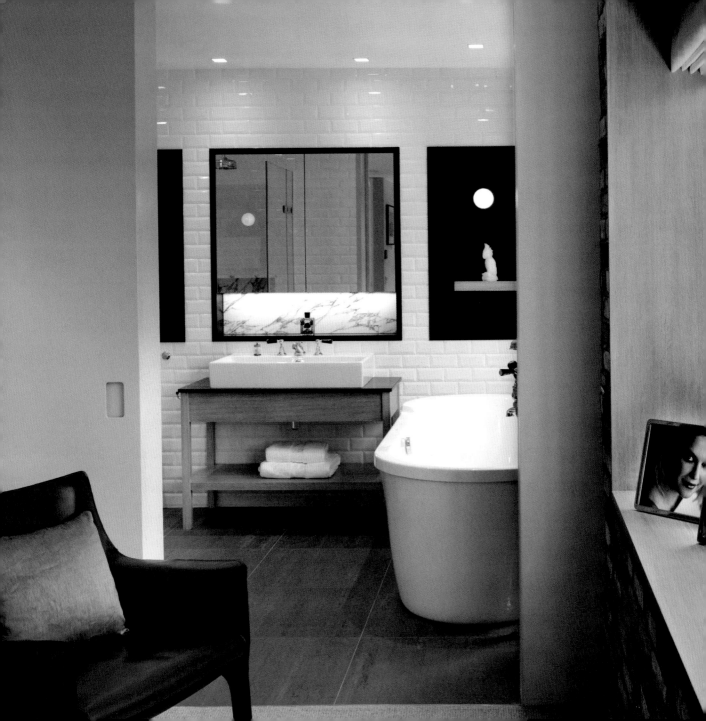

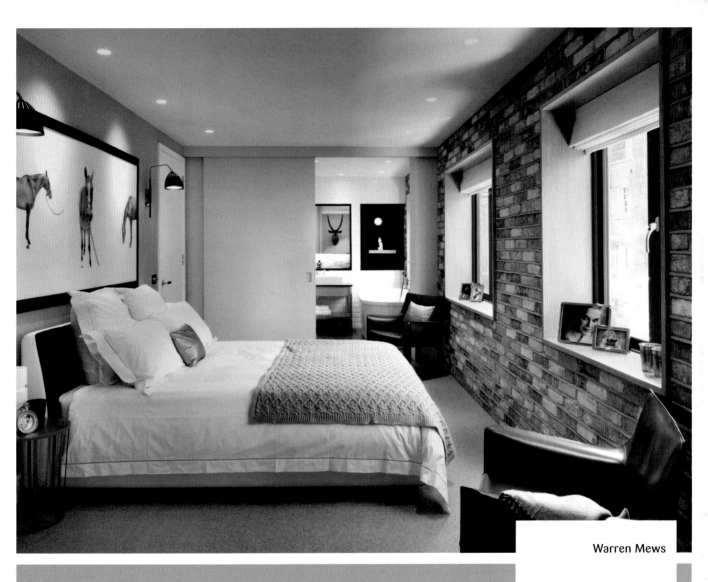

This bathroom flows into the master suite through a large sliding wall. Both bedroom and bath share a continuous brick wall. Very large, flat porcelain slabs on the floor contrast with the small-scale texture of the white subway tile walls. Two centered cross axes are defined in this simple square room by a large window and tub centered on one wall and the vanity and mirror on another.

Warren Mews

Designer: TG Studio

Location: London,
United Kingdom

Photographer: © Philip Vile

A big sliding wall as the door to the bathroom in a master suite allows the spaces to flow together most of the time, while still letting the bathroom be closed off when needed.

Third floor plan

Second floor plan

Ground floor plan

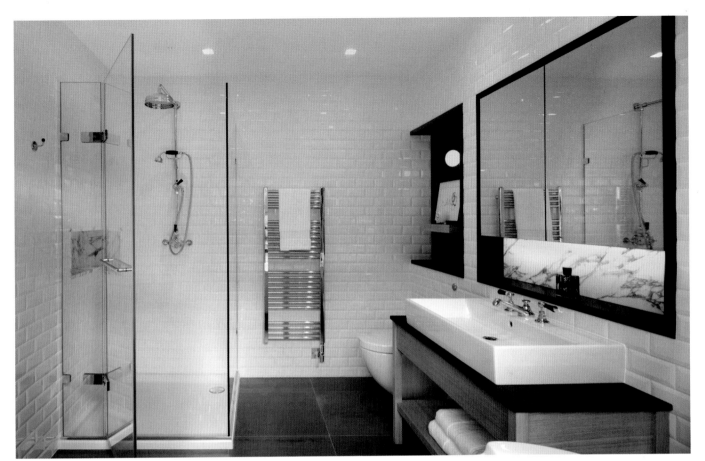

018

An elegant and relaxed bathroom needs a little space. Do not overfill the room. Allow the fixtures to "float" and the space to flow around them.

Two wood-lined niches flanking the vanity and a third with a mirror above the sink add visual depth to the space and reinforce the axis that connects the bathroom with the bedroom.

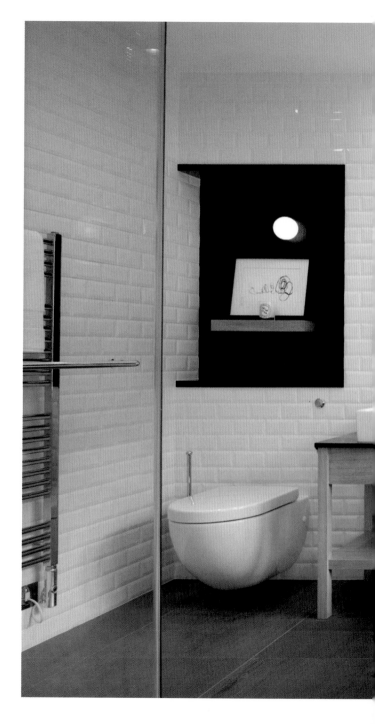

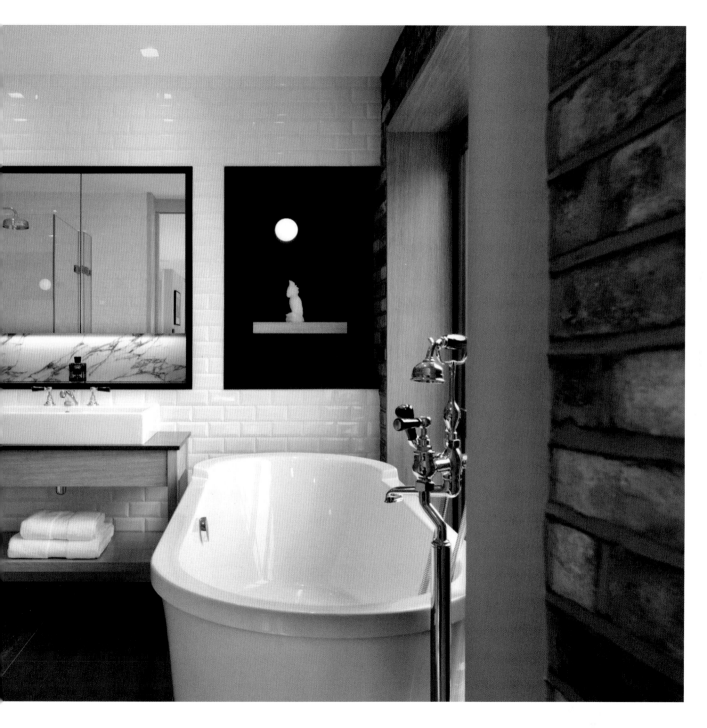

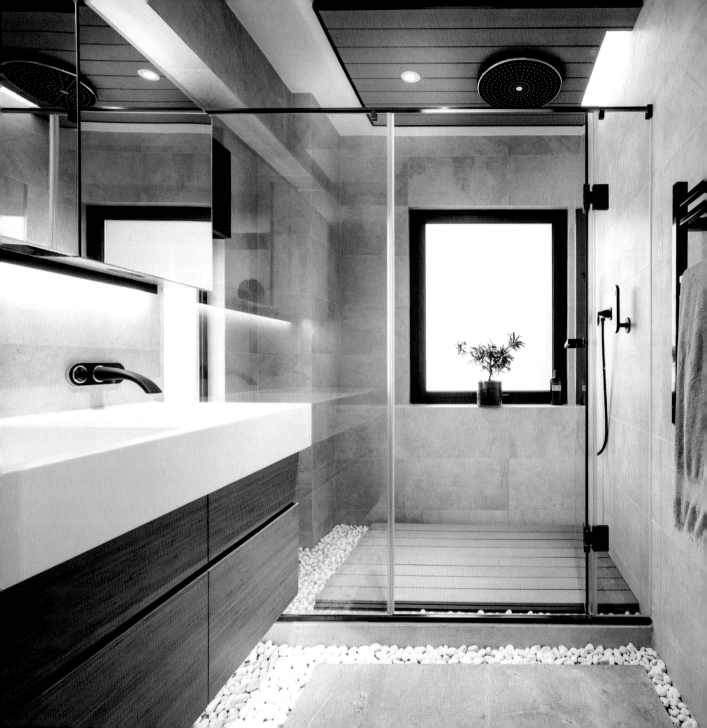

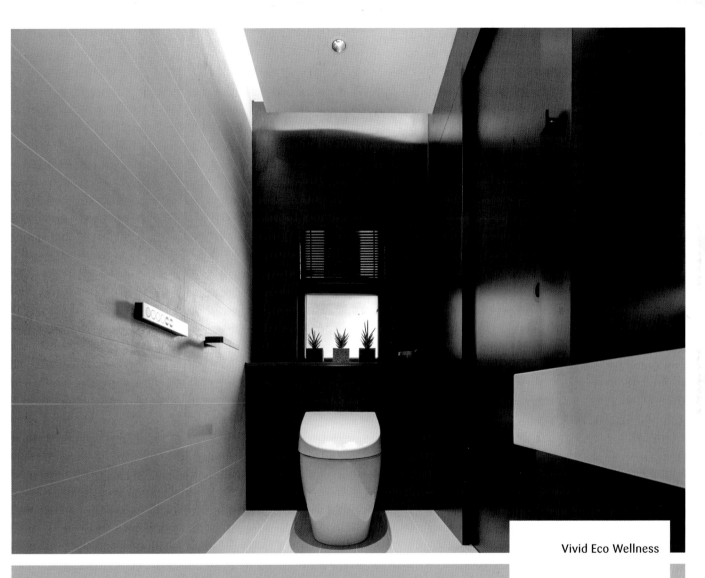

Vivid Eco Wellness

Designer: Liquid Interiors
Location: Hong Kong, China
Photographer: © Liquid Interiors

In these two small bathrooms the detached planes of walls, ceilings and floors float past each other, never quite touching. These disjointed planes, rendered in contrasting materials, suggest a continuation of the space flowing beyond the walls, which helps these small spaces feel just a little less constricted. Garden-like materials, wood deck planks and river rocks, enhance this feeling.

Master bathroom 's shower interior elevations

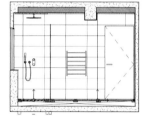
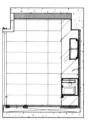

Master bathroom interior elevations

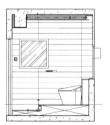

Guest bathroom interior elvations

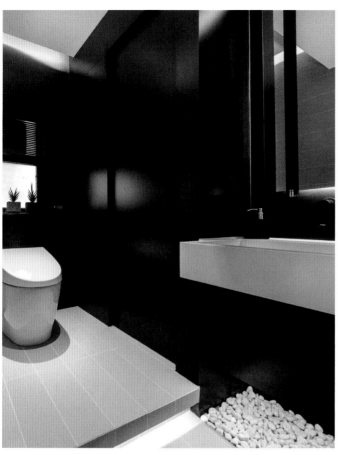

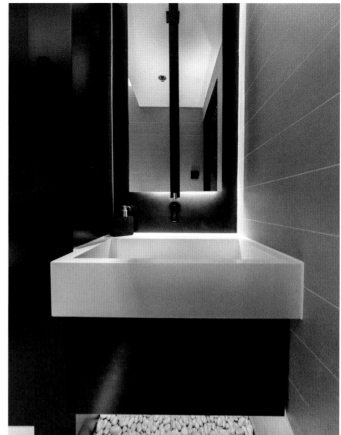

019

Breaking apart the planes of walls, floors and ceilings helps small spaces feel larger and provide troughs for hidden, indirect lighting. The river rocks are a creative touch.

General floor plan

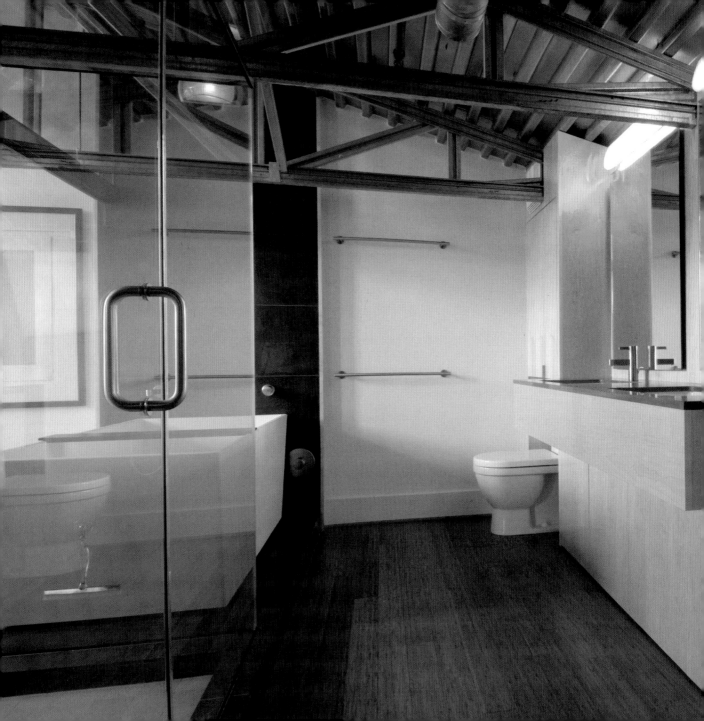

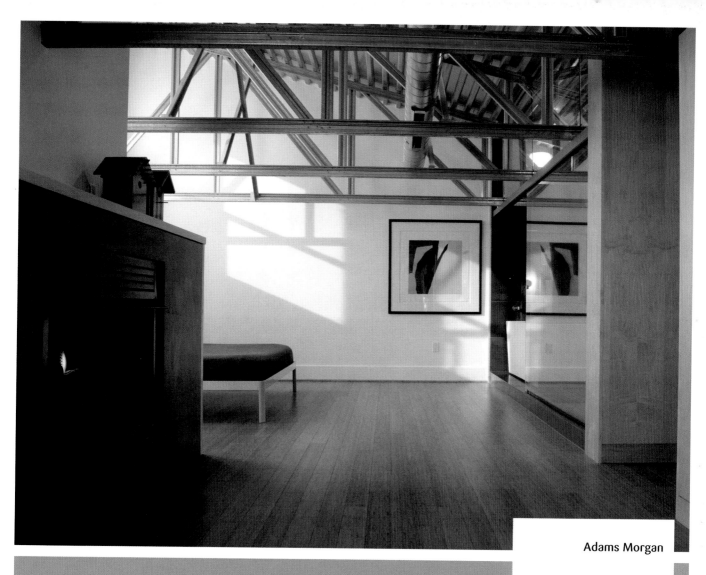

Adams Morgan

Architect: Steven L. Spurlock

Location: Washington, DC, USA

Photographer: © Brandon Webster Photography

A sliding glass wall between the master bathroom and bedroom allows this bathroom to feel big and open, and be flooded with natural light from the high clerestory windows in the bedroom. It also allows the tub to give on to a cozy fireplace in the master bedroom suite. The vanity is carved out of a very practical wall of storage.

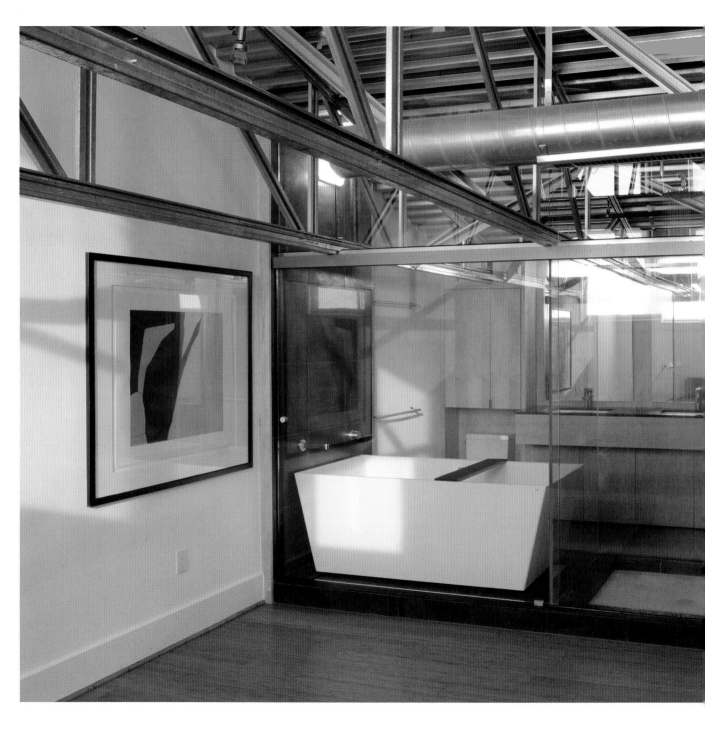

The very domestic and refined finishes used throughout the bathroom and bedroom contrast with the industrial look of this building's exposed structure.

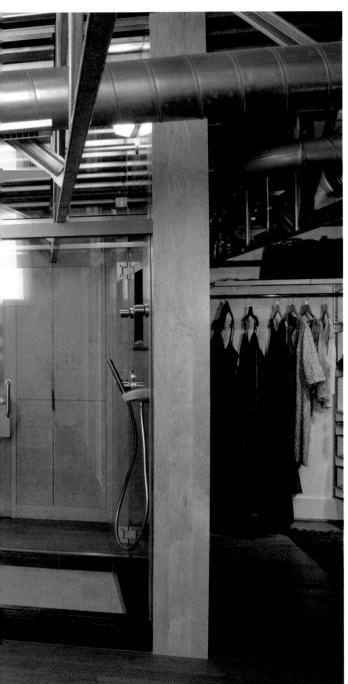

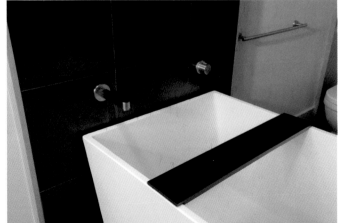

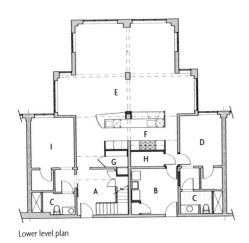

Lower level plan

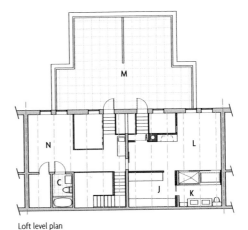

Loft level plan

A. Entrance
B. Laundry room
C. Bathroom
D. Study
E. Living/Dining area
F. Kitchen
G. Wine cellar
H. Pantry
I. Guest bedroom
J. Dressing room
K. Master bathroom
L. Master bedroom
M. Roof deck
N. Library/Music room

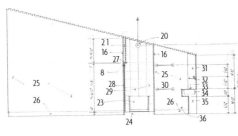

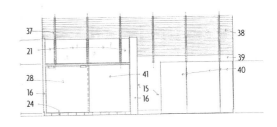

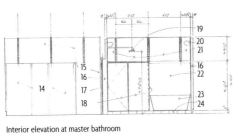

Interior elevation at master bathroom

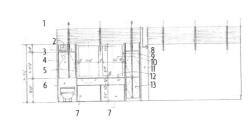

1. Existing metal ceiling
2. Existing exhaust fan. Relocate duct within cabinet and install new wall cap beyond
3. Fixed wood panel
4. 12" wall cabinet with 3 adjustable shelves
5. 1-1/2" full height wood side panel
6. Wood panel at wall beyond
7. Removable wood panel. Align face with side panel

8. Sliding door track
9. Wood panel at wall
10. Fixed plate glass mirror
11. Wood jamb
12. Wood vanity panel with stone countertop and under-mounted lavatories
13. Wood cabinet with 2 adjustable shelves
14. Wood partition

15. Open to beyond
16. Wood trim
17. Sliding wood door
18. Clear glass shower enclosure
19. Shower head
20. Light fixture
21. Fixed clear glass panel
22. Obscure glass door beyond
23. Tub
24. Stone tile platform

25. Existing gypsum board
26. Existing base
27. 1" x 3" Aluminum tube
28. Obscure glass sliding door
29. Stone tile
30. 24" towel bar
31. Full height wood panel
32. Towel ring
33. Stone countertop
34. Lavatory beyond

35. Plumbing chase
36. W.C. omitted for clarity
37. Existing truss
38. Existing metal ceiling beyond
39. Open
40. Wood partition. Joints centered on truss
41. Fixed obscure glass panel

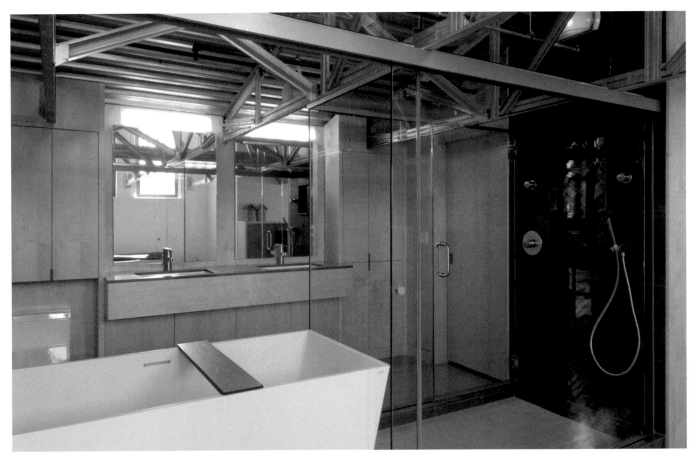

020

A built-in wall of storage around and under the vanity can provide a lot of space for all those little things that are often hard to find a place for. The cabinets are very shallow, allowing easy access to everything.

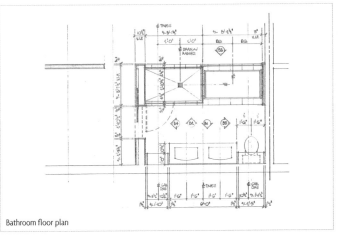

Bathroom floor plan

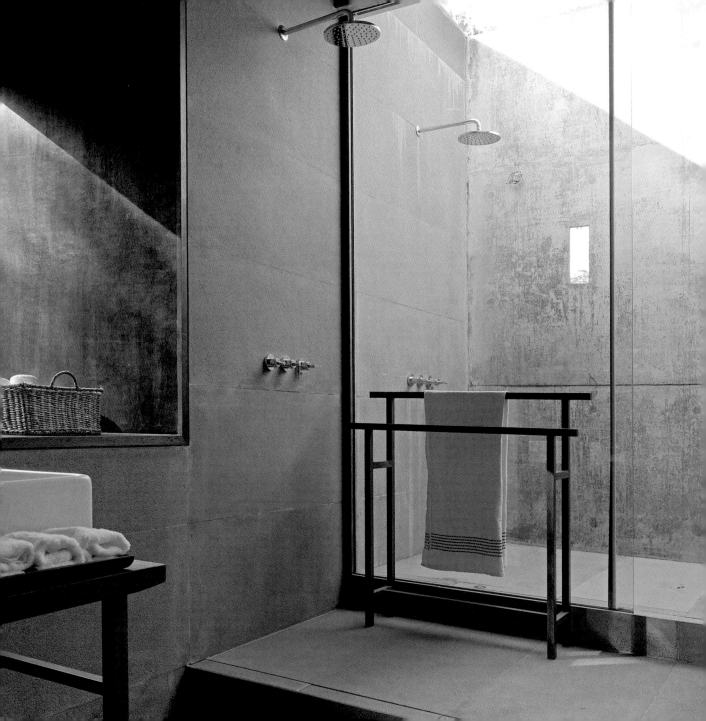

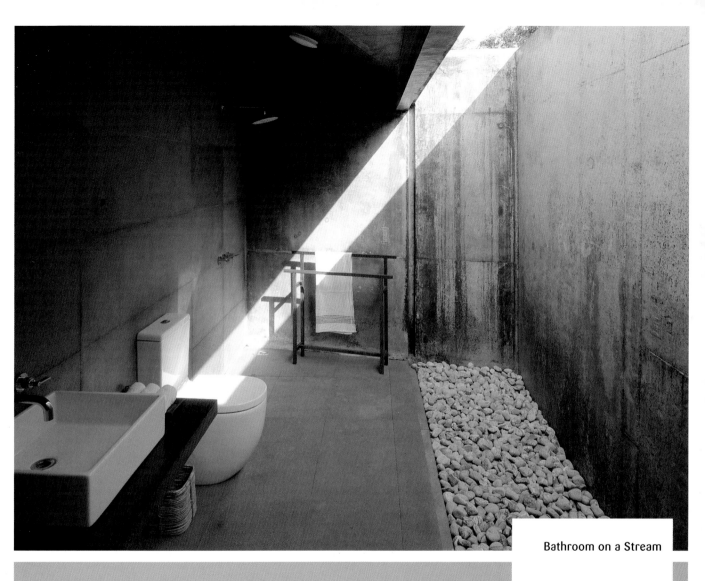

Bathroom on a Stream

Architects: Architecture BRIO
Location: Alibag, India
Photographer: © Sebastian
Zachariah Photographix

The house consists of two parts: the day areas such as the dining room, kitchen, living room and entrance veranda are separated from the master bedroom by a bridge that spans the stream. As monolithic as it looks from outside, the interior is spacious and luminous. Every section of the house, including the bathroom, is oriented to make full use of the views.

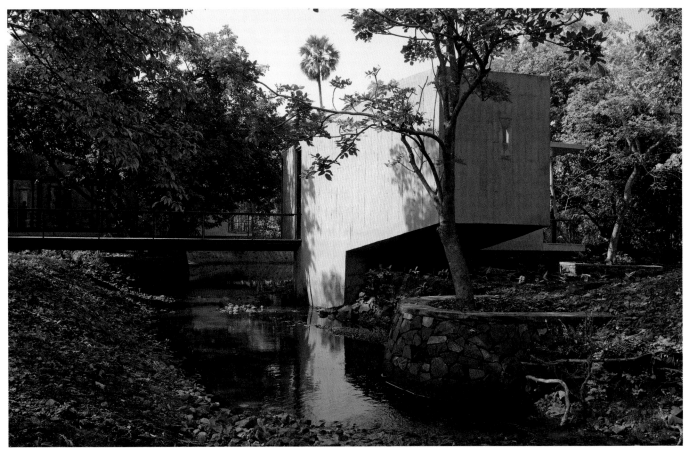

Site plan

021

Concrete is a porous material that needs to be sealed, especially when used in wet areas. If left untreated, moisture will stain its surface and encourage the growth of mildew.

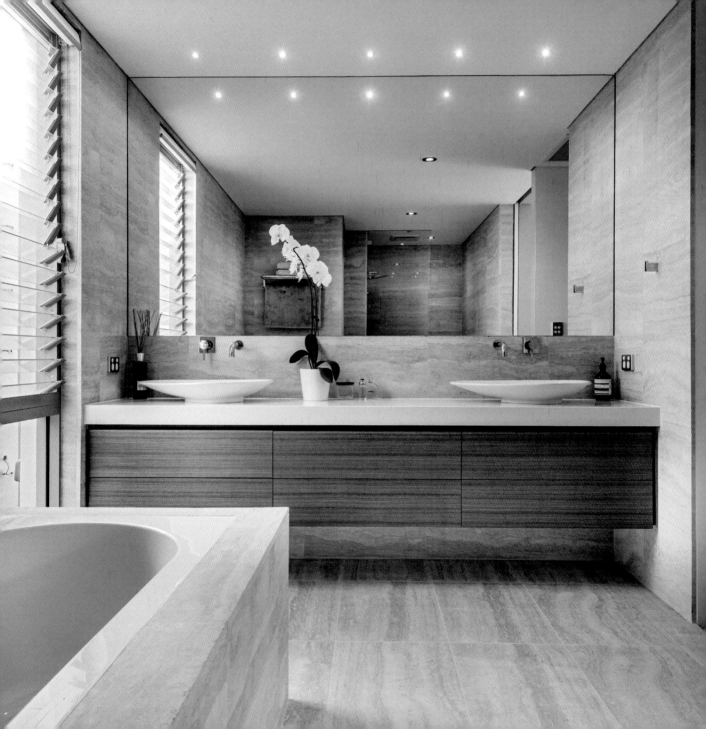

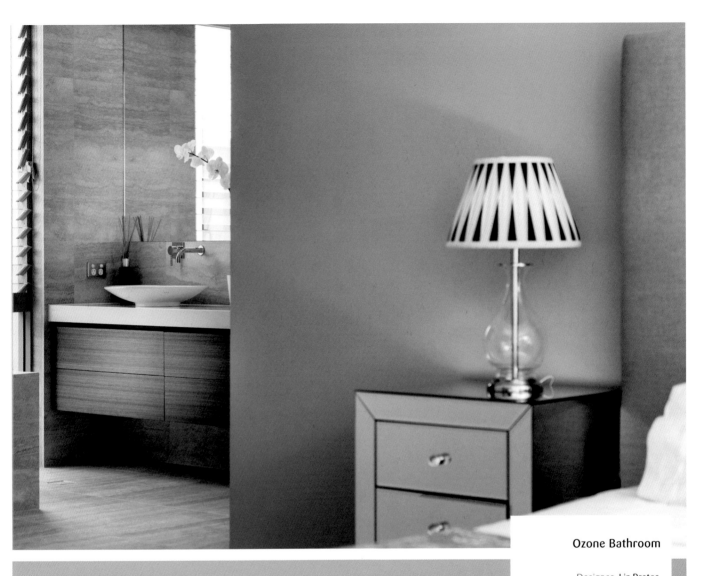

Travertine is the dominant material throughout this master suite with wood and white ceramic accents. This limited palette of finishes allows the forms to find their voice. Less is always more. The wavy veins of this stone and its neutral range of light browns with a subtle yellowish tinge make for an elegant yet relaxed bathroom that reminds one of the warm sandy beaches of western Australia.

Ozone Bathroom

Designer: Liz Prater, SWELL Homes

Location: Cottesloe, Perth, Australia

Photographer: © DMax Photography

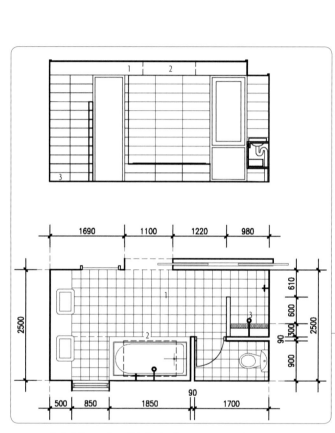

Master bathroom plan and interior elevation

1690 1100 1220 980

2500

610
600
300
300
2500
900

500 850 1850 90 1700

90

1. Gyprock™ lined
 bulkhead at 28 cm
 above bath and vanity
2. 1200 x 800 Velux™
 skylight directly above
 tub in bulkhead
3. 400 mm high tiled
 plinth
 in shower

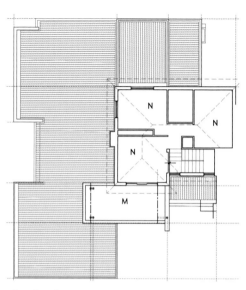

Upper floor plan

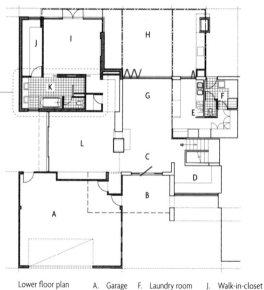

Lower floor plan

A. Garage	F. Laundry room	J. Walk-in-closet	
B. Porch	G. Dining area	K. Master bathroom	
C. Entry	H. Outdoors	L. Family room	
D. Study	dining area	M. Balcony	
E. Kitchen	I. Master bedroom	N. Existing	

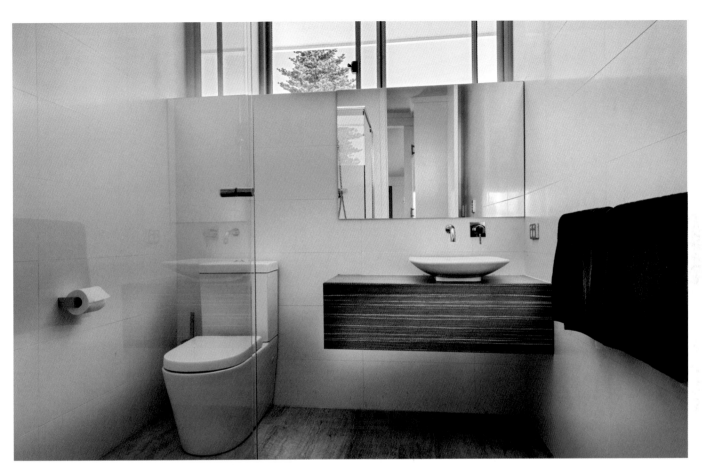

022

The use of stone in the
bathroom is not limited to the
floor. It's all in the selection of
the stone and its installation.
Travertine, like any type of stone
with venation, can be cut along
or across the grain.

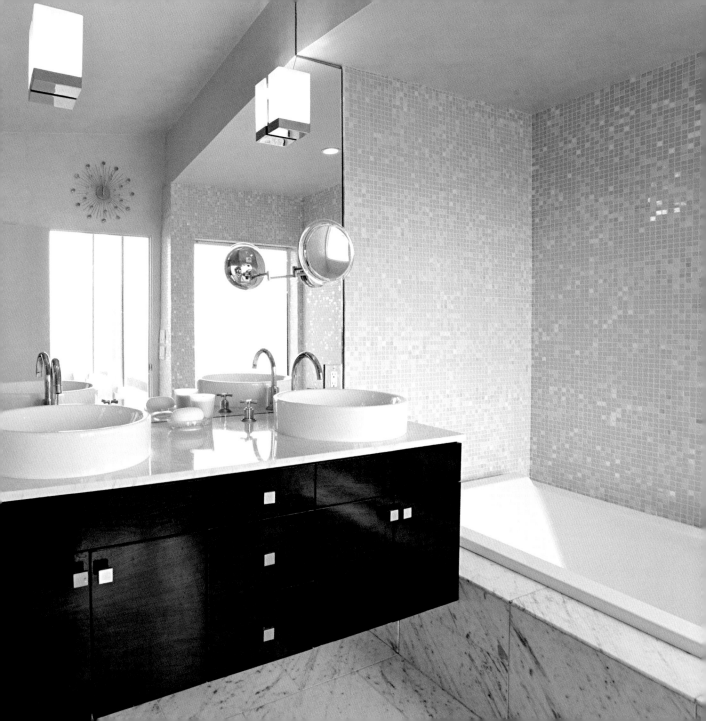

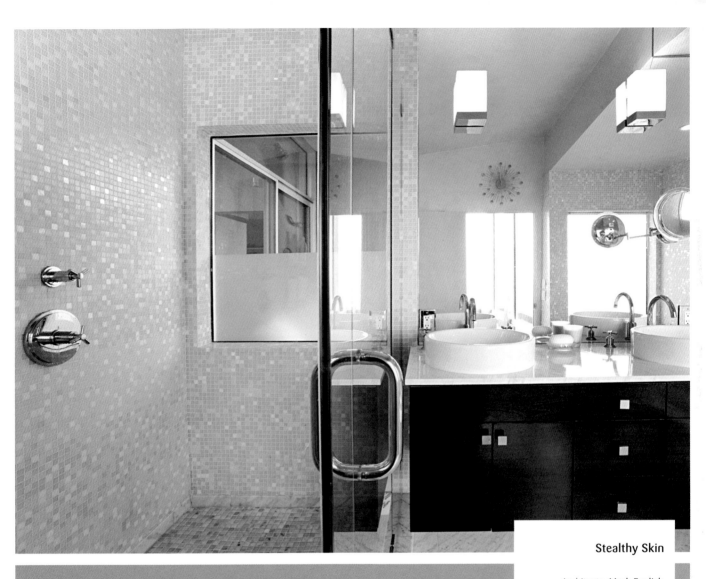

Stealthy Skin

Architects: Mark English
Architects

Location: San Francisco,
California, USA

Photographer: © Norma Lopez
Molina Photography

The master bathroom shows a calming palette with a pale silvery gray-green as a neutral backdrop for occasional stealthy touches of ornamental tiles that were placed by the client. Views are maximized through strategic placement of windows and mirrors. The custom ebonized-walnut vanity provides a visual anchor, while the Carrara marble adds subtle natural patterning.

Third floor plan

Second floor plan

A. Entry
B. Garage
C. Hall
D. Bathroom
E. Family room
F. Bedroom
G. Exercise room
H. Laundry room
I. Deck
J. Living area
K. Kitchen
L. Master bedroom
M. Closet
N. Dining area
O. Office

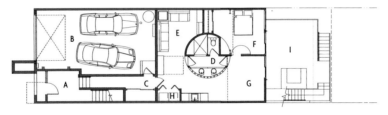

Ground floor plan

Master bathroom elevations

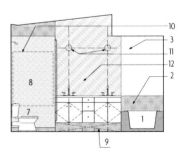

1. Tub
2. Wall tile
3. Gypsum board, painted
4. Window
5. Door to master bedroom
6. Built-in niche with open shelves
7. Toilet
8. Tempered glass shower enclosure
9. Open
10. Window beyond
11. Light fixtures
12. Mirror glued to wall

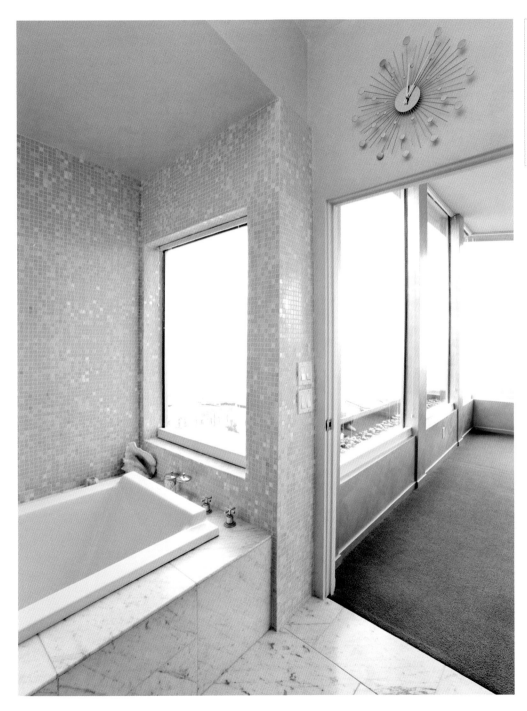

Dark wooden cabinetry is an elegant contrast to white marble and light colored tile, which can be used to set the mood for the rest of the colors in your bathroom.

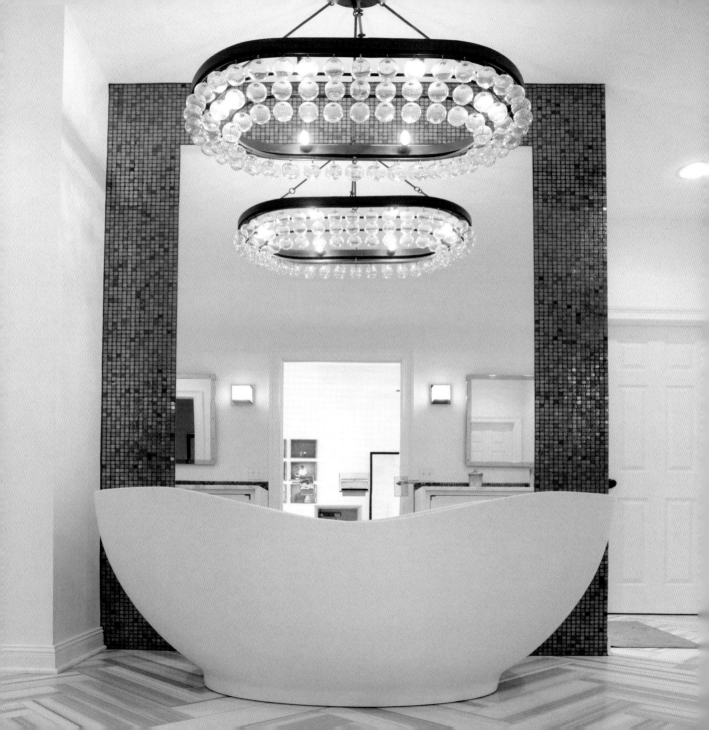

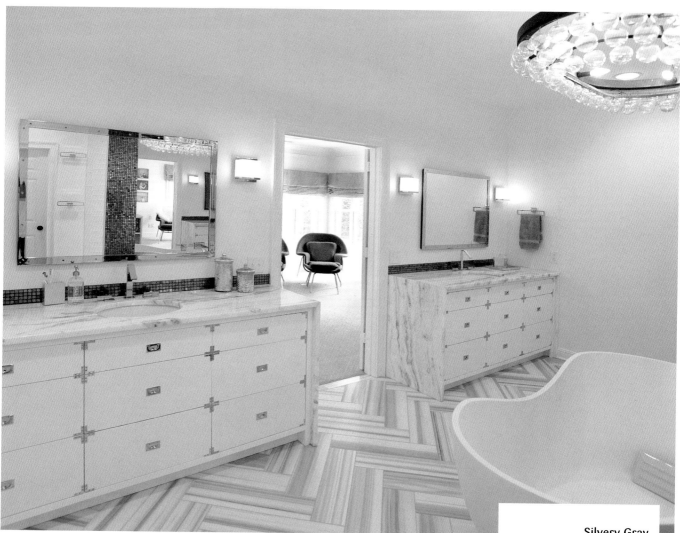

Rich materials used in a creative way make this a sumptuous bathroom, rendered in whites, grays and silvery metallic finishes. It's often the little details that count: repeating the silver mosaic tile on a backsplash band, or the clever marble herringbone on the floor. Two other bathrooms in this same house show a similar attention to detail.

Silvery Gray

Designer: REDO home & design

Location: Nashville, Tennessee, USA

Photographer: © Reed Brown Photography

024

Use materials in surprising ways. Here, a glamorous freestanding bathtub is centered in front of a tile framed mirror and opposite two "campagne" chests. All three elements are custom-made.

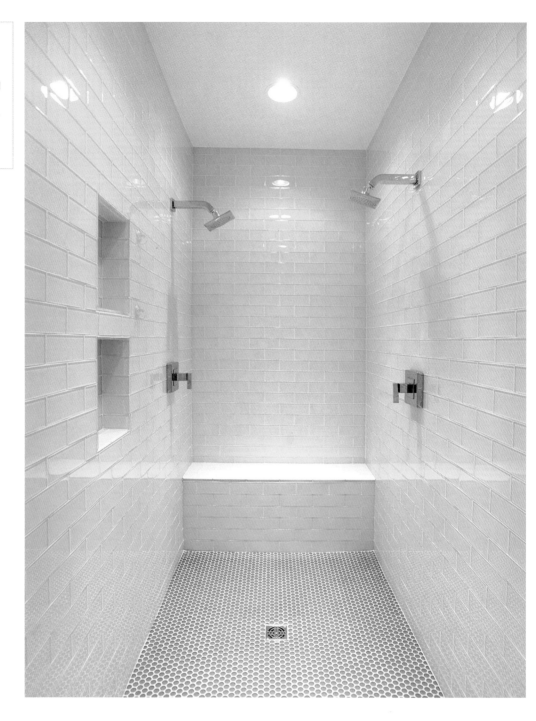

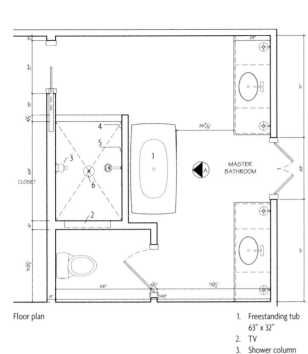

Floor plan

1. Freestanding tub
 63" x 32"
2. TV
3. Shower column
4. Controls
5. Body sprays
6. Rain head

MASTER
BATHROOM

CLOSET

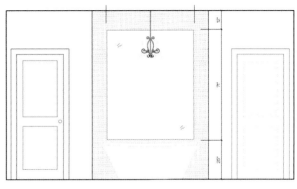

Elevation A

025

025

Back-painted glass tiles add texture and depth to the walls of a small shower stall, catching the light and scattering it. They are available in any imaginable color.

026

Updating a powder room or a bathroom can be as easy as covering the walls with some stylish wallpaper. Nowadays you'll find wallpaper that is tough enough to withstand humid conditions.

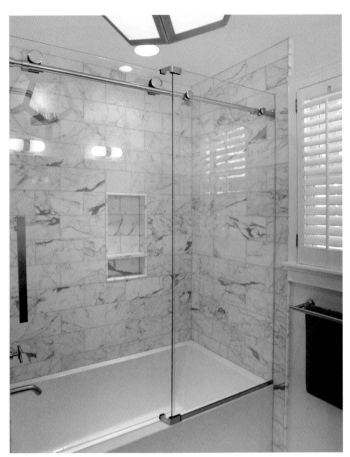

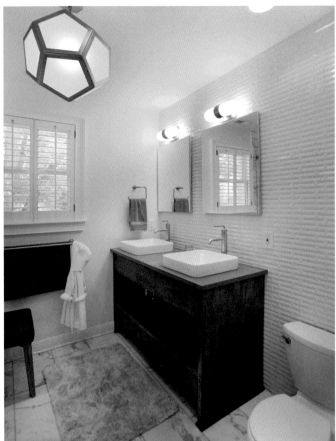

027

Carrara marble stands out nearly anywhere in the bathroom. Install it on vanity tops, floors, walls, tub decks and in the shower. Use it sparingly or generously depending on the look you seek.

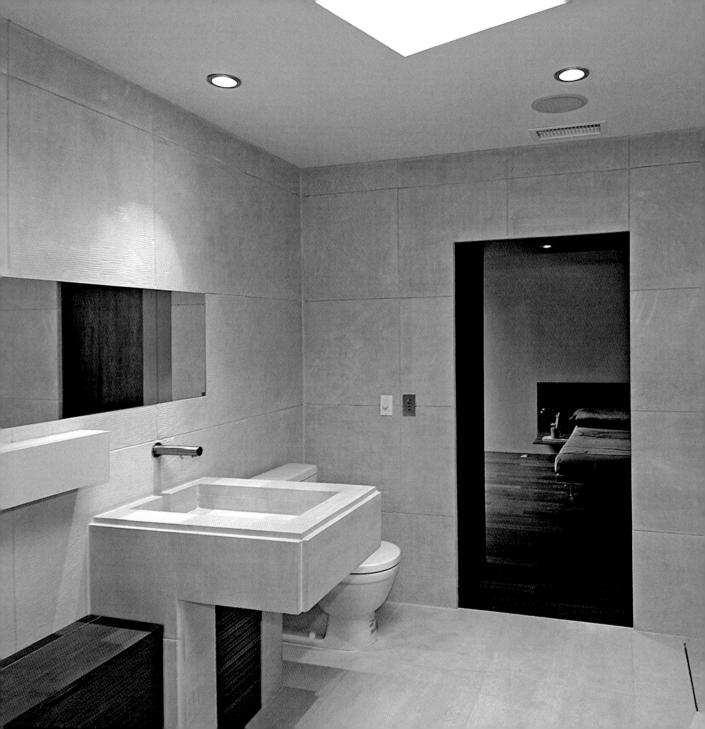

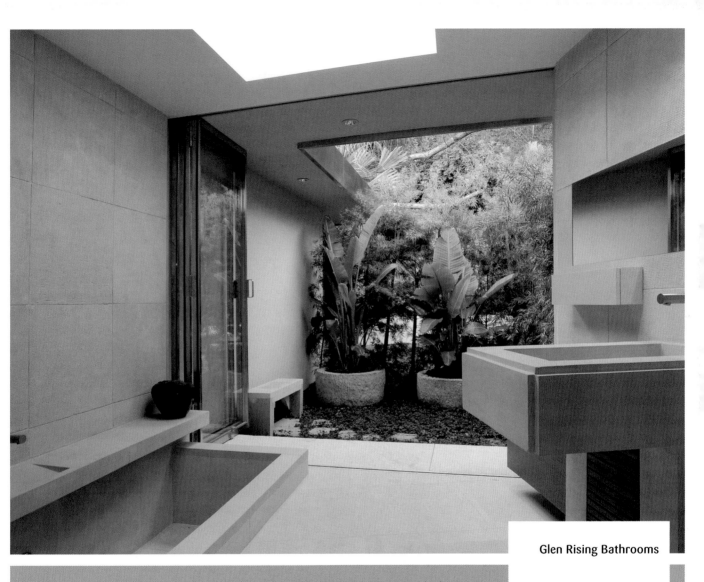

Glen Rising Bathrooms

A nondescript mid-century house was transformed into a luxurious home with elegant bathrooms evoking the opulence of an old world spa. An important factor in the design of these bathrooms is the creation of strong sightlines. These are achieved by placing feature floors and walls that encourage outdoor/indoor circulation. Live greenery was cultivated into the bathing areas to enliven the space while maintaining tranquility and privacy.

Designer: Janna Levenstein | Tocha Project

Location: Los Angeles, California, USA

Photographer: © Janna Levenstein

028

A spa-like steam shower is perhaps the perfect way to relax and replenish after a long workday. Many steam shower systems offer body massage jets: a temptation hard to resist.

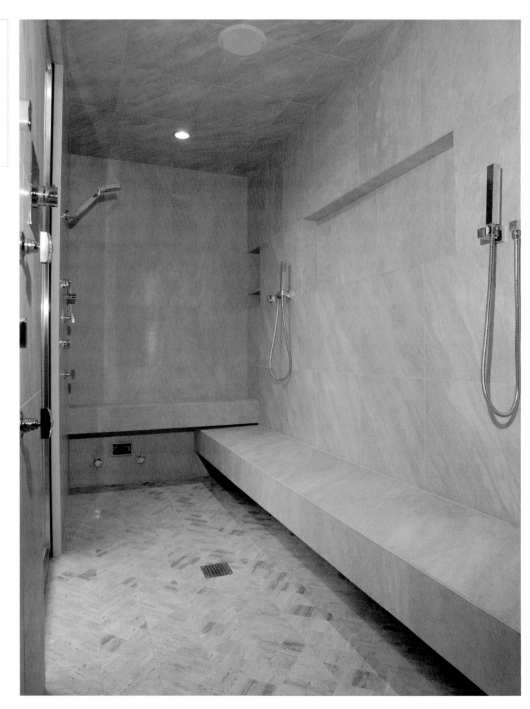

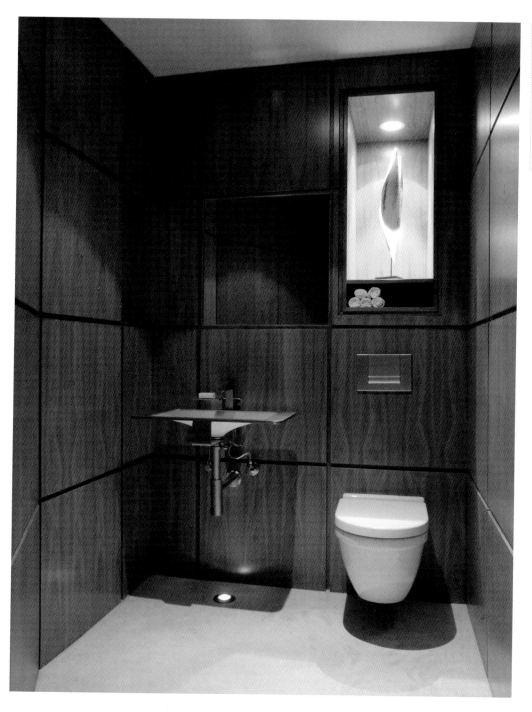

While wood paneling isn't usually recommended in bathrooms, it is however perfectly suitable in powder rooms as long you keep moisture away.

Every bathroom in the house is different with assorted exotic woods and different kinds of stone. Some washbasins are cast resin, others are hewn from rock.

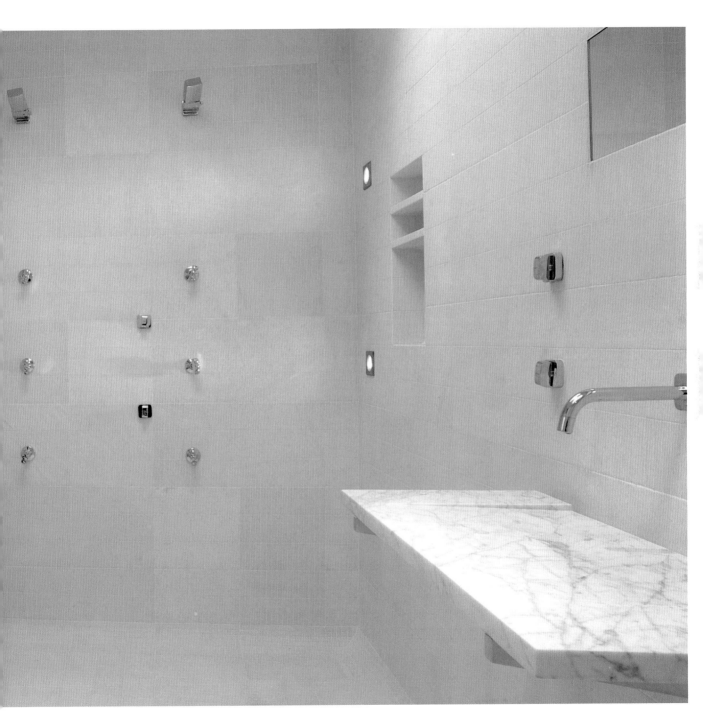

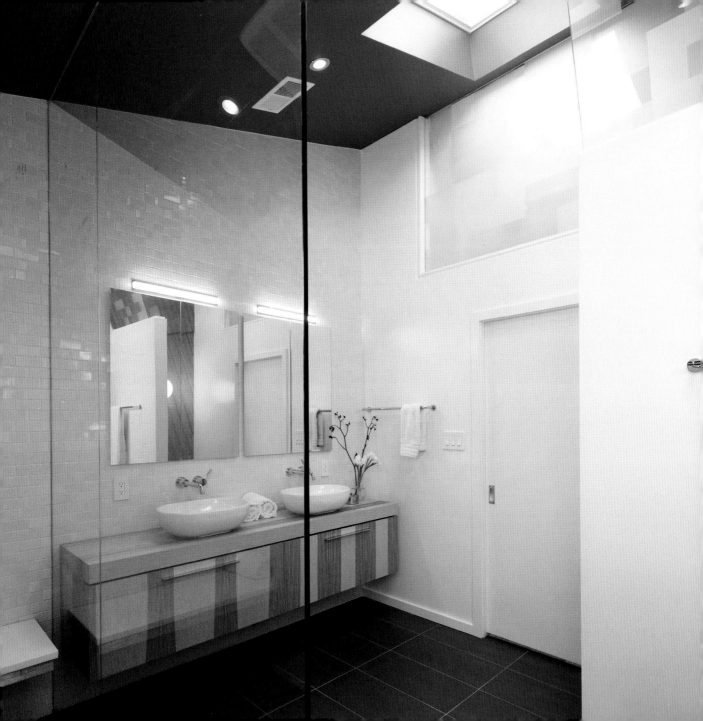

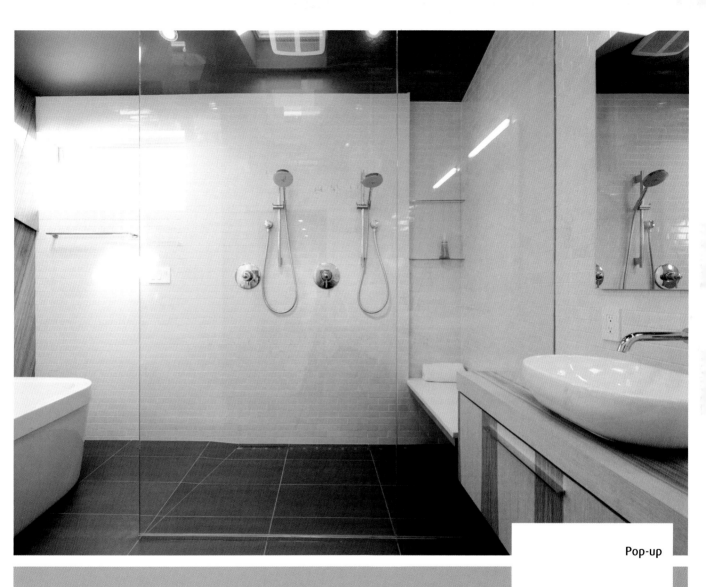

This project presented the challenge of creating a larger and more usable master suite in an existing two-story house. A portion of the 45-degree roof was removed to create a "pop-up," producing space for an expanded master suite, adding square footage without changing the footprint of the house. New skylights and transom panels allow abundant daylight without compromising privacy.

Architects: E/L Studio

Location: Arlington, Virginia, USA

Photographer: © Pepper Watkins

Before and after remodel axonometric views

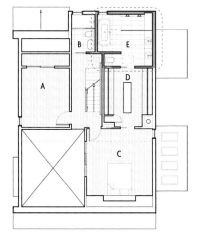

Second floor plan

A. Bedroom
B. Bathroom
C. Master bedroom
D. Master closet
E. Master bathroom

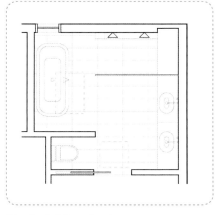

Enlarged master bathroom floor plan

The new bathroom features a separate toilet compartment, dual showers, separate soaking tub area and double vanity with ample storage.

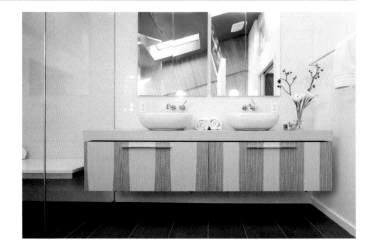

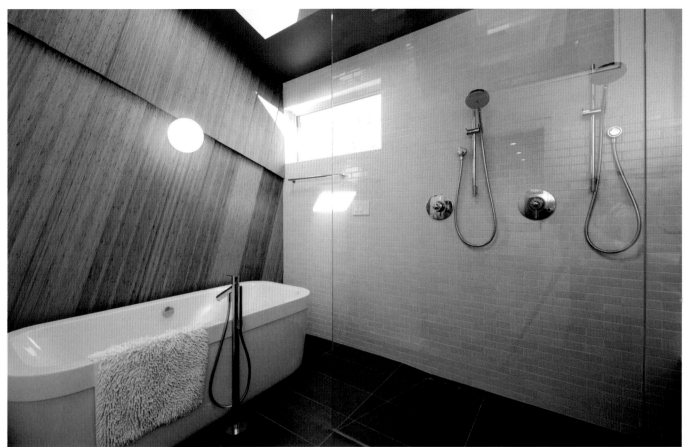

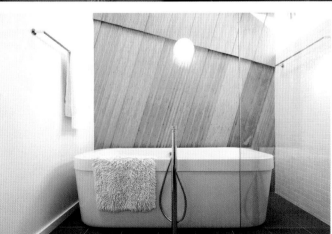

Bamboo paneling in the tub area adds
sensory richness for leisurely soaks.

030

Glazed ceramic tiles come in an endless array of styles, sizes, colors and textures. The glazing is a strong non-porous coating that won't fade from sunlight and is stain-, scratch- and fire-resistant.

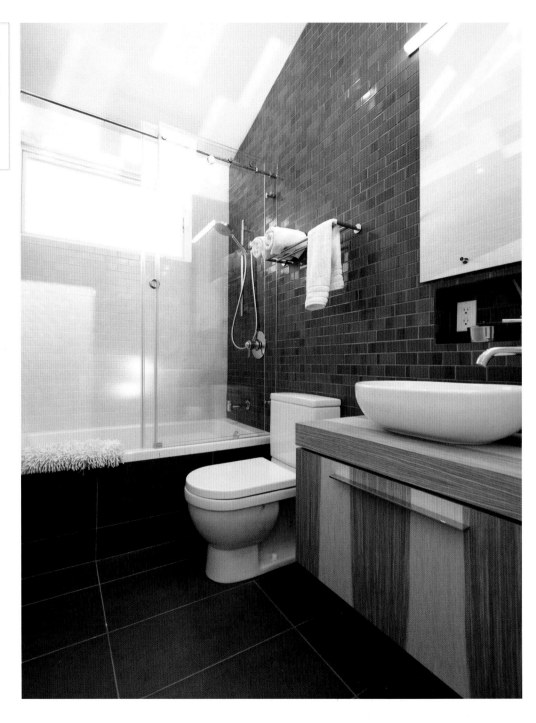

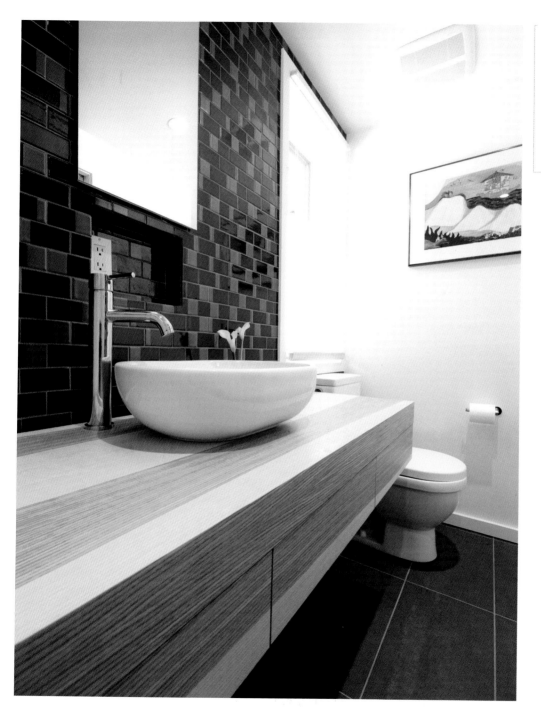

When it comes to choosing a finish for your bathroom floor, make sure you pick one that won't be slippery and won't scratch easily. Glazed ceramic tile is not recommended.

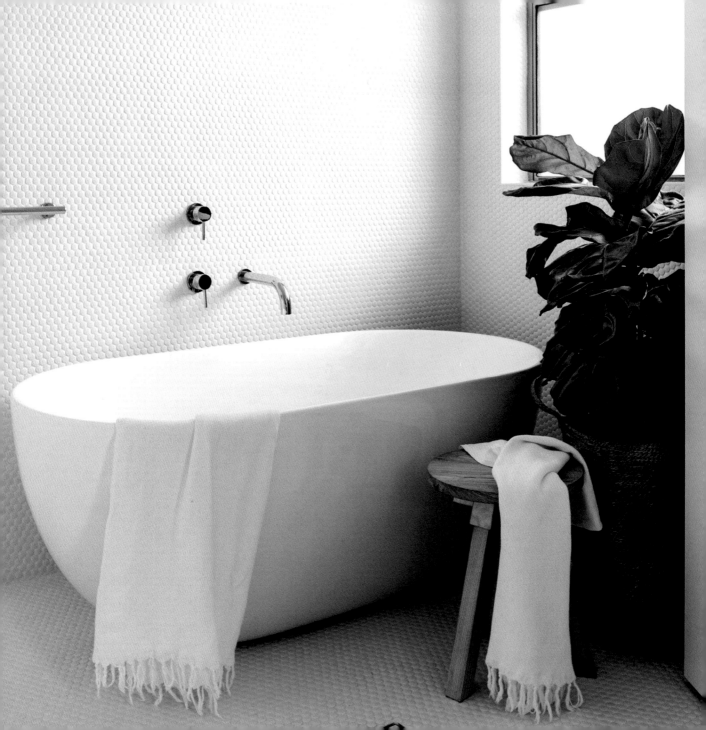

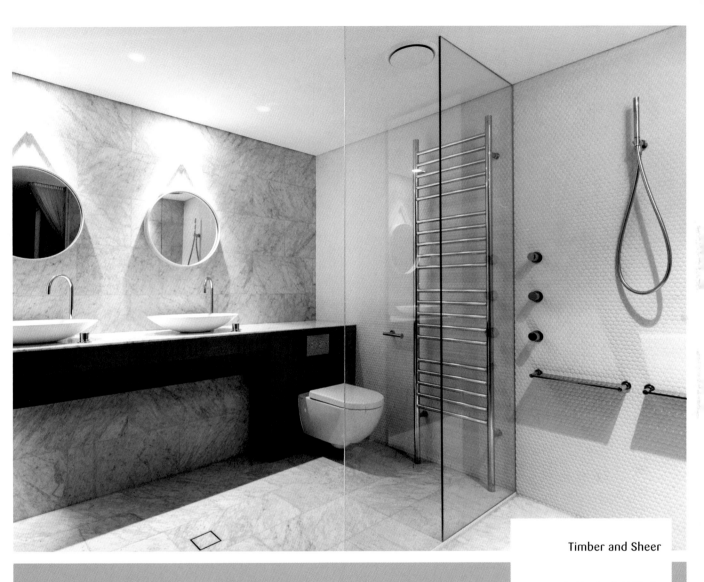

Timber and Sheer

Architects: C+M Studio

Location: Manly, Sydney, Australia

Photographer: © Caroline McCredie

This unique home embodies the perfect balance of open public and tranquil private spaces. The design of the master bathroom is only part of a larger project consisting of the transformation of an outdated and dark penthouse into a sophisticated, yet relaxed home with inviting living spaces for entertaining as well as comfortable and soothing private areas.

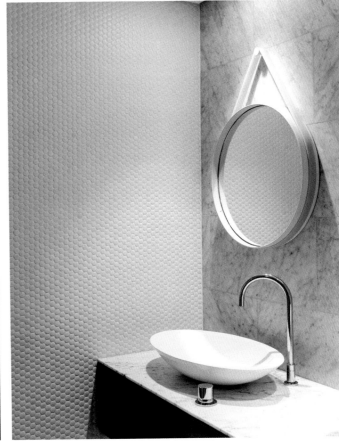

The use of natural materials such as mafi timber, sisal carpet, Carrara marble, beechwood stone, leather, felt and linen ensures a modern, simple and elegant home.

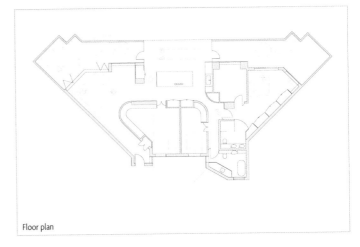

Floor plan

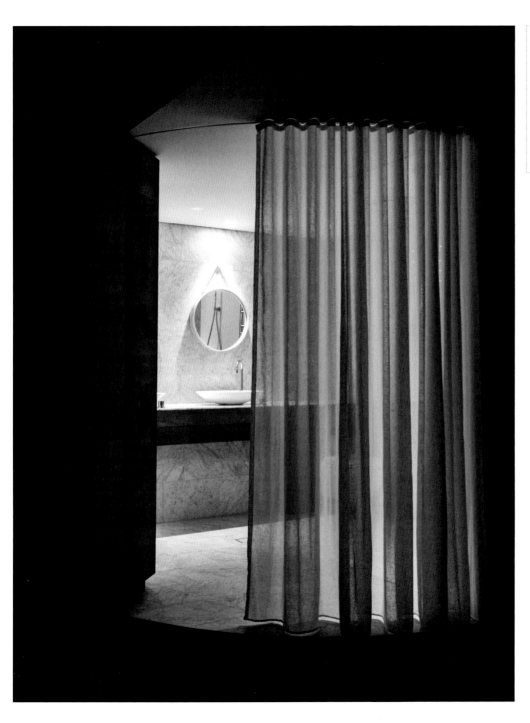

032

A sheer curtain can be a creative design solution to add privacy and soften spaces. Stylish, convenient and even economical, it can easily transform spaces.

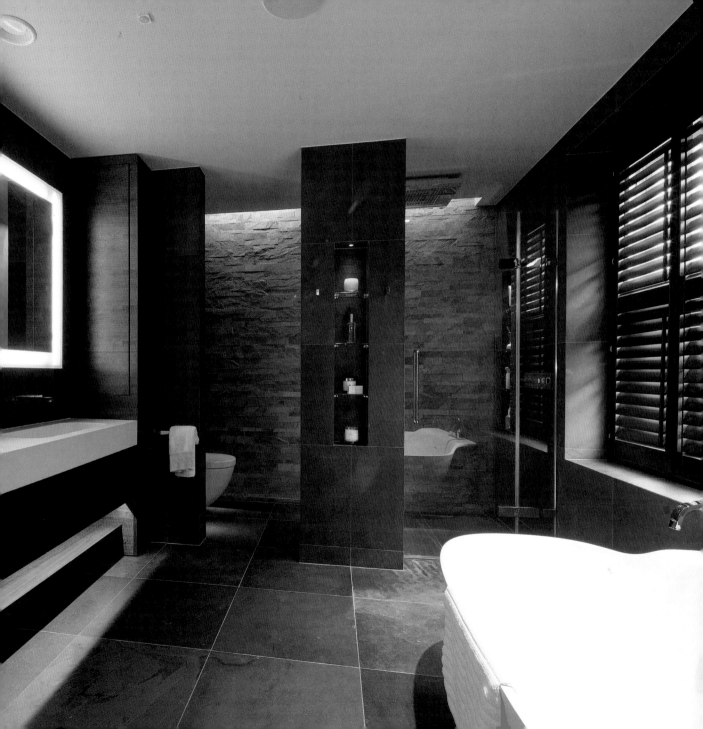

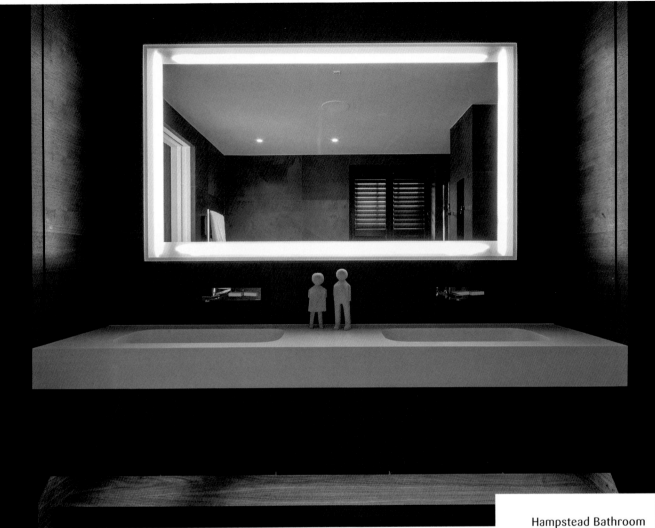

Hampstead Bathroom

Architects: KSR Architects
Designer: Folio Design

Location: London,
United Kingdom

Photographer: © Tony Murray

Planes of rich, dark materials, stone and wood, float past each other separated by deep troughs that allow for pleasant indirect lighting. Very careful attention to detail and to the alignment of joints and planes is what makes this bathroom feel so refined and comfortable. Open shelving niches serve for both display and storage.

Elevation at shower and WC enclosure

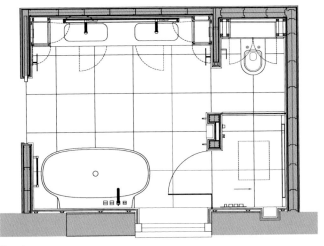

Floor plan

The master bathroom was designed to
create an oasis of sophisticated elegance
and bring together a moody yet stylish
natural palette of stone and timber.

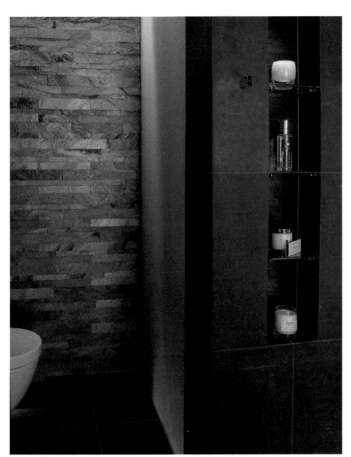

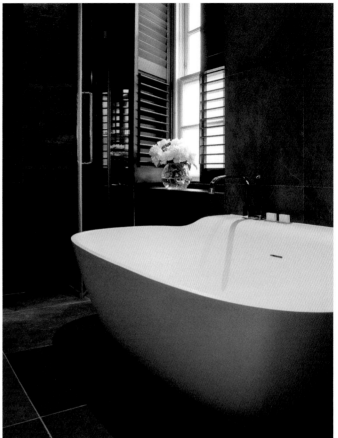

The designers have carefully aligned the joints in the stone slabs at the floor and the walls for a nice, finished look. The starting point is the centerline of the glass-shelved niche.

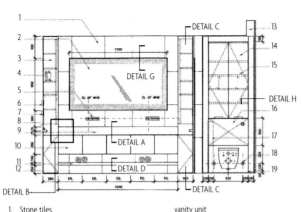

1. Stone tiles
2. Surface mounted mirror with demister and concealed LED lighting strip to perimeter (behind frosted edges)
3. Timber veneered MDF panel
4. 6 adjustable timber veneered MDF shelves inside the cabinet
5. Single lever taps
6. Mirror demister spur within joinery
7. Shaver socket within joinery
8. Towel rail
9. Wash basin slab
10. 5 drawers + 2 drawers for laundry basket with veneered front doors on each side of vanity unit
11. Timber veneered shelf
12. Timber veneered cabinet doors
13. Concealed lighting to feature wall
14. 25 mm timber veneered MDF cabinet doors
15. 25 mm timber veneered MDF shelves on adjustable fixings
16. Removable access panel
17. Stub stack to terminate at 900 mm above floor finish level max. Joinery to house stub stack. Allow for access
18. 2 wall washer lights
19. 50 mm high stone skirting

20. Timber veneered cabinet with 3 veneered cabinet doors + 6 adjustable 20 mm MDF veneered shelves
21. Surface mounted mirror with demister and concealed LED lighting strip at bottom
22. Shaver socket within joinery
23. 50 mm timber veneered MDF shelf with concealed strip lighting to underside
24. Downlight
25. Hinges by specialist
26. 2 robe hooks
27. Stone recess with 3 fixed toughened sandblasted low iron glass shelves. Exposed stone edges to be polished
28. 450 mm "D" handle door by specialist
29. Low iron glass door by specialist
30. Stone tiles

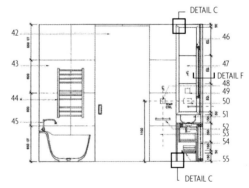

31. Concealed lighting to feature wall
32. IP rated downlight
33. Low iron glazed screen
34. 3 fixed toughened sandblasted low iron glass shelves in stone recess. Polished edges to exposed stone tiles within the recess
35. Thermostat and shower controls
36. Stone sill, reveals to window
37. Floor laid to fall in shower area
38. Unidrain™ Lighline shower channel system
39. Stone tiles
40. Heated towel rail
41. Deck mounted bath controls

42. Sliding door
43. Stone tiles
44. Heated towel rail with valves
45. Deck mounted hand held shower, spout and controls
46. Surface mounted mirror with demister and concealed LED lighting strip to perimeter behind the frosted edges
47. 6 adjustable 25 mm timber veneered MDF shelves with solid timber lippings behind 3 25 mm timber veneered MDF cabinet doors
48. Underfloor heating temperature control
49. Mirror demister spur within joinery
50. Shaver socket
51. Wash basin slab
52. Towel ring
53. Stone tiles
54. 85 mm wide void for drainage pipes
55. 50 mm timber veneered MDF shelf with strip lighting to underside

Master bathroom interior elevations

Detail A

1. Wash basin slab
2. Flush
3. Joinery

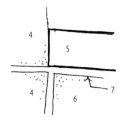

Detail B

4. Cabinet
5. Wash basin
6. Joinery drawers
7. 6 mm shadow gap panels aligned

Detail C

8. Cabinet door

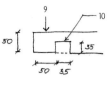

Detail D

9. Timber shelf to underside of wash basin
10. 35 x 35 mm recess for lighting aluminum profile

Detail E

11. Glass shelf
12. Stone niche joints

Detail F

13. Frame
14. 6 x 6 mm gap at junction with wall

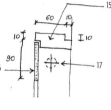
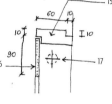

Detail G

15. Timber frame
16. Frosted strip at mirror's perimeter
17. Lighting behind mirror to lighting designer's details

Detail H

15. Hardwood zipping over veneered

033

Indirect lighting is easy on the eyes, but more ample lighting is needed around the vanity mirror. It's best if it comes from both sides of the mirror.

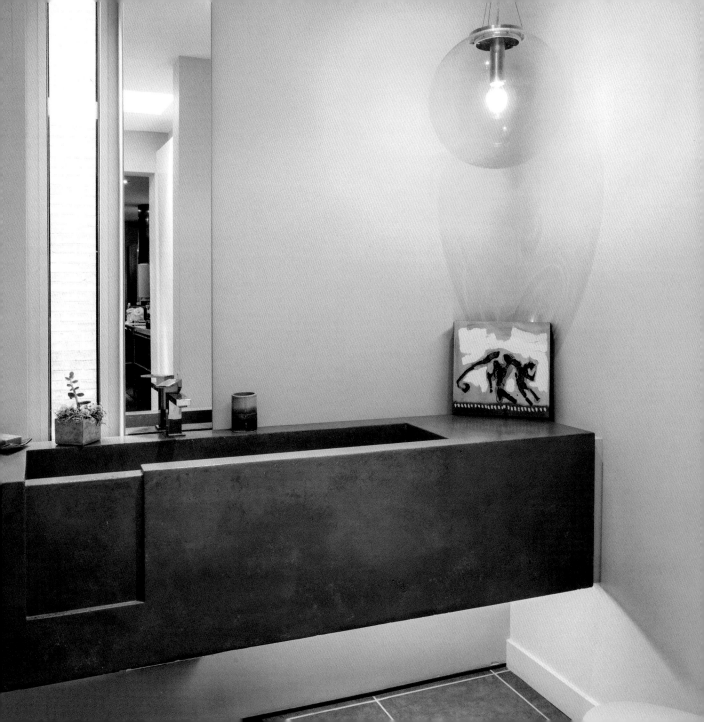

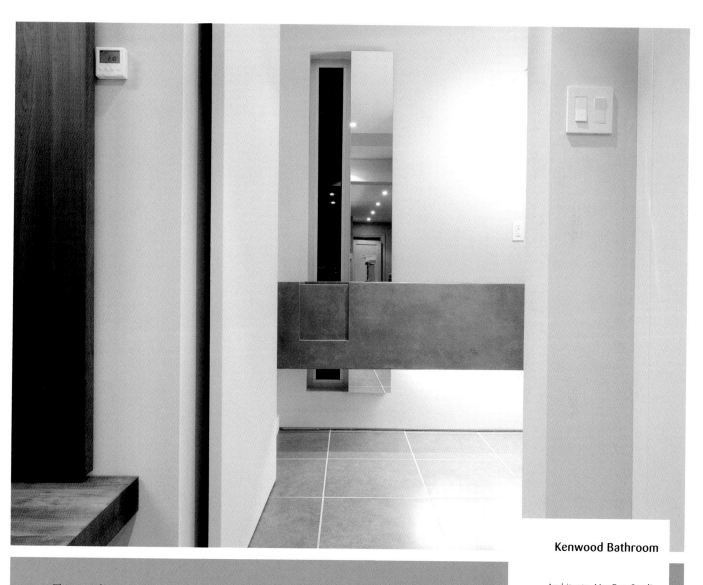

Kenwood Bathroom

This powder room is a unique space that makes the most of its small footprint. It is part of a one-story house addition project that also includes a new rear entrance, as well as interior and exterior storage. But what stands out the most of this project is the powder room with a six-foot-long polished concrete sink and vanity that counterbalances an 8" wide window slit with matching-sized mirrors.

Architects: LineBox Studio

Location: Ottawa, Ontario, Canada

Photographer: © Andrew Geddes, Union Eleven

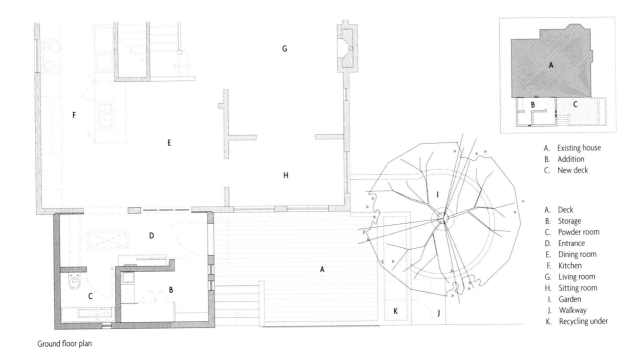

Ground floor plan

A. Existing house
B. Addition
C. New deck

A. Deck
B. Storage
C. Powder room
D. Entrance
E. Dining room
F. Kitchen
G. Living room
H. Sitting room
I. Garden
J. Walkway
K. Recycling under

034

Concrete can be poured
to shape any form, so it is
more about imagination and
craftsmanship to create a
sink that is both beautiful and
functional.

A sliding door separates the powder room from the entry hall and it is integrated with a custom bench. This feature is visually interesting and solves the small space issue.

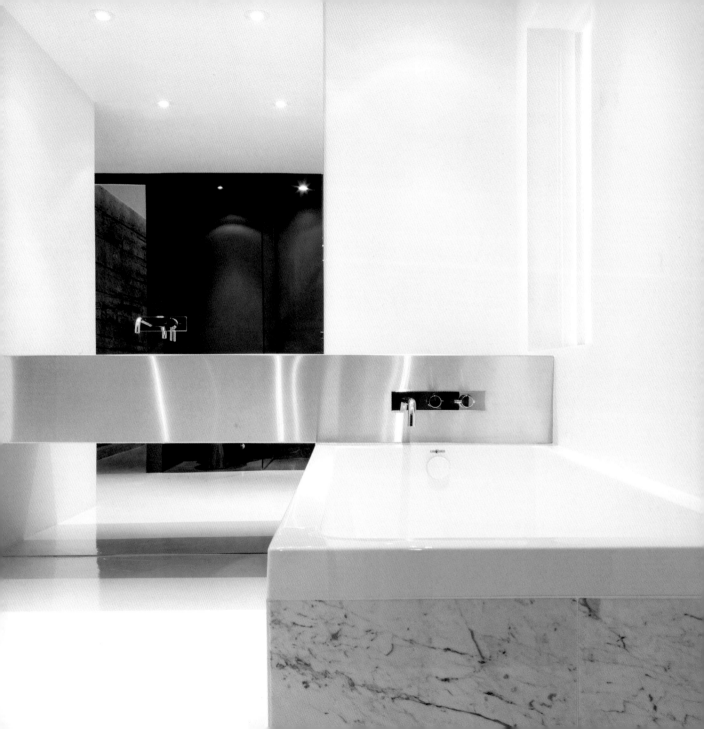

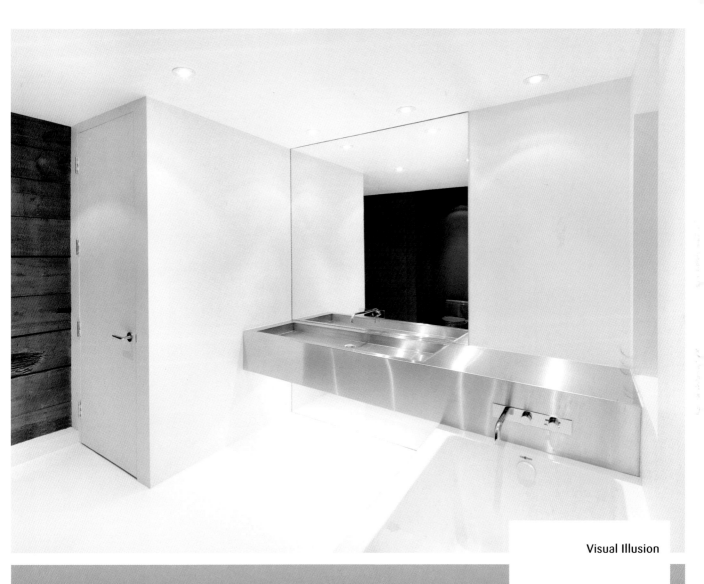

Visual Illusion

The contrast between the custom-built stainless steel vanity with its sharp, clean edges, and the very rough, unfinished wood plank wall sets up the dynamic of this bathroom. The wall of mirror behind the vanity visually expands the bathroom and makes the vanity float. The dramatic color change in the section of the bathroom opposite to the vanity defines a different area: shower and toilet.

Architect: Anne Sophie Goneau

Location: Montreal, Quebec, Canada

Photographer: © Adrien Williams

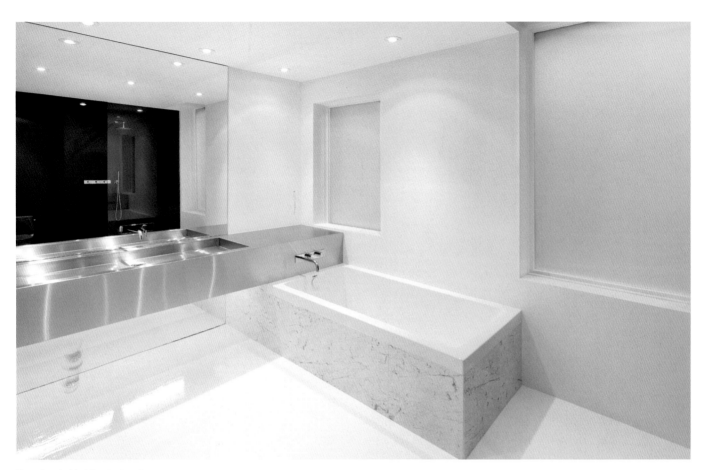

The mirror behind the steel vanity
reflects the gray smoked glass, and
gray walls and floor in the shower
and toilet areas creating the illusion
that the bathroom expands behind
the reflective surface.

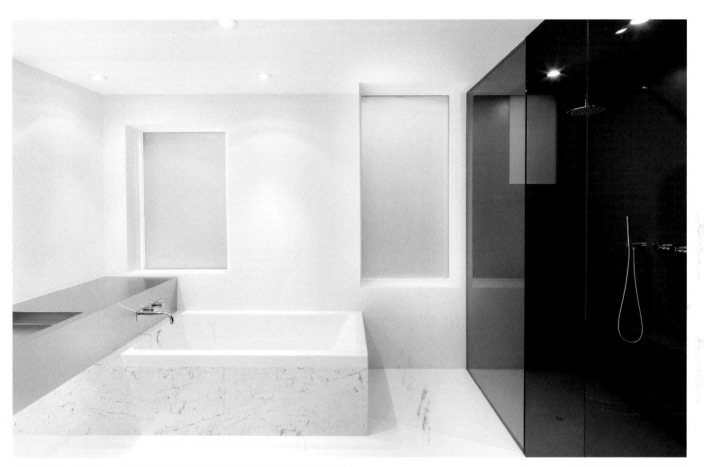

35

Glossy epoxy is an alternative to tile. It can be used on walls, ceiling and floors for a seamless effect. Some epoxy products can also be combined with urethane topcoats for better durability and color retention.

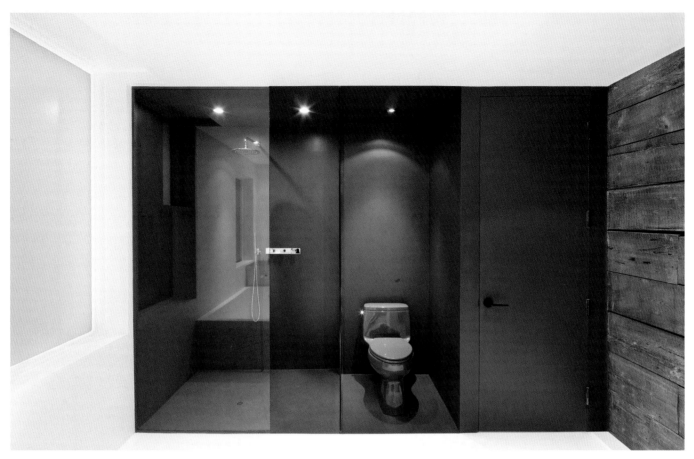

036

Polished, impervious surfaces
are typical and necessary in
a bathroom, but they can be
contrasted nicely with rough
materials on surfaces away
from water.

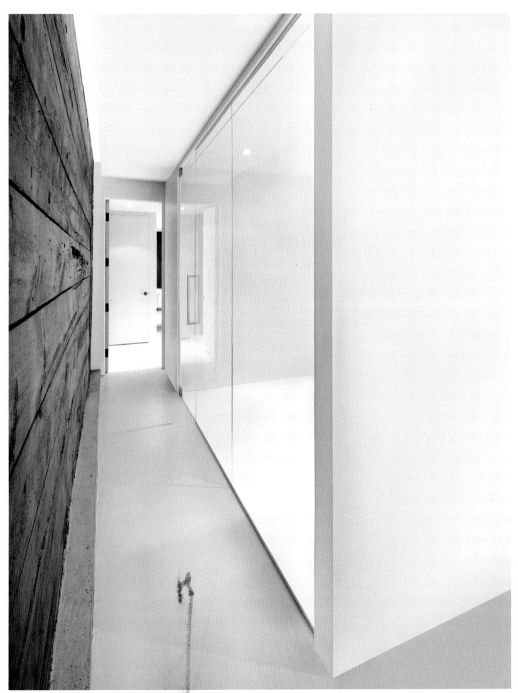

A wall of rough, knotty wood planks extends down the hall and into the bathroom to help tie the bathroom to the rest of the apartment.

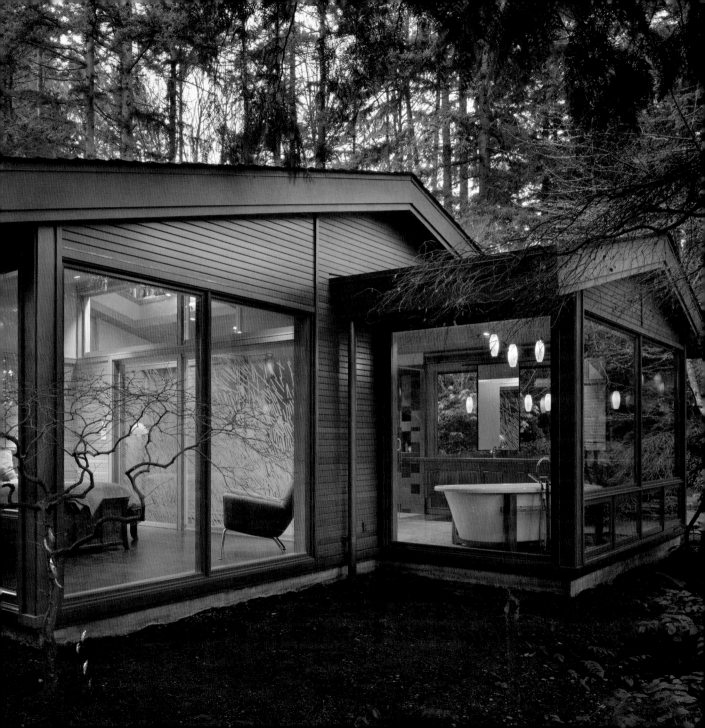

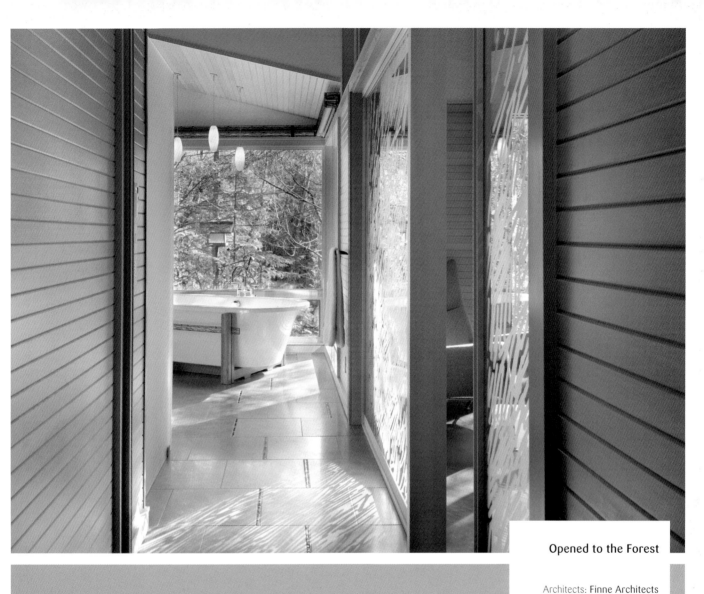

Architects: Finne Architects

Location: Seattle, Washington, USA

Photographer: © Benjamin Benschneider Photography

Big walls of floor-to-ceiling glass open this bathroom to a secluded forest clearing. Wood finishes throughout, especially the deeply sculpted vanity doors, reflect the woodland outside. The vanity mirrors are hung in front of the continuous windows, along with lighting to either side of the mirrors for even lighting of one's reflection.

037

An off-the-shelf tub can be turned into something unique by cradling it in a custom support. Note that its metal grill band matches the pelmets above the windows.

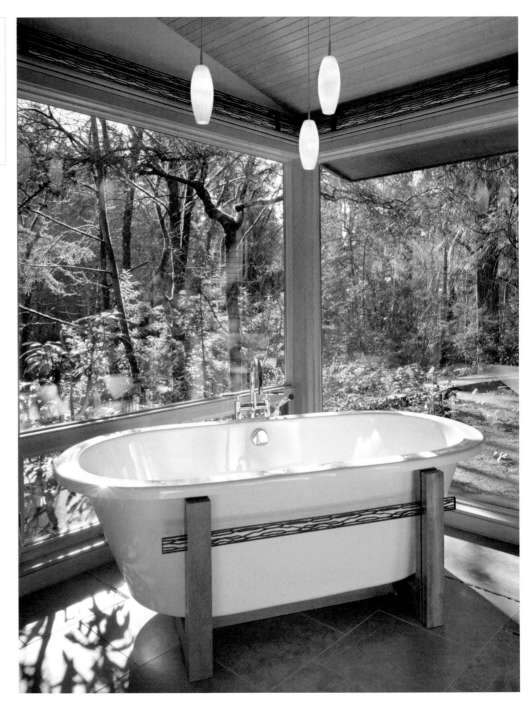

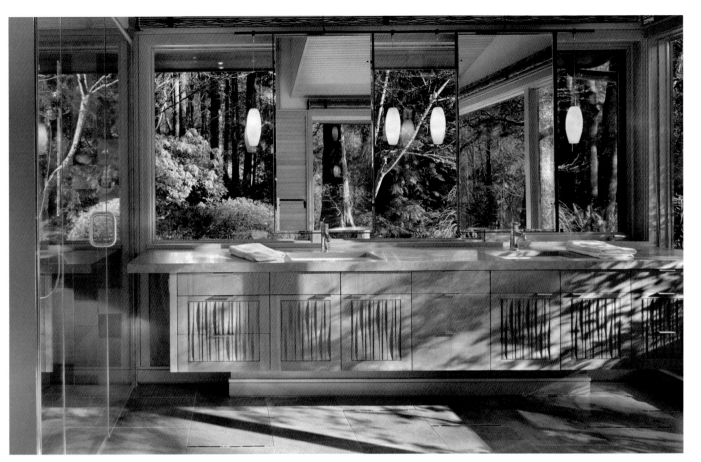

038

Casework consists primarily of cherry panels: some panels are smooth while others have been milled with a CNC (computer numeric controlled) router to make a texture evocative of "woven wood."

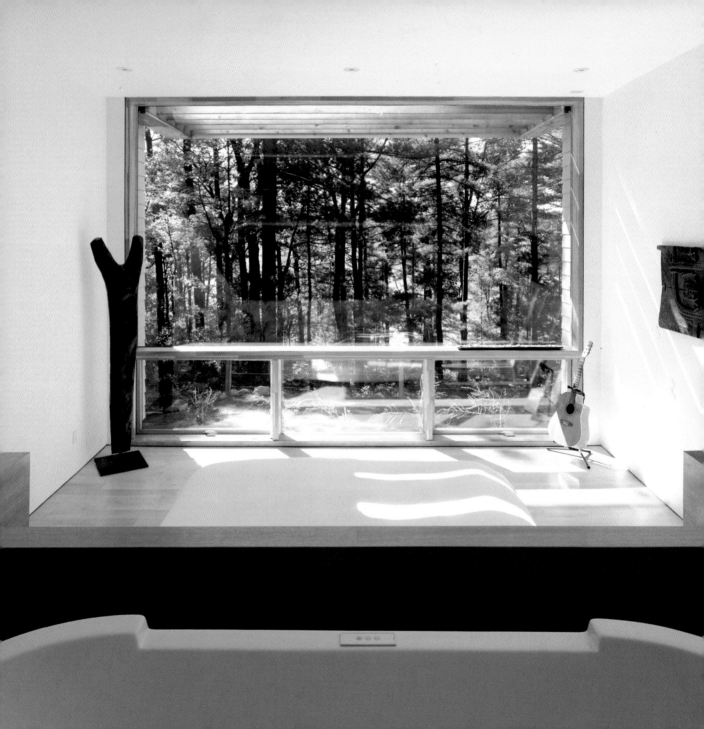

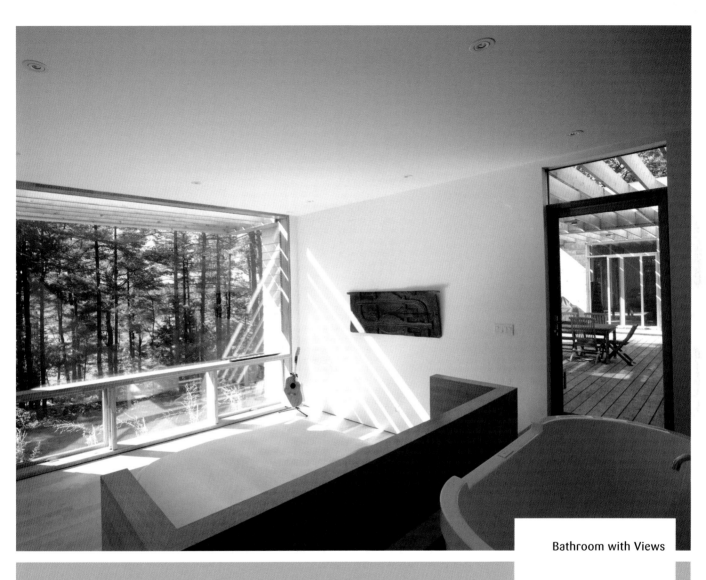

Bathroom with Views

Architects: TACT Architecture

Location: Toronto, Ontario, Canada

Photographer: © Terence Tourangeau

Like tiered seating in a theater, the tub and shower stall rise a few steps above the bedroom for views of the "stage"—a huge wall of window capturing an intimate view of the forest. Low walls provide a minimum of separation between the various tiers (bed, tub, bathroom) without blocking views through the floor-to-ceiling window.

A series of walls finished in various materials announce the functions of each space. Wood at the bedroom, stone for the tub, and glass at the shower.

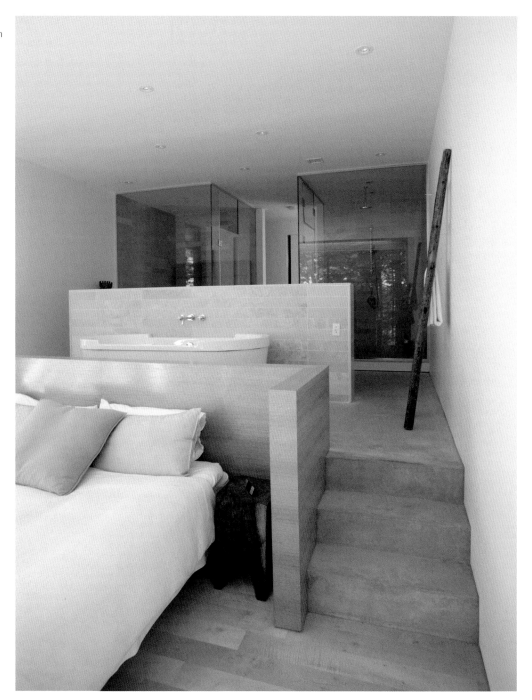

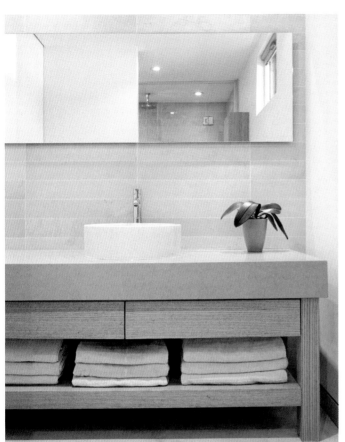

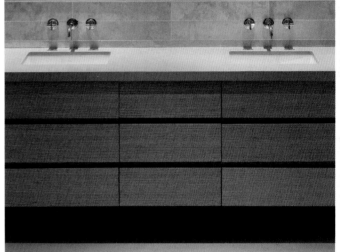

039

Changes in floor level can be used to create a dynamic spatial progression, with one area overlooking another, creating both separation and connection.

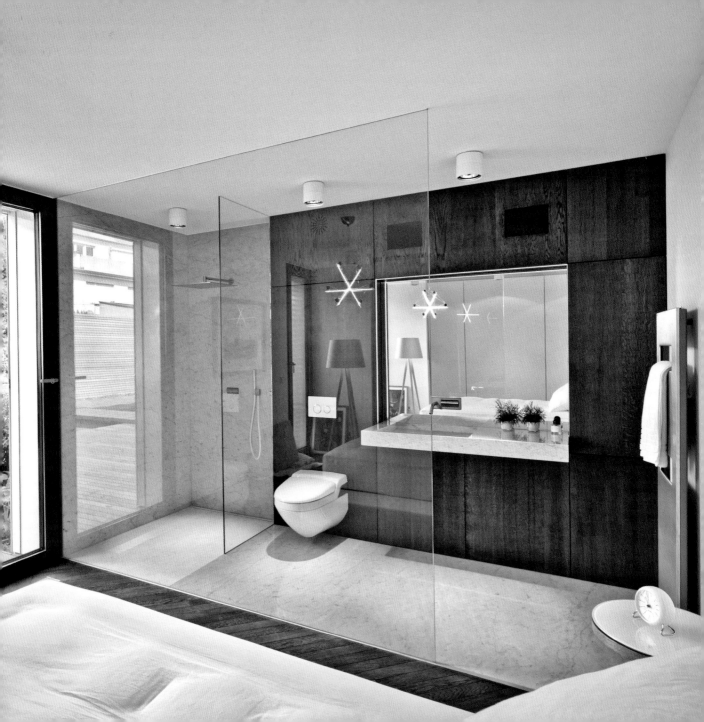

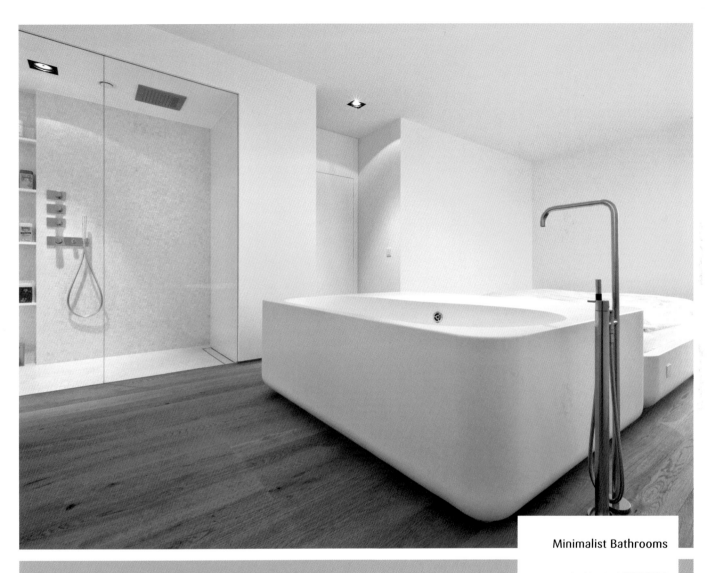

Minimalist Bathrooms

Architects: METAFORM
architecture

Location: Nommern,
Luxembourg

Photographer: © Steve Troes
fotodesign

Various bathrooms in this seven-unit building share a common language of simple forms and minimalist detail. Frameless glass partitions are set in recessed tracks for the cleanest possible detail, while recessed slot shower drains are finished in the same materials as the showers. In one clever gesture, the platform bed matches the adjacent tub.

Second floor plan

Third floor plan

Ground floor plan

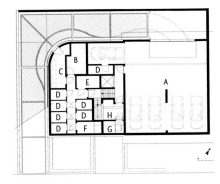

Basement floor plan

A. Garage
B. Laundry room
C. Trash room
D. Storage room
E. Heater/Boiler room
F. Electrical room
G. Mechanical room
H. Bicycle parking
I. Powder room
J. Living/Dining area
K. Kitchen
L. Bedroom
M. Bathroom

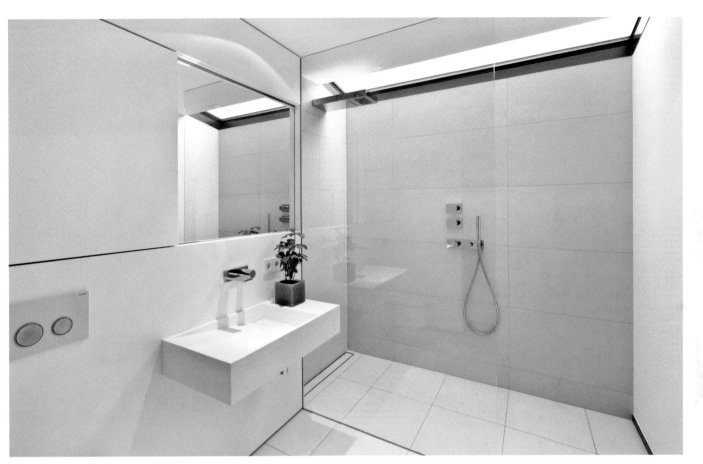

040

For the cleanest, most minimalist look, designers use recessed tracks to mount frameless glass partitions and avoid doors with their associated hardware.

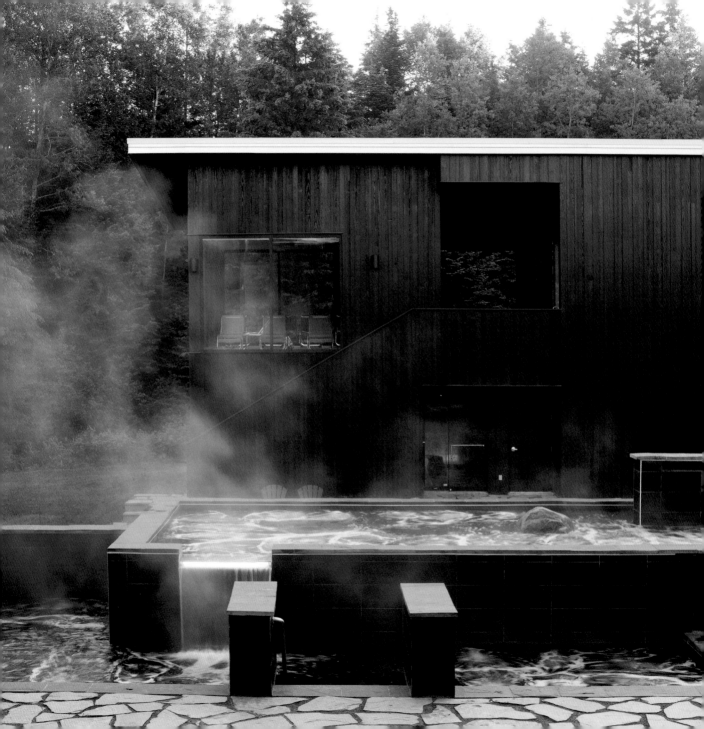

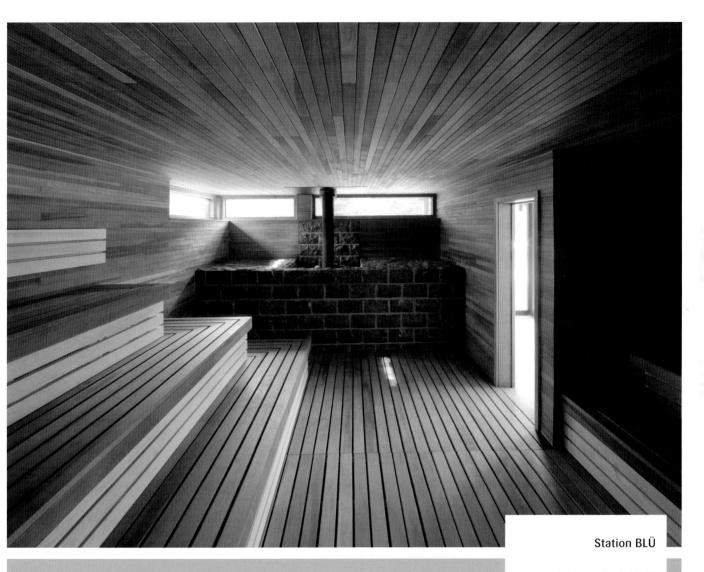

This resort complex on the outskirts of the Charlevoix region includes a restaurant, steam bath, sauna, massage areas, hot and cold pools, and many relaxation spaces. These functions are shared among three pavilions articulated around a landscaped area bordering a river. Its clean, contemporary architecture helps highlight the natural surroundings.

Station BLÜ

Architects: Blouin Tardif Architecture-Environment

Location: Montreal, Quebec, Canada

Photographer: © Stéphane Groleau

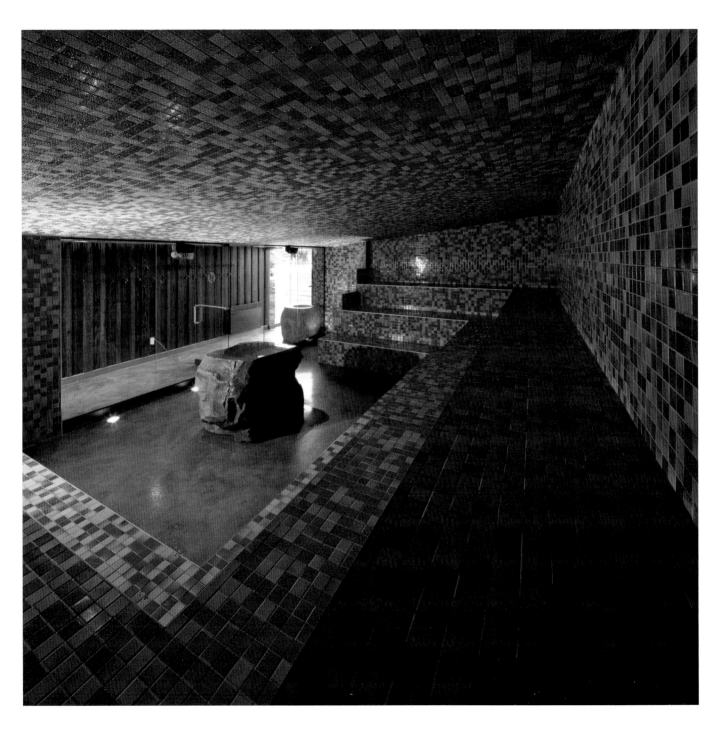

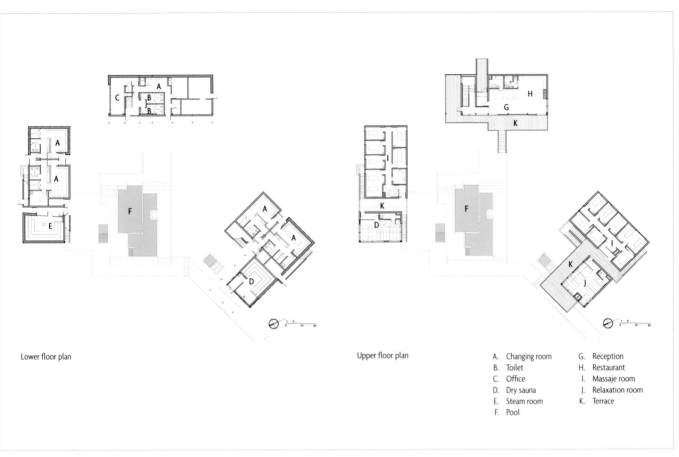

Lower floor plan

Upper floor plan

A. Changing room
B. Toilet
C. Office
D. Dry sauna
E. Steam room
F. Pool

G. Reception
H. Restaurant
I. Massaje room
J. Relaxation room
K. Terrace

The interior spaces are simple, giving the natural landscape the starring role. Bright colors are used only for specific elements, such as the restaurant's large banquette and the steam room.

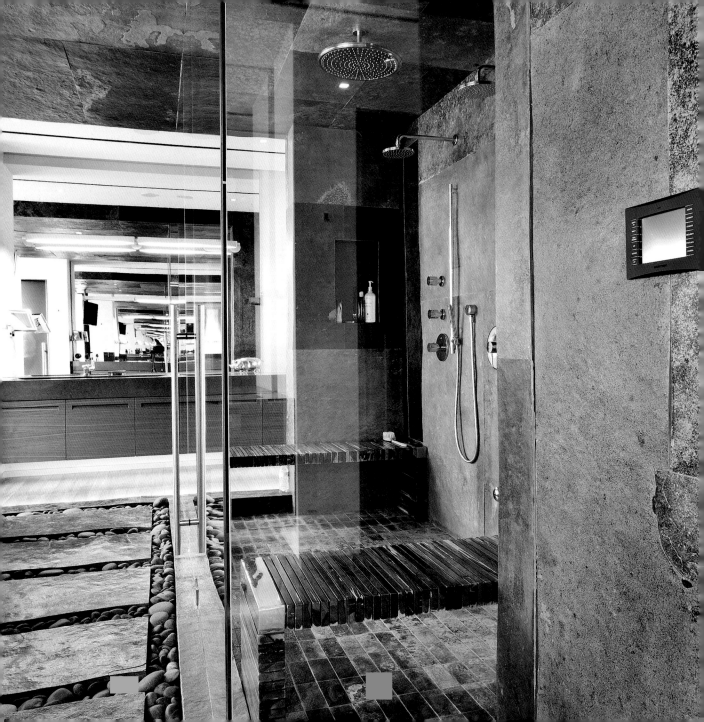

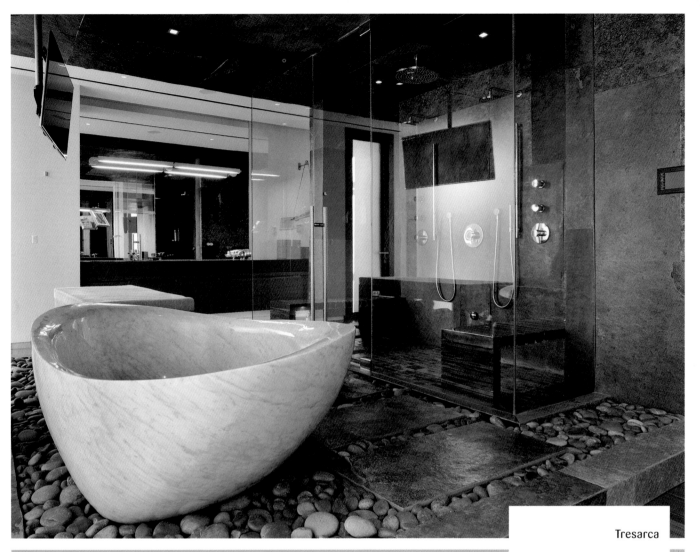

Two bathrooms at the top floor of a luxurious house are a study in contrast and complementation. Organic materials such as river rocks, split stone, and wood planks make one of these bathrooms a sort of garden grotto, while the hard, polished surfaces of the other creates a serene, minimalist retreat, both being light-filled and luxurious.

Tresarca

Architects and Interior Designers: assemblageSTUDIO, Design Lush, Living Penthouse

Location: Las Vegas, Nevada, USA

Photographer: © Bill Timmerman, Zack Hussain

A. Living room/Kitchen
B. Pool house
C. Pool
D. Bedroom
E. Garage
F. Roof deck
G. Lower courtyard
H. Entry
I. Roof garden

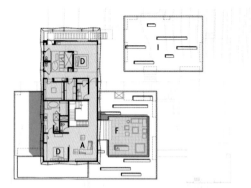

Second floor plan

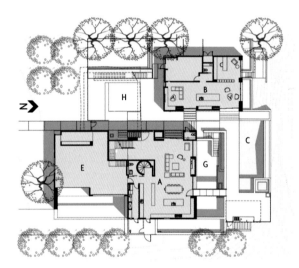

Ground floor plan

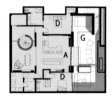

Basement plan

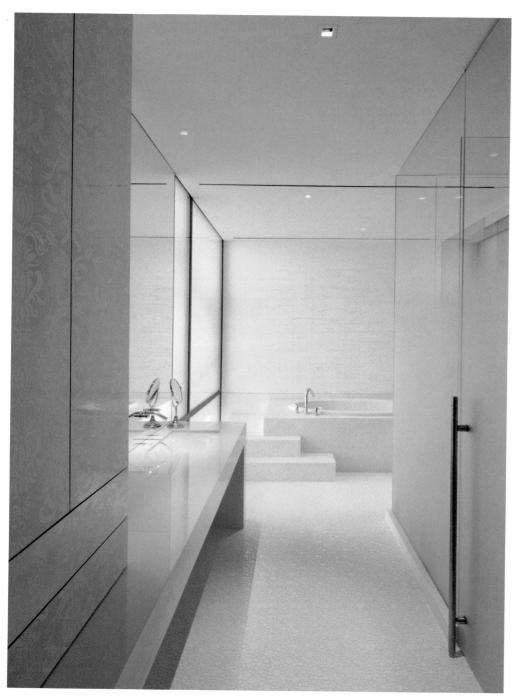

The second floor, where these two luxurious bathrooms are located, is comprised of two large bedroom suites and a sitting area.

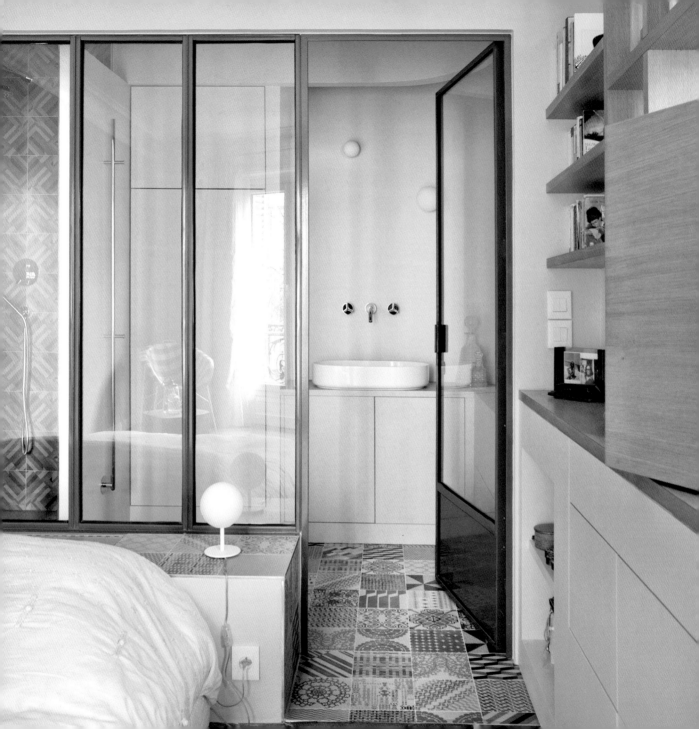

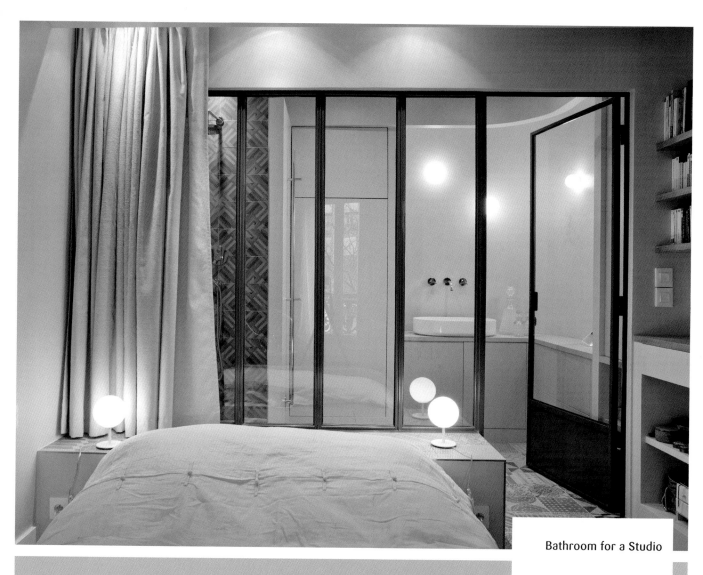

Architect: Olivier Chabaud
Architecte
Location: Paris, France
Photographer: © Philippe Harden

A small two-room apartment has been redesigned to optimize the use of space and improve circulation. The new design is conceived as an open space where the different areas are each defined by a specific selection and use of materials. The bathroom is a semiopen room that screens off the sleeping area from the entry. It frames the kitchen and organizes circulation.

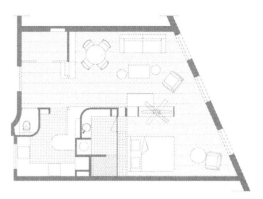

Apartment floor plan

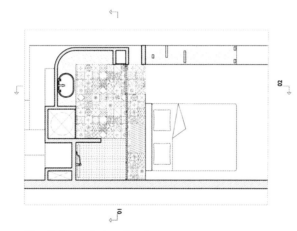

Enlarged bedroom and bathroom floor plan

Section 01

Section 02

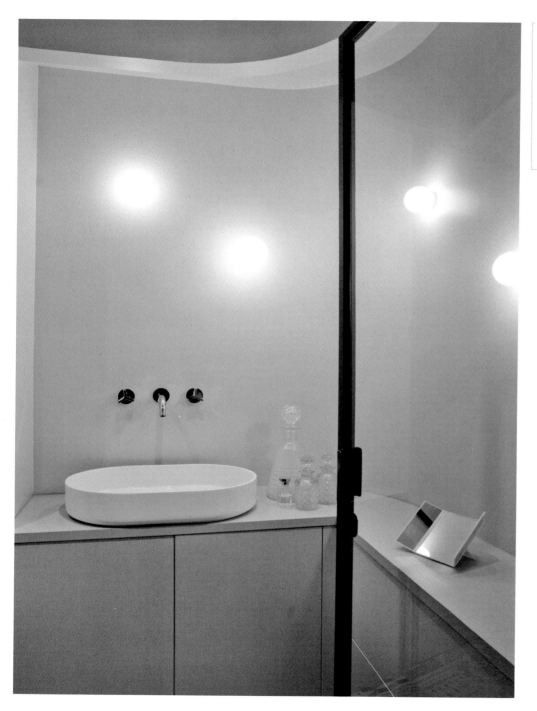

If privacy is not an issue, opening up the bathroom to the bedroom is a good space saving solution. This configuration also allows bringing light into an otherwise often dark interior room.

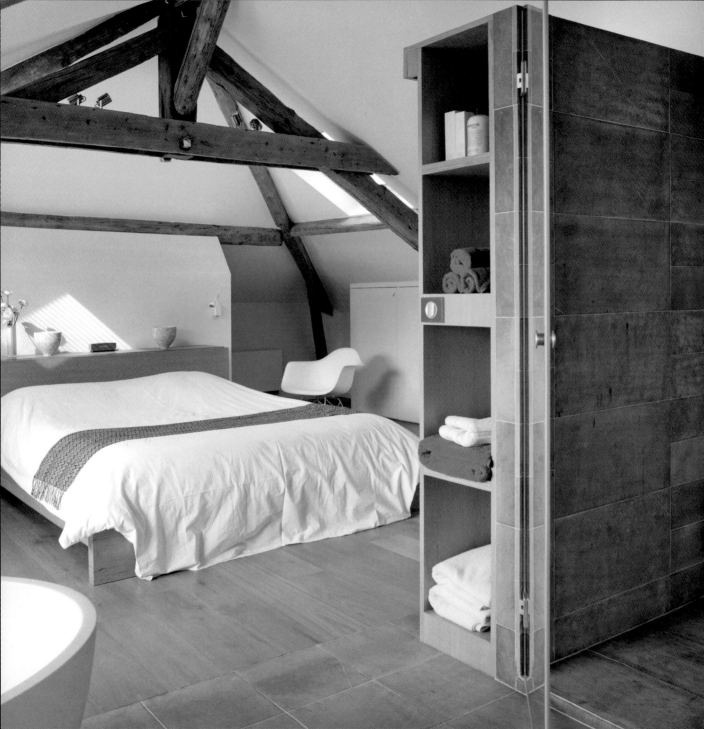

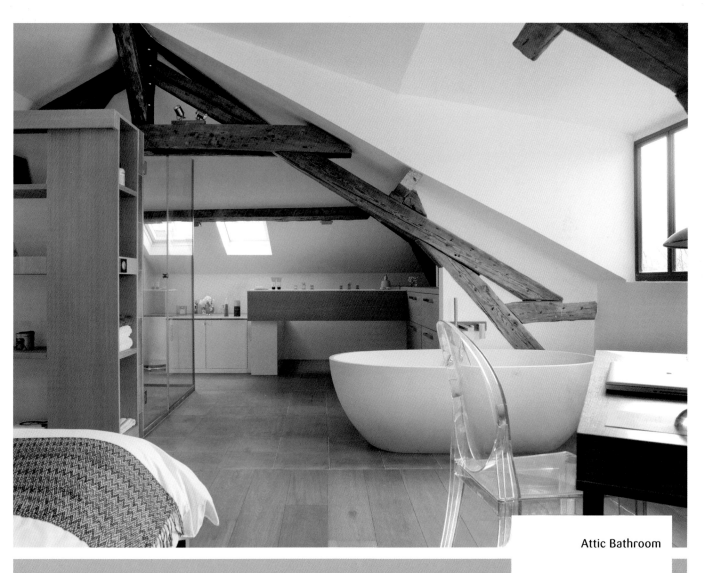

Attic Bathroom

Architect: Olivier Chabaud
Architecte
Location: Paris, France
Photographer: © Philippe
Harden

A nineteenth-century three-story house with basement on the outskirts of Paris underwent an expansive remodel bringing new life to its confined interior. As part of this remodel, the entire attic was transformed into a master suite with minimal separation between bedroom and bathroom. The timber framing of the roof is left exposed to give the space a rustic appeal contrasting with the sleek finishes and furnishings.

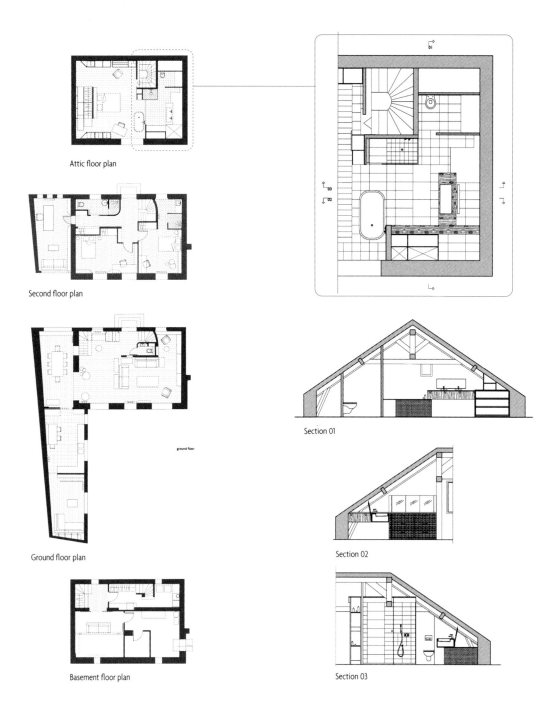

Attic floor plan

Second floor plan

Ground floor plan

ground floor

Basement floor plan

Section 01

Section 02

Section 03

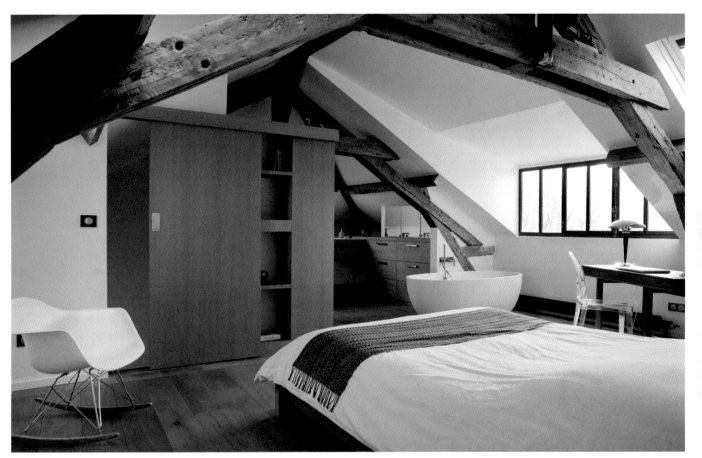

The design is developed around the notions of comfort and well being by means of ample spaces, a palette of neutral colors and various windows and skylights that infuse the space with an even light.

042

Freestanding tubs come in many shapes and styles. Their sculptural qualities make them a perfect addition to a room with its own special architectural identity.

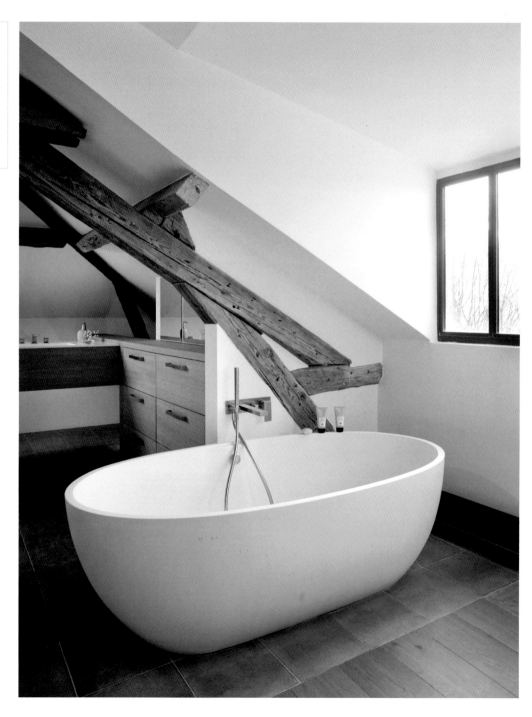

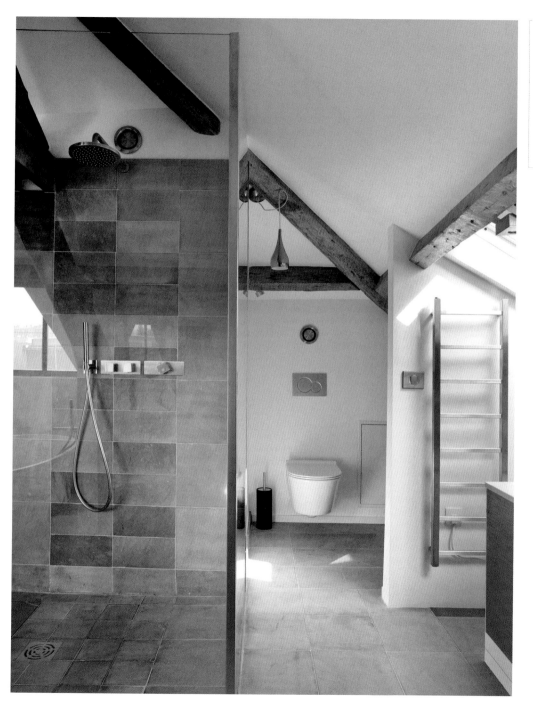

Curbless shower pans can be flush with floors in adjacent spaces allowing users to walk or roll in and out of the shower without tripping over a raised threshold.

INSPIRATIONS

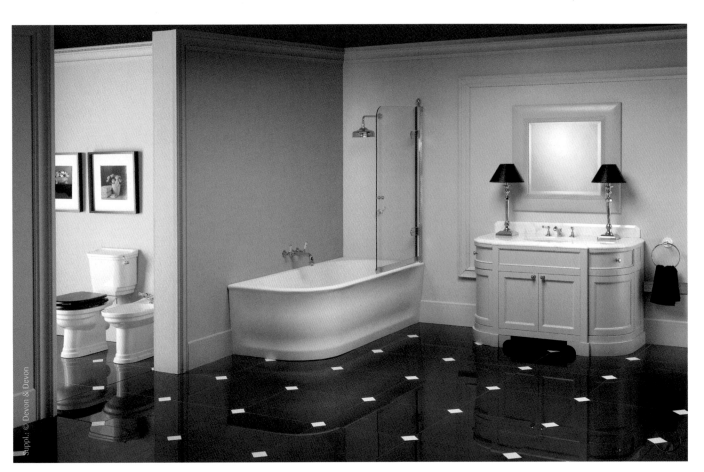

044

Pay the same attention to
decorating your bathroom as
you would for any other room
in the house. Like any other
room, the bathroom can be the
expression of your personality.

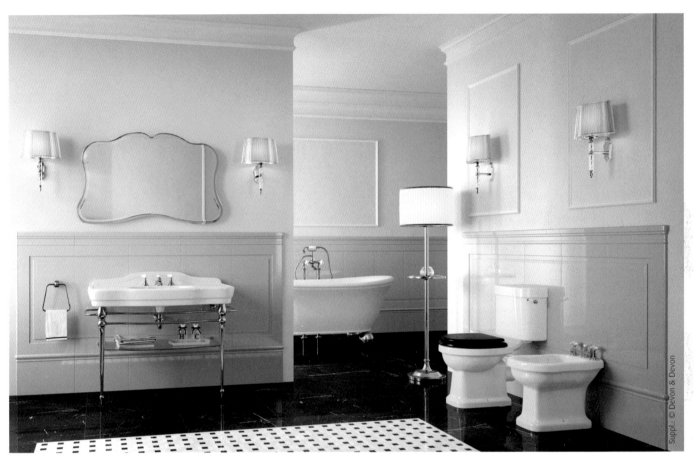

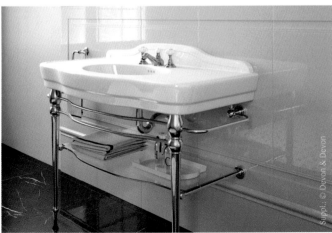

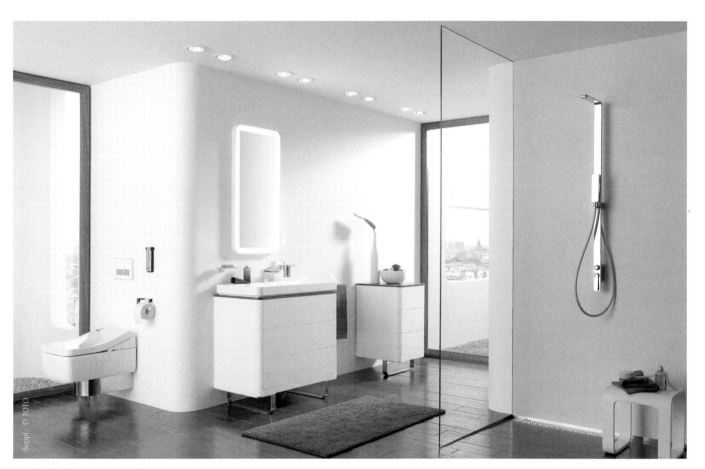

This all white bathroom with hardwood floor has a clean and open design that optimizes natural light. The wood frames of the floor-to-ceiling and the wood details of the cabinets are a contrasting warm color accent.

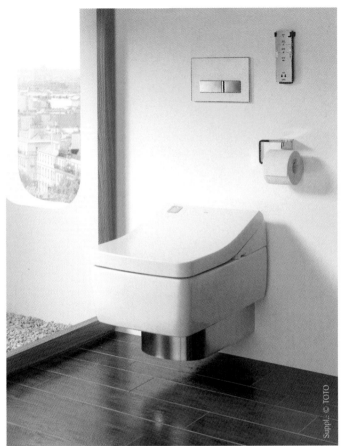

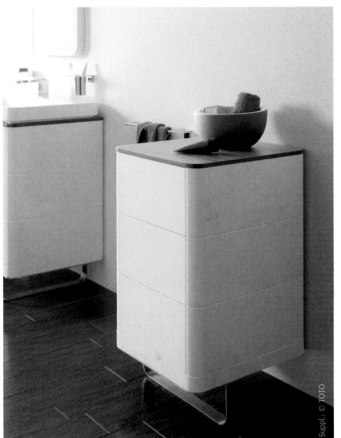

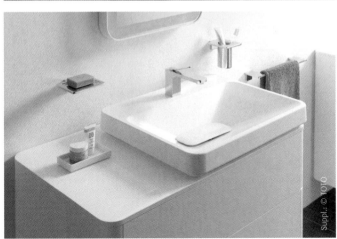

Maps, compasses, knotted ropes, and boat paddles are beautifully displayed on top of a credenza and line the walls of this black and white bathroom infusing a nautical motif..

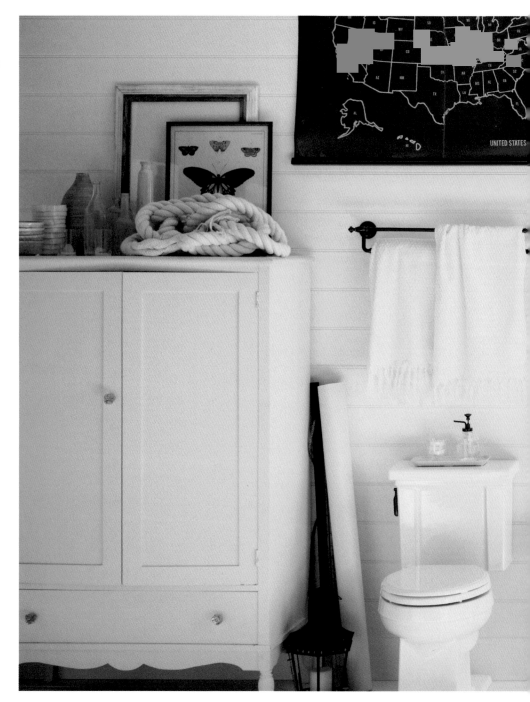

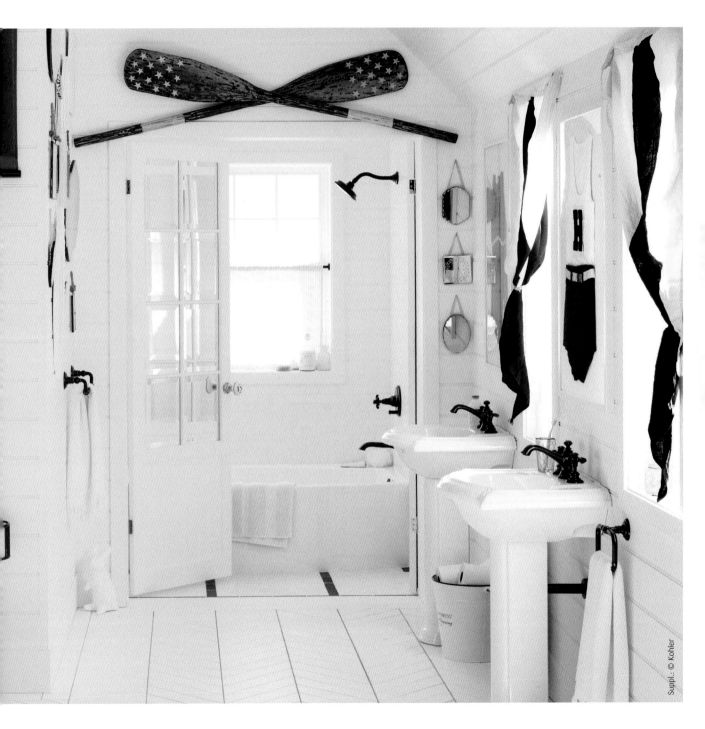

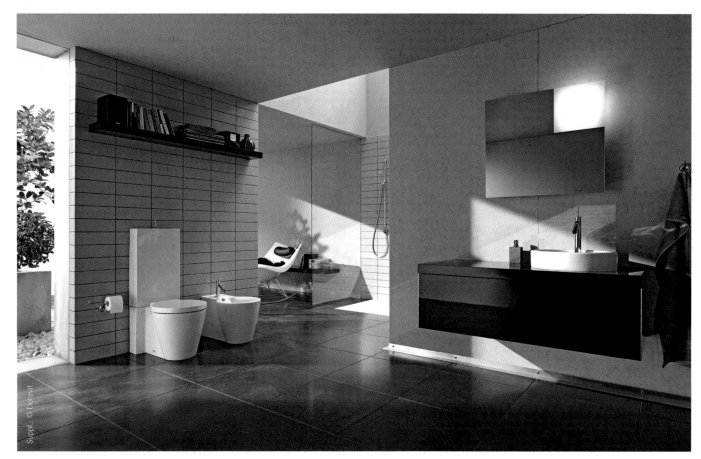

Suppl.: © Duravit

These wall-mount toilets and bidets butt
up against the tiled wall from the top of
the cistern to the foot of the pan creating
a flush line, easy to clean.

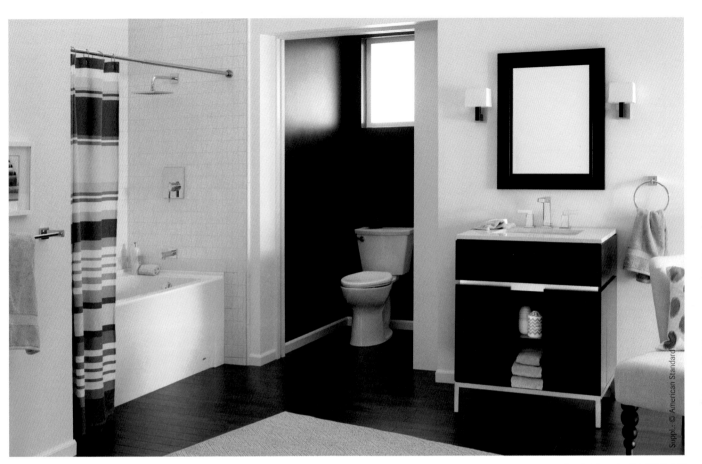

045

If you have a generously large space, an enclosed toilet compartment separate from the tub and sink area is the ultimate in privacy.

046

The floating vanity reinforces the airy feel of this bathroom. The room features a glass block wall filtering light without compromising privacy.

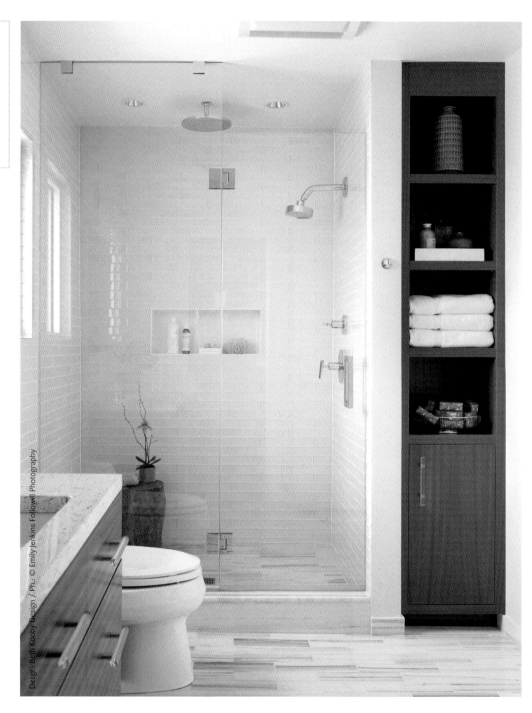

Desgr.: Beth Kooby Design / Ph.: © Emily Jenkins Followill Photography

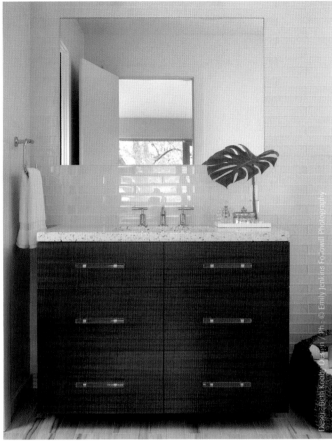

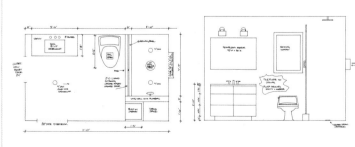

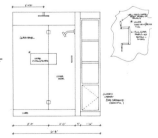

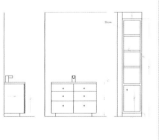

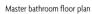

Master bathroom floor plan

Master bathroom interior elevation at vanity

Master bathroom interior elevation at shower

Vanity and linen cabinet elevation details

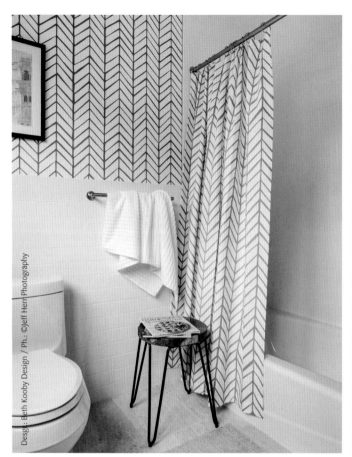

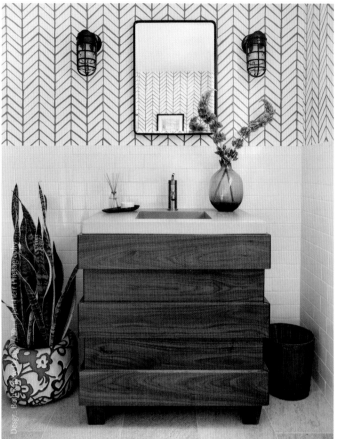

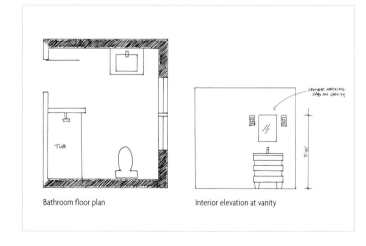

Bathroom floor plan

Interior elevation at vanity

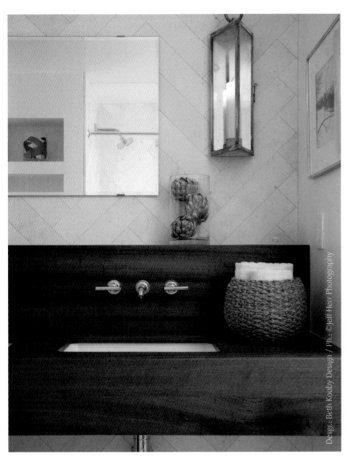

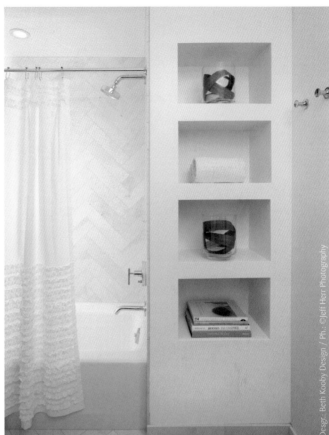

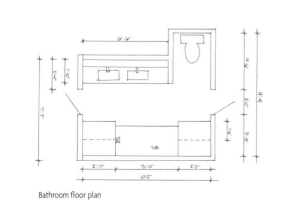

Bathroom floor plan

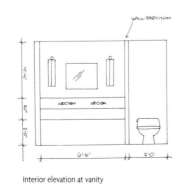

Interior elevation at vanity

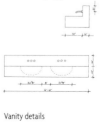

Vanity details

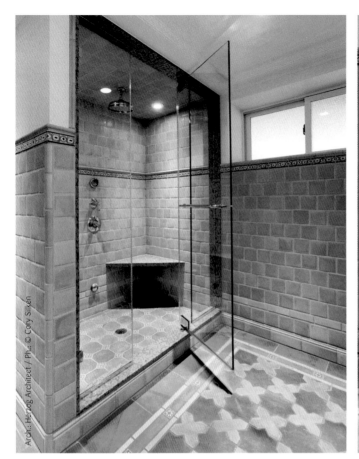

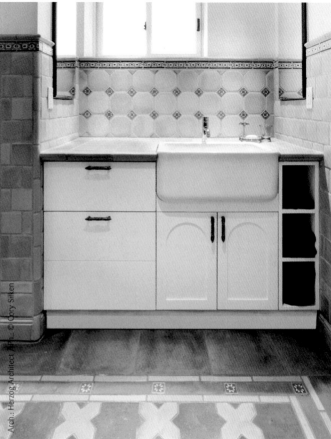

A storage space under a stair was
transformed into a Moorish bathroom /
steam shower with several different
handmade ceramic tile patterns including
a tile "rug" in the center of the room.

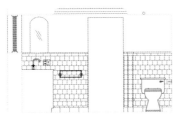

North elevation

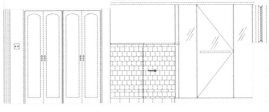

East elevation

South elevation

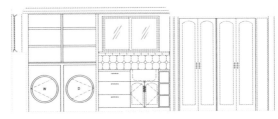

West elevation

North vestibule elevation

South vestibule elevation

East shower elevation

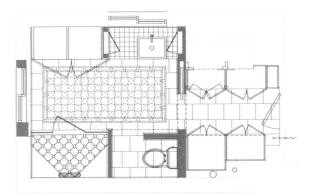

Bathroom floor plan

The bedroom and a bathroom, overlooking the living area on the floor below, benefit from the expansive views of the outdoors through the large windows of the double-height living room.

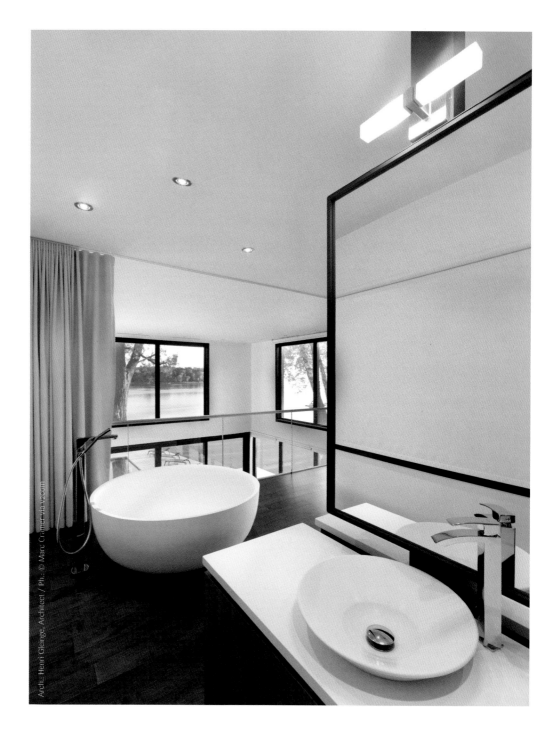

Arch.: Henri Cleinge, Architect / Ph.: © Marc Cramer via vzcom

Main floor plan

Loft floor plan

Basement floor plan

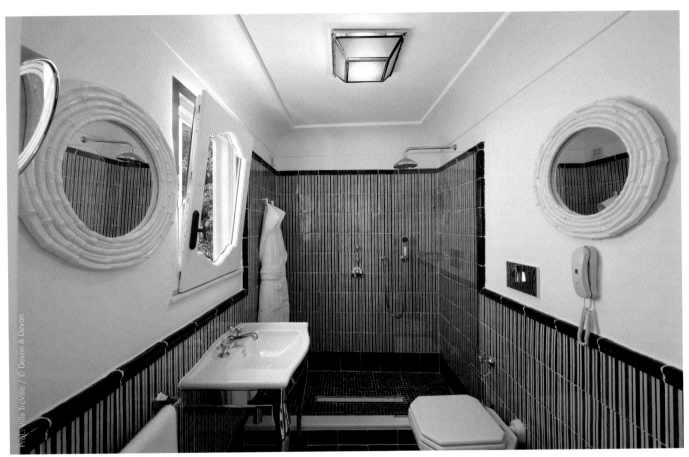

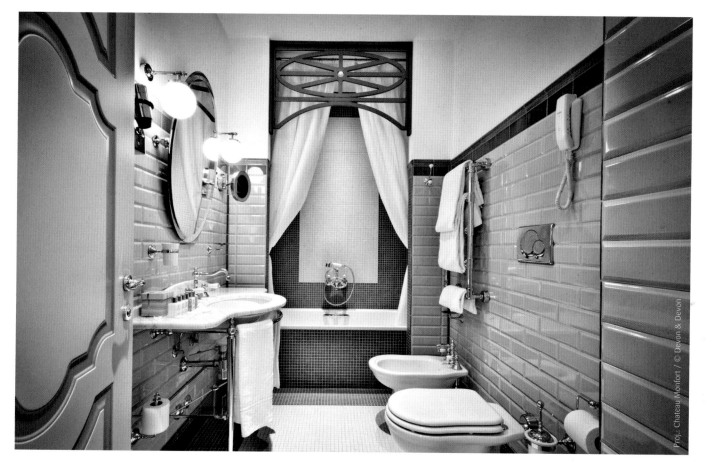

047

Wainscot has an effect on how we visually perceive a room. A low wainscot makes a room look long, while a taller wainscot makes the room look taller especially if the color above the wainscot is of a lighter color.

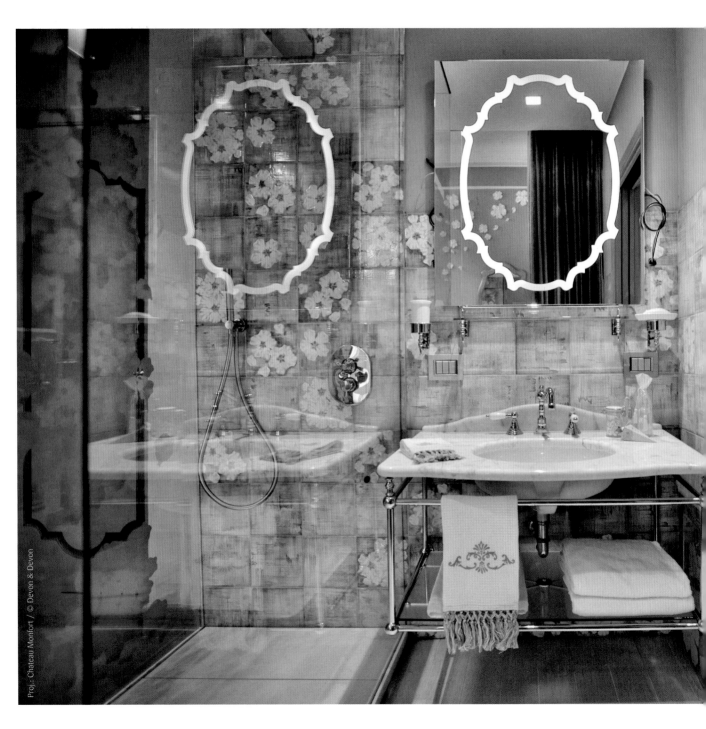

Etched glass adds style and functionality to a bathroom. For instance, it can simply be a decorative separation or it can screen off the shower from the rest of the space.

Proj.: Chateau Monfort / © Devon & Devon

049

A central wall can be used as a divider and at the same time accommodate the plumbing, in this case, for both the sink and the shower.

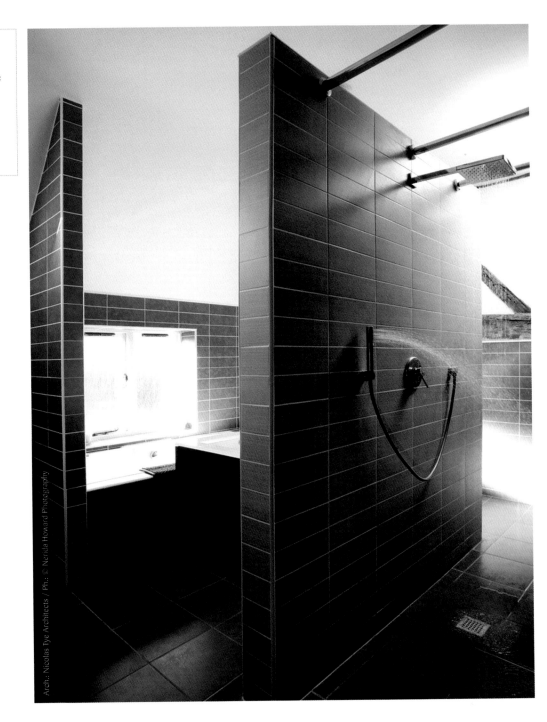

Arch.: Nicolas Tye Architects / Ph.: © Nerida Howard Photography

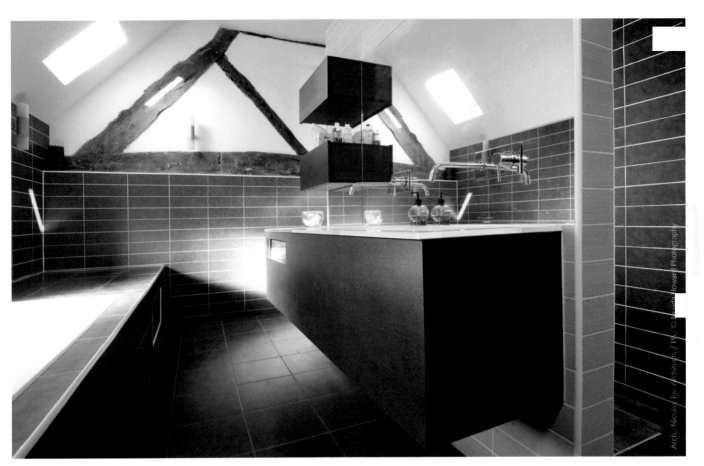

The fittings and the tiles create an elegant and stylish bathroom that is able to complement a nineteenth-century remodeled barn's exposed wood beams.

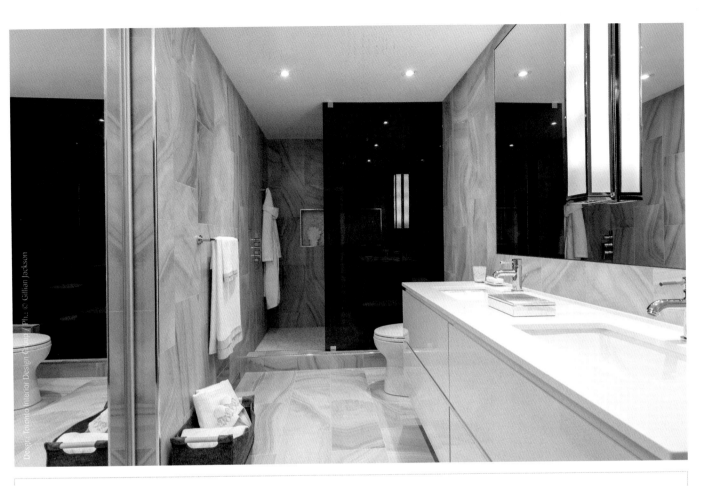

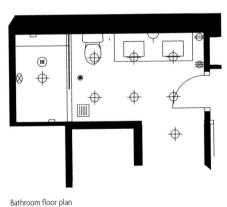

Bathroom floor plan

Interior elevation at bathroom's vanity

Interior elevation
at bathroom's shower

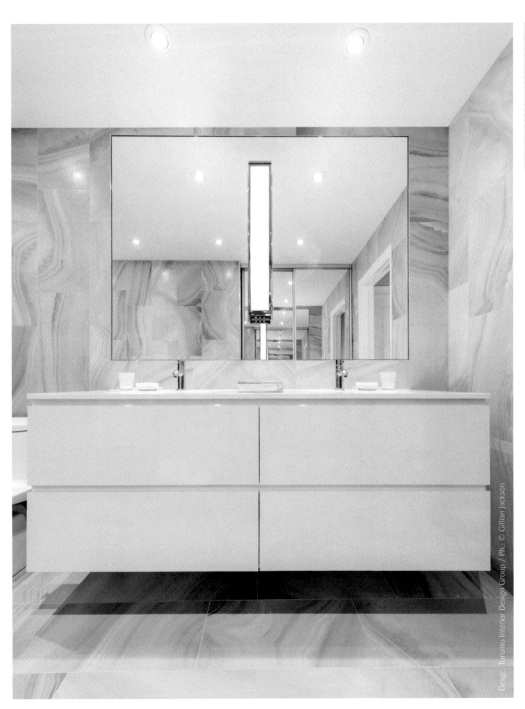

Design: Toronto Interior Design Group / Ph.: © Gillian Jackson

050

Combine patterned porcelain tiles with white accents for a luxurious yet fresh look.
A simple floor-to-ceiling glass partition adds spatial depth, while maintaining the flow through the room.

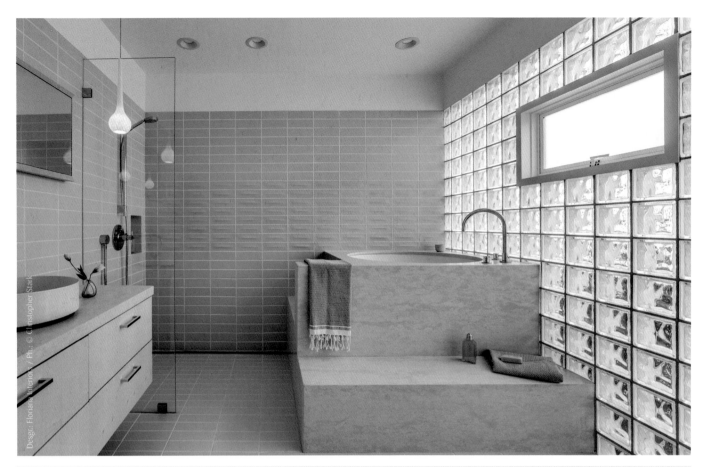

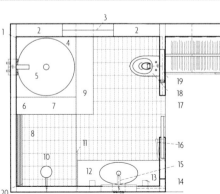

Bathroom floor plan

1. Ceiling height 8'-0"
2. Existing glass wall to remain
3. Existing window to be replaced
4. Tub surround at 33" above floor finish
5. Hansgrohe™ tub faucet to replace existing faucet
6. 18" high step
7. Horizontal tub surround, steps, and countertop are ASN™ Bohemia Gold Limestone
8. Infinity drain
9. 12" step
10. Hansgrohe™ shower system to replace existing
11. Glass wall to ceiling height
12. Alape® vessel sink
13. Sconces
14. Alfina® medicine cabinet in English Sycamore 25"W x 30H" x 5" D
15. Hansgrohe™ wall faucet to replace existing
16. Pivoting mirror 14" W x 70" H
17. Floor tile: "Classic" Heath Ceramics® 3"x9" in Canvas color. Accent in the vertical surface tile: "Dimensional" Crease Out 3"x9" tile in "Canvas" color
18. Toto™ Acqua wall hung toilet
19. Geberit™ in-wall tank system 2 x 4 install
20. Ceiling height 9'-0"

Desgs: Florian Interiors / Ph.: © Christopher Stark

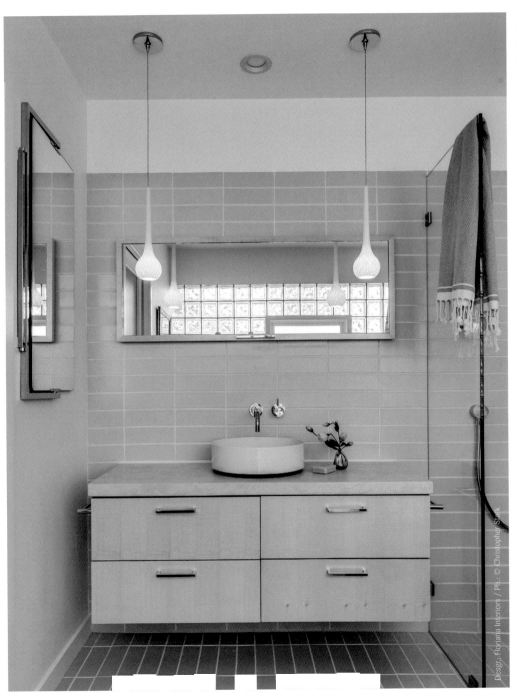

The floating vanity reinforces the airy feel of this bathroom. The room features a glass-block wall filtering light without compromising privacy.

Design: Floriana Interiors / Ph.: © Christopher Stark

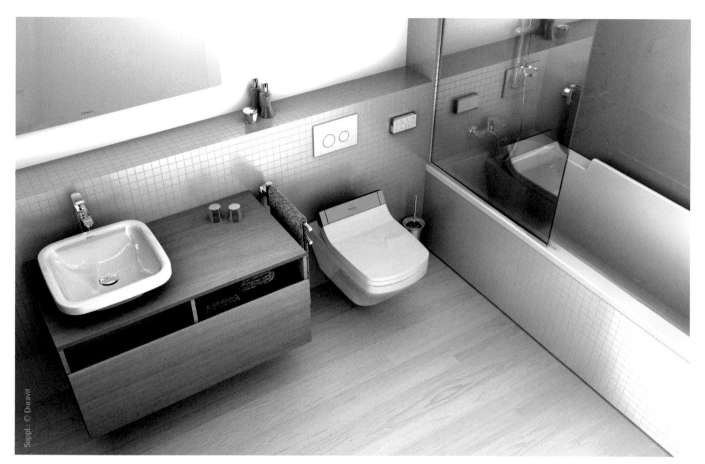

051

The layout of this bathroom concentrates all the plumbing fixtures on one single wall to simplify the rough plumbing. This solution is the most appropriate for small bathrooms.

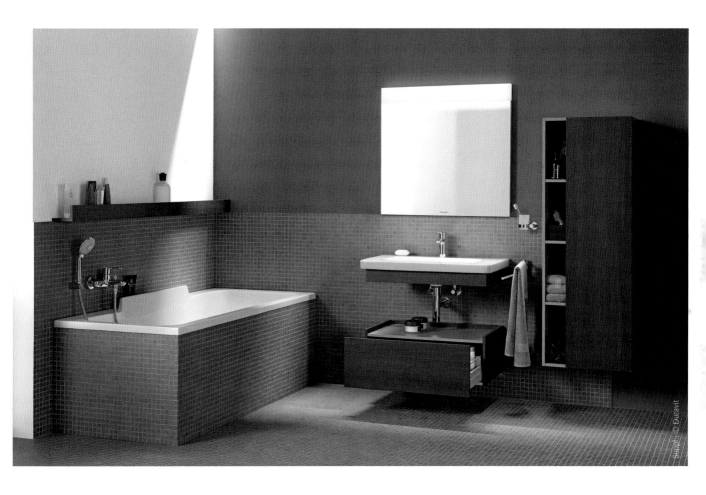

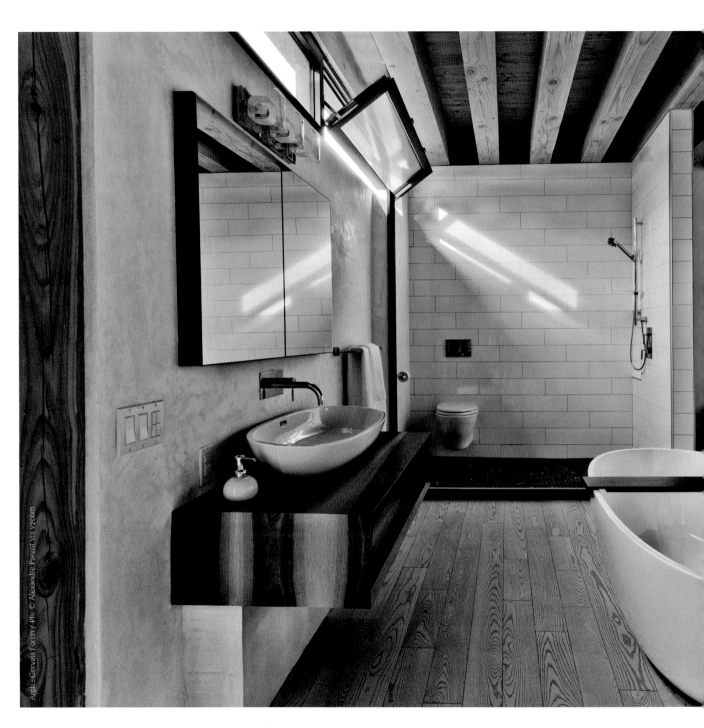

Transom windows are ideal for bathrooms as they provide enough light and ventilation, while maintaining privacy.

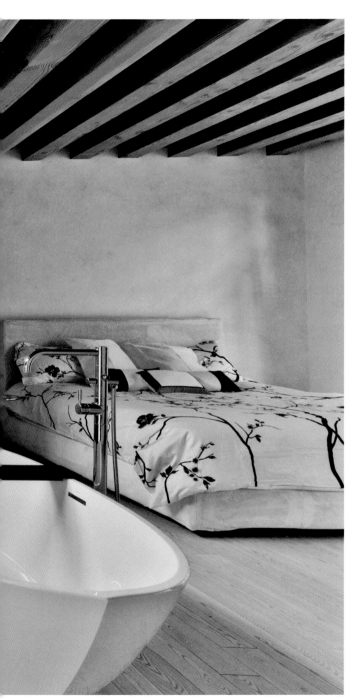

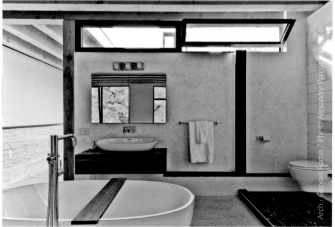

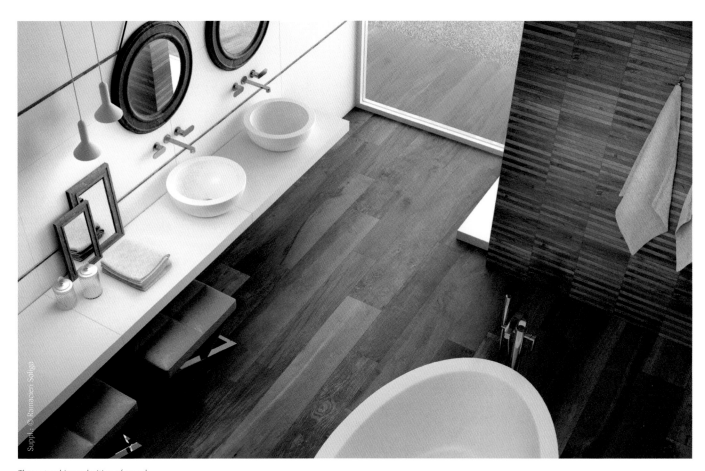

The natural irregularities of wood
combined with the high performance
of porcelain stoneware offer a durable,
versatile, innovative and undisputed charm.

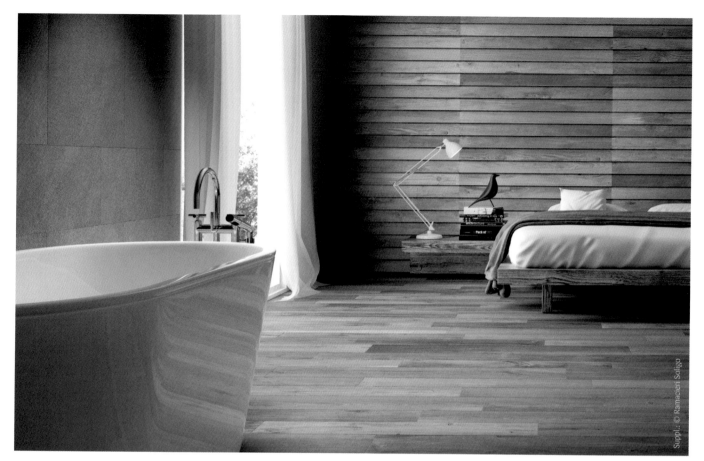

053

Engineered wood flooring is actually real wood flooring designed to withstand changes in temperature and humidity. An alternative is high-quality wood-like laminate.

The clean lines of this bathtub echo the simplicity of the room. The minimalistic atmosphere focuses on the framed view of the natural environment promoting a sense of well-being.

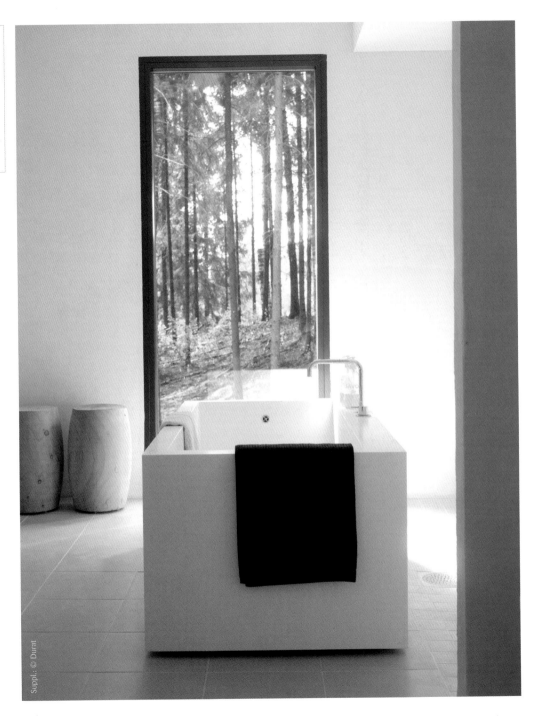

Suppl. © Durat

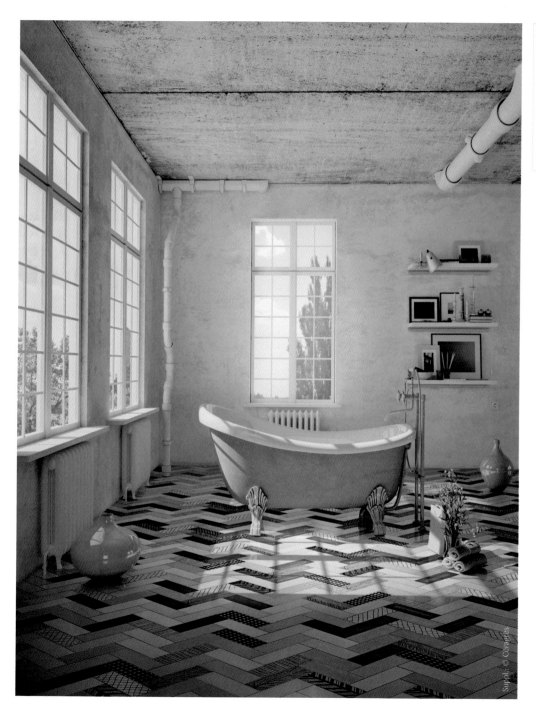

055

Add zest to a bathroom with fun patterns and chromatic combinations. Mix and match colors, patterns and solids focusing on a single surface so as not to create an overwhelming atmosphere.

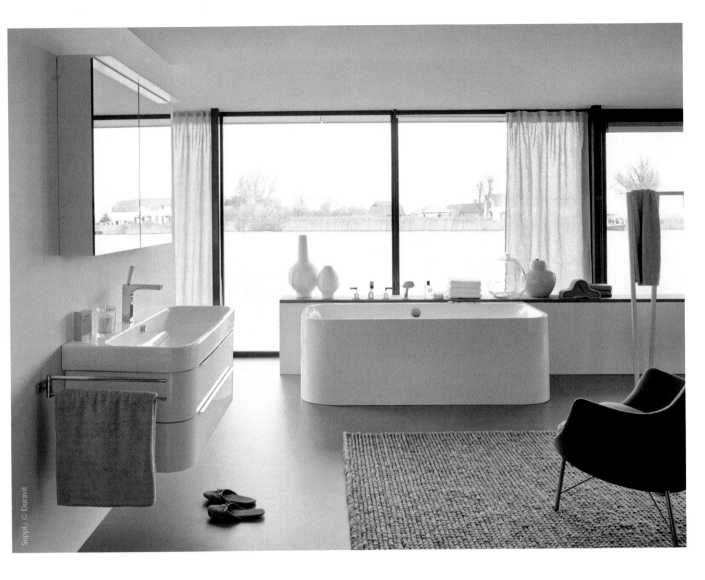

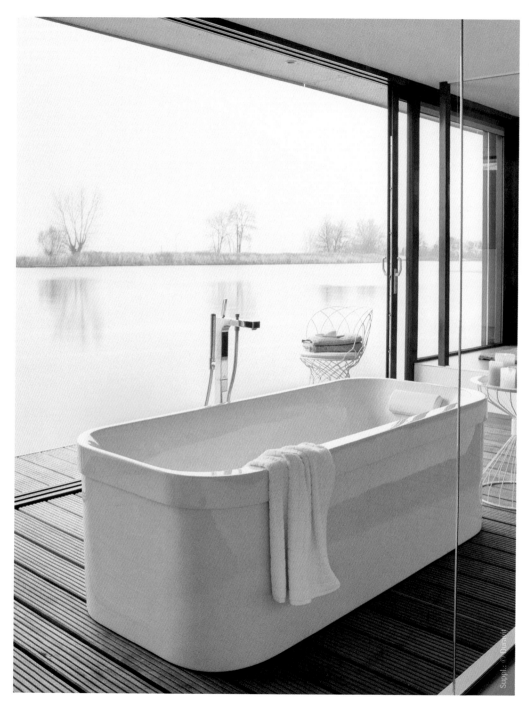

Duravit™ explores the design possibilities of previous series of tubs that come with or without whirlpool. The Happy D.2 model can either be freestanding or a corner unit.

Suppl.: © Duravit

Mixer taps, shower hoses
and bathtub spouts combine
practical and modern features
into designs that add final
touches to a bathroom.

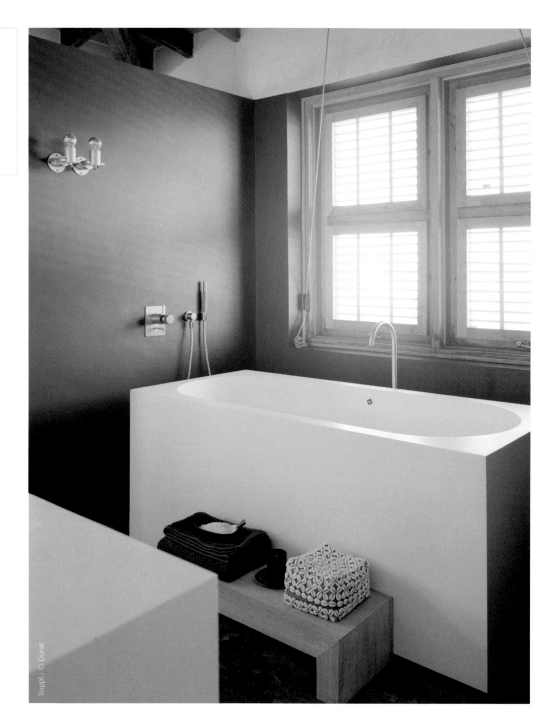

Suppl.: © Durat

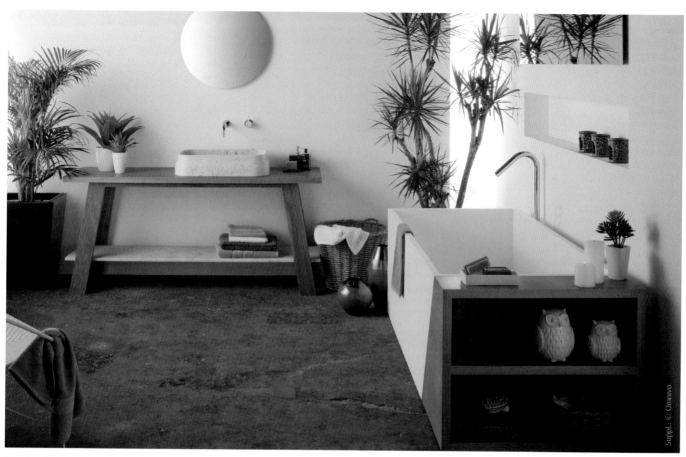

The uncomplicated, elegant form of the basin combines with superior materials such as natural stone to create a luxurious everyday item with eternal appeal.

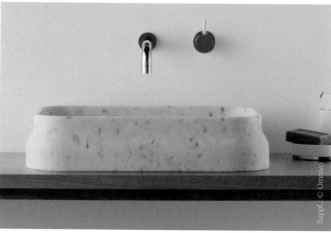

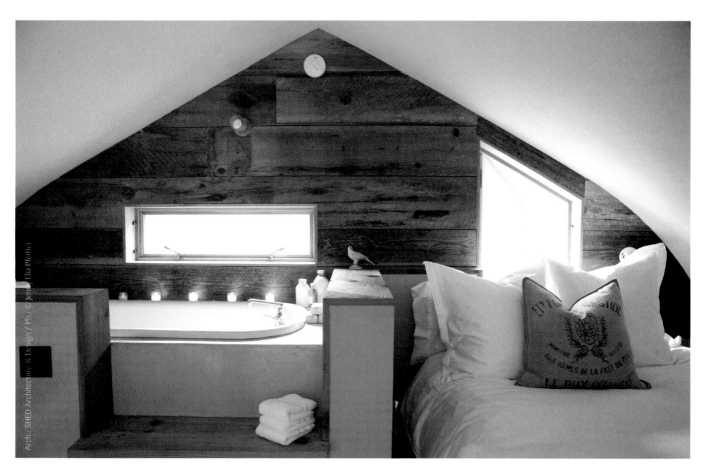

Arch.: SHED Architecture & Design / Ph.: © Jenny Ilia Pfeiffer

057

Direct access from the outside is great for a bathroom when there are outdoor activities like swimming or horseback riding, so you can use the bathroom without traipsing dirt through the house.

Arch.: SHED Architecture & Design / Ph.: © Jenny Ilia Pfeiffer

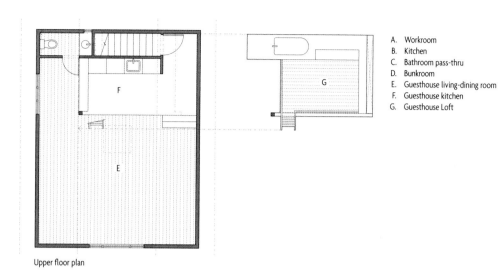

A. Workroom
B. Kitchen
C. Bathroom pass-thru
D. Bunkroom
E. Guesthouse living-dining room
F. Guesthouse kitchen
G. Guesthouse Loft

Upper floor plan

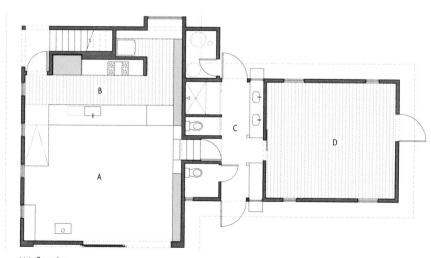

Main floor plan

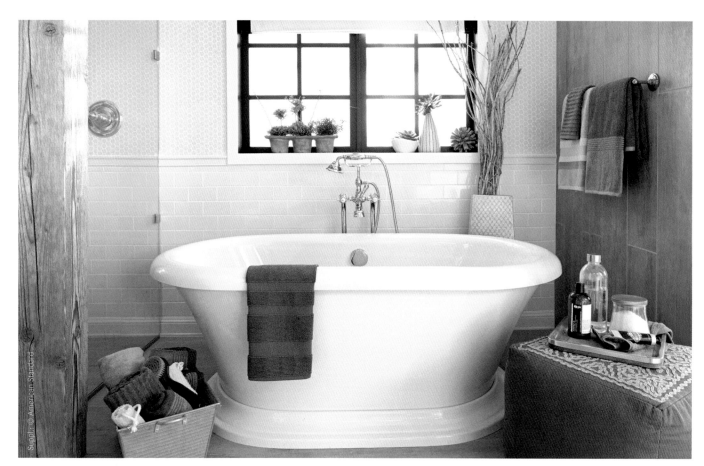

An airy loft bath is fitted out with the
St. George Freestanding Soaking Tub as
its focal point. The sculptural and well-
proportioned design of this tub is
a tribute to the craftsmanship at the turn
of the twentieth century.

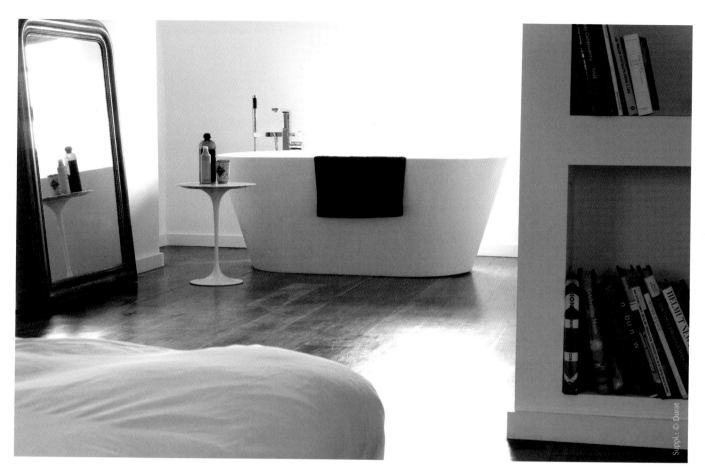

058

Freestanding tubs are finished on all sides so they don't have to be tucked into the corner of a room. But before selecting the bathtub, it is important to determine the location of the water pipe in the room.

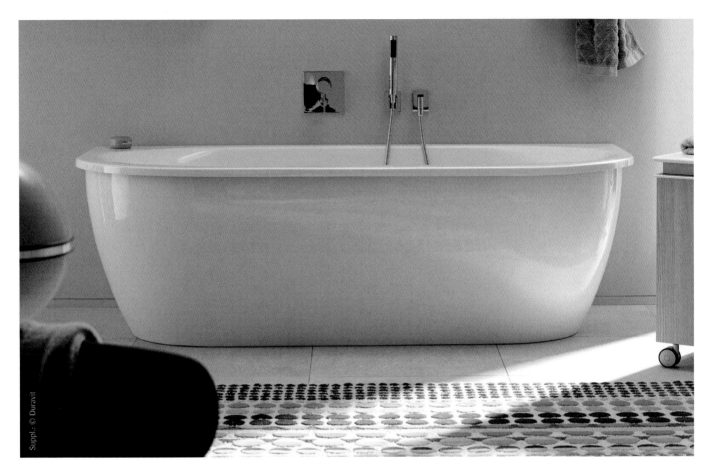

Suppl.: © Duravit

059

Consider how you want your tub filled. Some tubs have holes drilled on their deck to house faucets and tub spouts. A tub that has no holes drilled in it will require floor or wall-mount fittings.

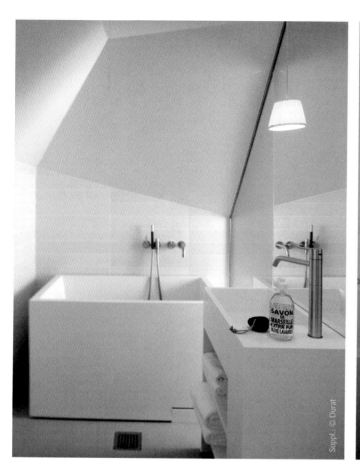

Suppl.: © Durat

Suppl.: © Durat

060

The space under an attic ceiling can be an asset when planning your bathroom. The sloping ceiling creates a cozy nook where your bathtub can be installed.

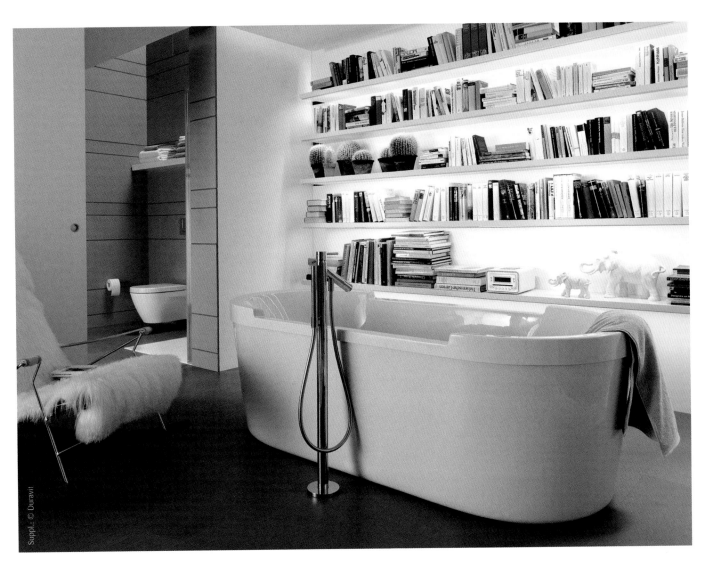

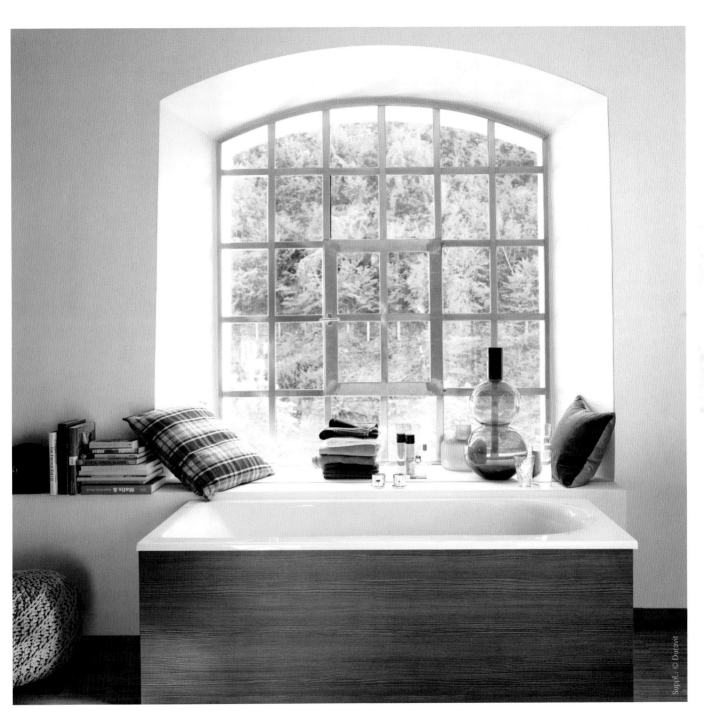

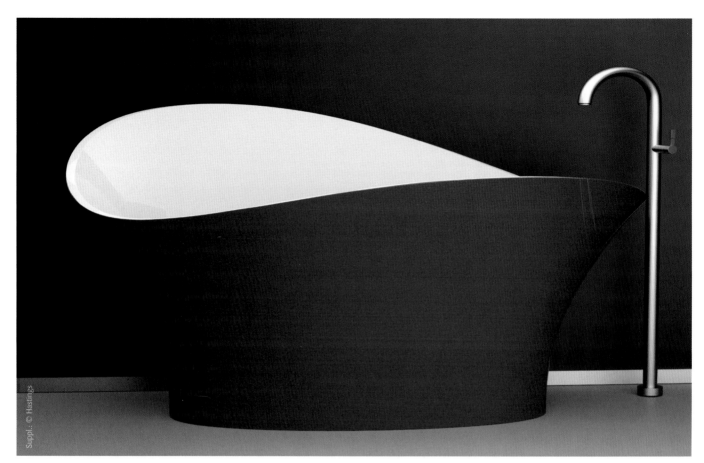

061

Natural stone or Corian™ are common material choices for the fabrication of freestanding bathtubs. Both materials can be used seamlessly to produce a wide variety of designs.

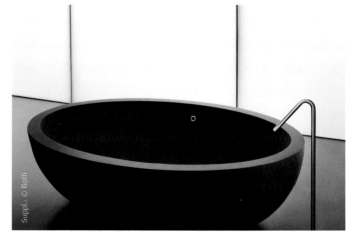

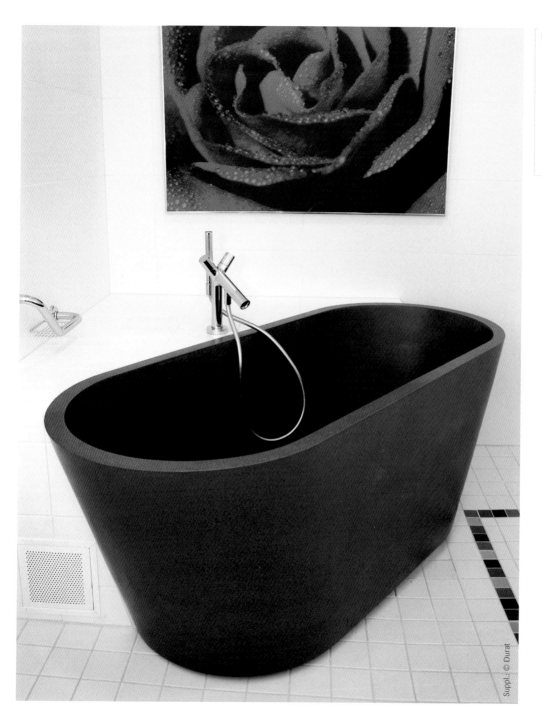

Recycled plastic bathtubs break into the market of bathroom fittings for the environmentally aware consumer. Available in many shapes and colors, they bring energy and zest to a bathroom.

Suppl.: © Durat

A bathtub carved in natural stone makes for a unique addition to a luxurious bathroom. Marble, travertine, sandstone and granite are the most sought-after choices for the quality of the tones and texture.

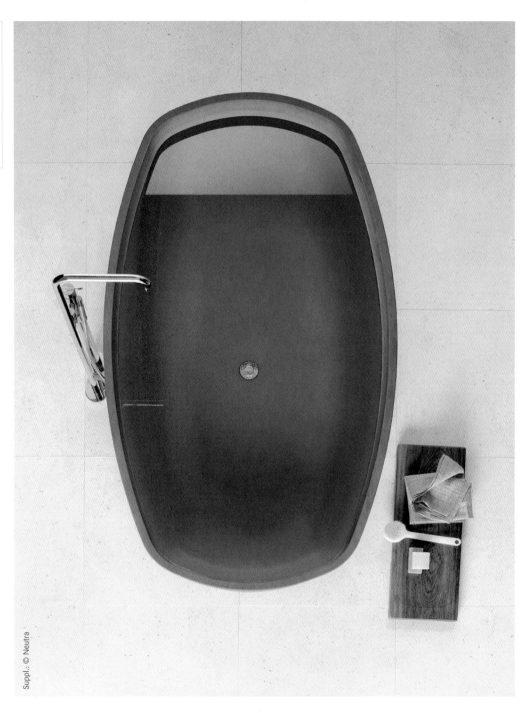

Suppl.: © Neutra

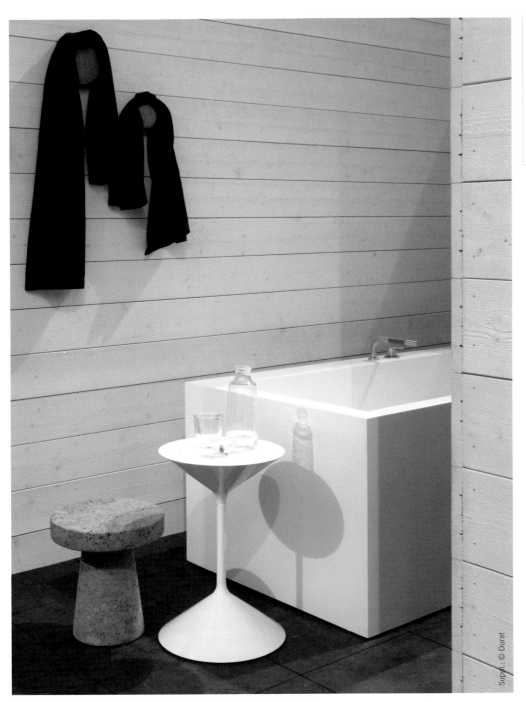

064

There's no reason why a bathroom should lack panache. Accessorize and add the finishing touches to your bathroom decor to make it your own stylish oasis away from daily stress.

The most tranquil corners of the home
are the best for intimate moments of
pleasurable solitude soaking in a tub.

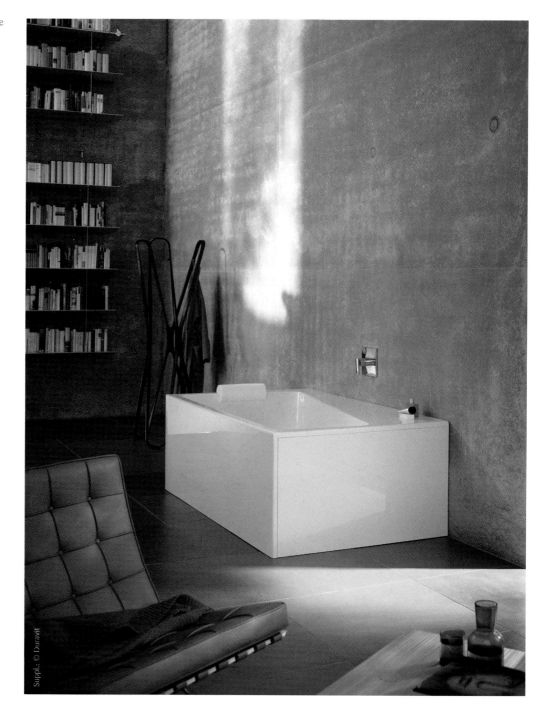

Suppl.: © Duravit

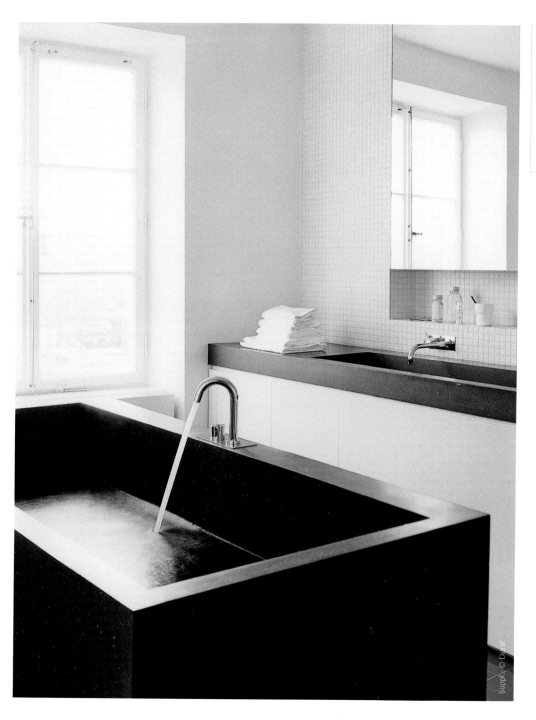

A quite and secluded space is perhaps all you need for a relaxing moment. Nothing around to distract, but a bathtub to soak in. Simplify the décor of this area to enhance the bathing experience.

066

There is more to bathroom
design than just selecting and
installing the basic fixtures.
Turn your bathroom in a
comfortable wellness retreat
think about every detail from
finishes to towel rails.

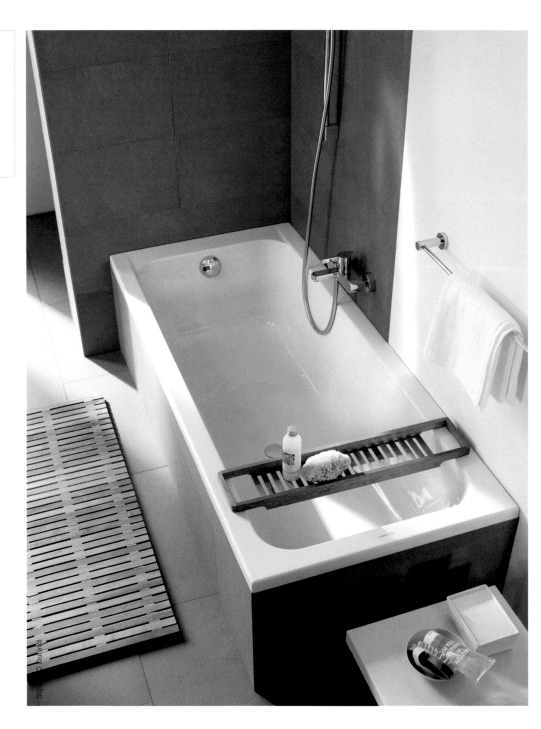

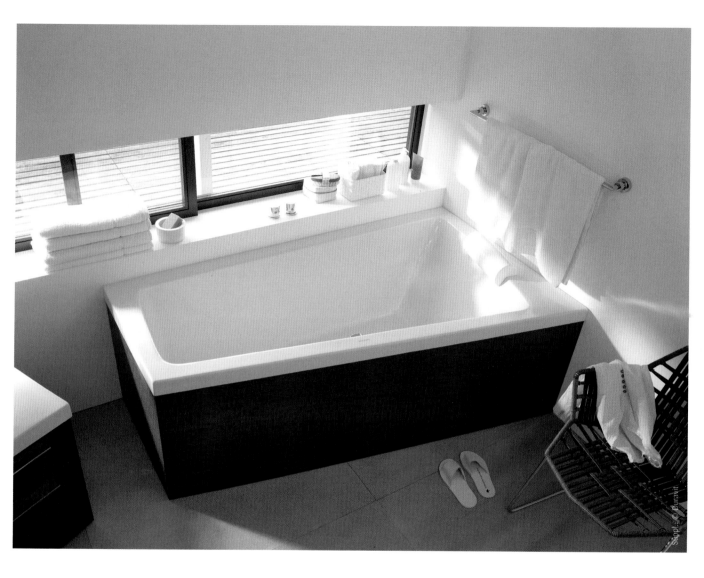

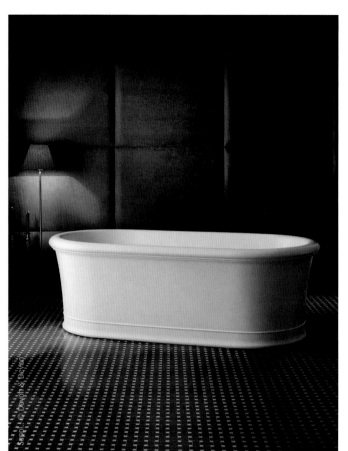

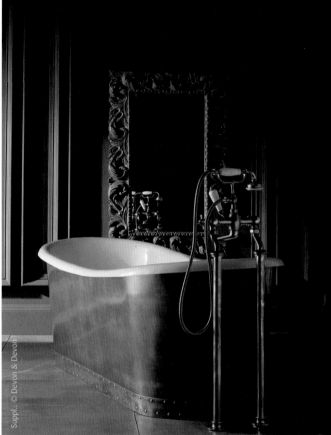

067

Freestanding tubs celebrate luxury and sensuality. They are, along with the showers, the largest fixtures in the bathroom, and as such, they are key for setting the style of the bathroom.

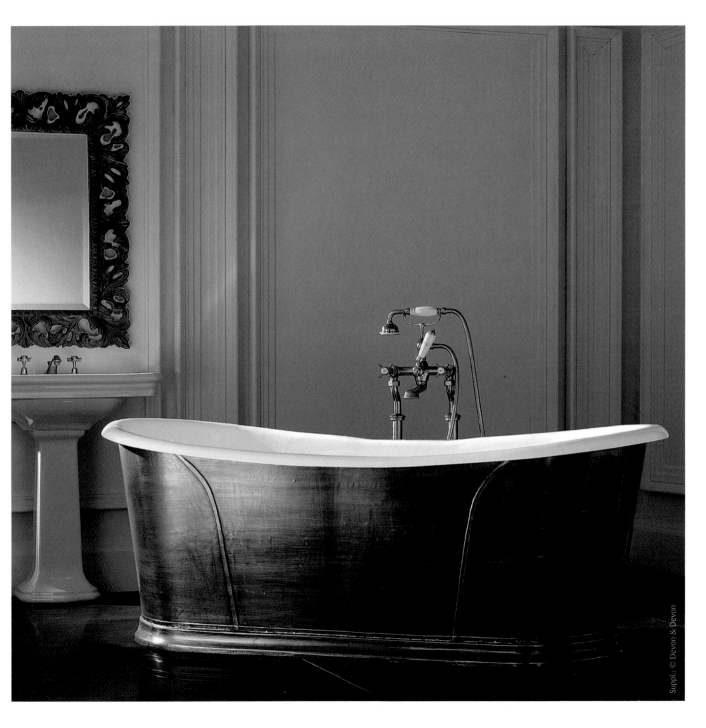

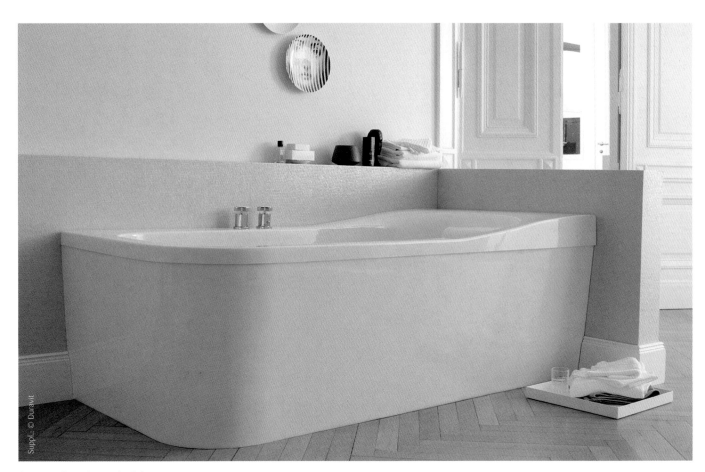

Generous dimensions and soft forms are
devised to offer comforting ergonomics
for a complete revitalization of the body
and the mind. At the same time, design
of bathtubs evolves to satisfy all space
requirements without sacrificing design.

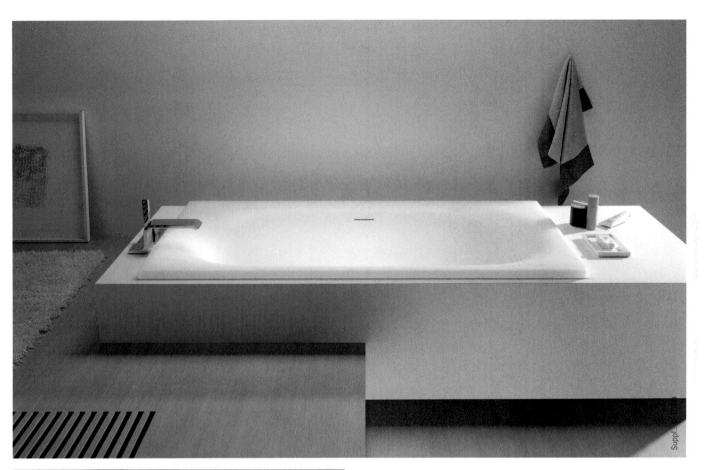

Suppl.: © TOTO

Suppl.: © TOTO

There is a wide range of whirlpool models that offer bubble massage to enhance a bathing experience. With sloped backrests allowing for a comfortable deep soaking, they are all we hope for a pampering treat.

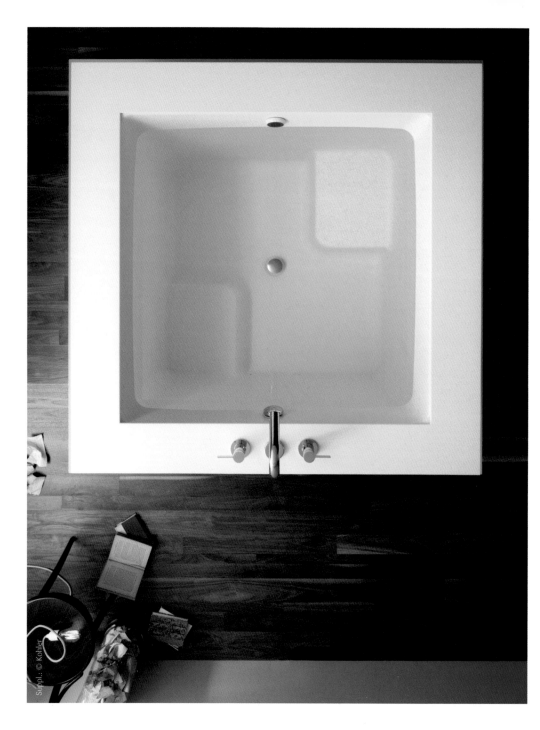

Suppl.: © Kohler

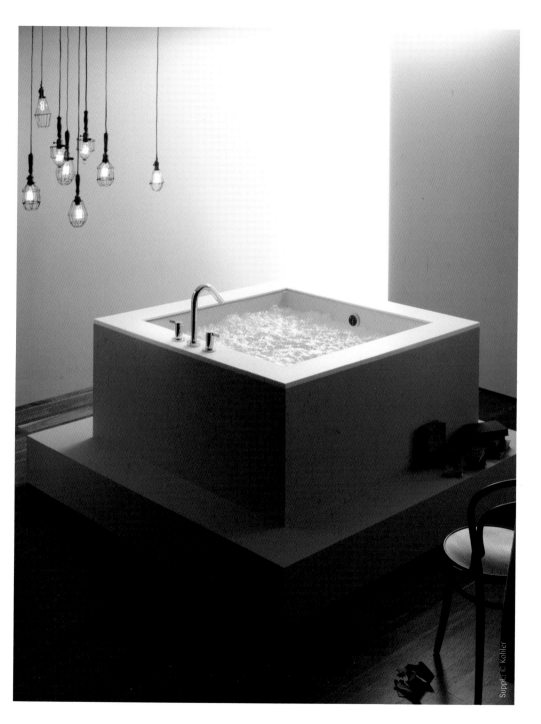

068

It is known that light and color together with water have therapeutic effects on our health and inner harmony. Complete the experience with relaxing melodies and bath oils and scents.

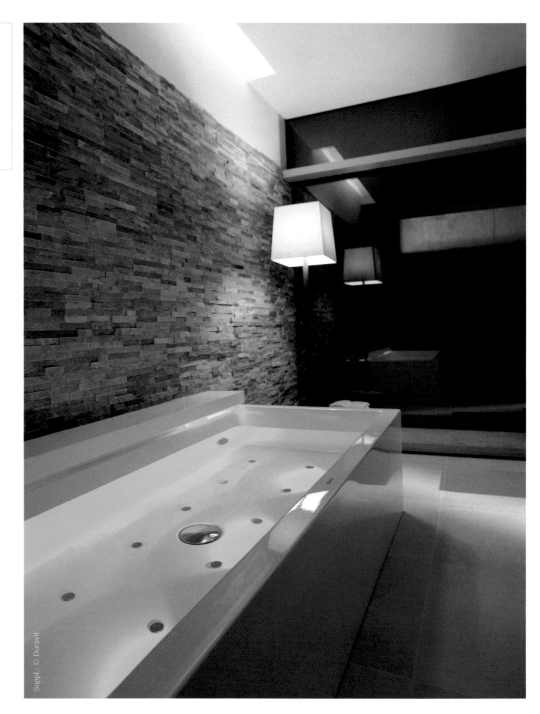

Suppl.: © Duravit

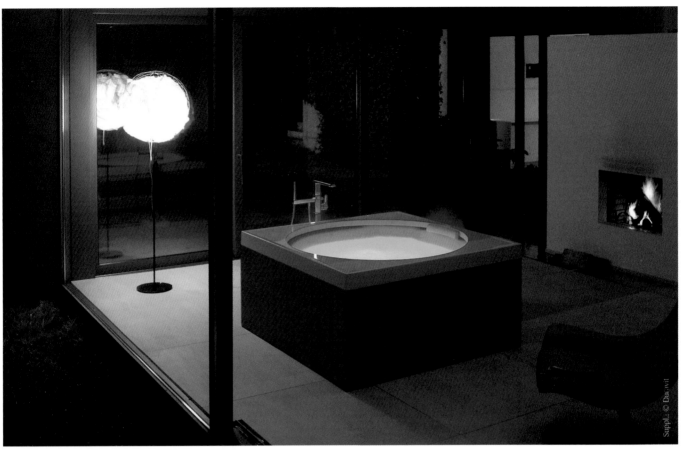

Suppl. © Duravit

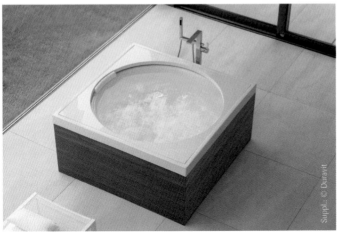

Suppl. © Duravit

Blue Moon by Duravit™ is more than an ordinary bathtub. Its extra depth makes it more like a Jacuzzi and a mood-setting colored light system enhances the bathing experience.

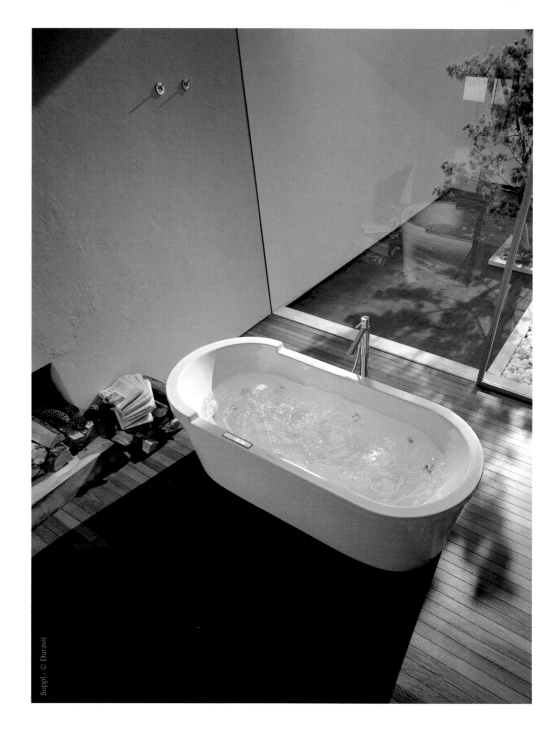

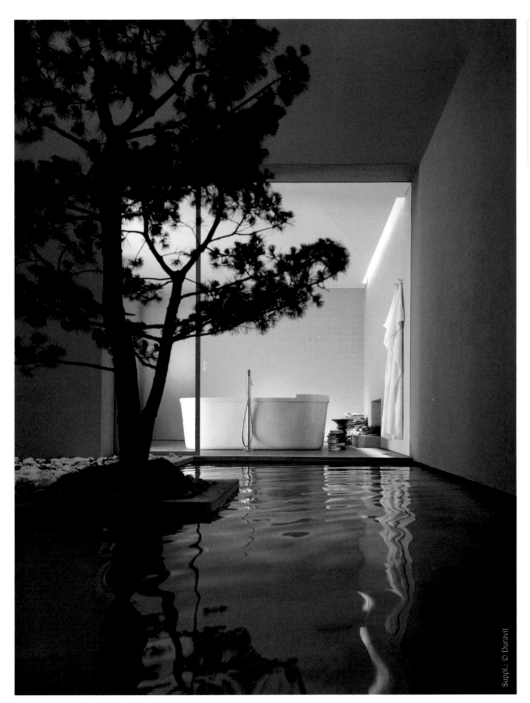

069

Make natural landscape the focal point of your Zen bathroom letting abundant daylight in the room and minimizing the barrier between interior and exterior.

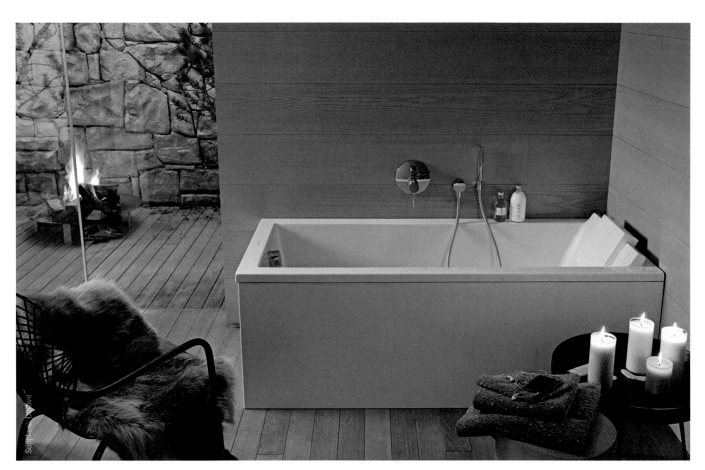

070

Dimming lights, candlelight or
the flickering of a lit fireplace
bring charm, warmth and
calmness, which can turn the
bathing area into a place where
you can soak away your worries.

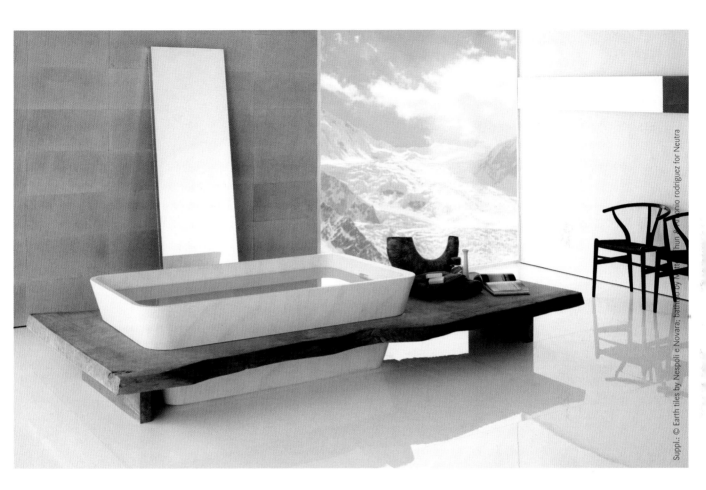

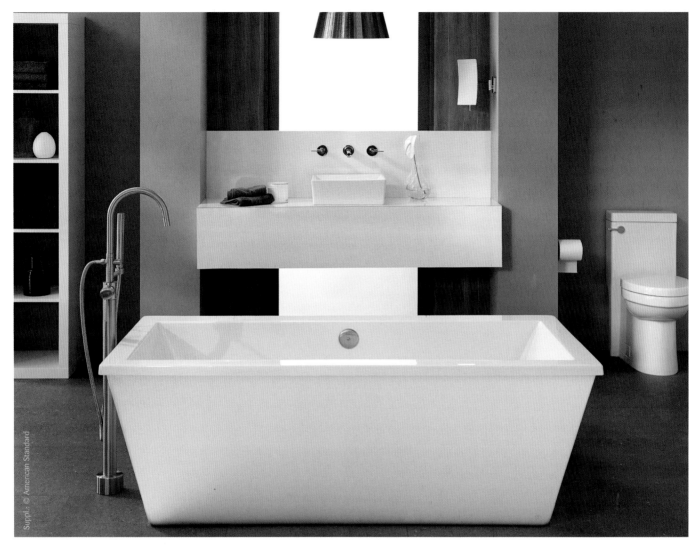

Suppl.: © American Standard

The balance of colors and the symmetry
of this bathroom design create a
calm atmosphere with the Seagram
freestanding bathtub as its bold and
geometric focal point.

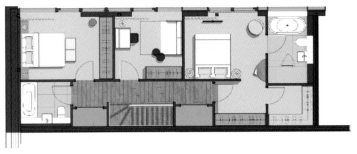

Upper floor plan

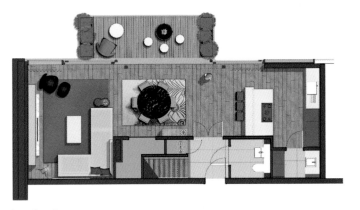

Lower floor plan

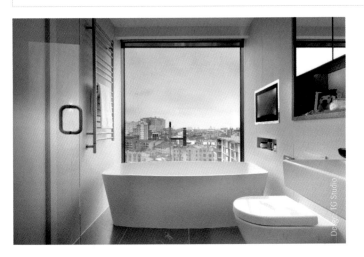

TG Studio's idea for the interior design of this bathroom was based on the concept of photography inspired by the views over the city. A freestanding bathtub by Clearwater Baths™ is strategically placed to make the most of the views.

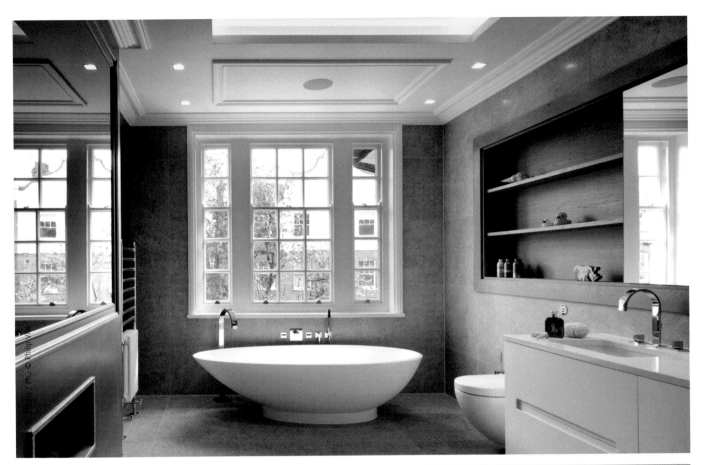

071

Limestone floor and walls set a luxury feel alongside other feel-good factors such as the working fireplace and mood lighting. A chrome towel-rail radiator adds a touch of refinement.

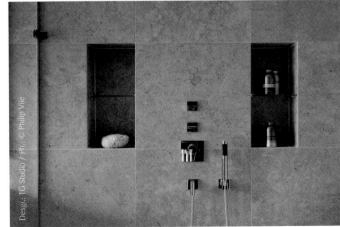

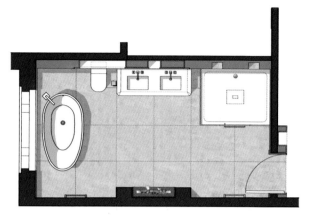

Master bathroom floor plan

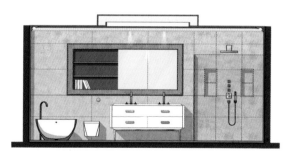
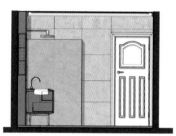

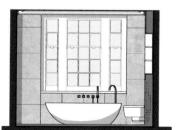

Master bathroom interior elevations

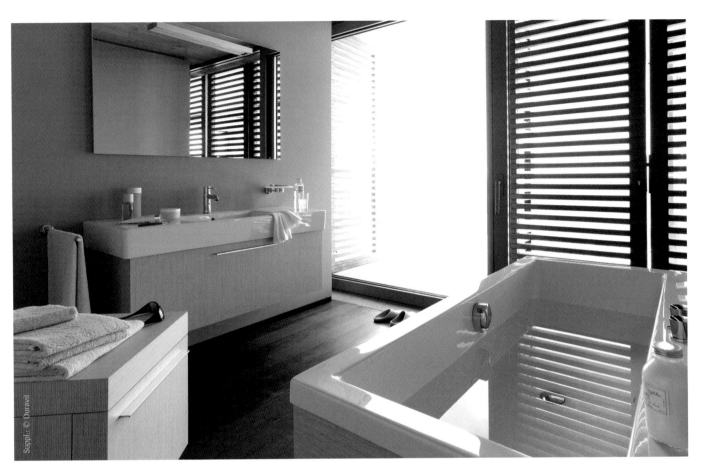

The same finish applied to the different fixtures creates a unified design. In this case, the light wood finish of the vanity and console match the finish of the bathtub's skirt.

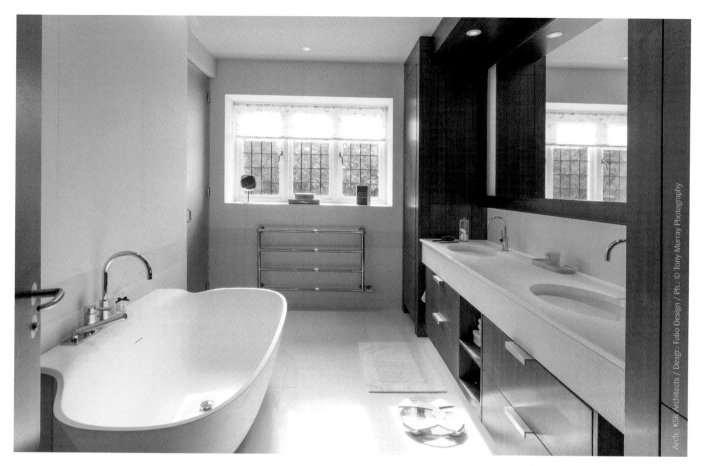

Arch.: KSR Architects / Desg: Folio Design / Ph.: © Tony Murray Photography

The wood-paneled wall unit integrating the vanity, mirror above, under-basin storage, and full-height cabinets contrasts with the freestanding oval bathtub against the opposite wall.

Supply © American Standard

072

Surround your tub with a skirt using a material to match that on the walls. The tub deck can be a nice stone in the same color range or in a complementary color as an accent.

073

Towel warmers are an affordable indulgence that come in various designs and configurations to accommodate any possible needs.

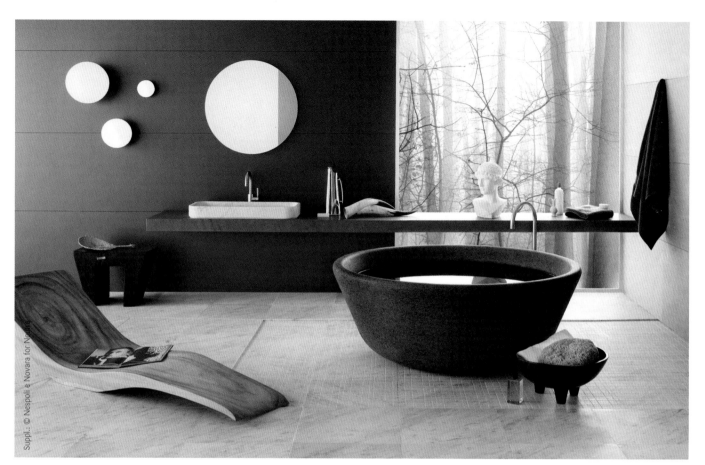

074

Turn a room of your home into a spa-like retreat with finishes that bring the natural world indoors. Soft lines remind one of flowing waters and rolling hills or sand dunes creating a soothing environment.

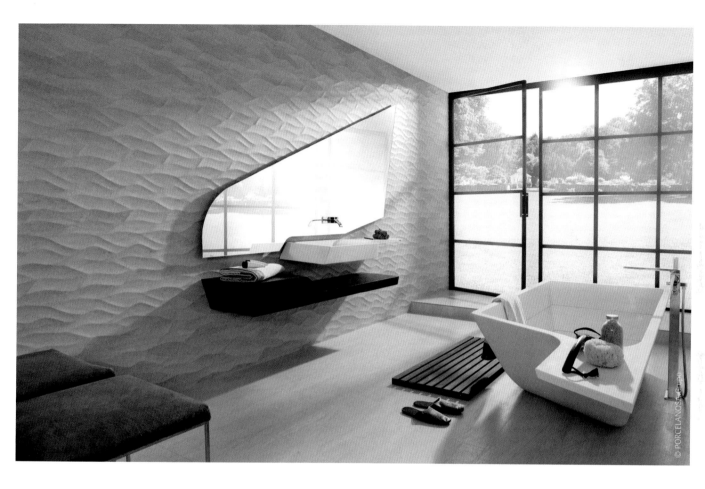

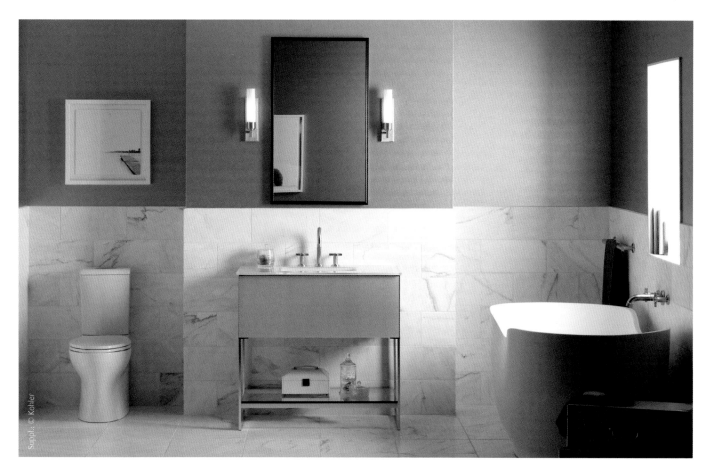

White marble wainscot dresses up
a bathroom and helps integrate the
matching white plumbing fixtures
and the gray vanity.

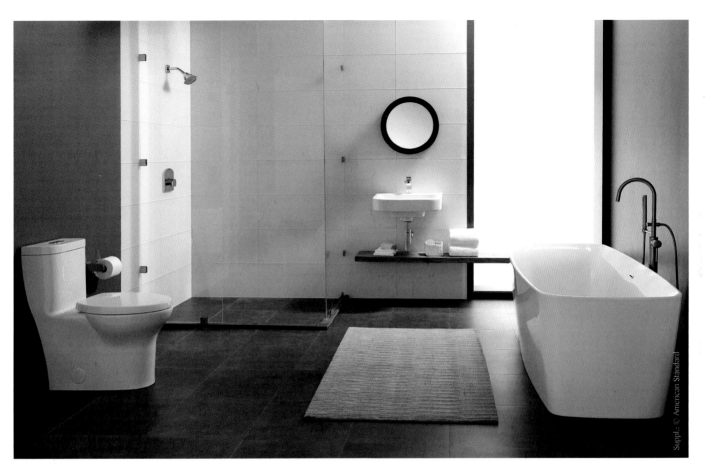

Suppl.: © American Standard

075

A clear-glass shower enclosure helps maintain the open space feel. It is particularly effective in small bathrooms. Note the symmetry created by the glass pane and the window flanking the vanity.

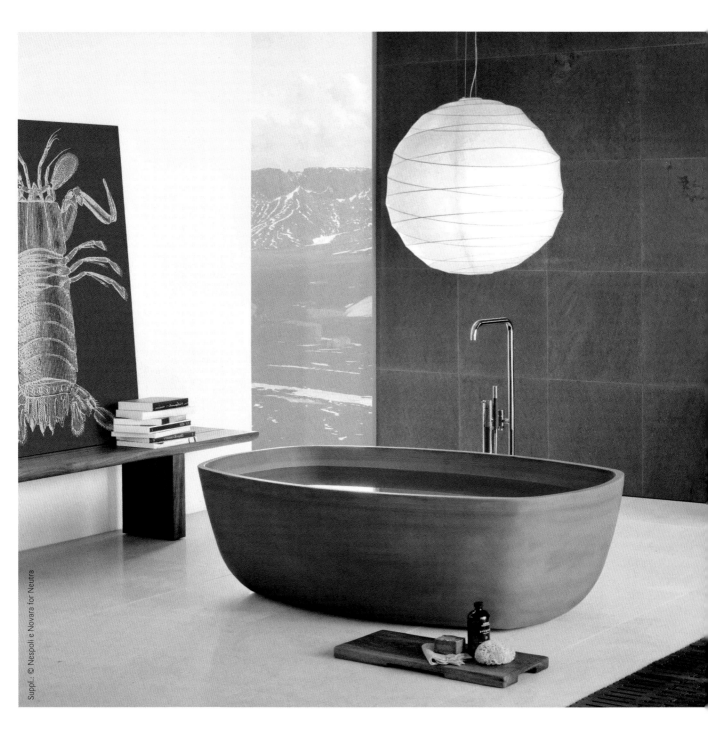

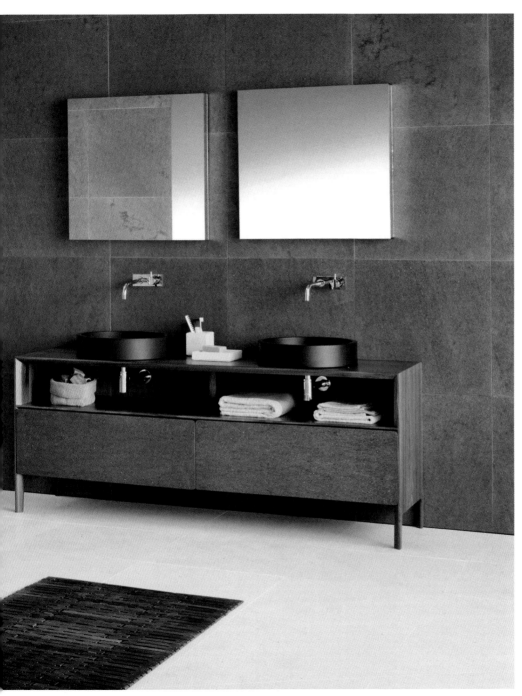

The subdued tones of this Asian-inspired bathroom contribute to a serene and comforting atmosphere. The wood accents make the space more inviting without overpowering its airy character.

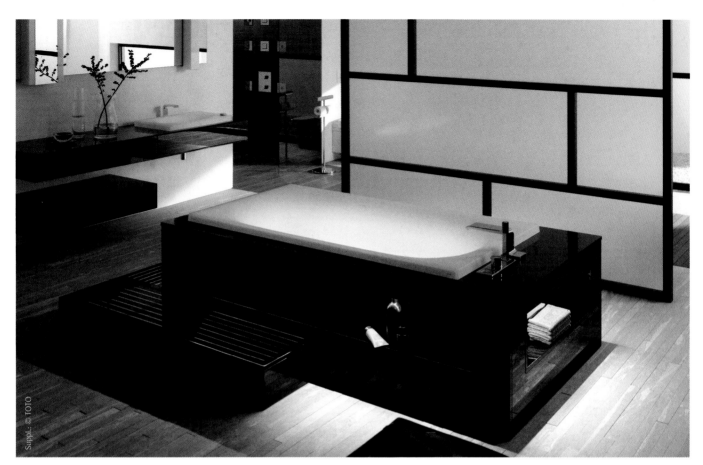

Suppl.: © TOTO

076

There are endless options to create a beautifully organized bathroom with items that are just as nice to look at as they are useful.

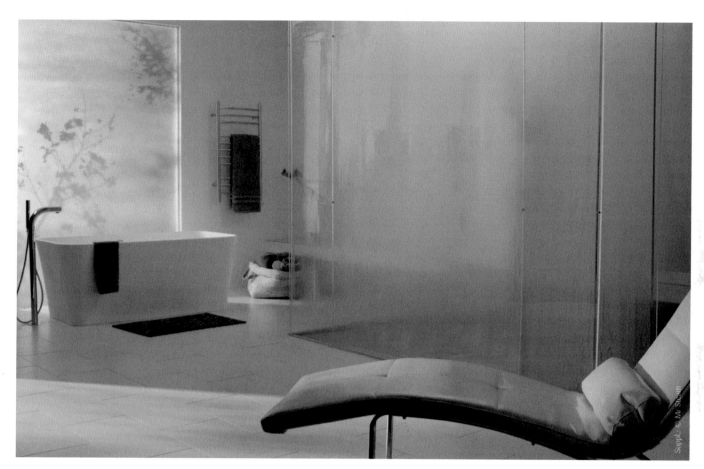

Soft muted colors, clear and translucent materials, and dim light are the backdrop to a soaking tub and a chaise longue with curvy lines for a water world-inspired design.

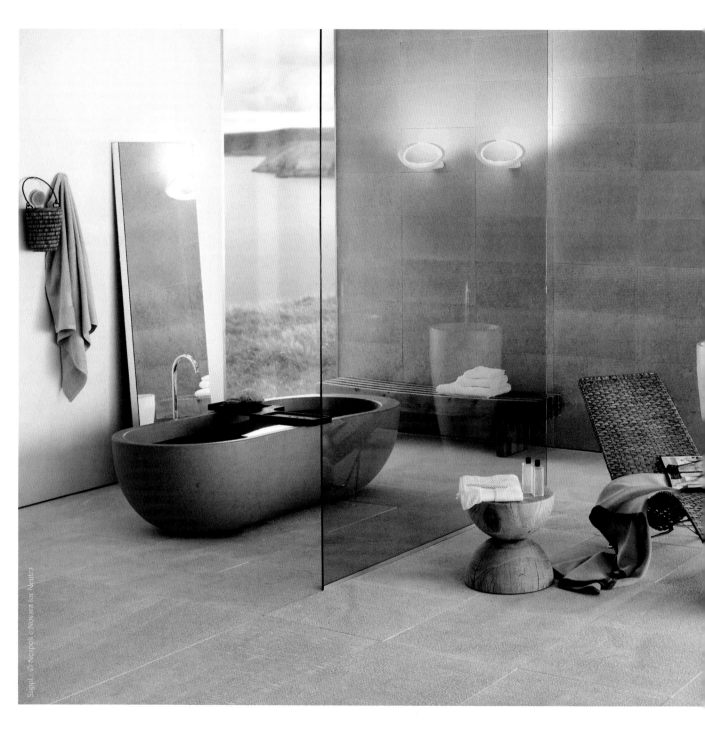

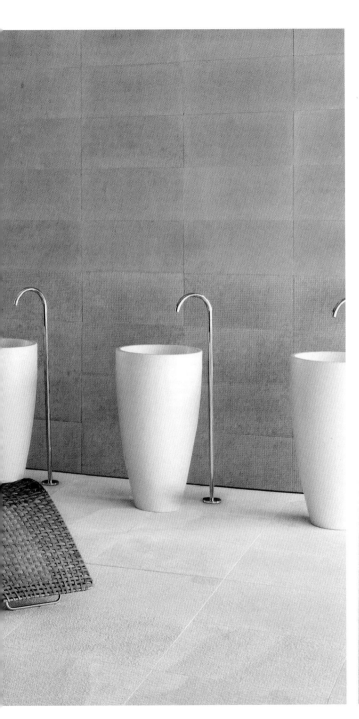

There are few pleasures in life as pleasurable as a soothing bath that eases away the cares of the day. Soaking tubs are generally deeper than regular tubs to enhance the bathing experience.

Suppl. © Neapolis-Novara for Neutra

Large slabs of natural stone cover the walls, the floor and tub surrounds of this bathroom. By using a single finish throughout, emphasis is put on the forms that constitute the room.

Third floor plan

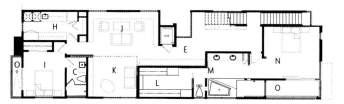

Second floor plan

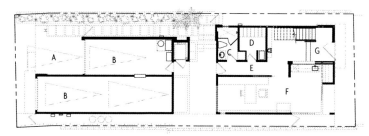

Ground floor plan

A.	Carport	H.	Laundry	O.	Deck
B.	Garage	I.	Bedroom	P.	Family room
C.	Bathroom	J.	Media	Q.	Powder room
D.	Storage	K.	Office	R.	Pantry
E.	Hallway	L.	Master closet	S.	Kitchen
F.	Studio	M.	Master bathroom	T.	Dining room
G.	Entry	N.	Master bedroom	U.	Living room

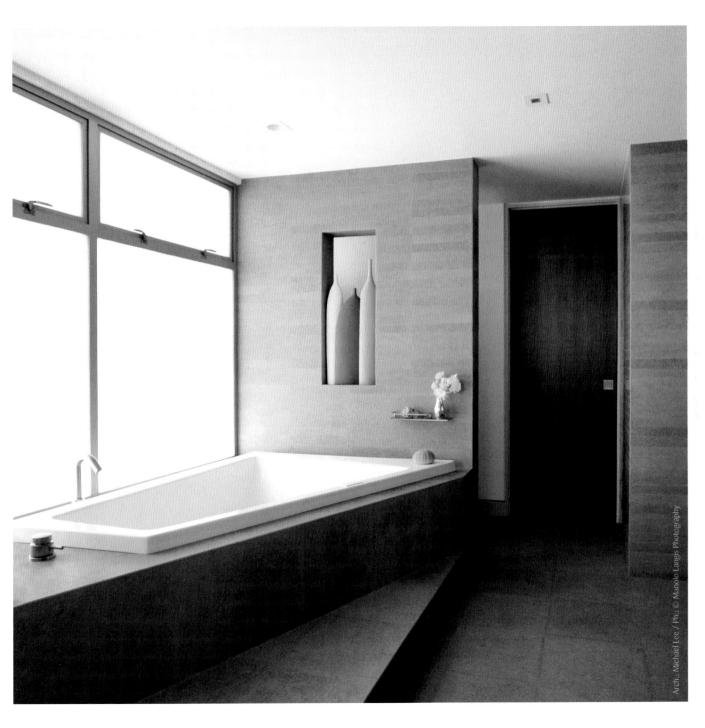

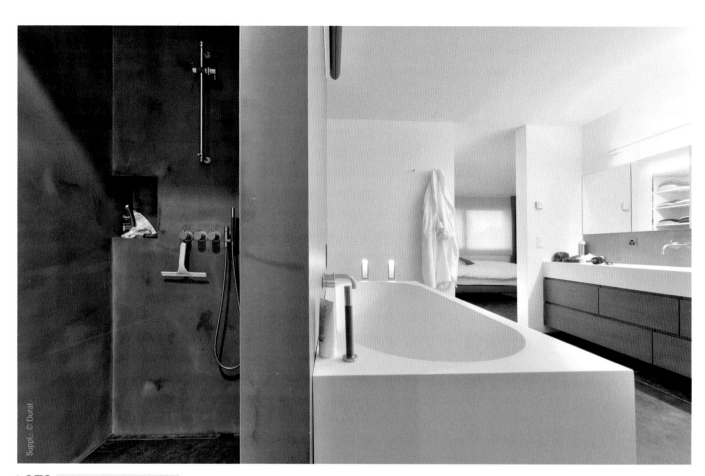

078

This bathroom has two very clear areas separated by a wall: white dominates the area of the vanity and the bathtub, which is installed against the wall, while dark gray is the color chosen for the shower behind the wall.

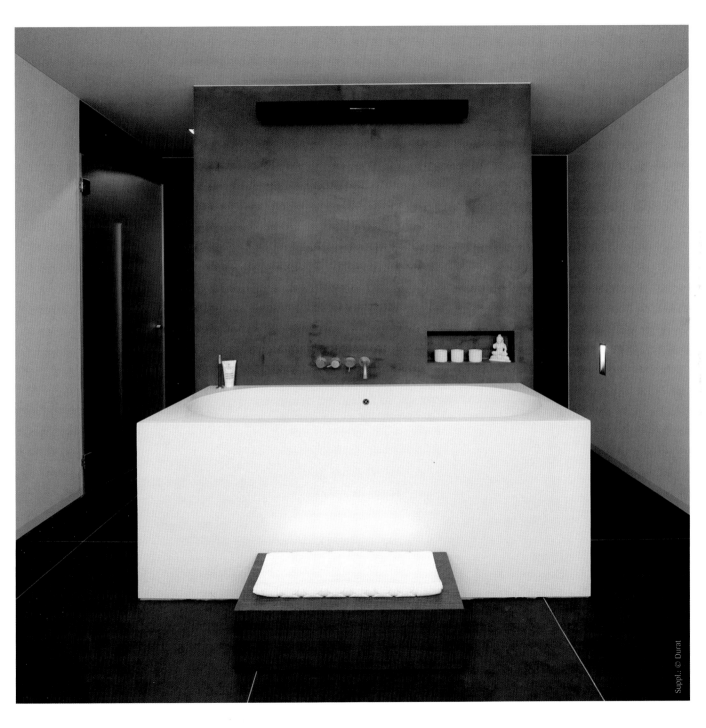

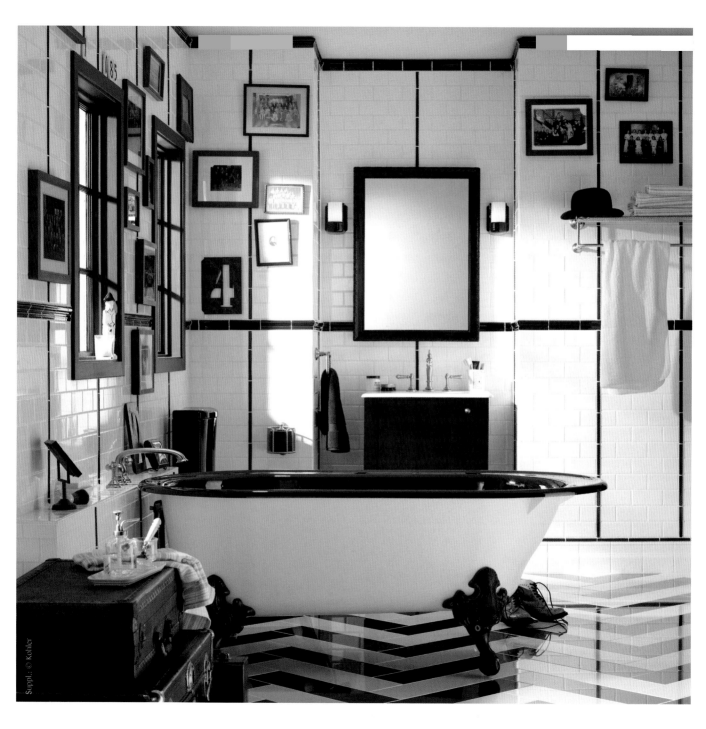

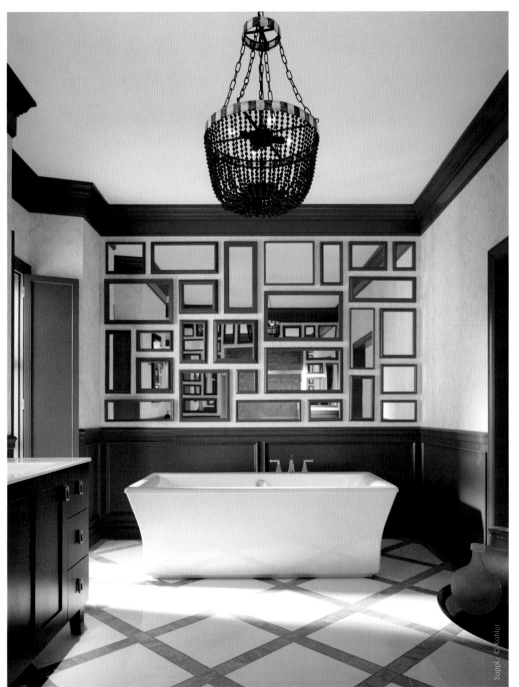

A freestanding tub is often the focal point in a bathroom. Placing it in front of a feature wall can enhance its presence. In this case, the feature wall is made out of framed mirrors of different sizes and proportions that offer a fragmented reflection of the room.

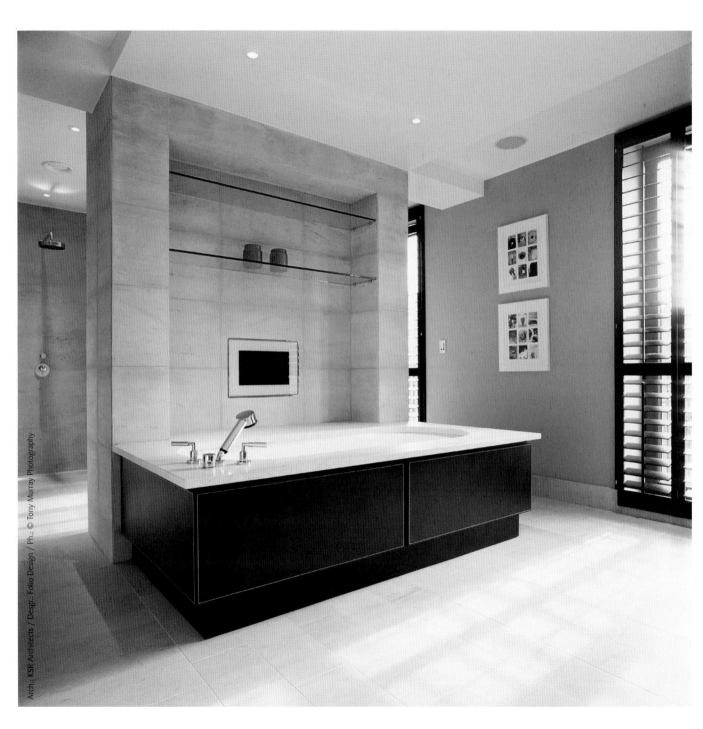

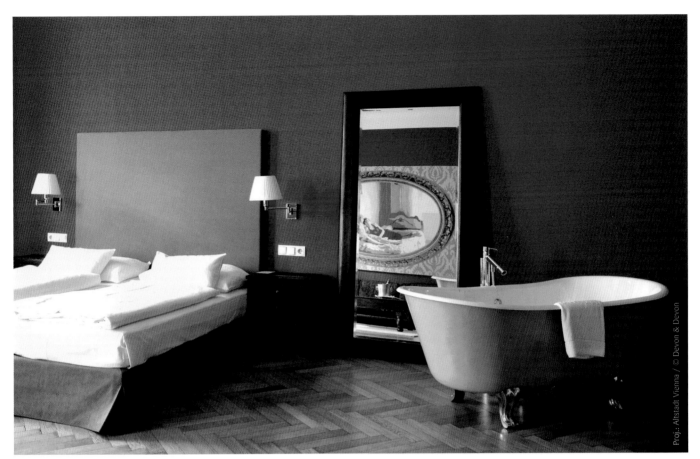

Proj: Altstadt Vienna / © Devon & Devon

079

The bathtub is no longer
an exclusive fixture of the
bathroom. As a fixture made
for relaxation, it can be
incorporated in the bedroom.
This gives the opportunity for
a much roomier bathroom.

080

Claw-foot tubs are just as beautiful as they are great for taking a soak. Because of their artistic qualities, they are best installed in large spaces where one can walk around.

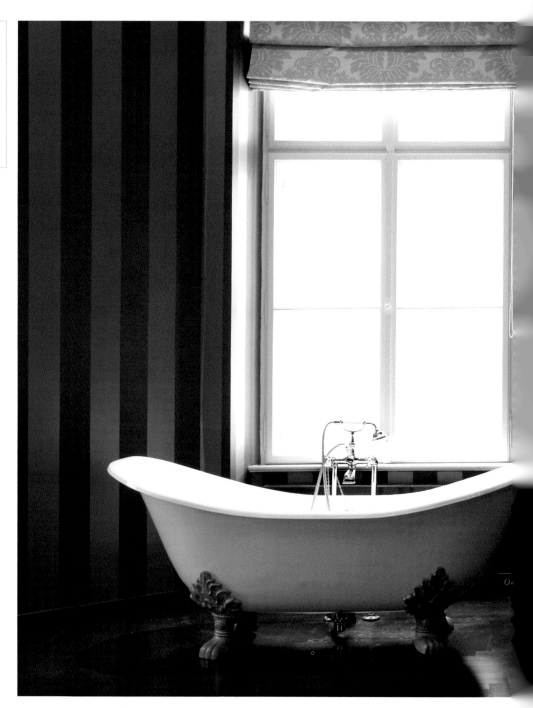

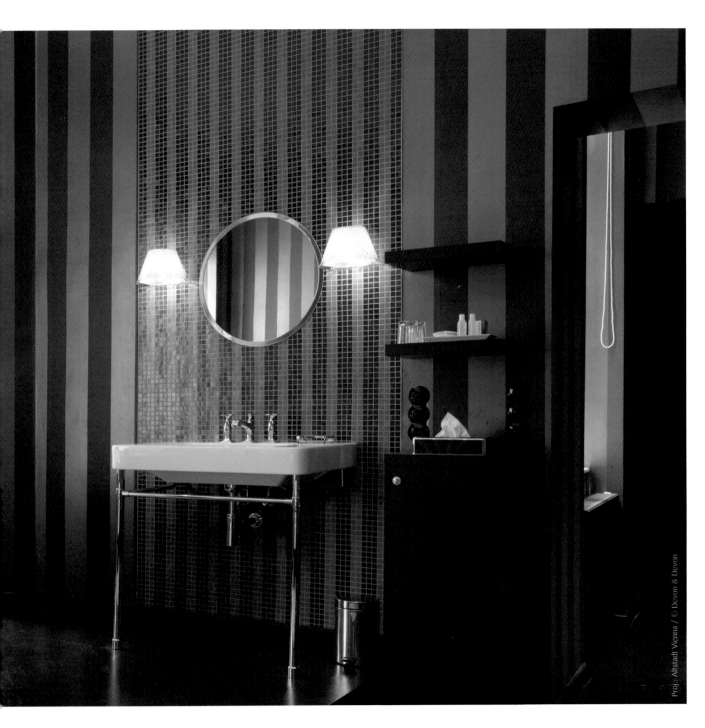

081

Freestanding tubs often require pillar bath faucets unless they are built into the tub. Since they are floor mounted, they allow you to install the tub anywhere you want.

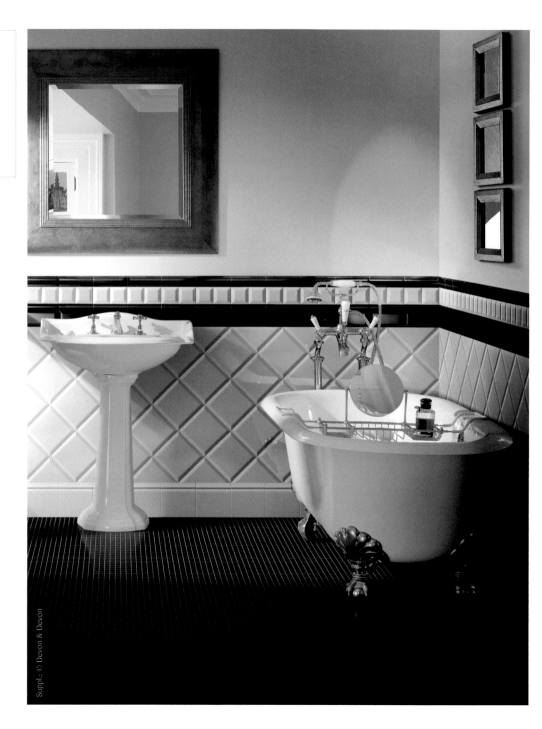

Suppl.: © Devon & Devon

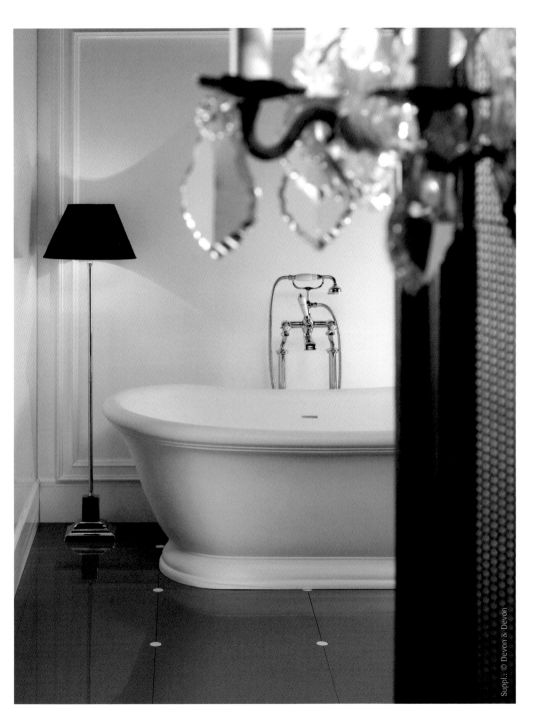

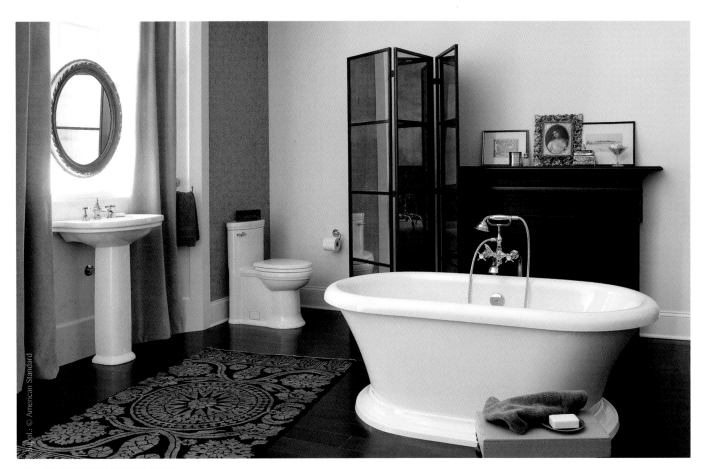

082

Freestanding tubs come in
many sizes and styles to
fit any décor, traditional or
contemporary. They are,
without a doubt, the center
of attention of any bathroom,
regardless of the style.

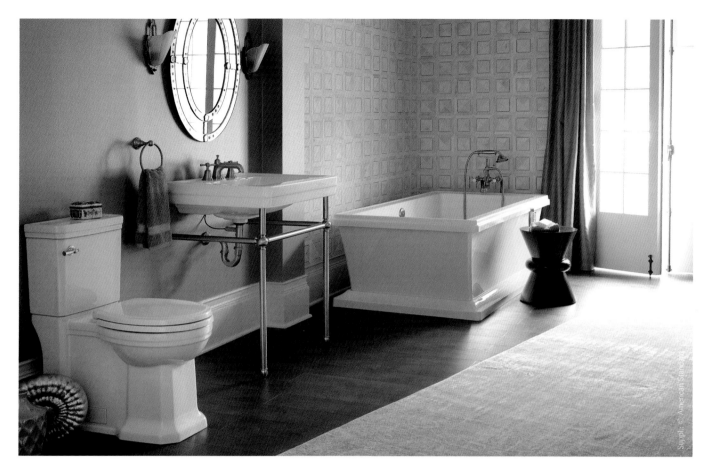

In large spaces, wall finishes can make a distinction between different areas. In this case, the eye-catching wallcovering is the backdrop to the freestanding bathtub.

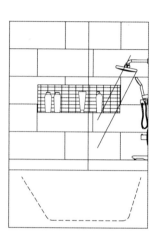

Bathroom interior elevations

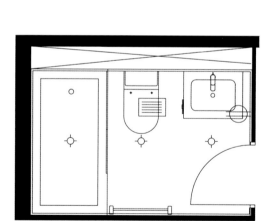

Bathroom floor plan

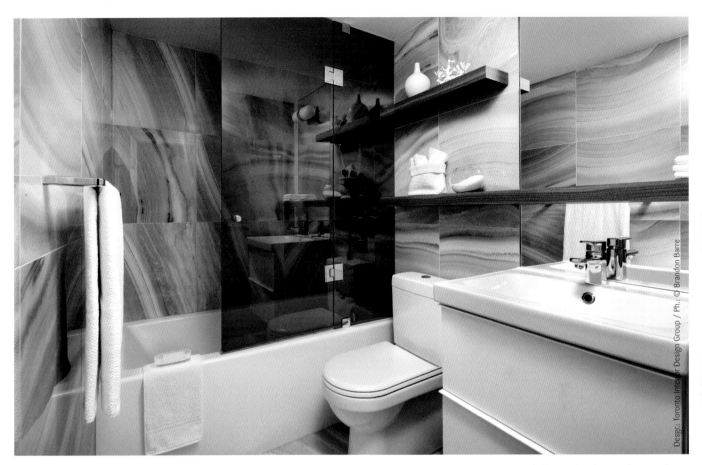

The hues in the tile are soft to avoid overpowering the space. The range of colors also picks up on the vibrant orange undertones of the floating walnut shelving.

Desgr.: Toronto Interior Design Group / Ph.: © Brandon Barre

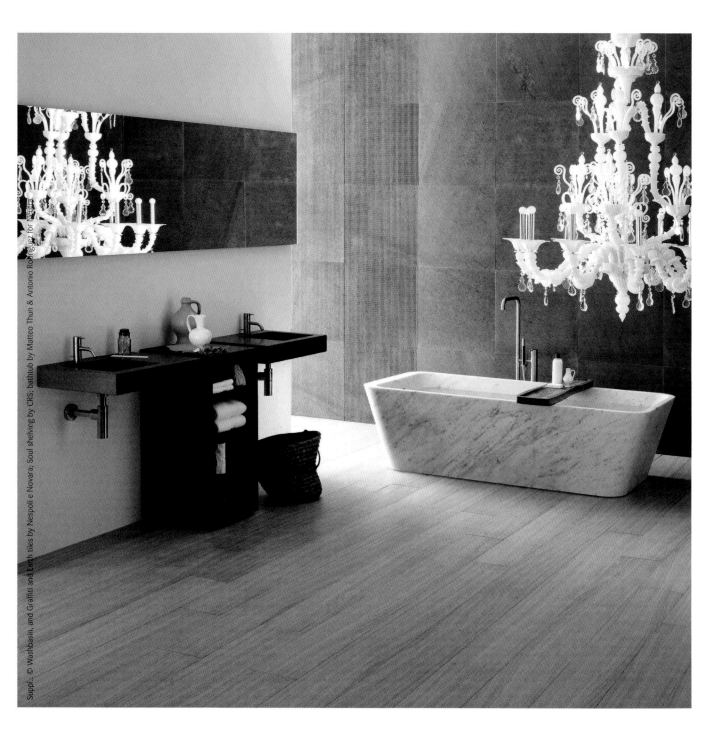

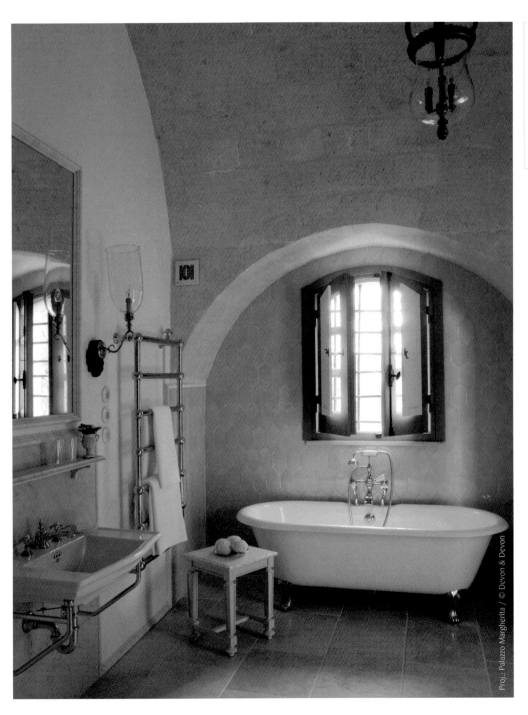

The Draycott bathtub of Devon&Devon™ is as suitable to a rustic arched ceiling and fresco wall environment as to a sophisticated and modern interior.

Proj.: Palazzo Margherita / © Devon & Devon

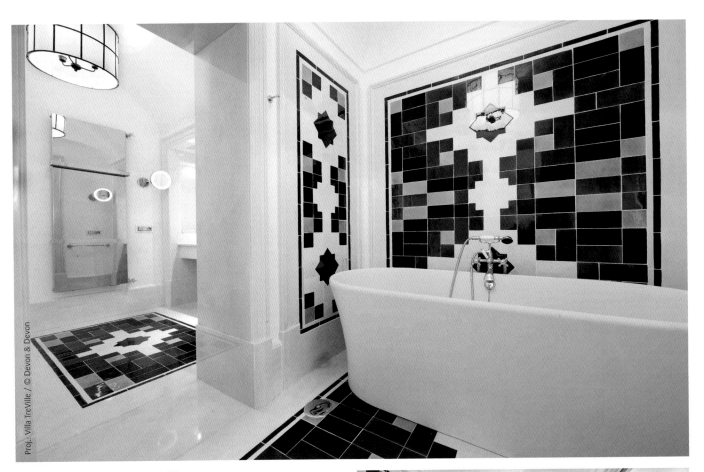

084

The bathrooms of Villa Tre
Ville were remodeled using
locally sourced materials and
local craftsmen, and fitted
out with fixtures that enhance
the architectural and spatial
qualities of the spaces.

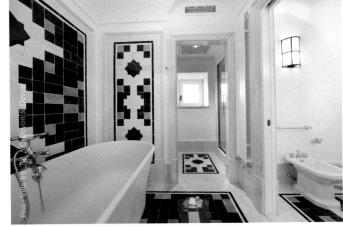

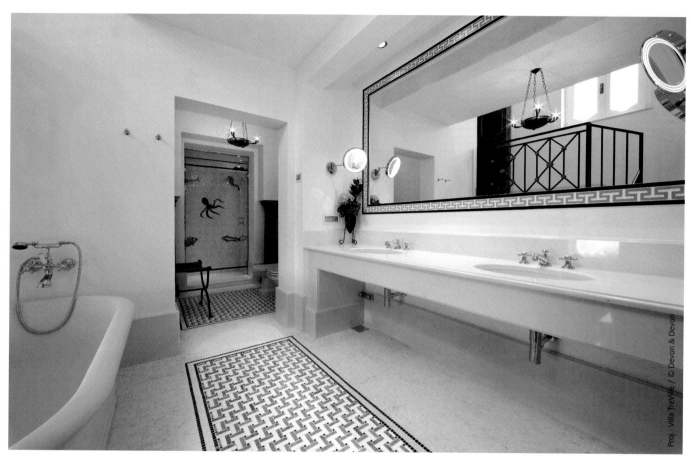

Proj.: Villa TreVille / © Devon & Devon

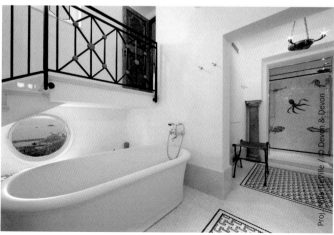

Proj.: Villa TreVille / © Devon & Devon

085

The texture produced by a mosaic rug not only makes for an excellent anti-slip surface, but also endows a bathroom with a unique personality.

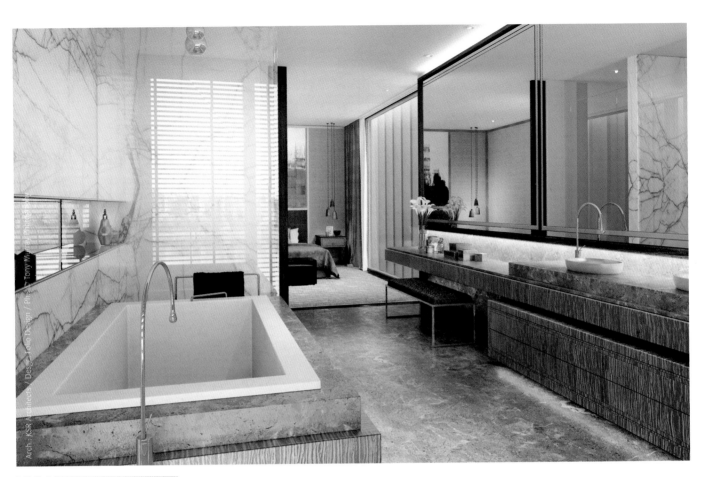

Arch.: KSR Architects / Design: Tollo Design / Photo: Tony Murray Photography

086

Mixing different types of stone in a single space is not an easy and simple task. The main thing to keep in mind is that you don't want patterns to compete. Choose one main stone and a second one to use as an accent.

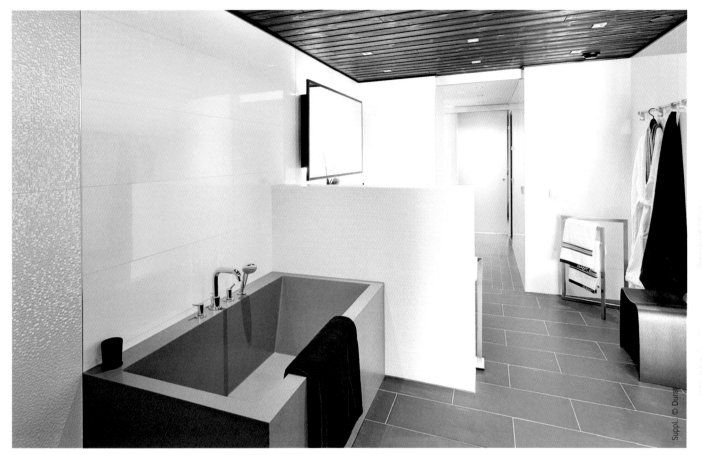

Suppl. © Duravit

087

Avoid floor-to-ceiling partitions to separate areas in your bathroom. Low walls and clear or translucent partitions are a better solution to screen a shower or a toilet and at the same time maintain an open feel.

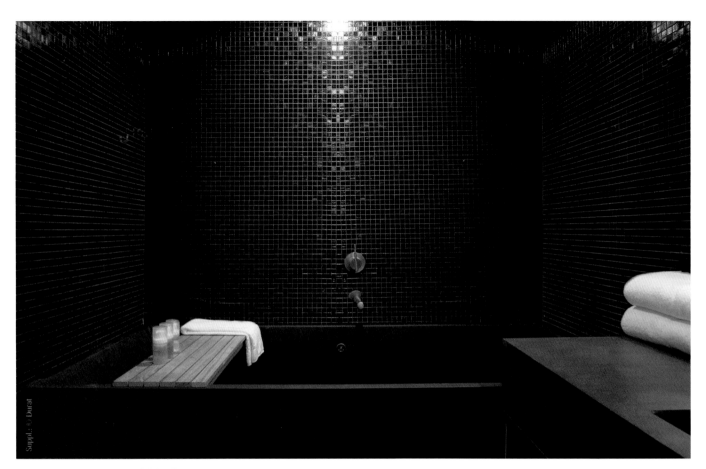

Suppl: © Durat

088

Black does make a room feel smaller, but you don't need to spend long hours in a bathroom. That is why the bathroom can be a space where you can indulge the most daring decorating ideas.

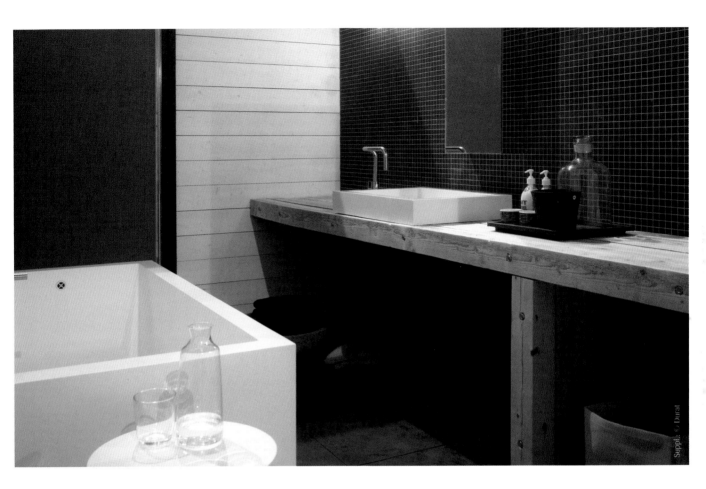

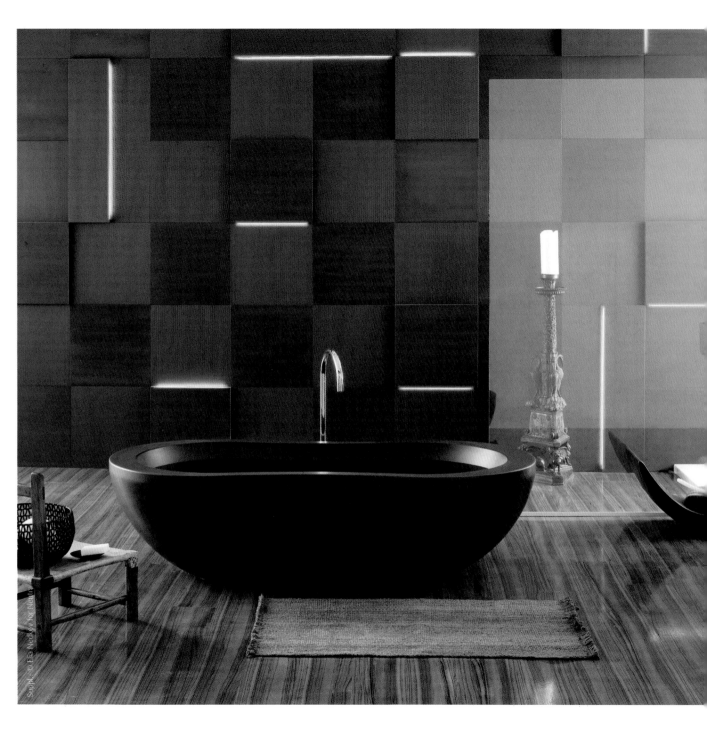

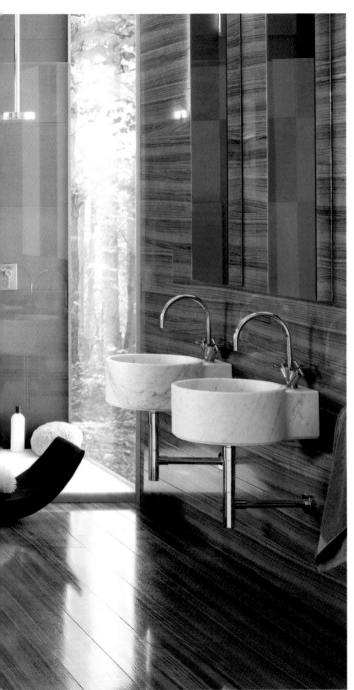

High-end fittings are sometimes crafted as jewel-like fixtures to exceed the users' expectations and bring a sparkle to a lavish bathroom.

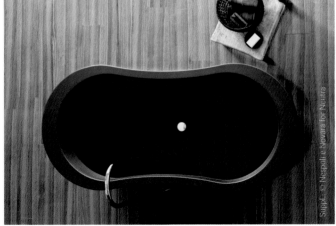

Suppl. © Nespoli e Novara for Neutra

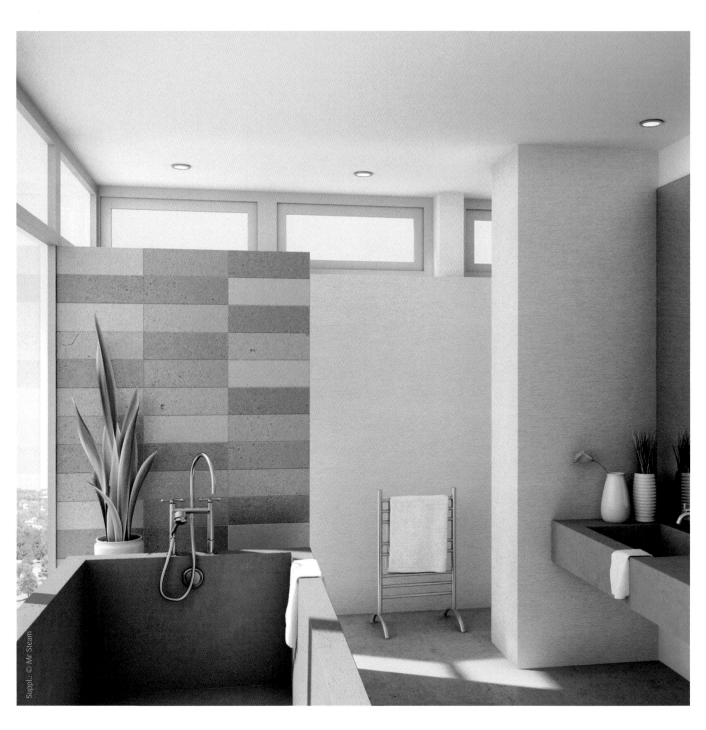

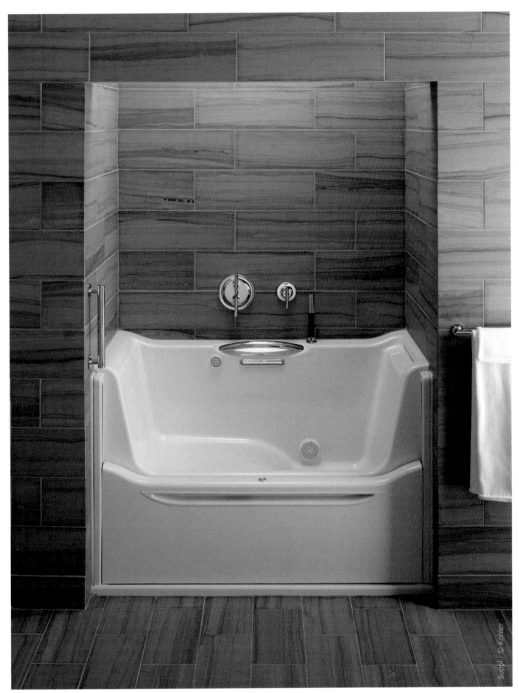

Kohler® offers an ADA-compliant tub allowing for an easy entry from a standing or seated position thanks to its rising front wall. Other features include an integrated grab bar and a chair-height seat.

Suppl.: ©Kohler

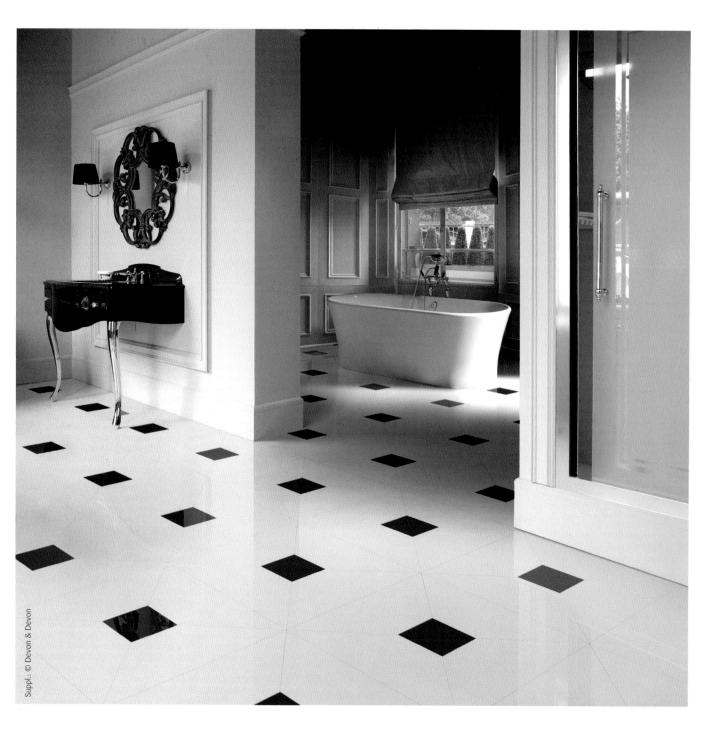

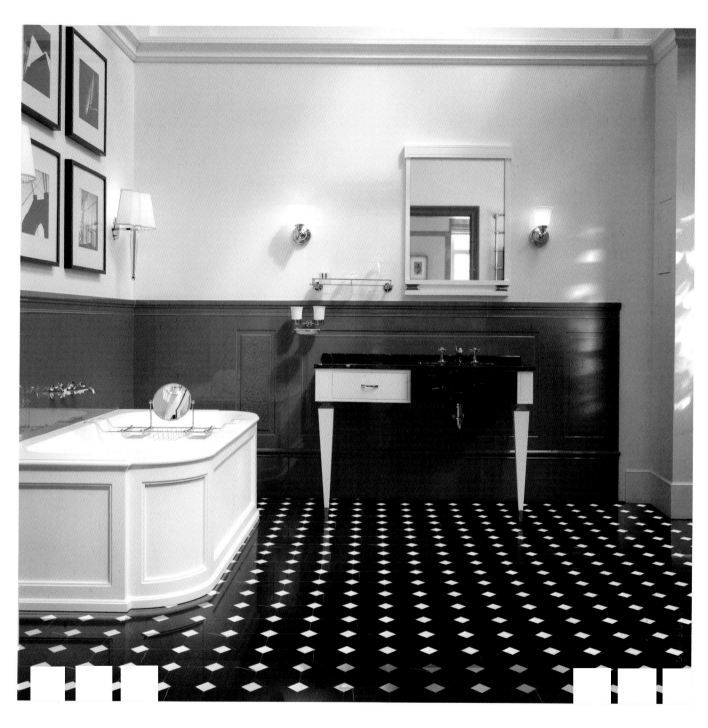

089

Muse Collection of Oceanside
Glasstile™ offers a myriad
of color blends and patterns.
Create your own blend
combining any of the colors and
finishes: matte, iridescent and
non-iridescent.

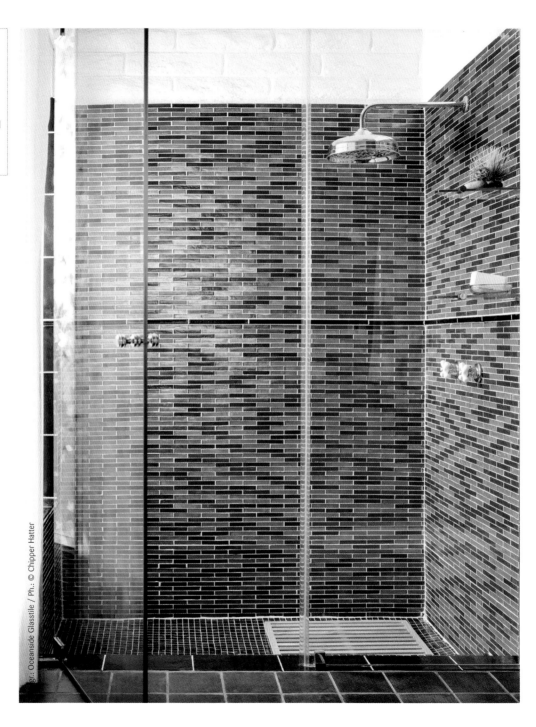

Oceanside Glasstile / Ph.: © Chipper Hatter

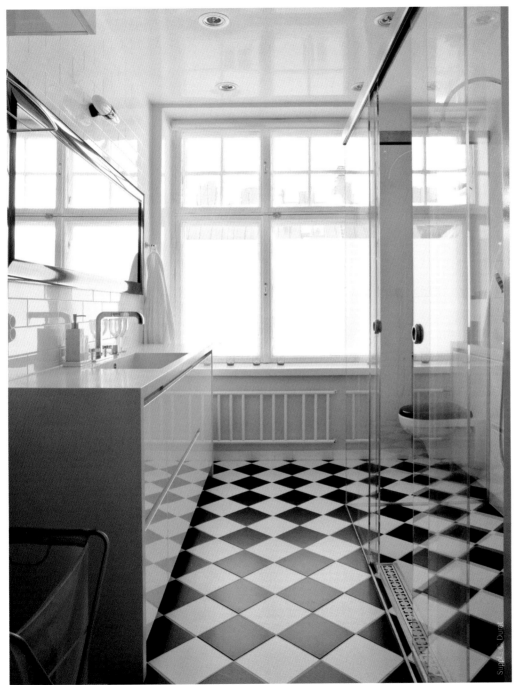

In a long and narrow bathroom, with the vanity along one long side and the toilet and shower along the other, a glass partition with sliding doors keeps the two areas separated, while preserving the integrity of the room.

Transparency and reflection
are physical properties of a
material that can be used to
enhance the qualities of a
design.

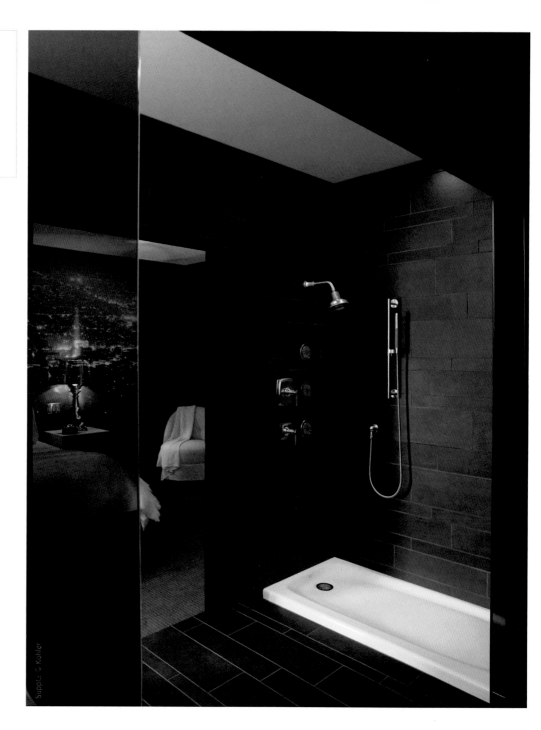

Suppl: © Kohler

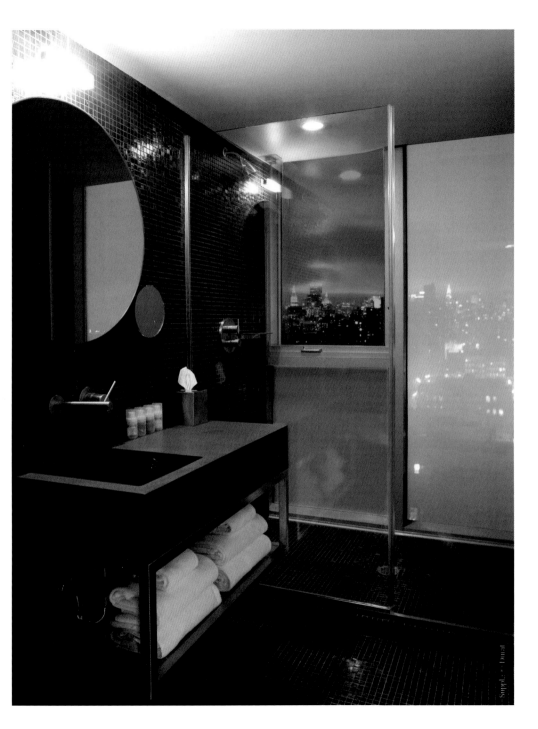

Special nebulizers and thermostatic mixers are the unique features that define these two shower columns of SAMO™'s Trendy line.

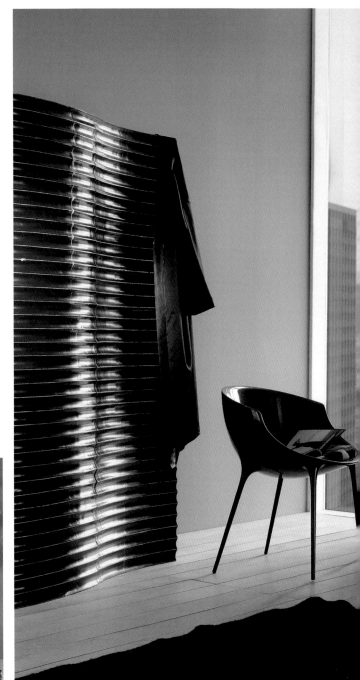

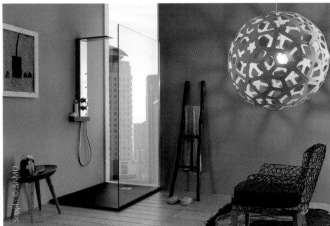

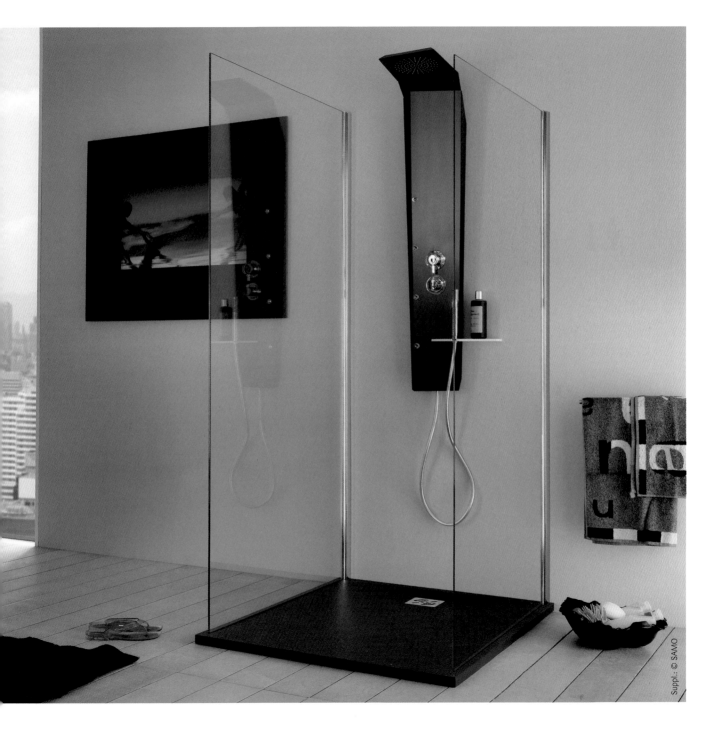

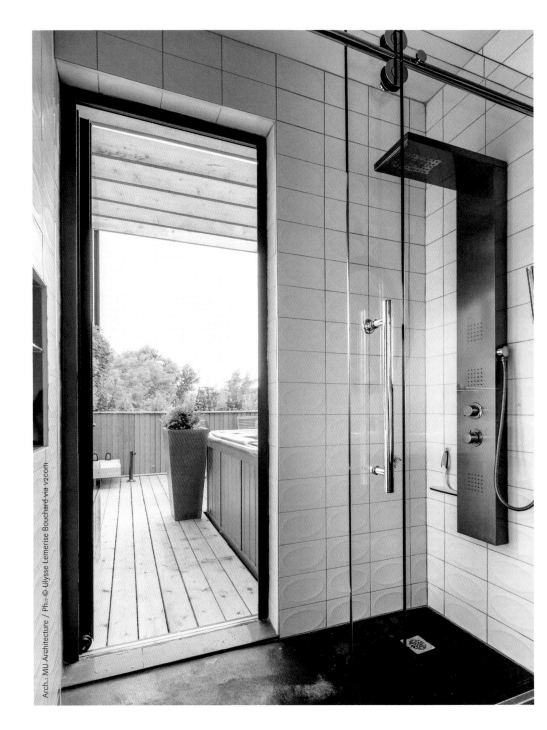

Arch.: MU Architecture / Ph.: © Ulysse Lemerise Bouchard via v2com

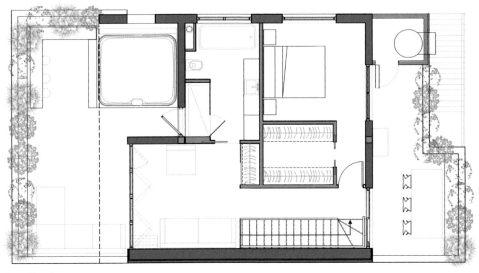

General floor plan

The master bedroom and bathroom
of a two-level penthouse communicate
with outdoor spaces. The shower leads
directly to a Jacuzzi area through a
glass door.

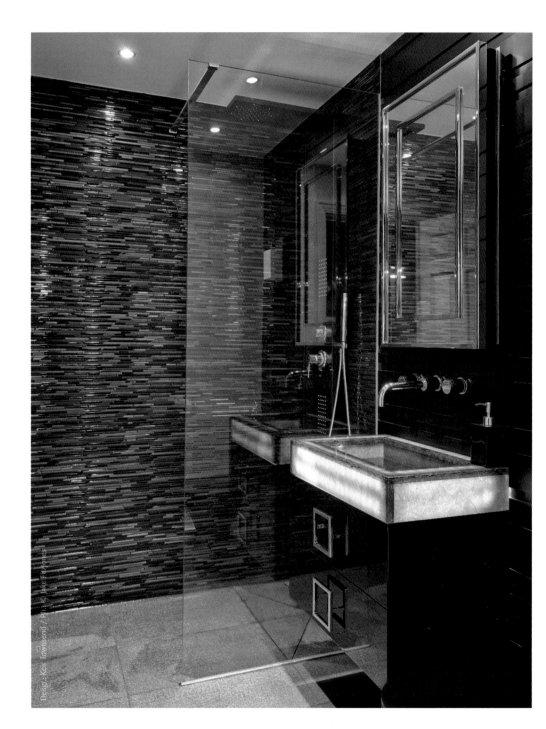

Desgn: Keir Townsend / Ph: © Jake Fitzjones

This master bathroom features a custom-made graphite color sink in recycled glass lit from within with LED lighting and fitted with chrome and black onyx faucets.

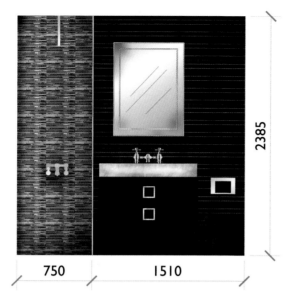

2385

750 1510

Bathroom interior elevation

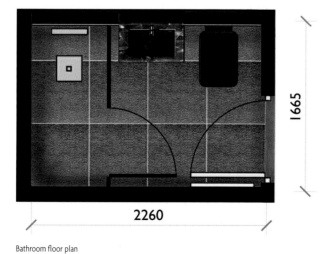

1665

2260

Bathroom floor plan

The remodel of the bathrooms at Château Monfort in Milan, Italy, combines functionality, beauty and comfort. The design makes a reference to the past of the hotel through the use of ceramic tiles, pastel colors and elegant consoles.

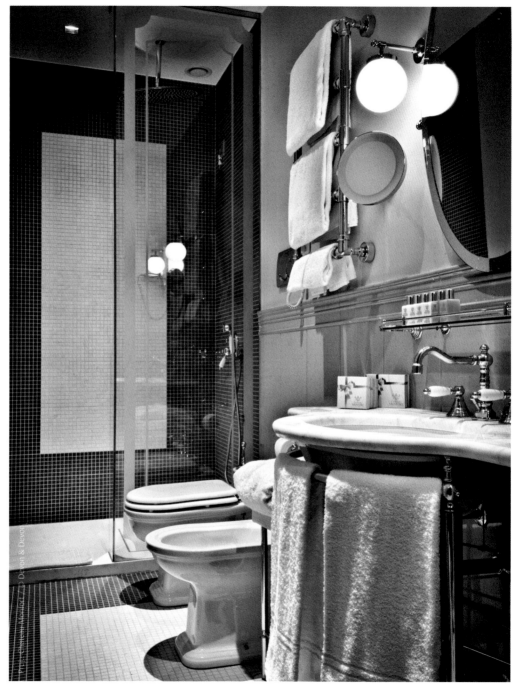

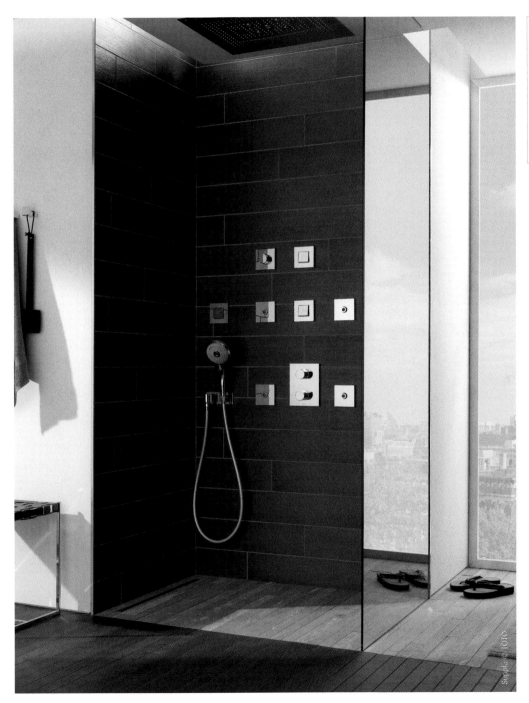

Supple © TOTO

091

The extension of a hardwood floor into a shower is made with wood-stamped concrete, which is more durable and requires less maintenance since it doesn't warp, splinter or fade.

092

Unlike stone or concrete, wood expands and contracts with humidity. Failing to take this factor into consideration in a design where these two materials meet may cause the wood planks to warp.

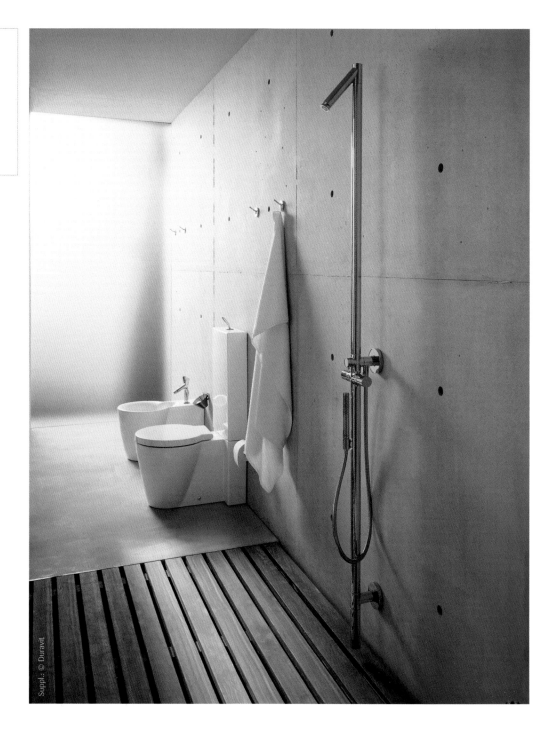

Suppl.: © Duravit

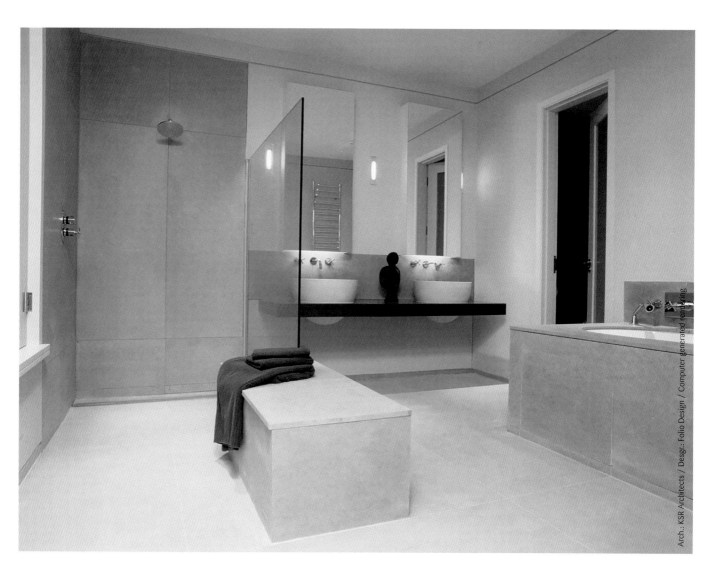

Arch.: KSR Architects / Desgn.: Folio Design / Computer generated rendering

093

Tiled custom showers are a common choice because they offer design variety. One major aspect to consider when installing a shower is the construction of its base and waterproofing.

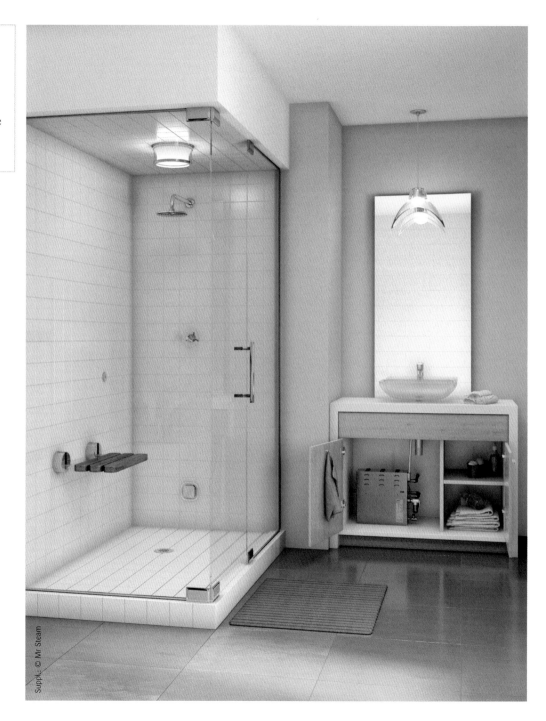

Suppl.: © Mr Steam

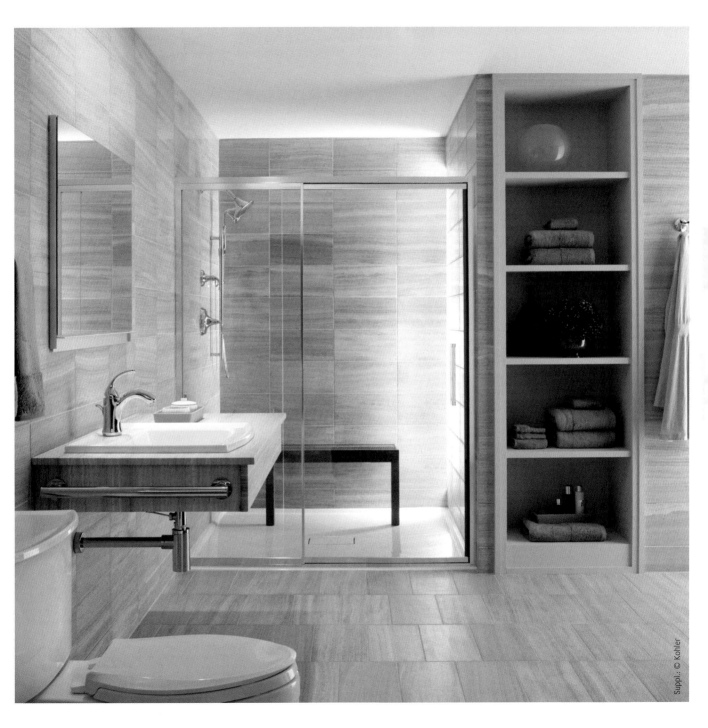

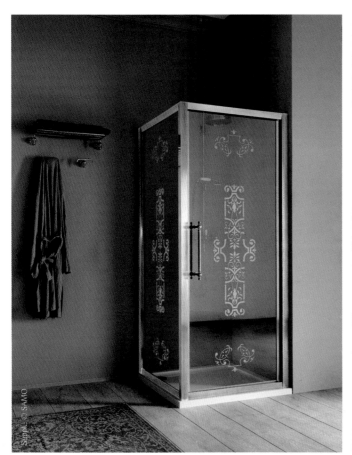

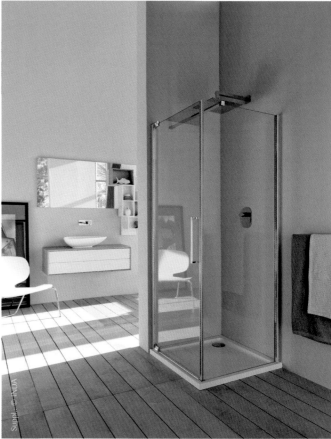

Shower enclosures come in many styles and finishes. Samo™ and Inda™ have enhanced the range in order to meet the varied needs and desires from classic tastes with models evoking baroque splendor to linear designs.

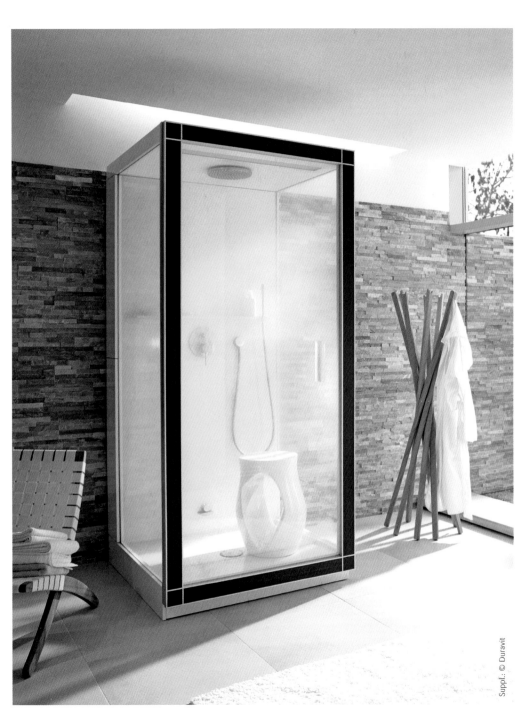

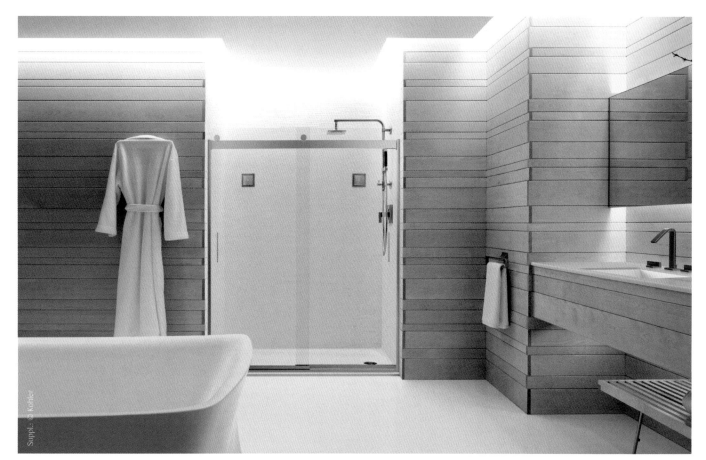

094

Lighting coves provide even lighting without glare, very effective for bathrooms. Coves also visually detach the walls from the ceiling, creating an amplifying effect.

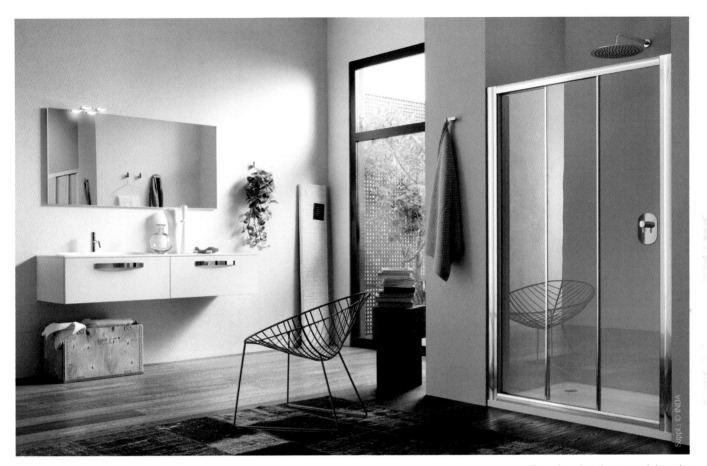

These clear-glass shower panels keep the look of this bathroom open and airy. The simple design of this shower enclosure goes well with the plain window frame and the wall-hung vanity unit.

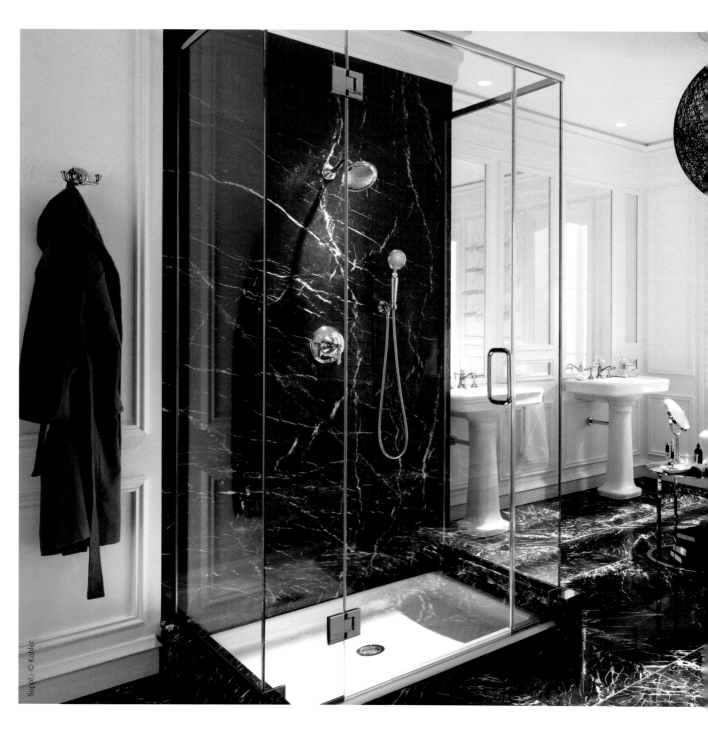

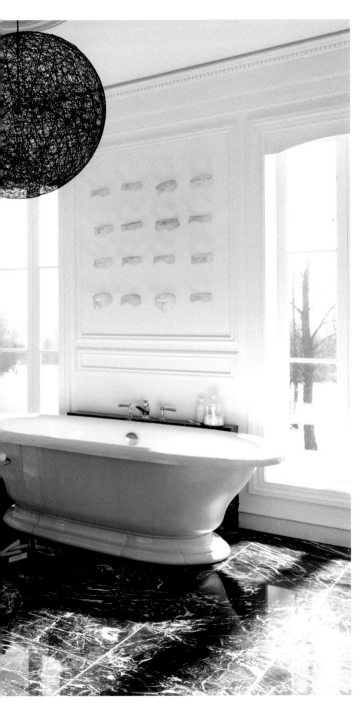

The richly veined black marble floor and feature wall add a sophisticated touch to this classical bathroom accessorized with chrome fittings and modern decorating items such as the light fixture and the side table.

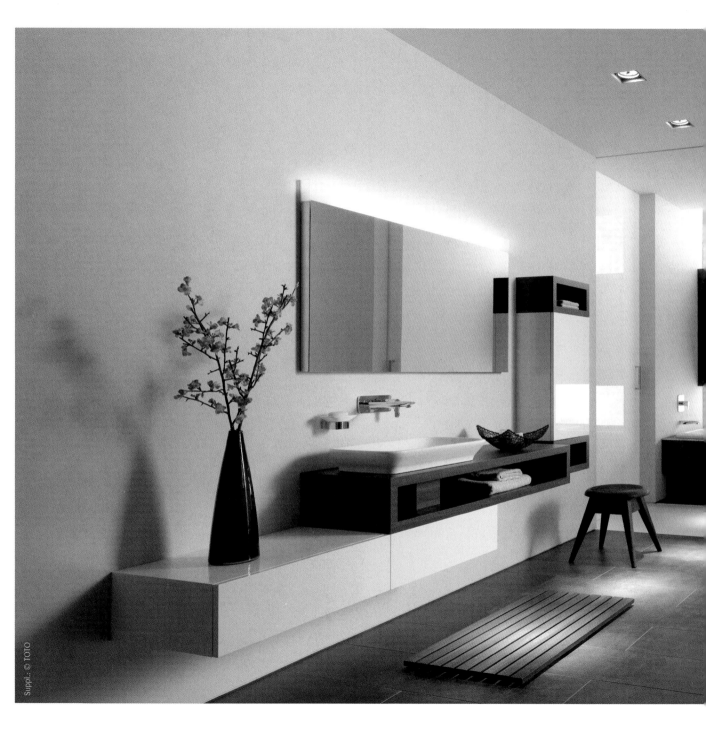

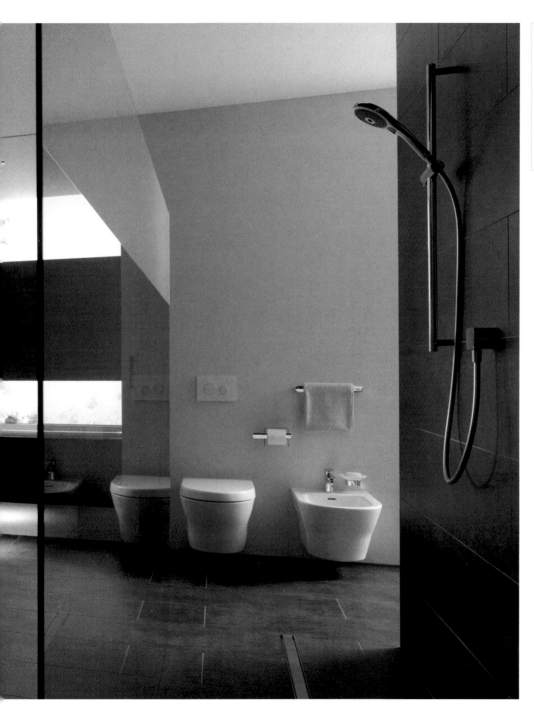

A little luxury goes a long way in bathroom design: modular storage solutions, beautiful fittings, walk-in-showers. In all, contemporary bathroom design can set a room to a spa-like atmosphere to lull the senses.

Aside from the vanity, everything follows a light colored scheme. The wall glass tiles, the large mirror, the frameless shower enclosure and the skylight keep the bathroom bright and well illuminated.

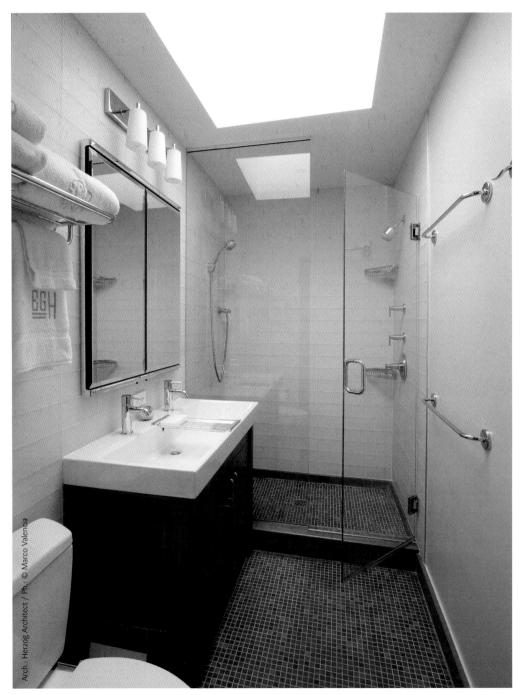

Arch.: Herzog Architect / Ph.: © Marco Valencia

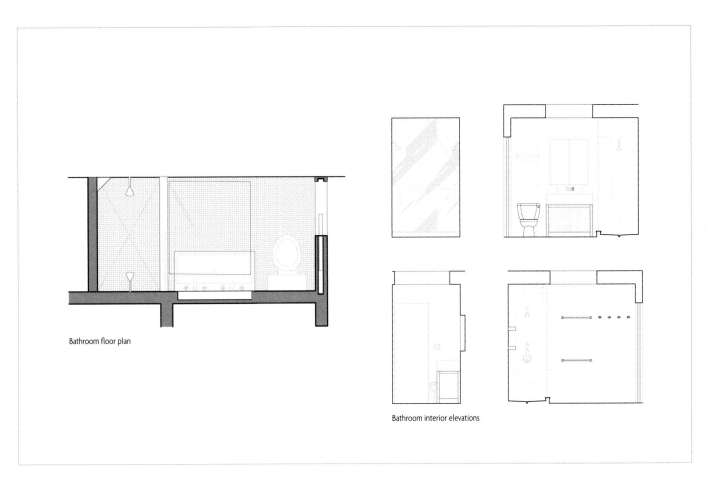

Bathroom floor plan

Bathroom interior elevations

Suppl.: © Kohler

Suppl.: © MGS

096

Upgrade your standard fixed
showerhead for a spa-like
showering experience. Most
designs can accommodate
various configurations without
making any in-wall plumbing
changes.

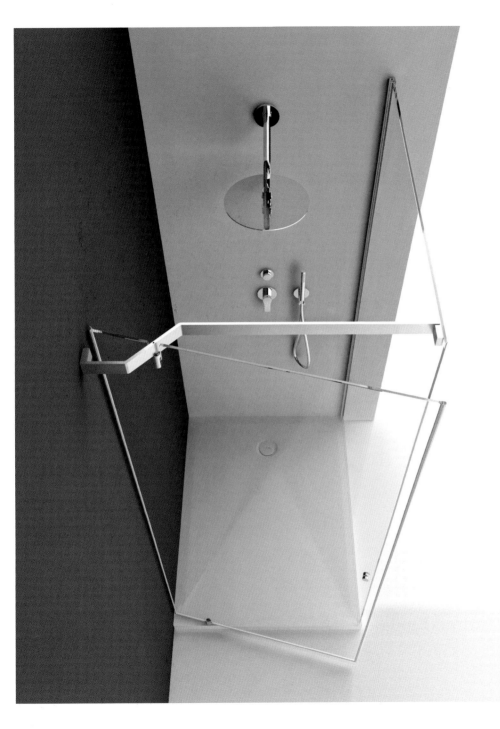

The Tape Shower cubicle by Boffi™ differs from most shower enclosures in that it has a pivot door. This feature enhances the frameless design by downplaying any obvious door hinges.

Suppl.: © Boffi

Because stone is a natural material, color, texture and grain pattern vary from piece to piece. Use these variations to your advantage to create unique visual effects.

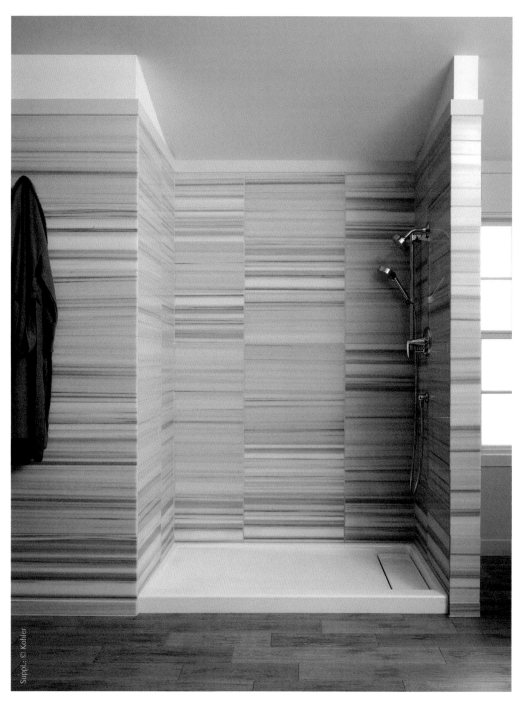

Suppl.: © Kohler

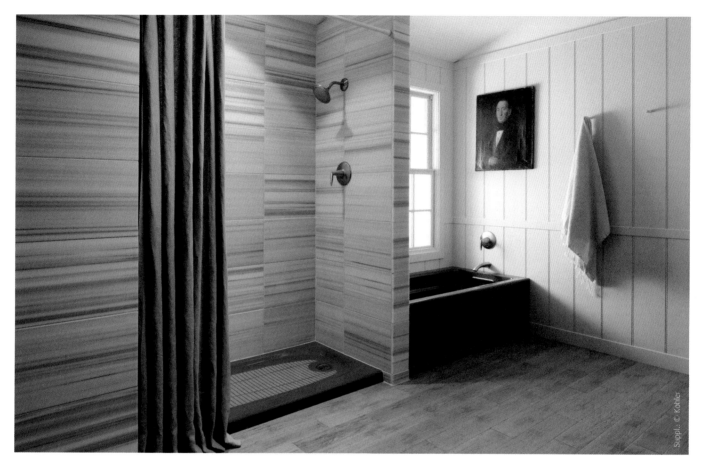

Separate shower and tub are a modern addition to what seems to be a ranch house-type of construction. The natural stone partitions contrast yet harmonize with the board-and-batten walls.

097

Cove lighting is mainly used for general lighting. However, it can also create interesting visual effects when used to put a focus on a feature wall or on a display.

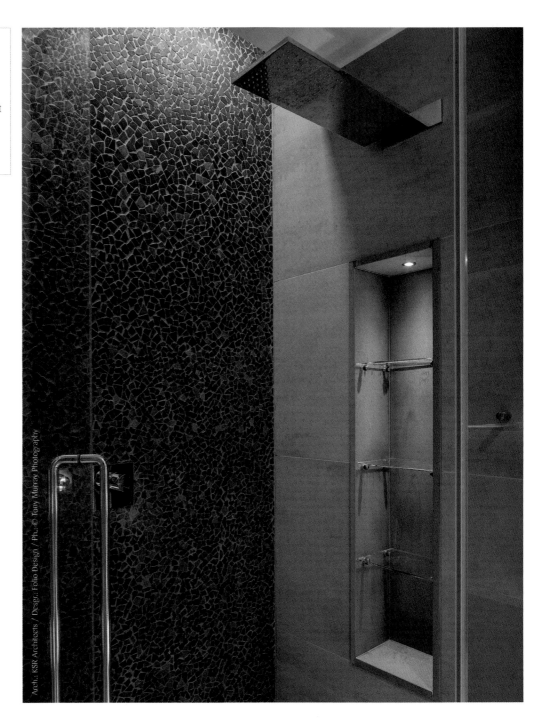

Arch.: KSR Architects / Desgn.: Folio Design / Ph.: © Tony Murray Photography

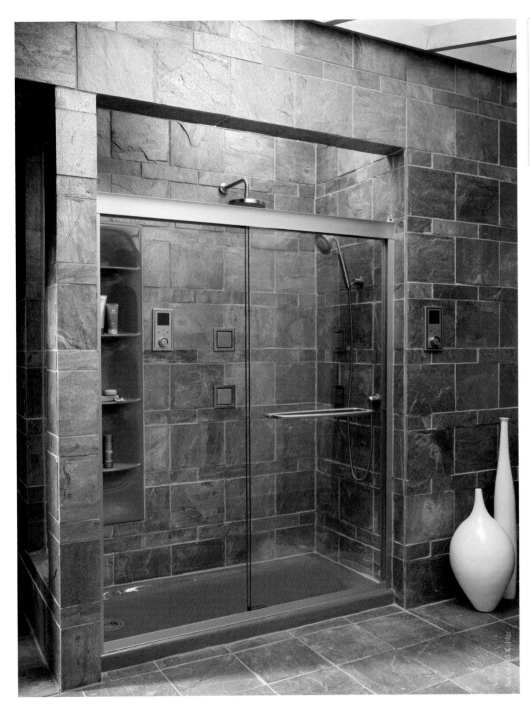

098

Add some texture into your bathroom. For instance, slate gives the space a natural feel. Because slate has a very subtle texture, you can use it throughout or on a specific surface as an accent.

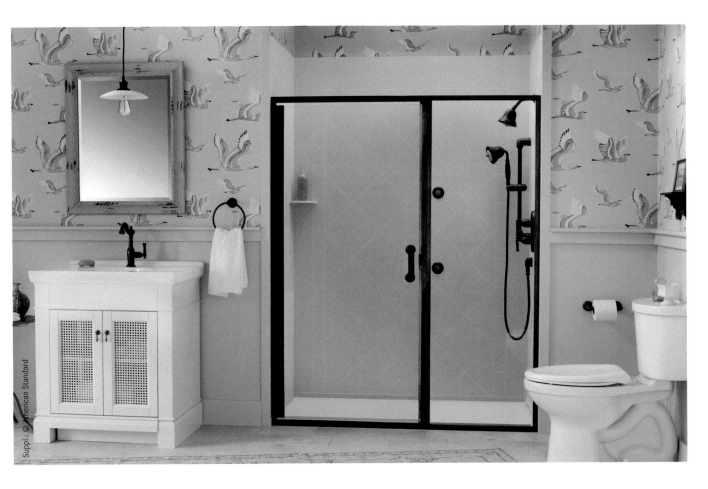

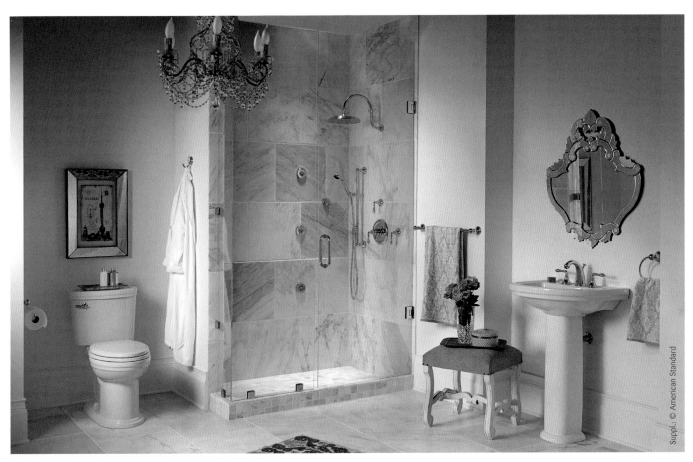

Suppl.: © American Standard

Venetian mirrors, crystal chandeliers and veined marble make for an elegant old-world experience. The area rug reminds one of the picturesque Roman mosaics.

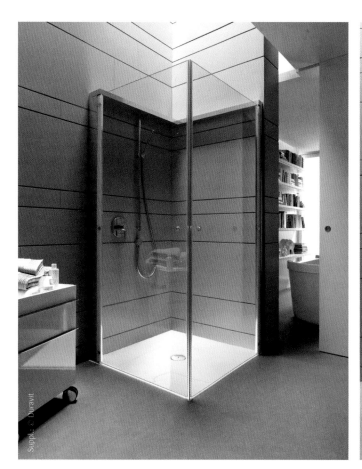

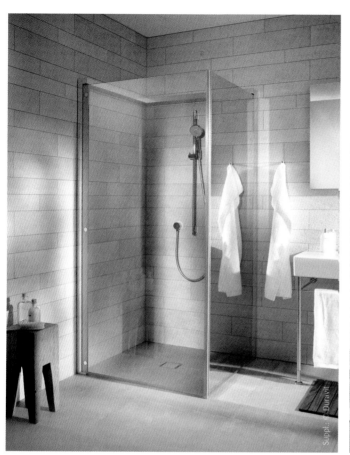

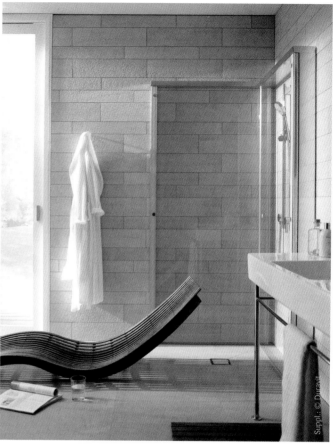

099

To keep a calm atmosphere in your bathroom, keep in mind that furniture should be sparse and functional.

Simplicity and practicality make the traditional aspen wood sauna a modern home trend. What better way to unwind and soothe your senses than in a spa-like room that can fit in your home?

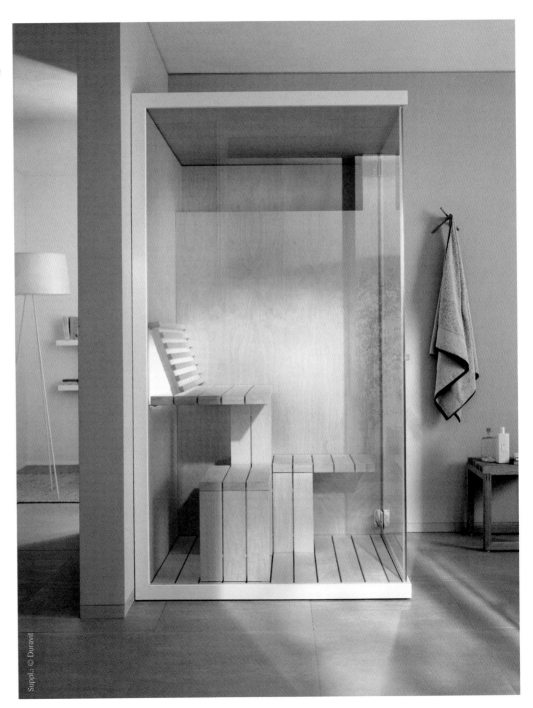

Suppl.: © Duravit

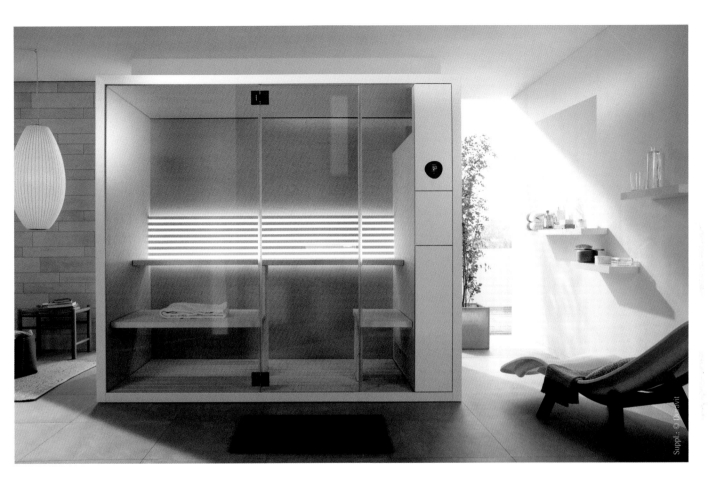

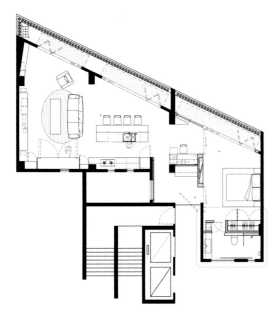

General floor plan

Bathroom interior elevations

Detail front elevation

Detail section

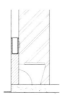

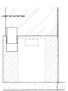

Detail front elevation

Detail section

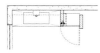

Plan detail at vanity

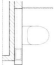

Plan detail at WC and detail elevations

Plan detail at Cabinet

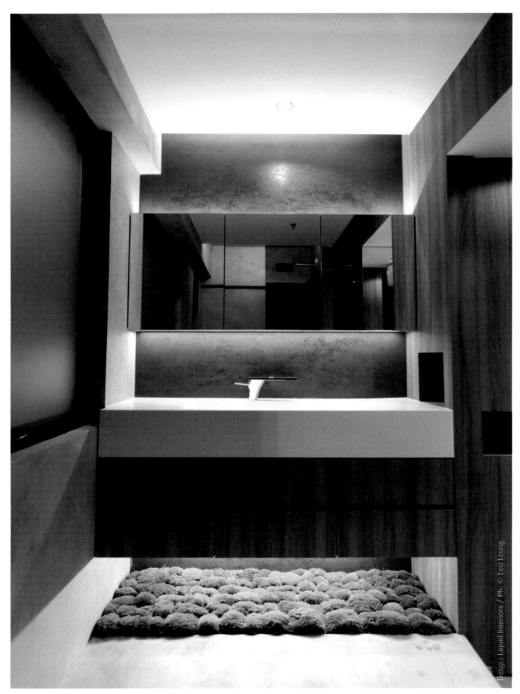

This playful moss-like mat under the vanity adds a touch of whimsy to this bathroom inspired by the colors found in the deep forest.

Desg.: Liquid Interiors / Ph.: © Leo Leung

100

A rich wood grain can pair with many warm and cool colors providing a comfortable atmosphere and a rich contrast.

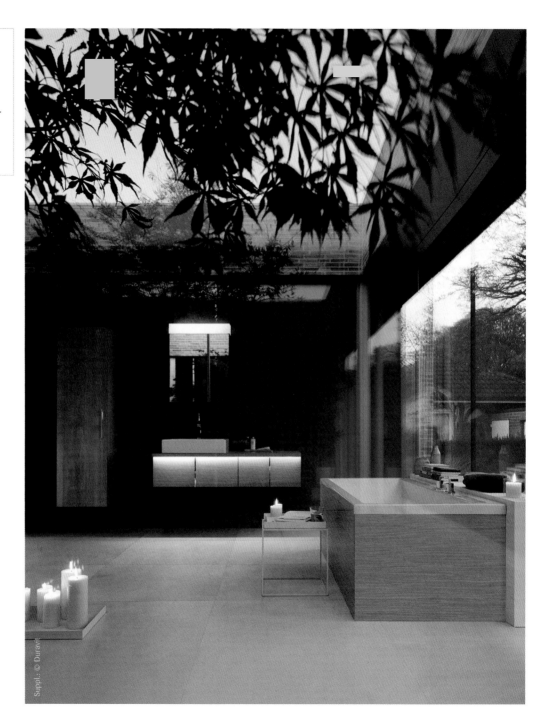

Suppl.: © Duravit

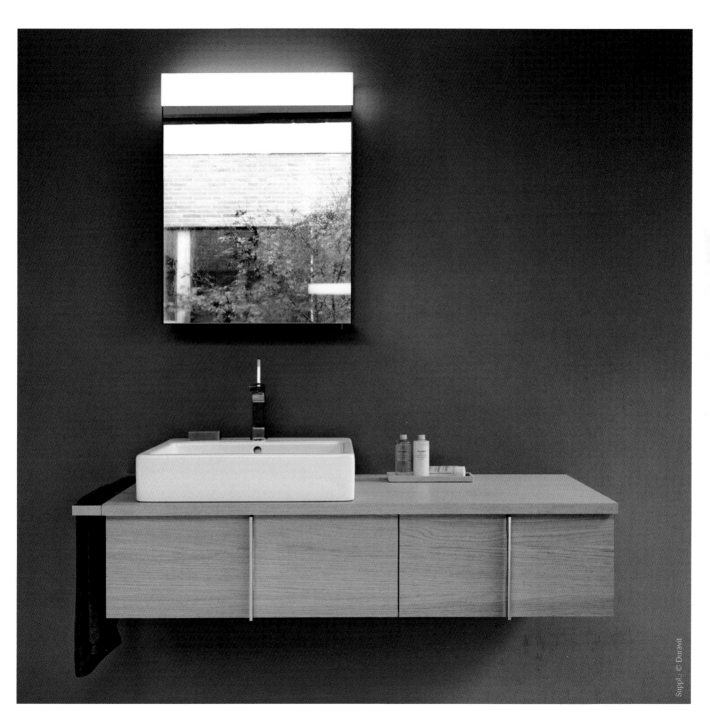

101

Hardwoods are no longer exclusive to furniture, millwork and flooring. New technologies offer watertight solutions that minimize the warping, peeling and watermarks of the fixtures in contact with moisture.

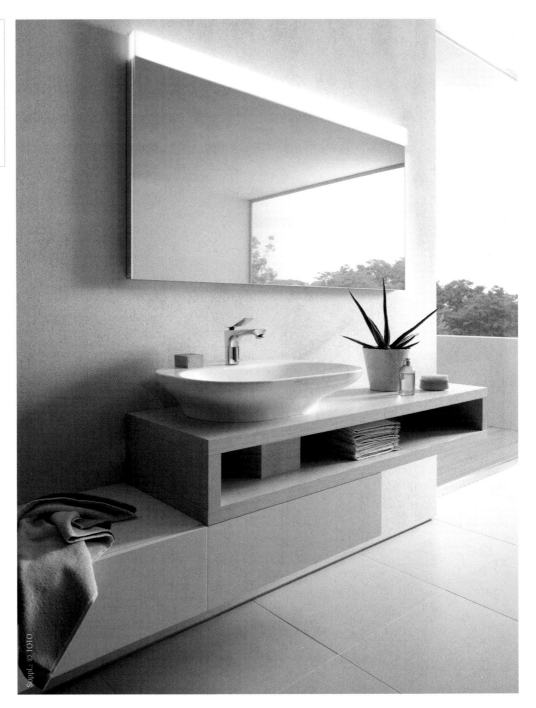

Suppl.: © TOTO

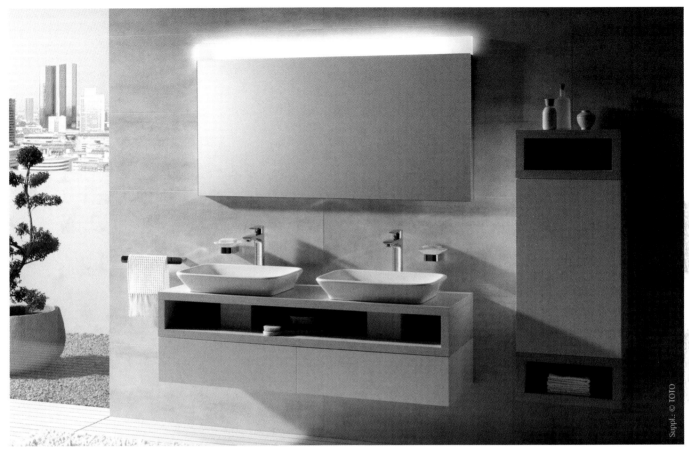

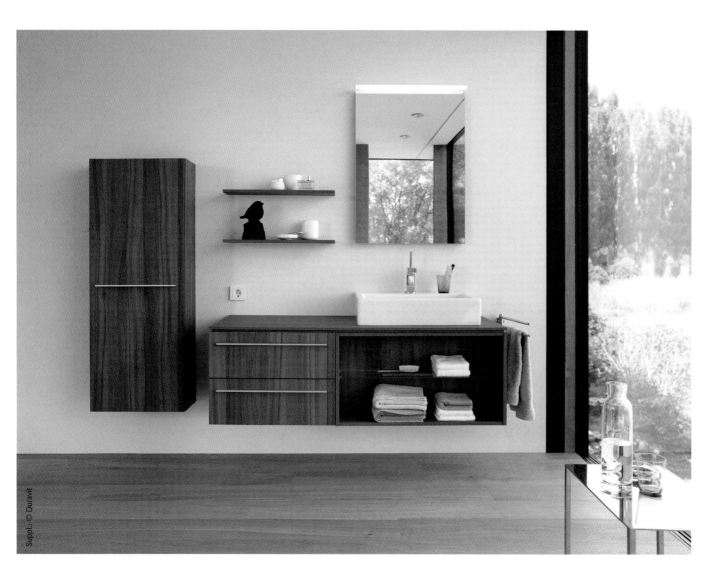

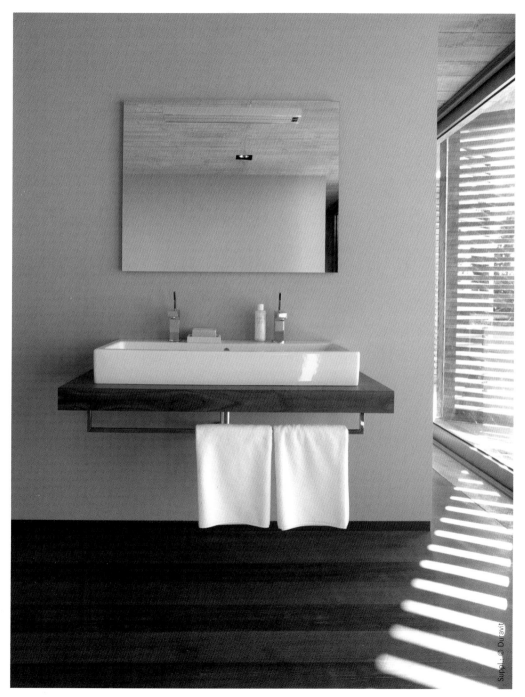

The design of bathroom fixtures and cabinetry shows an increasing adaptation to the architectural spirit and the lifestyle of our times with items that aren't bulky, but rather light without compromising utility.

Suppl. © Duravit

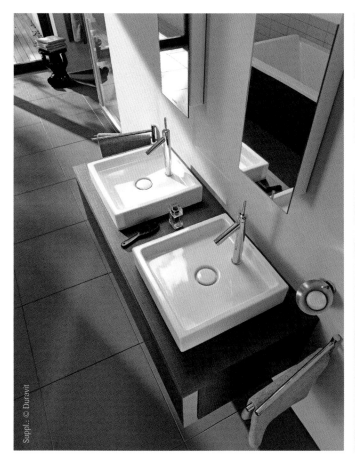

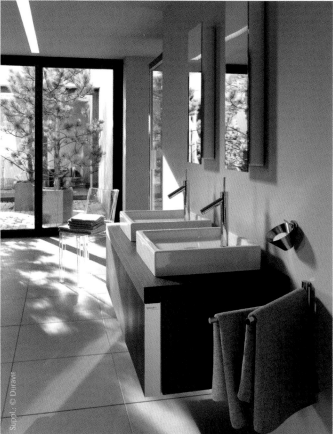

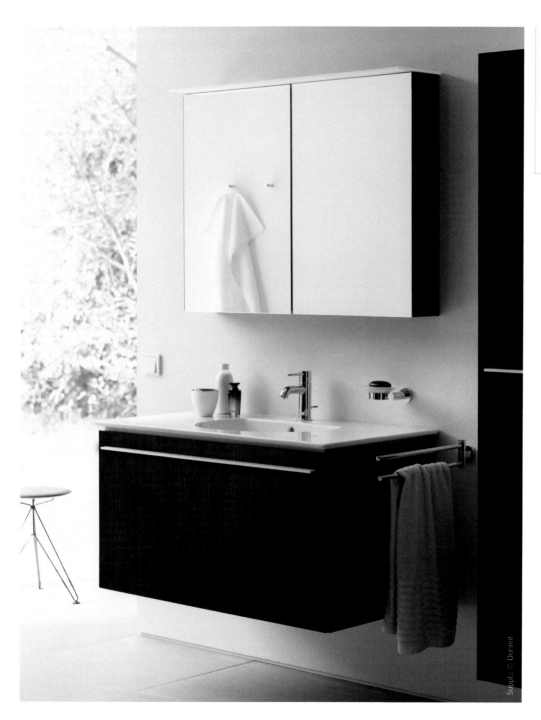

102

Mirrored cabinets combine a good balance of style and convenience offering multiple viewing angles and providing easy access to essential toiletries, while complementing your décor.

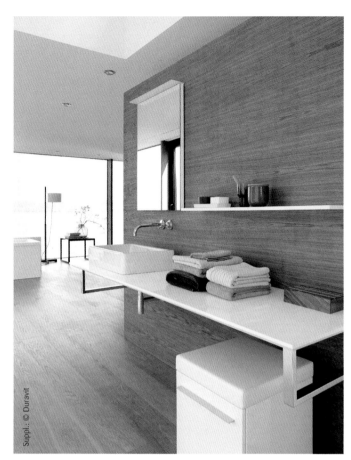

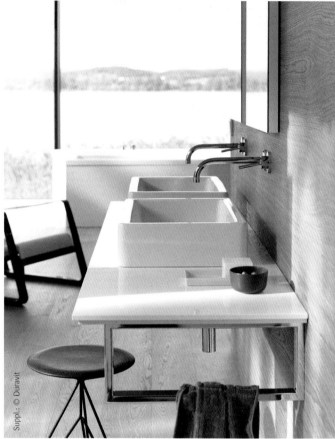

This sleek white vanity unit enhances
the modern style of the space with
floor-to-ceiling windows, tall ceilings
and minimal furnishing and decoration.

Suppl.: © Duravit

Suppl.: © Duravit

Suppl.: © Duravit

If there is a fixture that can be moved out of the bathroom without compromising privacy, that would be the vanity.
The only consideration is plumbing.
The vanity would go perfectly in a small foyer off the bathroom.

Suppl.: © Durat

103

Built-ins are great architectural features that can be found in old homes, but they rarely exist in bathrooms. To add storage space in the occasion of a bathroom remodel, steal space from an adjacent closet.

Nothing better than a bathroom brightened by abundant natural light to wake up in the morning. Avoid bulky storage units and solid separations so that light reaches every corner of the room.

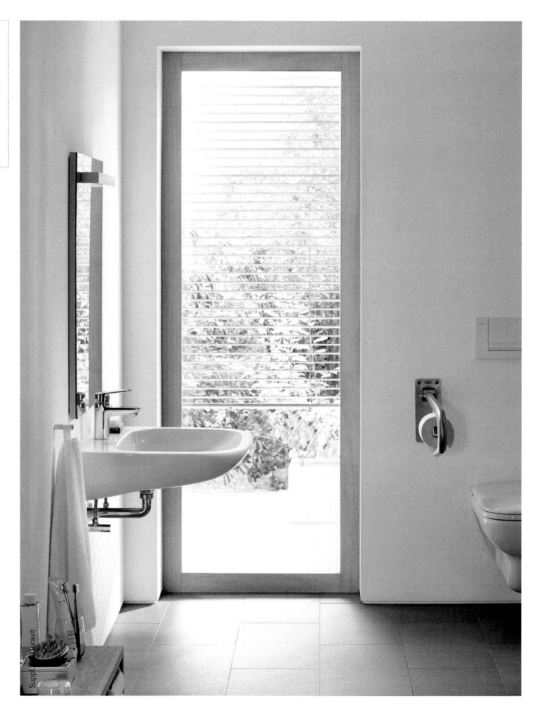

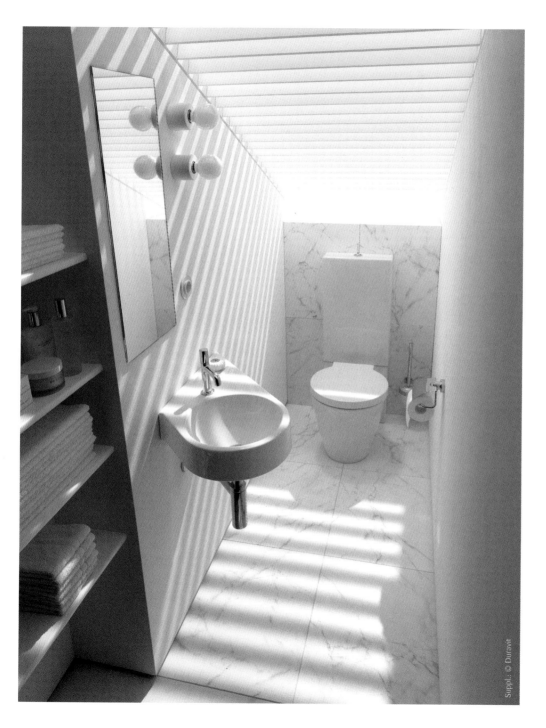

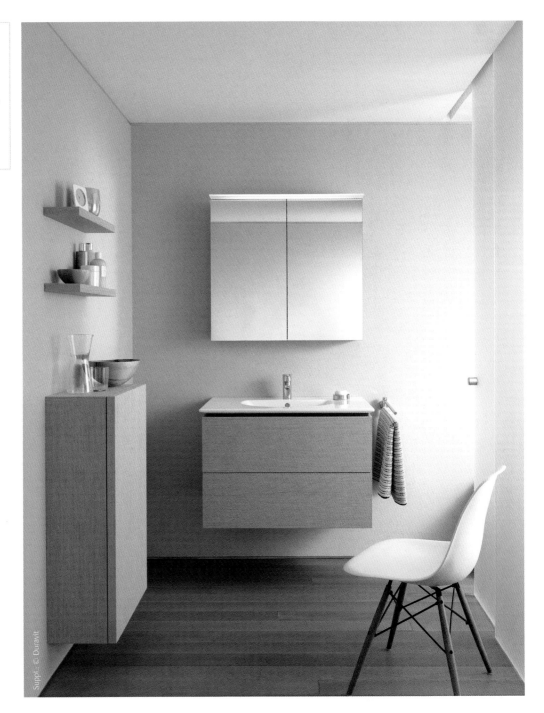

105

Good natural ventilation and adequate location of vent fans in bathrooms can reduce fluctuations in relative humidity and eliminate condensation problems.

Suppl. © Duravit

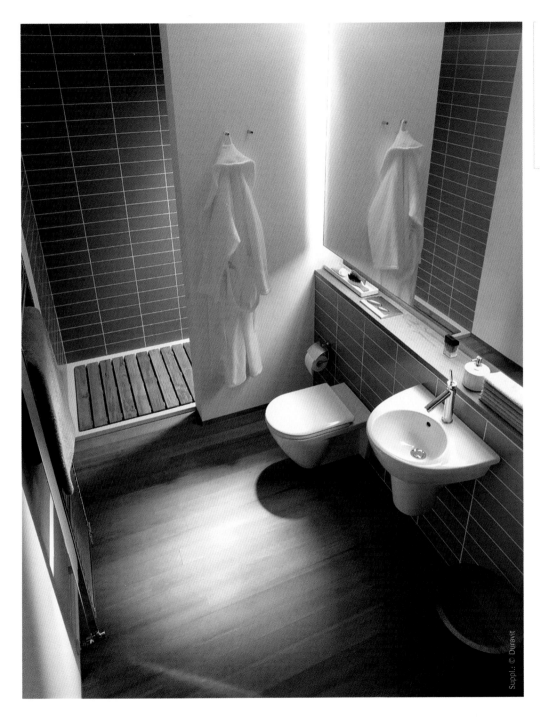

A bathroom layout with plumbing in two or more walls offer design flexibility, but involve more work. Fewer plumbing walls limit design choices, but on the other hand reduce labor and expense.

Suppl.: © Duravit

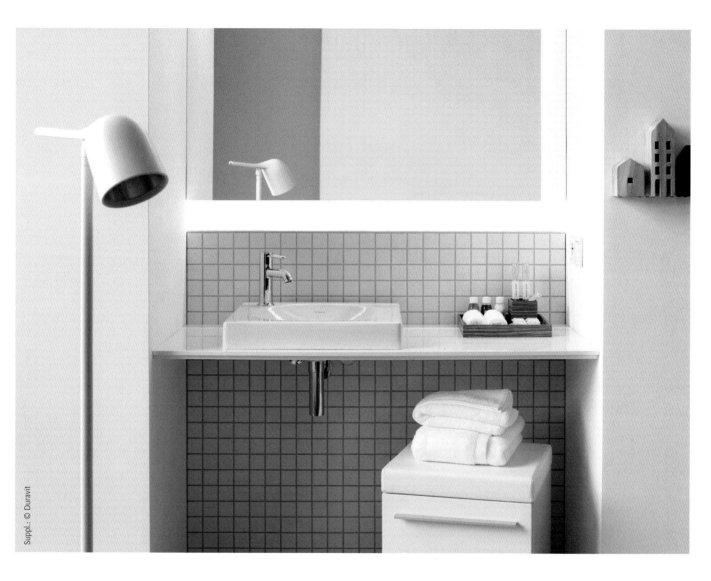

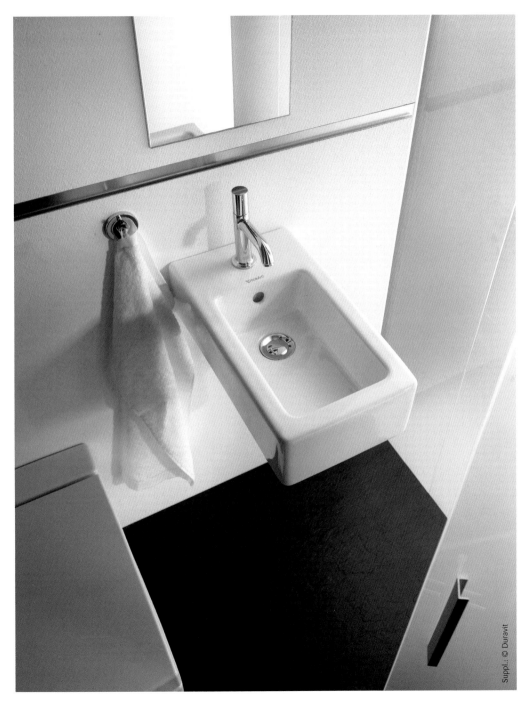

Wall-hung washbasins are ideal where space is limited and work particularly well with contemporary décor.

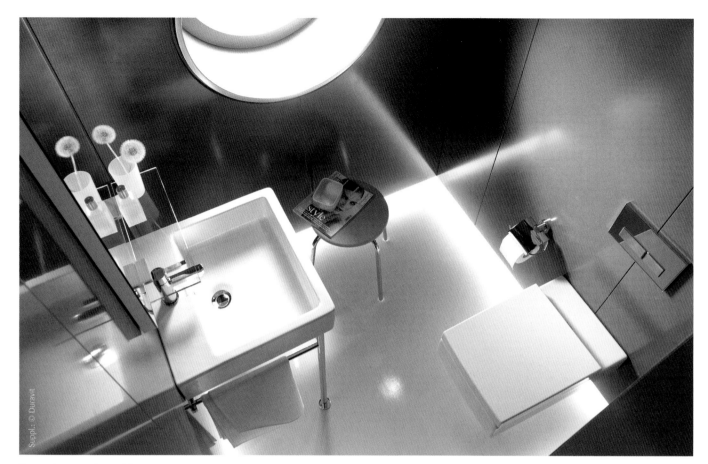

Suppl.: © Duravit

The nearly square shape of the washbasin and the clean lines of the metal console pair well with the striking, yet straightforward design of this bathroom.

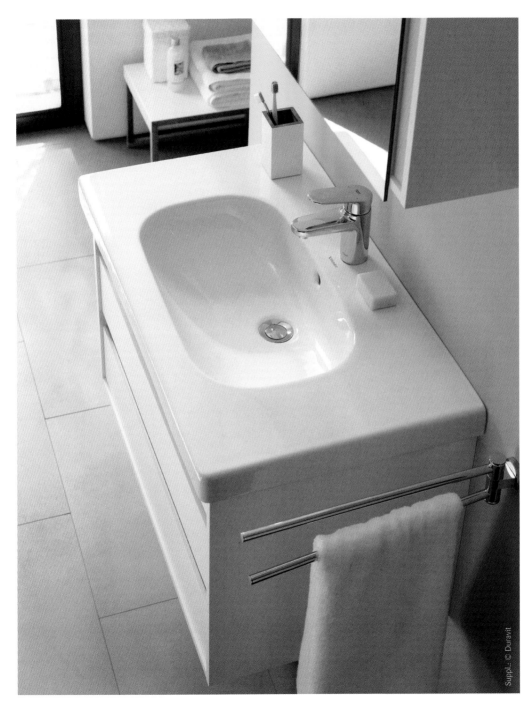

The bright colored walls bring attention to the vanities creating a focal point, while adding an energizing touch to the room.

Suppl.: © Duravit

A separating wall between the washbasin and the tub-shower area adds a personality touch. This design also includes a tub-high bench for bathing products, avoiding the need for wall niches or shelves.

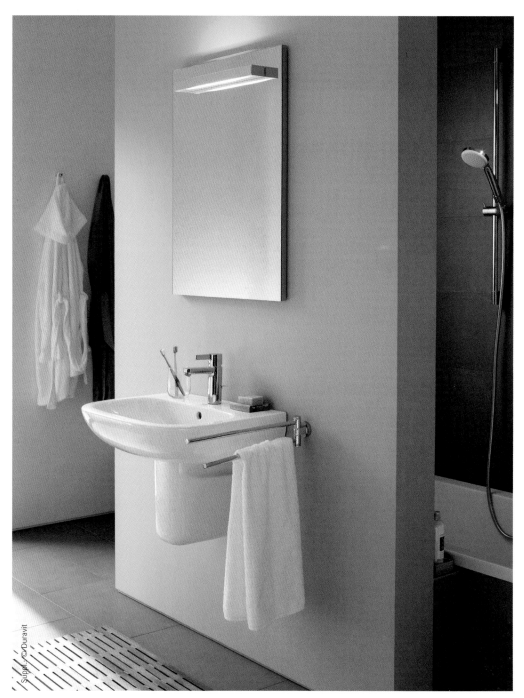

Supply ©Duravit

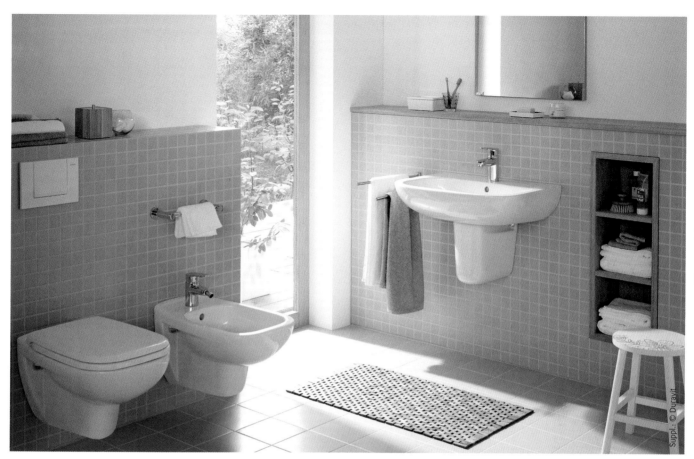

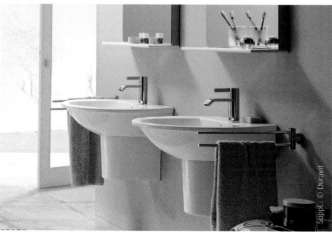

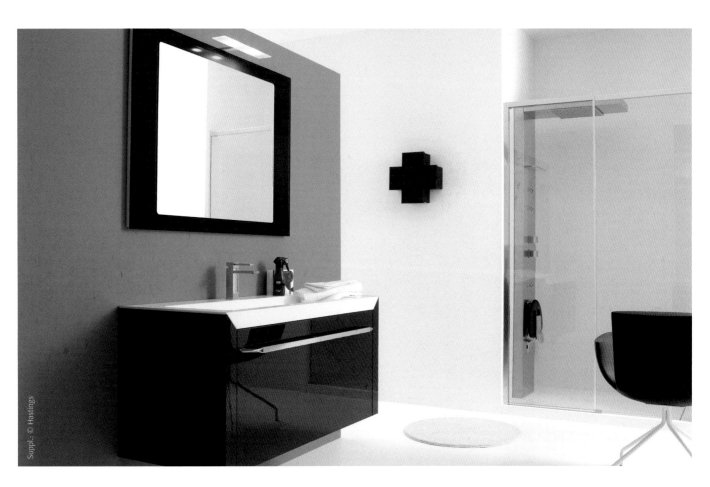

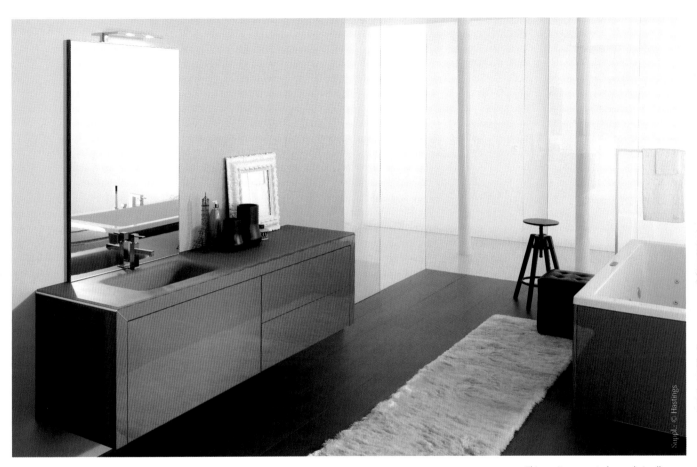

Suppl.: © Hastings

This vanity seems to be made in all one piece. This bright orange fitting along with the same color tub surround add a playful accent to a minimalist bathroom design.

If space allows it, a double-sink design provides great convenience in shared bathrooms.

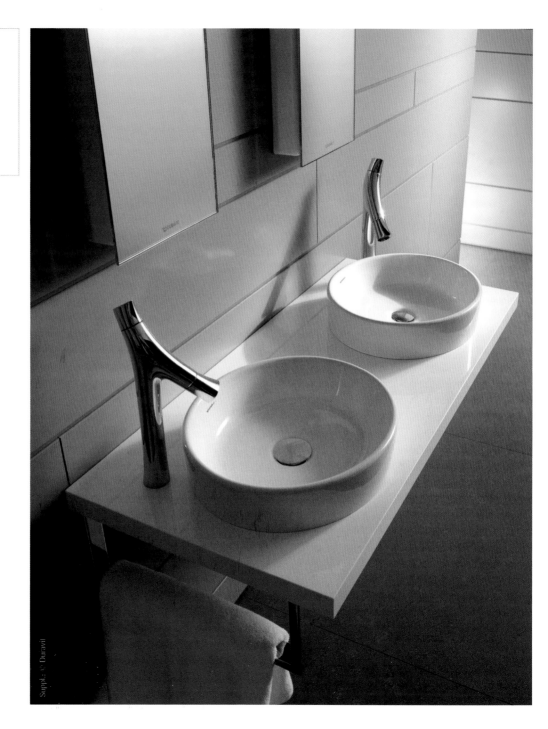

Suppl: © Duravit

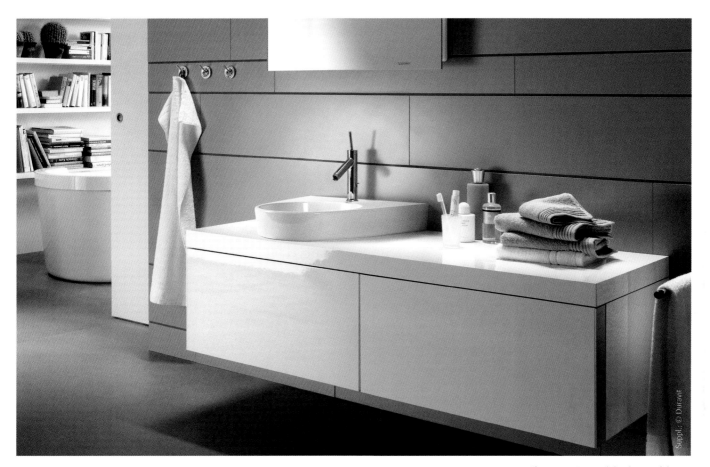

The proportions and the design of the wall-hung vanity unit echo the horizontal pattern of the wall. The plentiful storage space, the hooks and towel rail offer a clean and organized look.

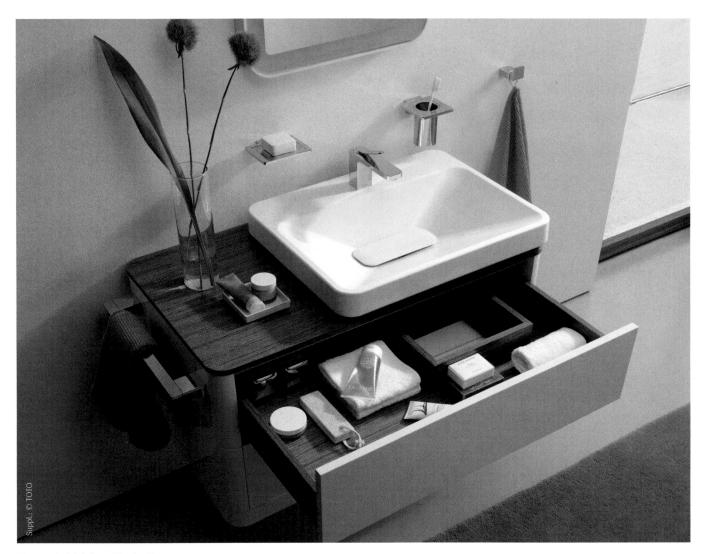

The rounded detail combined with
the wooden surfaces warm up the
streamlined design of this vanity unit.
Its simple design isn't an obstacle for
its generous storage capacity.

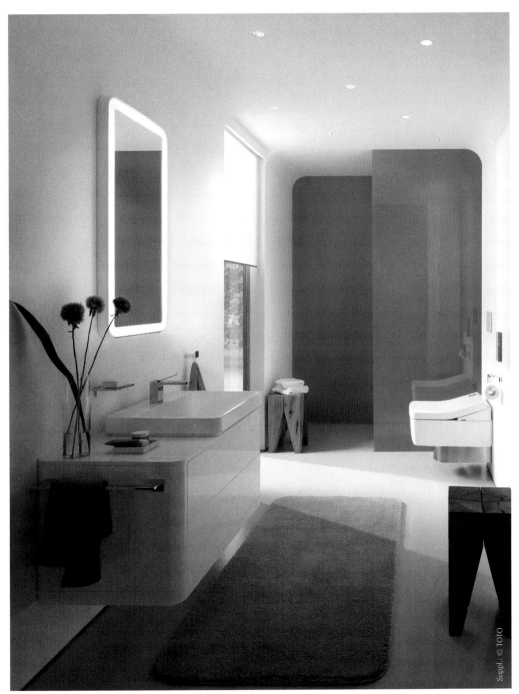

The interior design and the selection of fittings work together to create a unifying look by means of a minimalist choice of finishes and colors. The rounded corners are a repeating detail that reinforces the modern design of this bathroom.

Suppl.: © TOTO

This playful, yet clean bathroom design combines an old-fashioned, oversized sink and personalized stools. In contrast, the symmetrical placement of the cabinets and light fixtures keep a calm atmosphere.

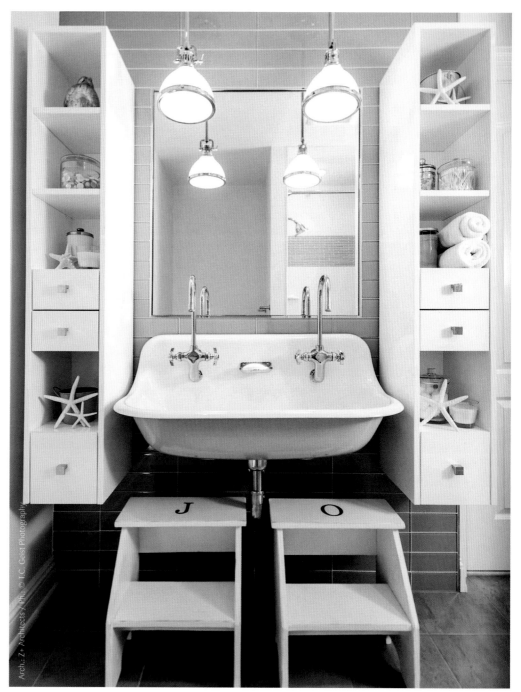

Arch.: Z+ Architects / Ph.: © T.C. Geist Photography

Interior elevation at sink

Bathroom floor plan

Bathroom axonometric view

1. Wall mounted sink
2. Wall mounted storage
3. Barn light electric sconce

Add a vintage touch to your bathroom with refurbished old light fixtures and an extra-deep enameled cast-iron sink combined with walls finished in subway tile in the color that best suits your design concept.

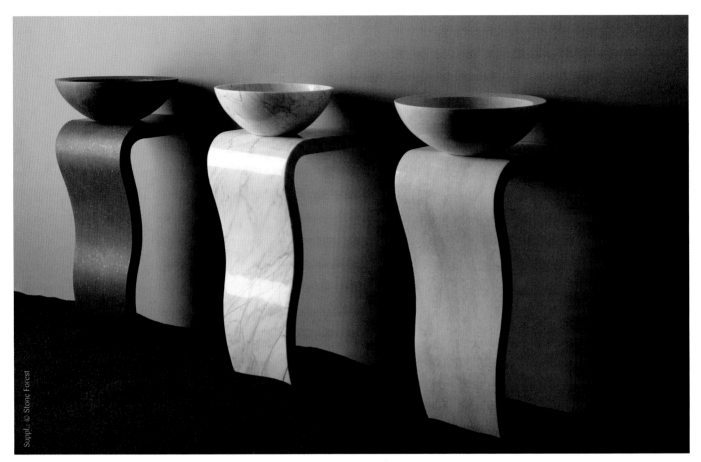

Suppl.: © Stone Forest

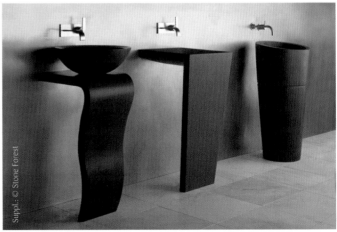

Suppl.: © Stone Forest

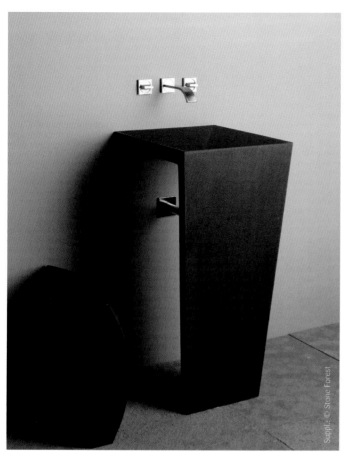

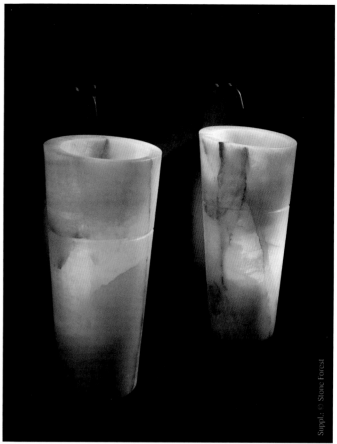

Made of precious stones like marble and onyx, these pedestal washbasins bring artistic flair to an elegant bathroom, or better yet, to a bathroom's anteroom mixing with artwork.

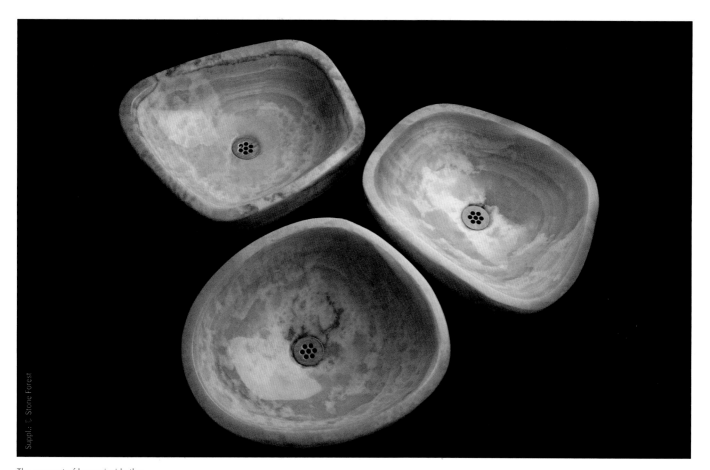

The concept of luxury inside the
bathroom is redefined with the use of
precious materials in the production of
fittings such as washbowls.

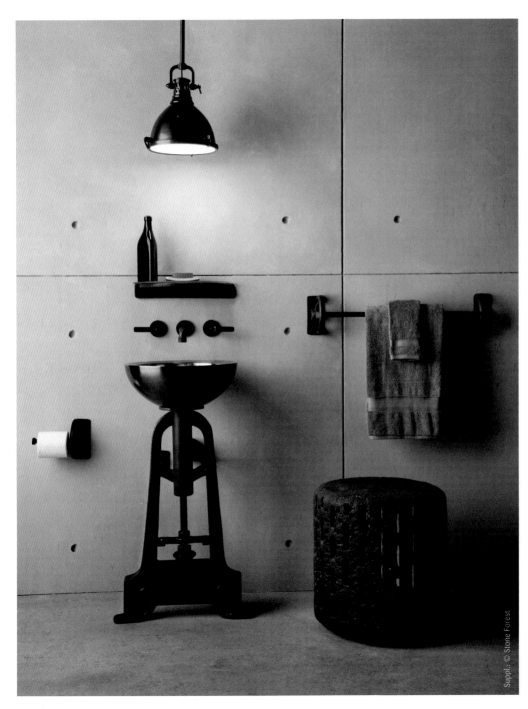

This industrial-looking pedestal sink reminds one of nineteenth-century artifacts. The stand is entirely made of cast iron, and the sink comes in antique dark or light copper and in stainless steel.

Suppl.: © Stone Forest

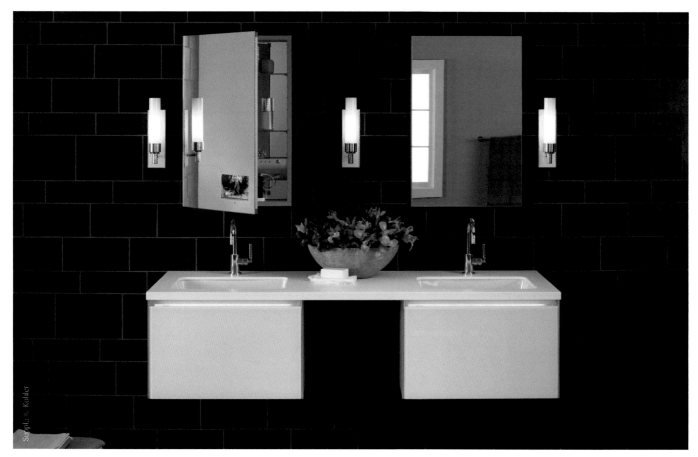

A modern single-slab countertop with two sinks and two undermounted cabinets create a strong design statement against a black tile wall. Mirrored medicine cabinets and simple sconces complete the crisp look.

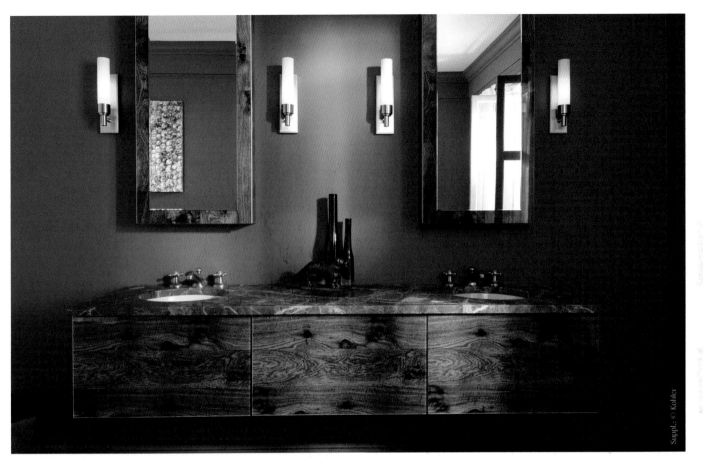

The rich wood cabinet and veiny marble countertop are of a matching chocolate color. This traditionally inspired vanity unit works well with contemporary accents such as the chrome and etched glass sconces.

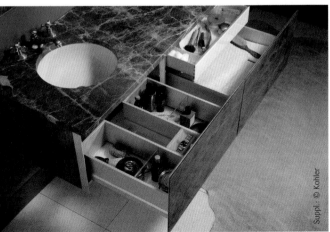

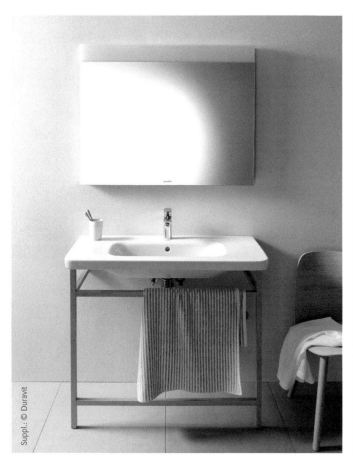

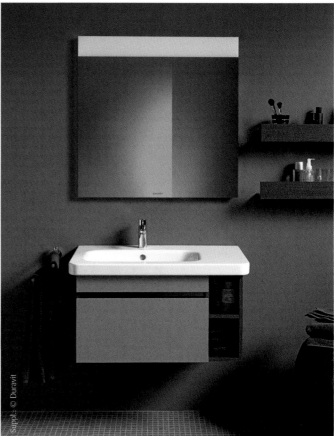

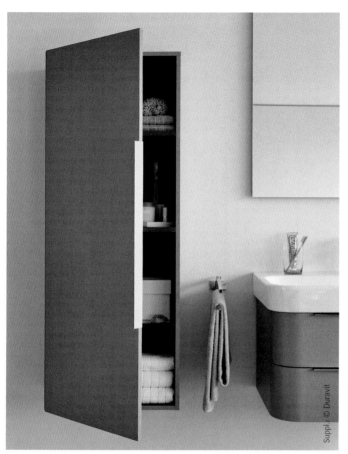

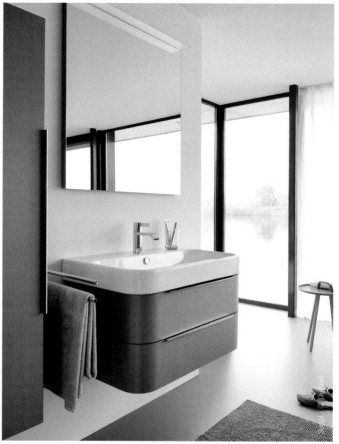

Suppl. © Duravit

109

Get the most out of the wide range of vanity designs. Open shelves and cubbies, drawers, closed cabinets or any of these options combined offer plenty of stylish storage opportunities.

The clear and understated basin design harmonizes with that of the vanity unit and of the overall bathroom design.

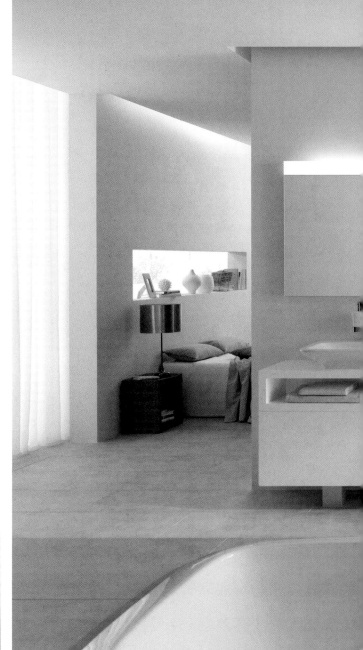

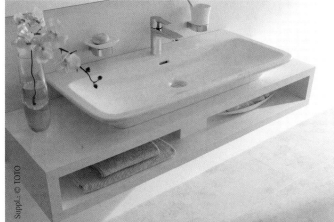

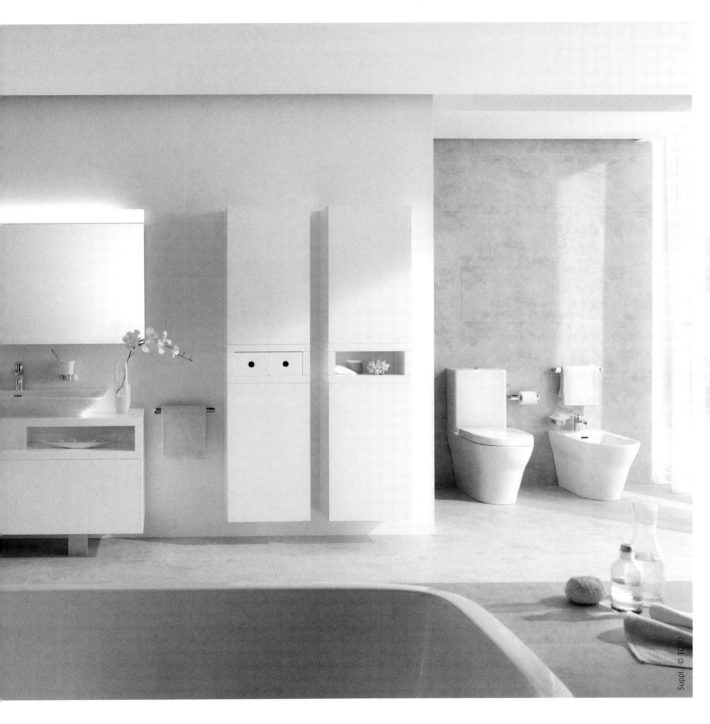

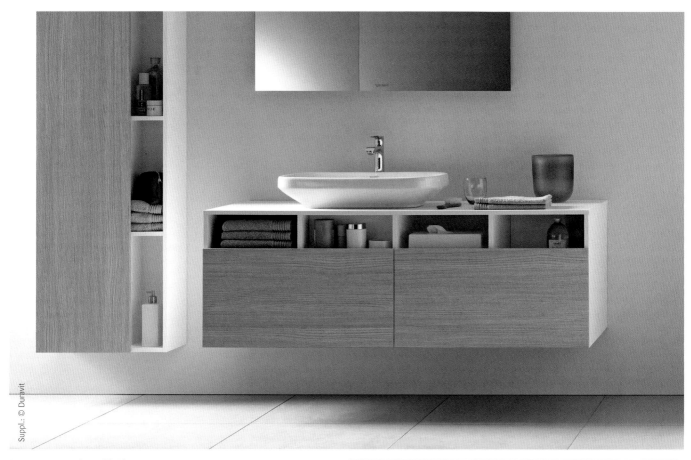

New generation of wood finishes
get better and better at withstanding
moisture. These finishes made of
synthetic resins seal the wood surfaces,
reducing contraction and expansion
in humid environments.

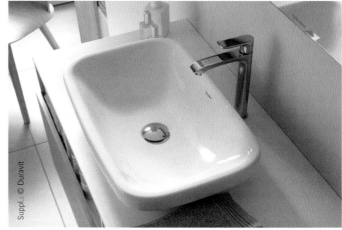

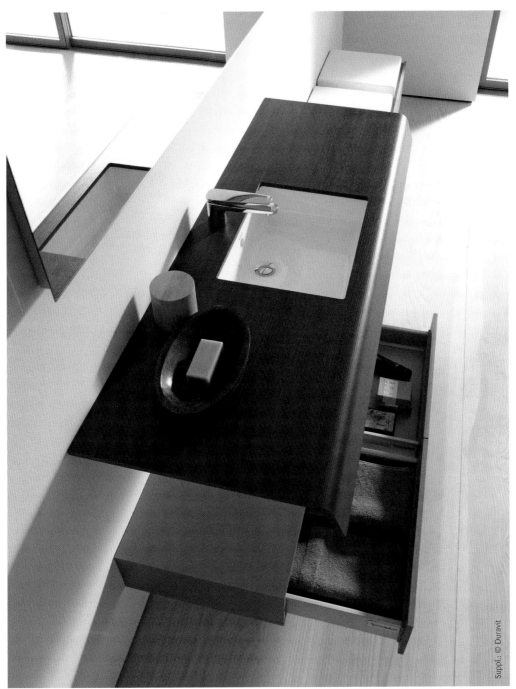

This vanity is designed to be mounted on top of a washbasin. It is characterized by its bent edge and its floating appearance. The natural wood finish enhances the decorative character of this bathroom fitting.

Suppl.: © Duravit

110

Include good lighting in your bathroom design. Indirect lighting works best because it doesn't produce glare. LED strips are thin enough to hide behind the lip of most cabinet fronts.

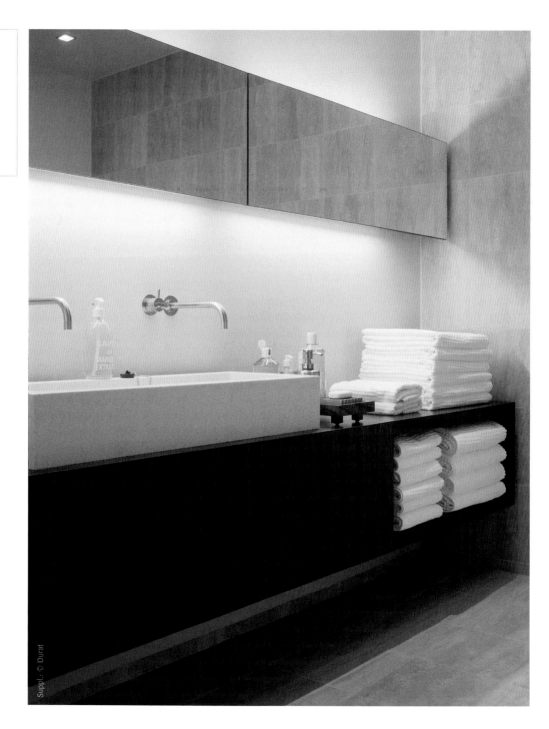

Suppl.: © Durat

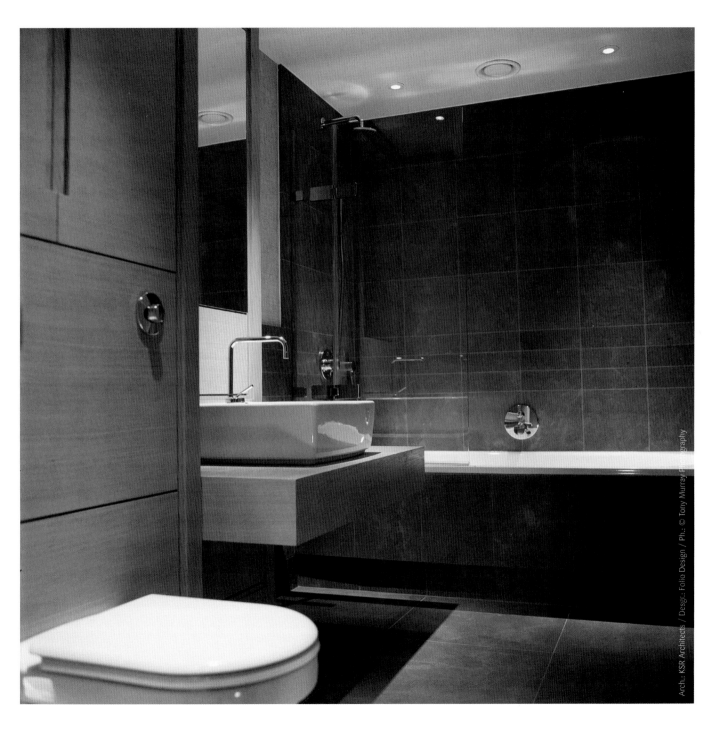

Arch.: KSR Architects / Desg.: Folio Design / Ph.: © Tony Murray Photography

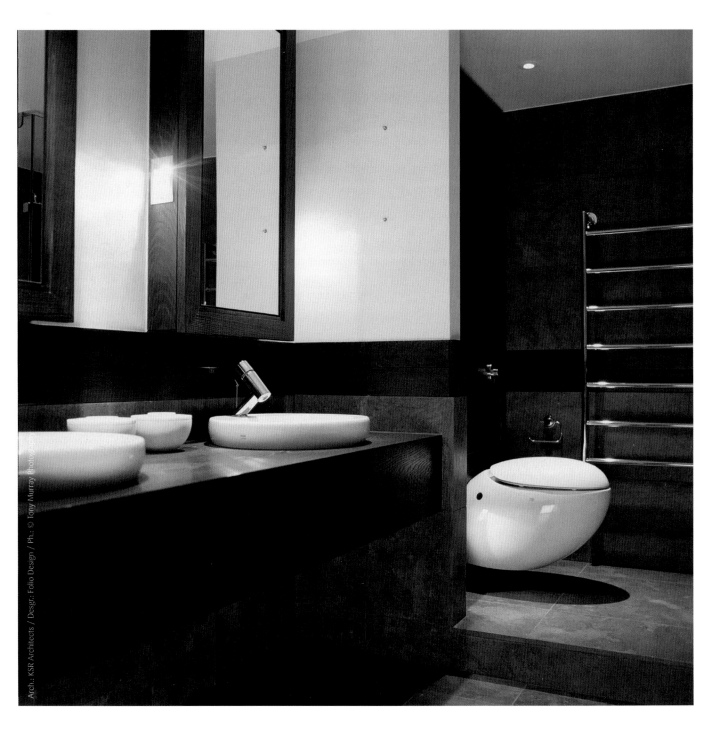

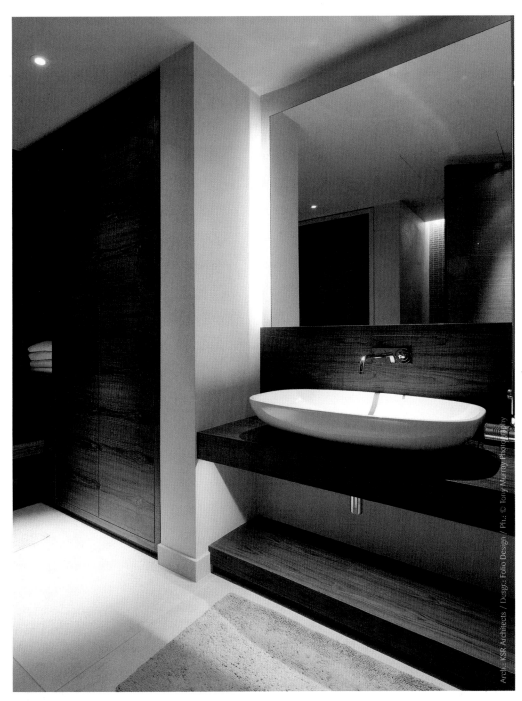

These wooden vanity countertops are designed like fine pieces of furniture. The same material is used as an accent combined with other finishes—like stone or ceramic tile—or by itself against a contrasting finish such as a light paint color.

The choice in bathroom furniture and materials influences the overall mood of the space, where efficient storage solutions play a decisive role in making the room as pleasant as possible.

Arch.: Nicolas Tye Architects / Photo: Nerida Howard Photography

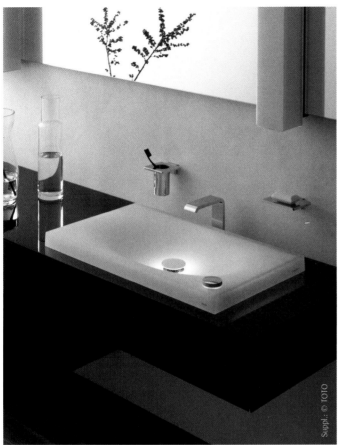

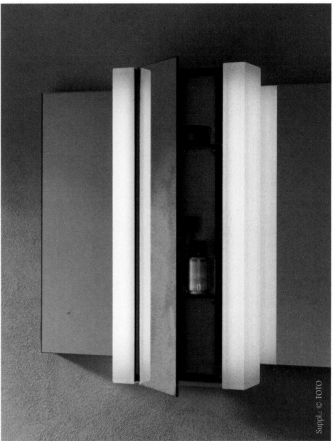

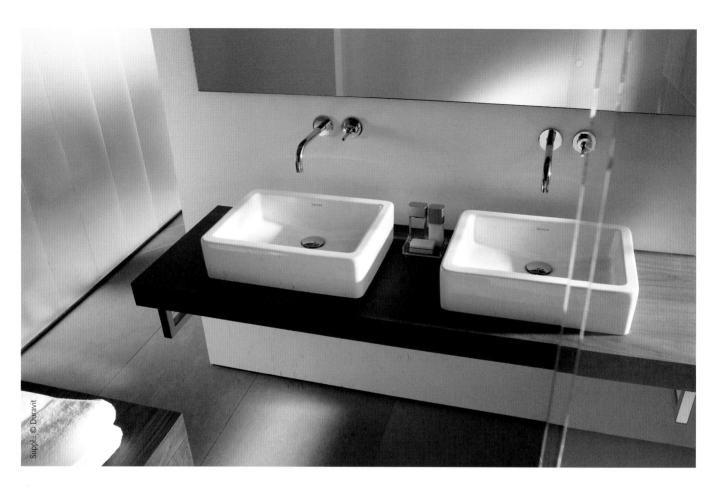

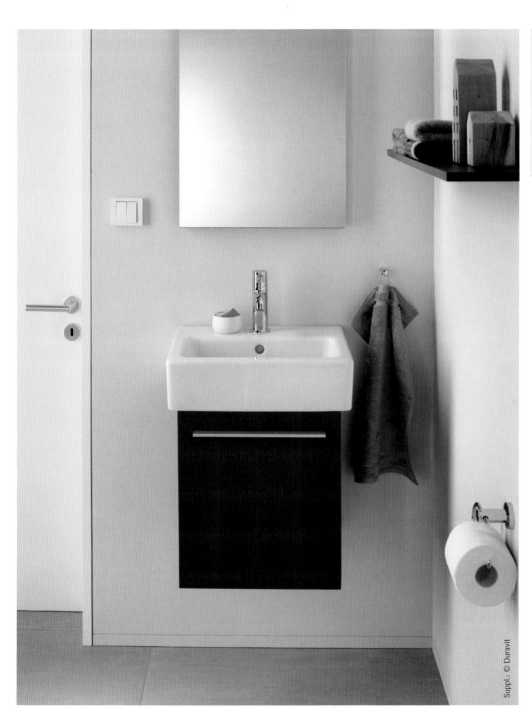

111

Frameless mirrors come in a wide variety of shapes and designs, often incorporating lighting. They can make a subtle design statement without calling too much attention to themselves.

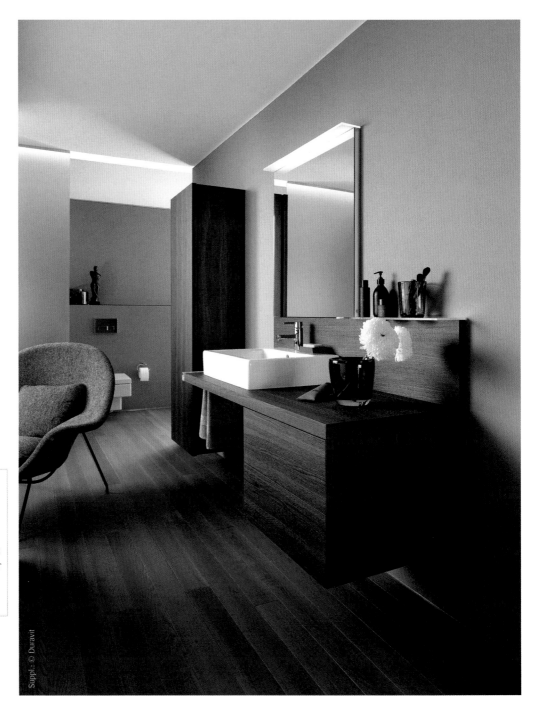

112

While vanity units with under-basin storage are practical, the simpler design of an elegant basin mounted on top of a sleek bench top is a perfect option for those preferring the minimalist look.

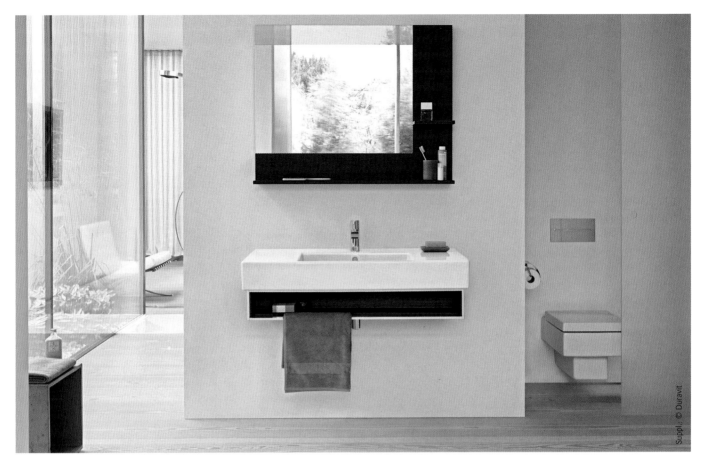

Suppl. © Duravit

Mirrors can enhance a space
in many different ways. In this
simple bathroom, the mirror
reflects a window with views of
greenery, bringing nature into
the room.

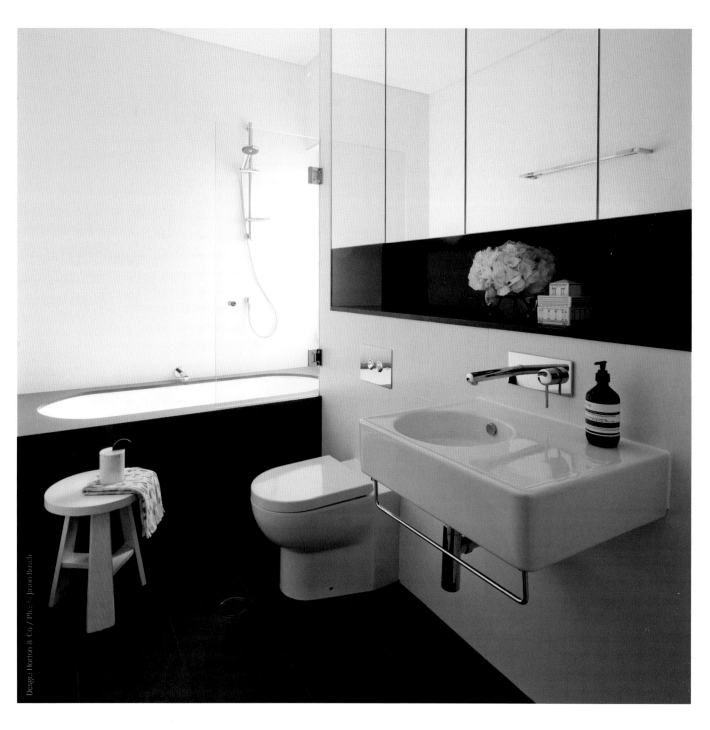

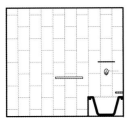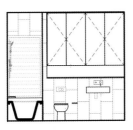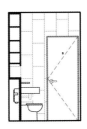

Bathroom floor plan and interior elevations

This existing bathroom was remodeled to replace a separate tub and shower with a bath shower freeing up space. The storage was incorporated above the basin and concealed cistern with a niche and mirrored cabinets.

114

The different sizes, proportions, and shapes of mirrors available, framed or unframed, concealing a medicine cabinet or incorporating lighting allow great flexibility when decorating a bathroom.

115

When using mirrors in a bathroom—like in any other room—consider the items and surfaces that it will reflect to avoid awkward visual effects or glare if it reflects a light fixture.

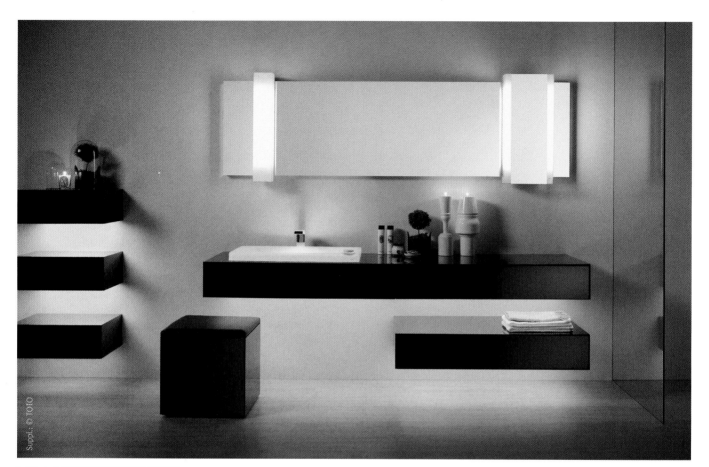

116

If you are looking for a modern design in your bathroom, choose a vanity unit and cabinets that look like freestanding furniture. For a more dramatic effect, float these items off the floor with light underneath.

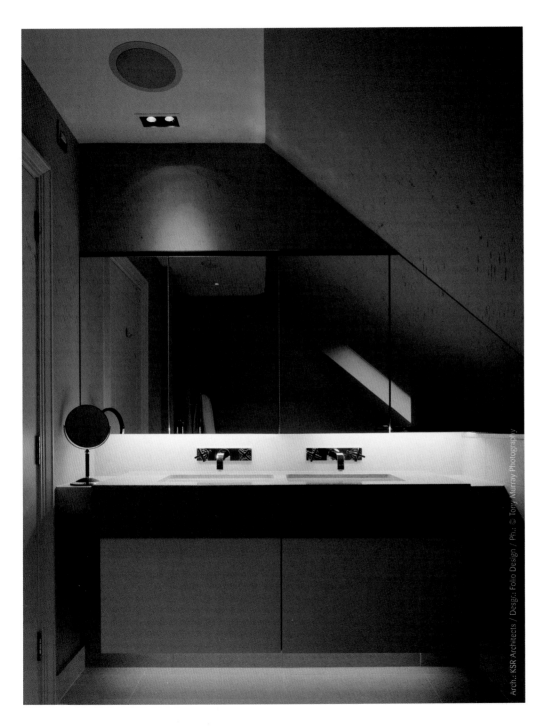

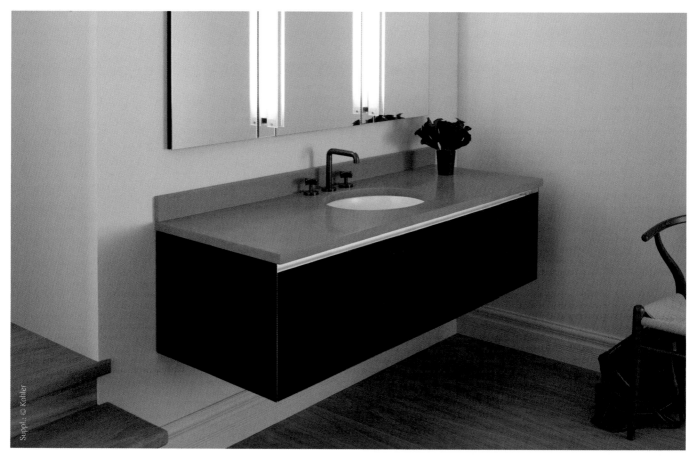

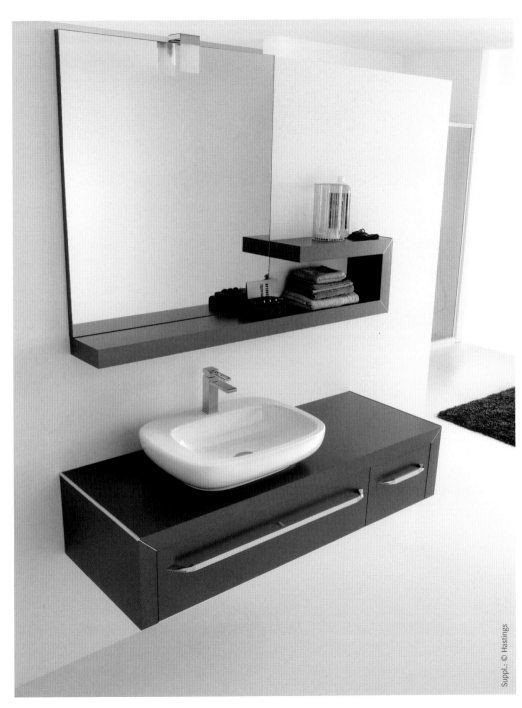

Compact furniture designs and efficient storage solutions contribute to cutting the clutter in a bathroom, which is usually the smallest room of a home and where every inch counts.

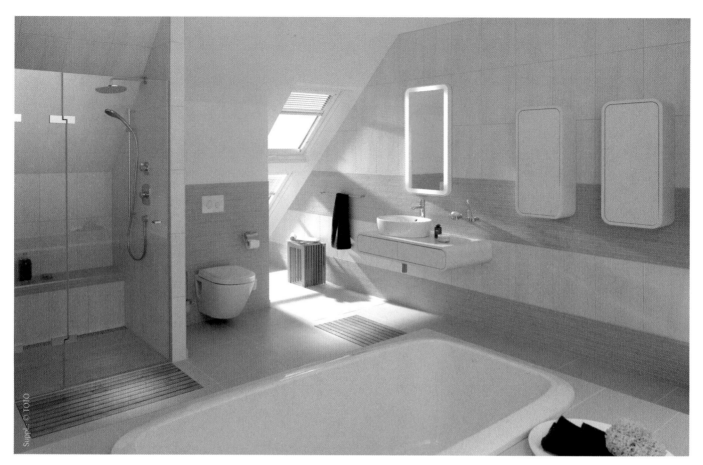

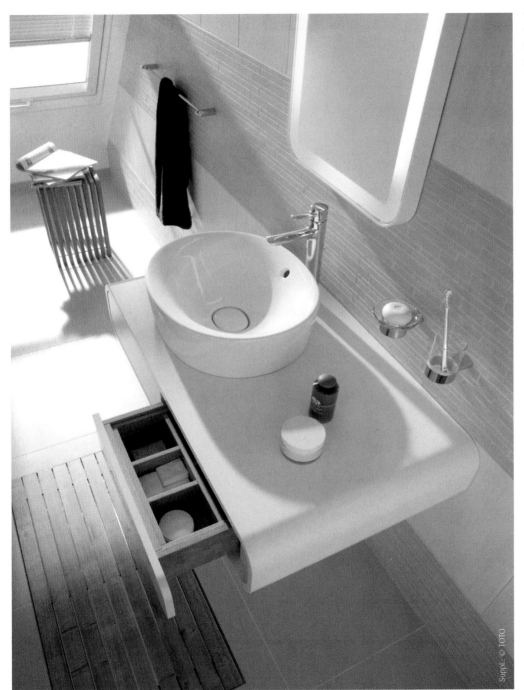

The design of the NC collection by TOTO© features furniture with rounded corners, contributing to the creation of retro-modern-style bathrooms.

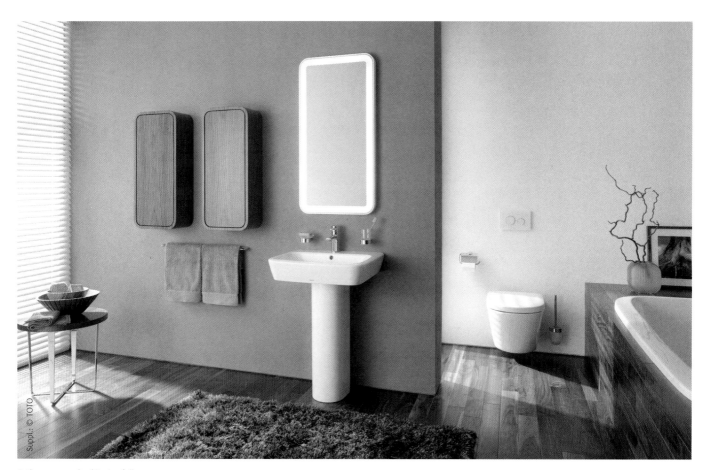

Suppl.: © TOTO

Bathroom wood cabinetry follows a specific manufacturing process. Wood surfaces for bathroom use are treated to make them resistant to both water and high levels of humidity.

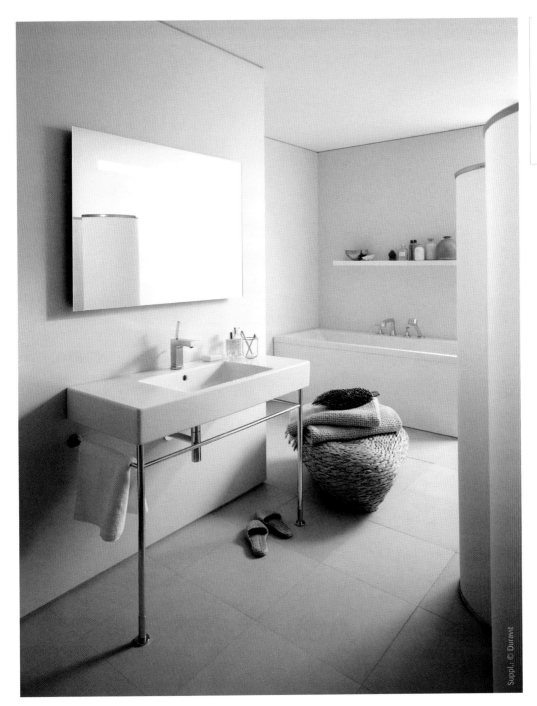

Irregularly shaped bathrooms allow a layout with different areas. One section can accommodate the vanity and the water closet, and another section can be reserved for the shower and tub.

Suppl.: © Duravit

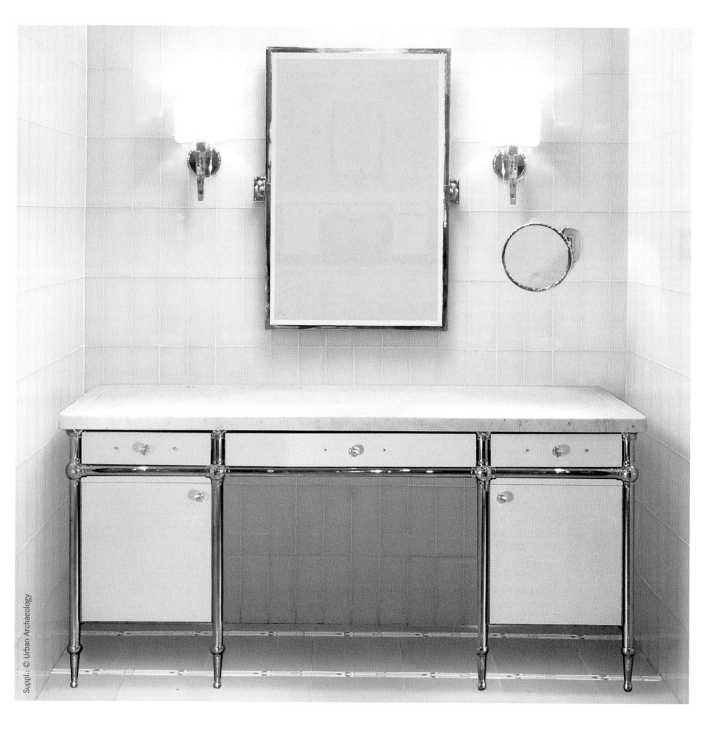

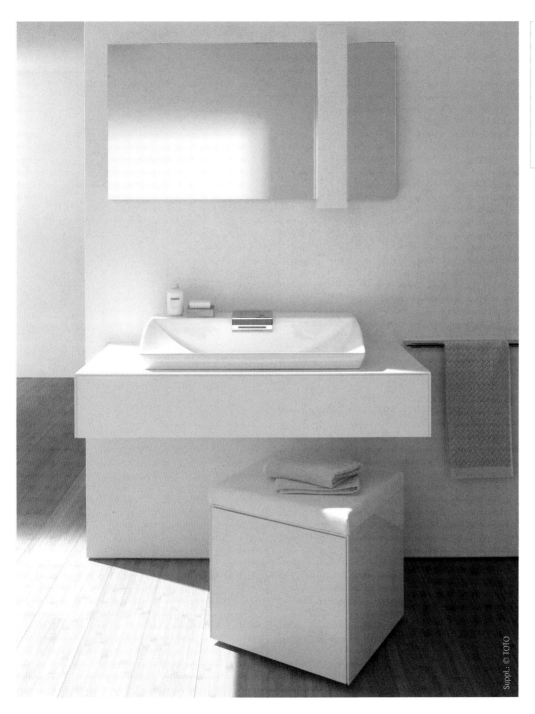

Modern bathroom design avoids redundant details and accessories. Light colors, compact fittings, glossy finishes, effective storage solutions and efficient lighting visually enlarge a bathroom.

Suppl.: © TOTO

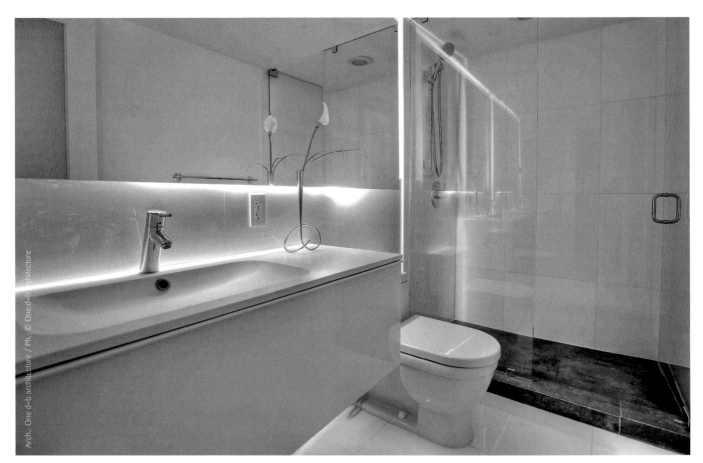

119

A well-planned lighting plan makes a world of a difference. A backlit mirror and under-vanity lighting highlight the design of the bathroom.

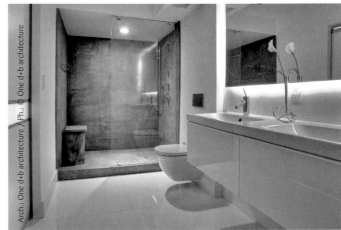

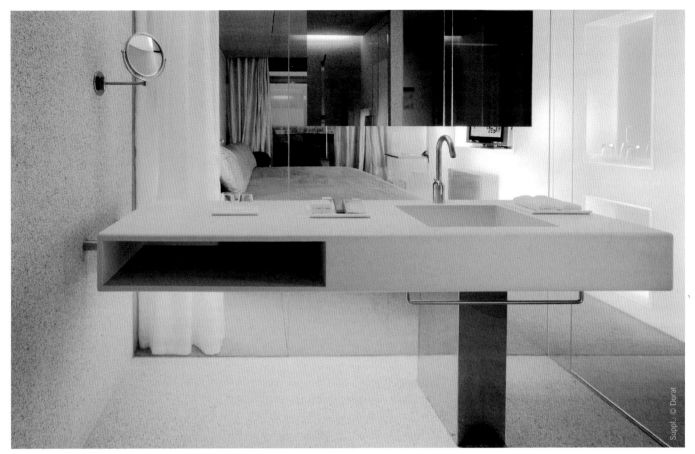

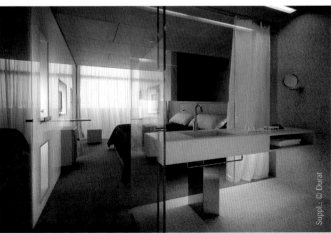

Suppl.: © Durat

Suppl.: © Durat

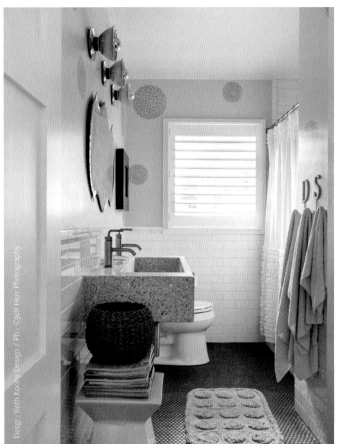

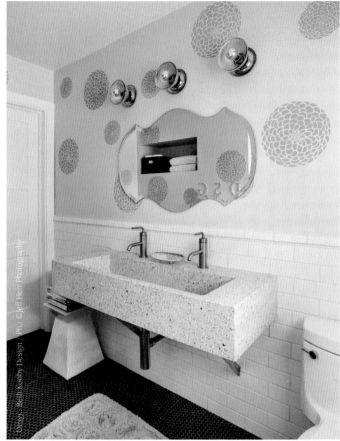

120

Creative tile ideas can add a unique decorative touch. Most tile manufacturers offer their costumers the option to mix and match colors and patterns. If that is not enough, you can create your own tile design.

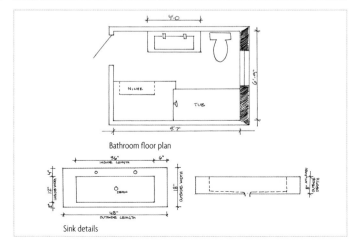

Bathroom floor plan

Sink details

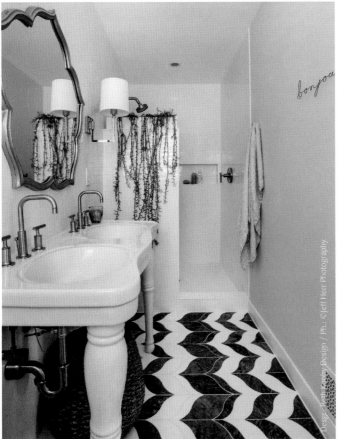

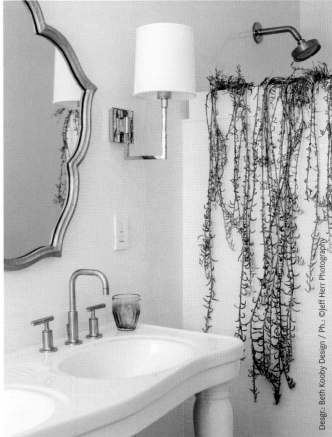

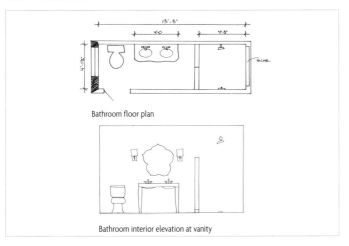

Bathroom floor plan

Bathroom interior elevation at vanity

121

Sometimes, a special touch is what takes to perk up a dull bathroom. You can personalize it with items you really like and turn your bathroom into a room that you can be happy to walk into.

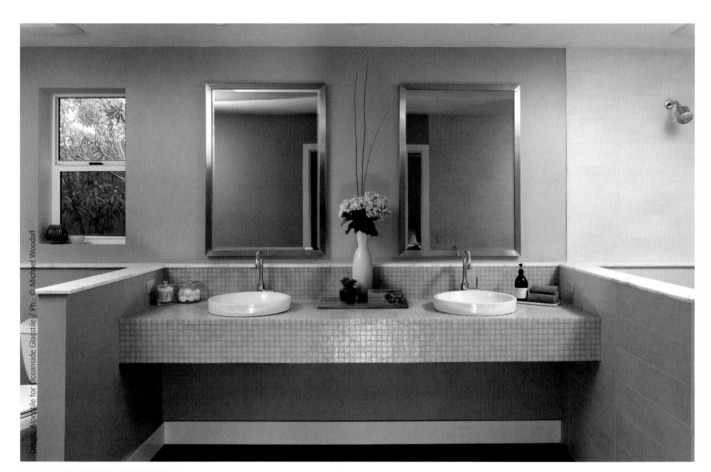

122

Glass mosaic tile is a suitable material for any surface thanks to its versatility offering infinite color, pattern, texture, and form design opportunities.

123

Mosaic tiles are ideal for adding a decorative accent. They are suitable for all types of surfaces: walls, floors, countertops and backsplashes.

A pedestal sink and toilet were chosen to match the style of the wainscot. The décor is rounded off with wallpaper featuring a wavy pattern and a chandelier for a traditional style.

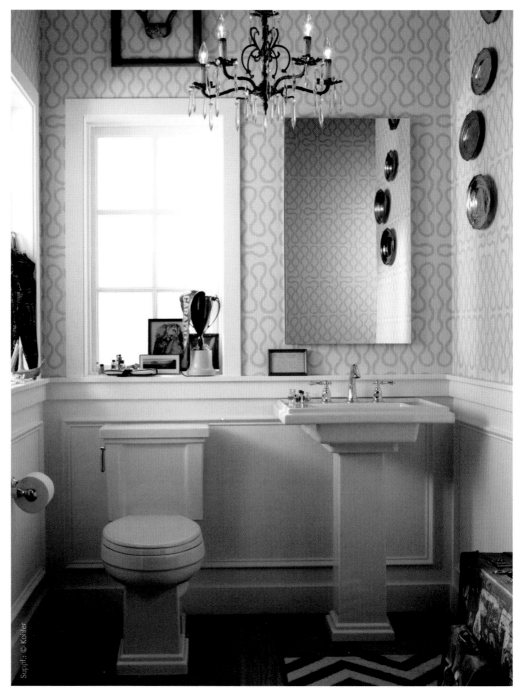

Suppl.: © Kohler

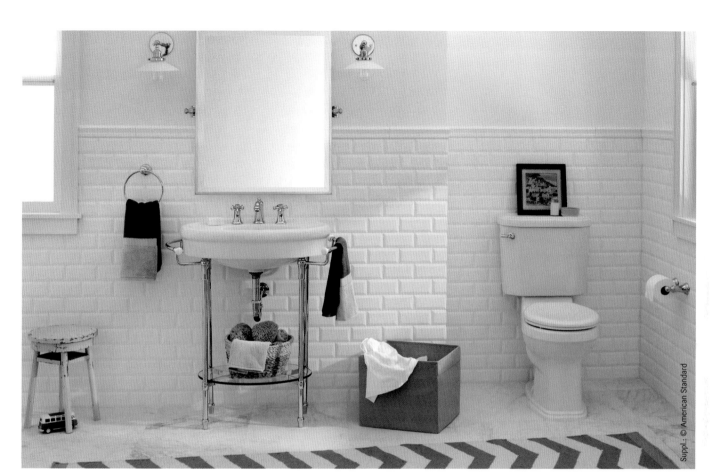

White subway tile always adds timeless appeal to a bathroom providing a bright and crisp atmosphere perfectly adequate for a bathroom environment.

Suppl.: © American Standard

The Duke chrome aluminum console
and the Etoile porcelain basin by
Devon&Devon™ are the height of
classic refinement with a contemporary
flair and the perfect addition to a
sophisticated room.

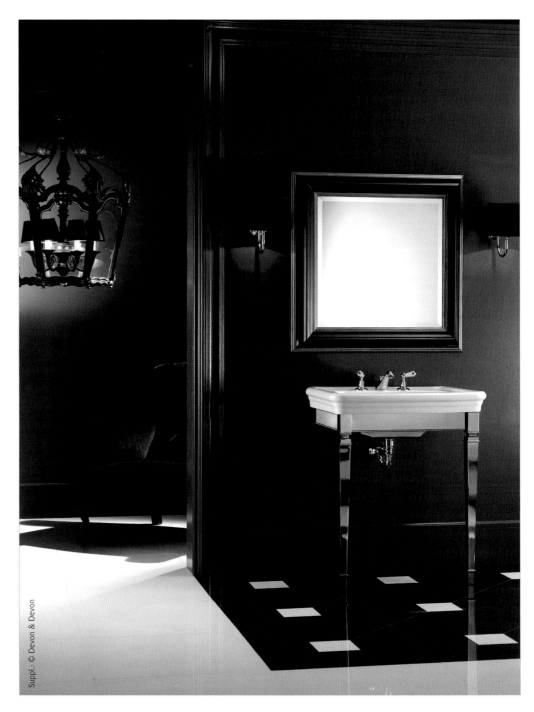

Suppl.: © Devon & Devon

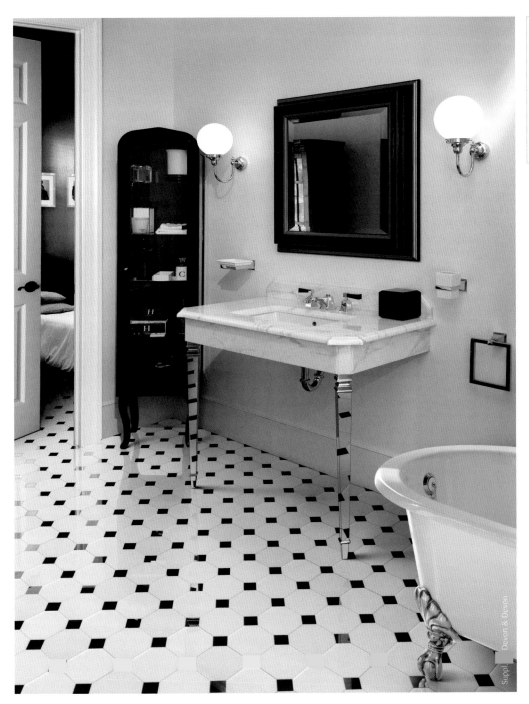

The small black tiles create diagonal lines that give the impression that the pattern continues beyond the walls. In fact, the floor pattern in this bathroom continues to the adjacent bedroom.

Suppl. | Devon & Devon

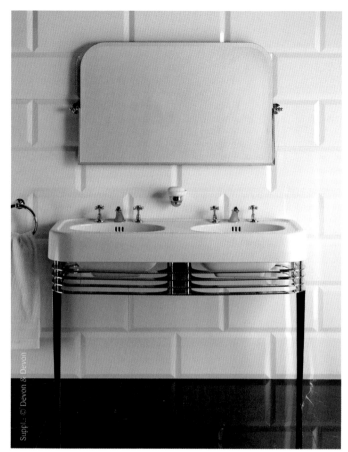

Suppl.: © Devon & Devon

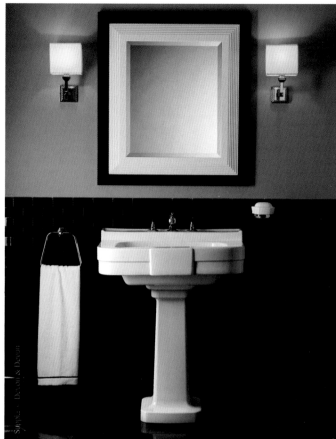

Suppl.: © Devon & Devon

Pedestal and console sinks have an
elegance and timeless appeal.
They add grace, beauty and a classic
touch to a bathroom. Accessorized
with vintage faucets, they recreate the
old-world charm.

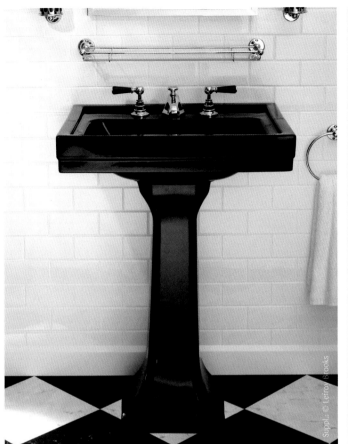

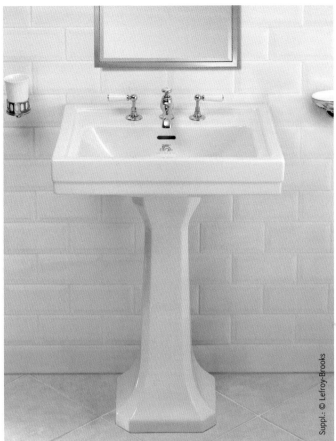

Suppl.: © Lefroy-Brooks

Suppl.: © Lefroy-Brooks

125

Exotic wood vanity cabinet fronts take you on a journey in far lands enhancing the bathroom experience.

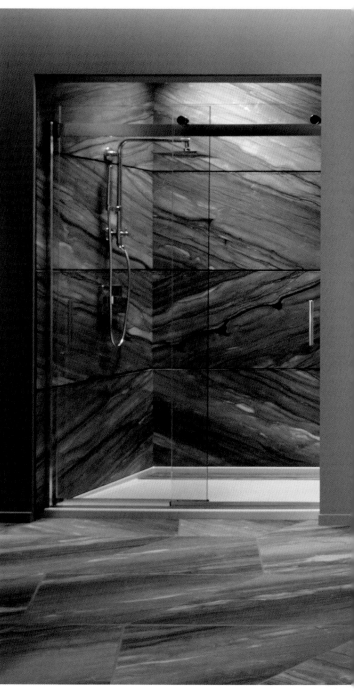

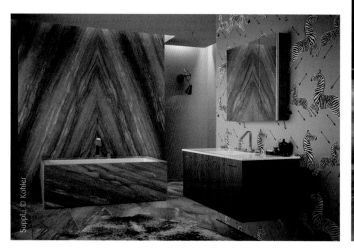

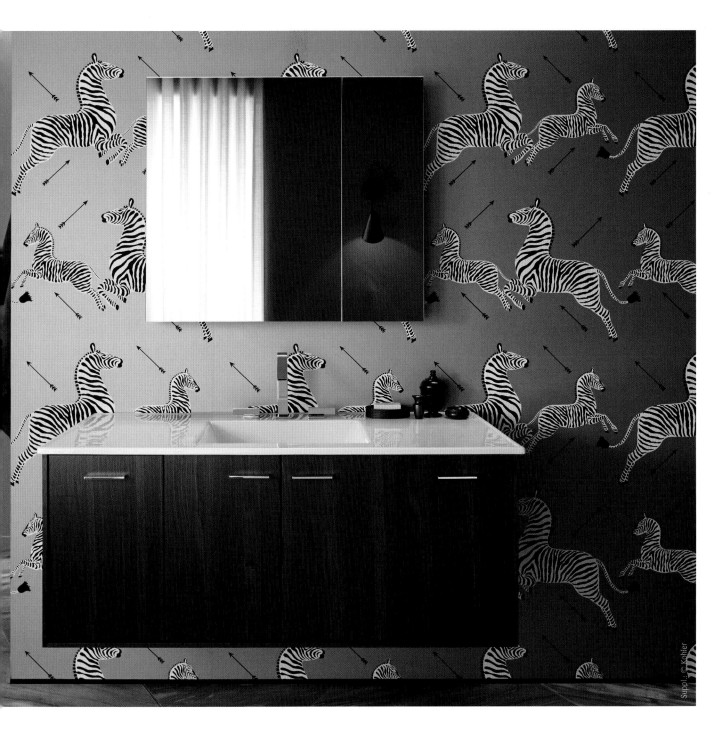

Vanity mirrors with integrated lighting eliminate the issue of having to find suitable lighting that not only is efficient, but also works well with the style of the bathroom.

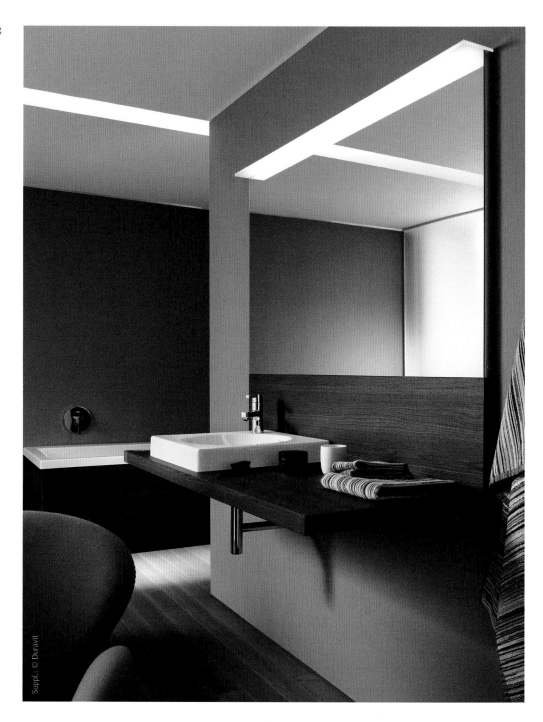

Suppl.: © Duravit

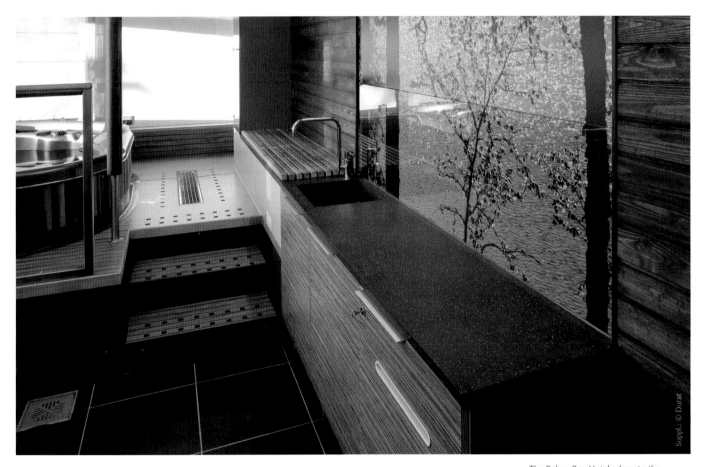

Suppl.: © Durat

The Rokua Spa Hotel, close to the
Oulu region of Finland, integrates the
magnificent natural setting into its
design. Natural materials and views
of the surroundings inspire a sense of
wellness.

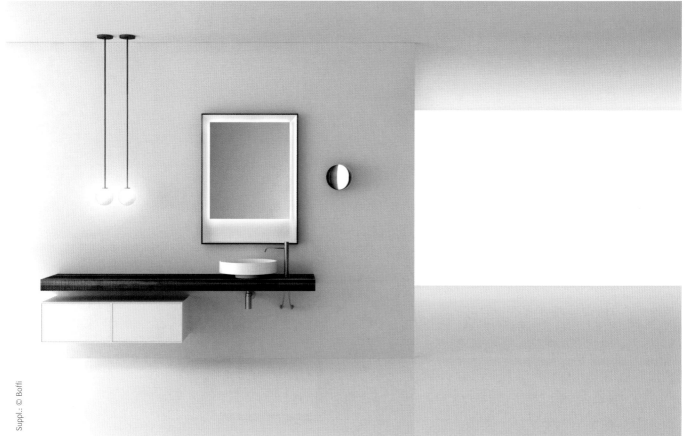

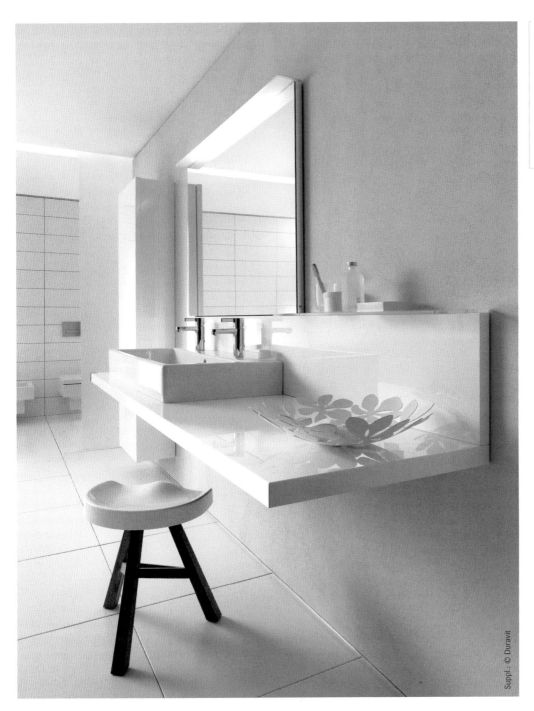

Wall-mounted vanities can be very practical in bathrooms that require wheelchair accessibility to facilitate a face forward approach.

Suppl.: © Duravit

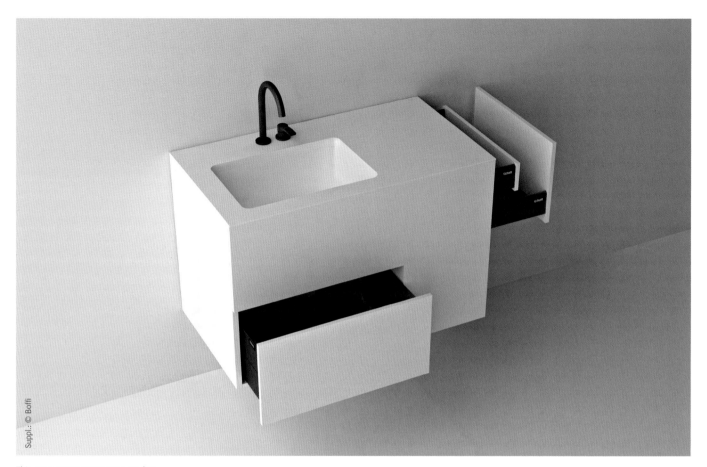

This compact vanity unit is a perfect
addition for a small bathroom designed
to maximize storage space.

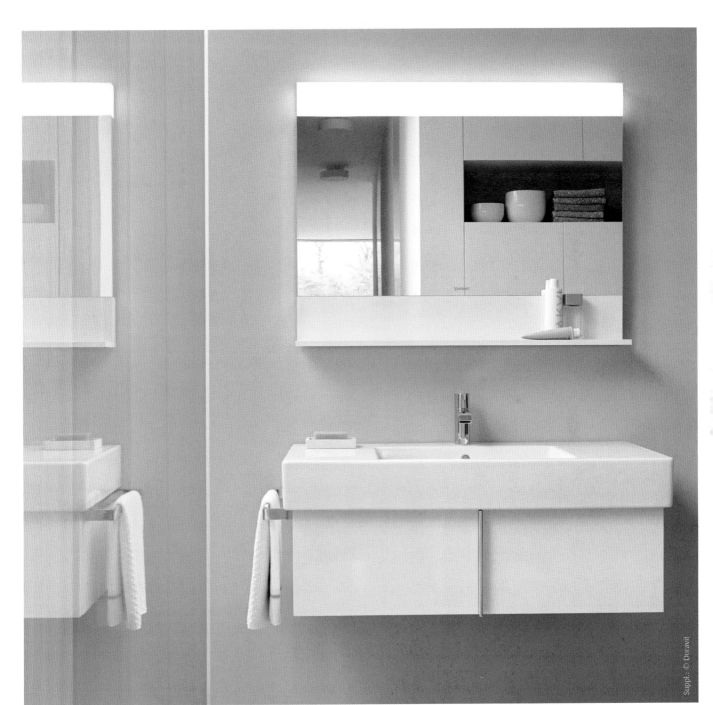

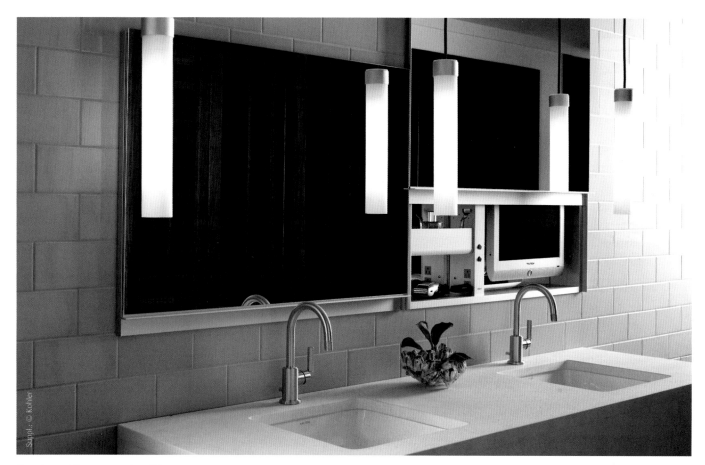

The mirrors of these recessed medicine
cabinets slide up to expose their interior
conveniently equipped with shelves,
integrated lighting and electrical outlets.

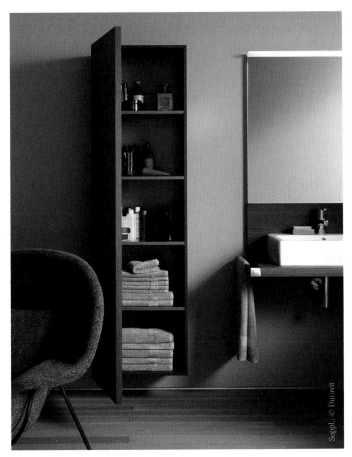

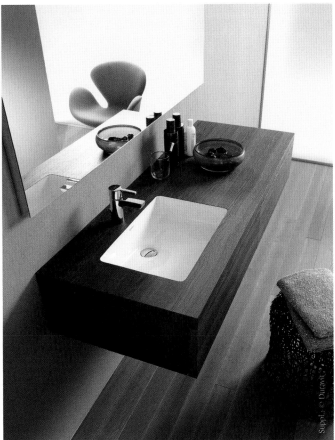

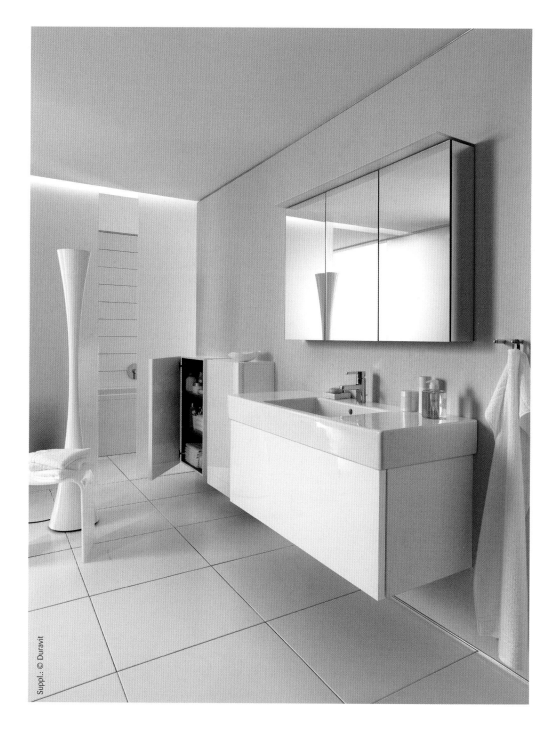

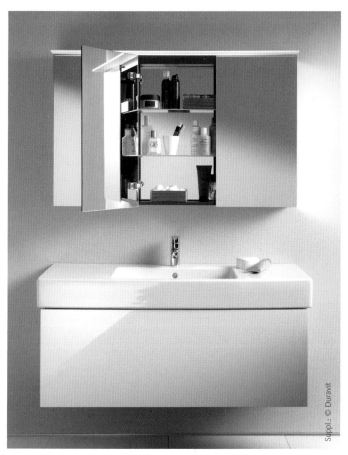

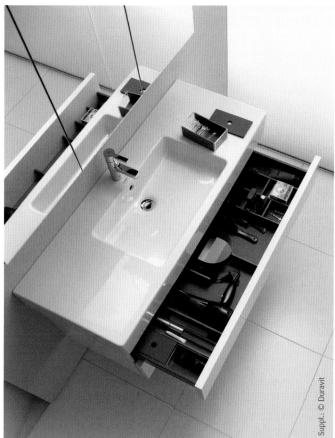

All-white bathrooms bring brightness and freshness, while contrasting textures play up the different surfaces without overstating any particular component.

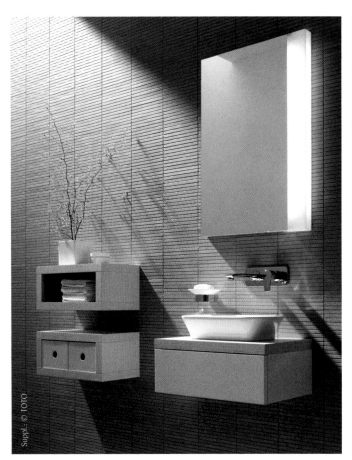

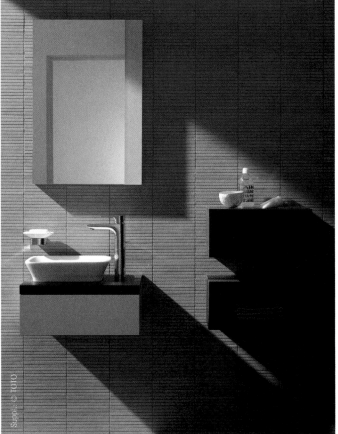

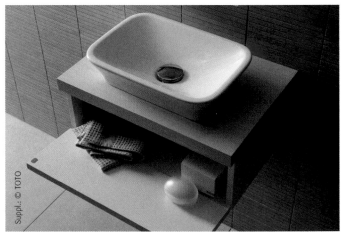

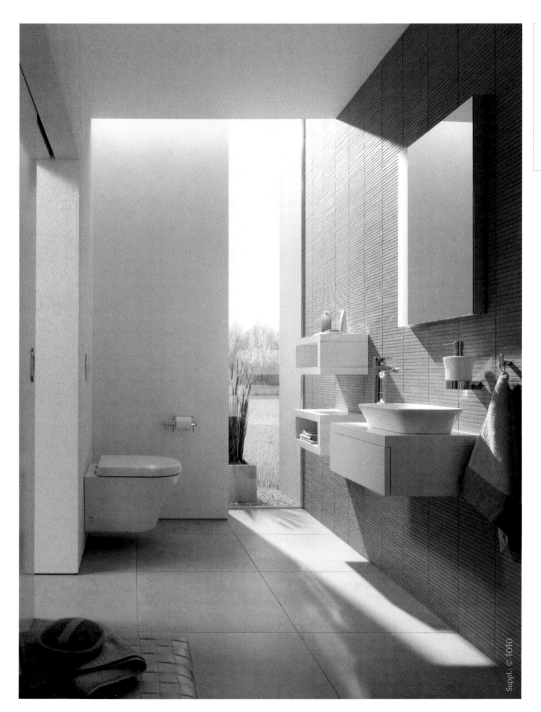

127

Modular cabinets offer great flexibility. Explore your storage possibilities mixing and matching different styles and finishes and playing with their arrangement.

Vessel sinks offer a distinctive look to any bathroom, traditional or modern. They are a new take on those beautiful China washbowls used during Victorian times.

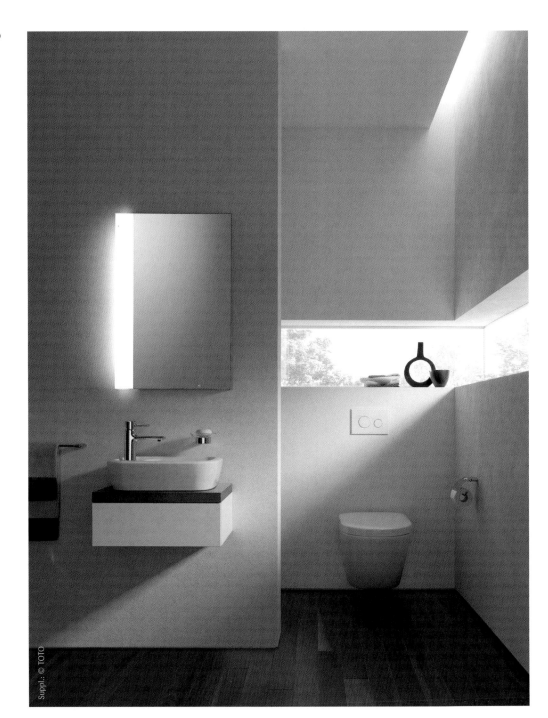

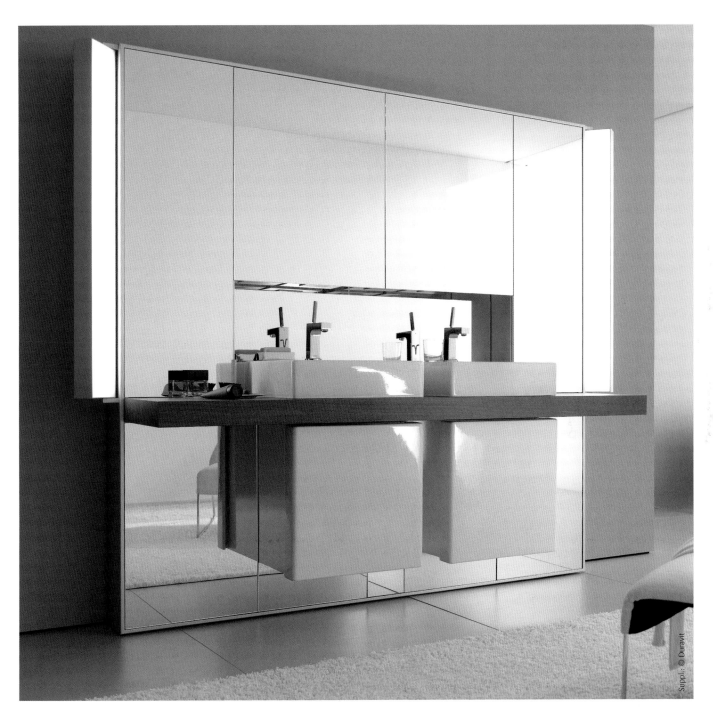

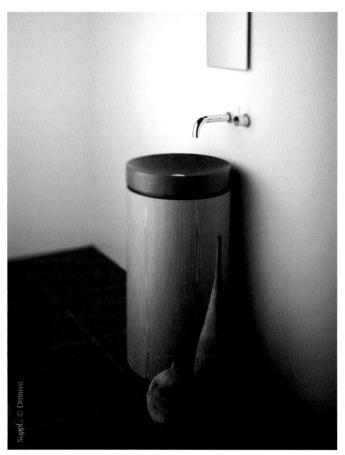

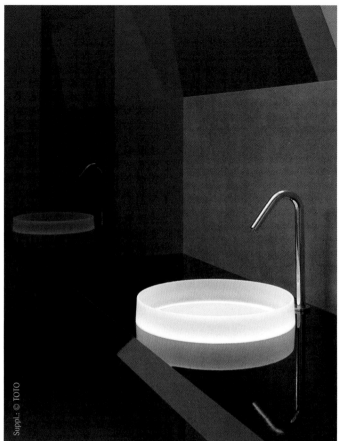

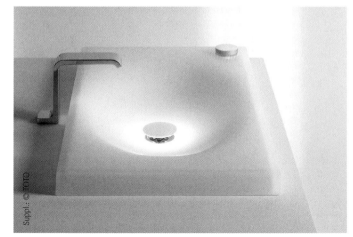

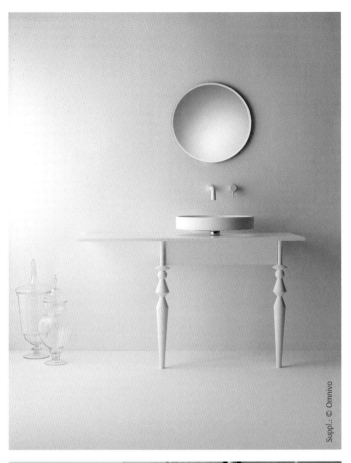

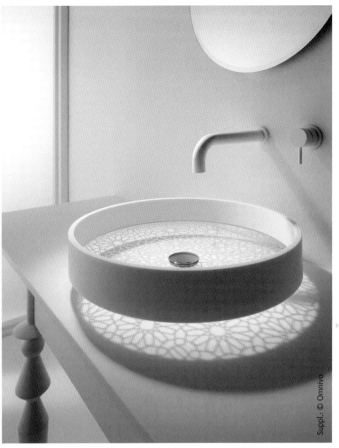

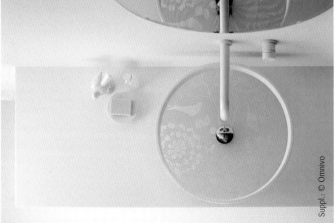

The artistic quality of this washbasin makes it a focal point in any bathroom. The pattern on the etched glass bottom is reflected on the dark surface of the vanity, creating a striking floating effect.

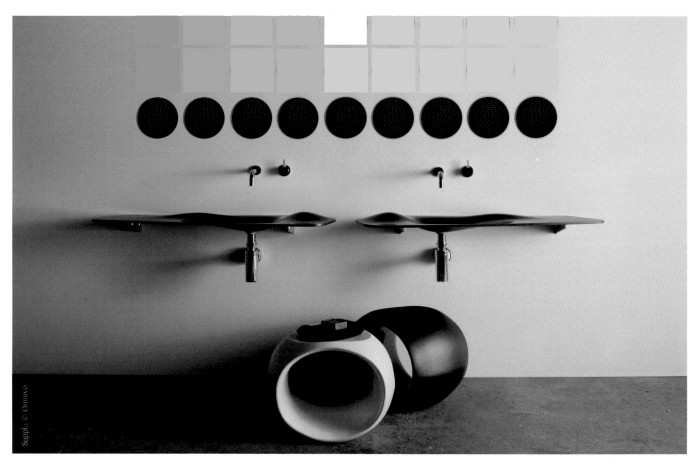

Suppl.: © Omnivo

The undulating shape of this washbasin reminds one of sandy dunes or of the wavy movement of the water. This imitation brings a natural element into the bathroom environment.

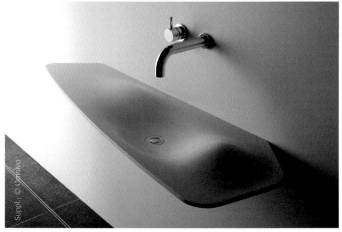

Suppl.: © Omnivo

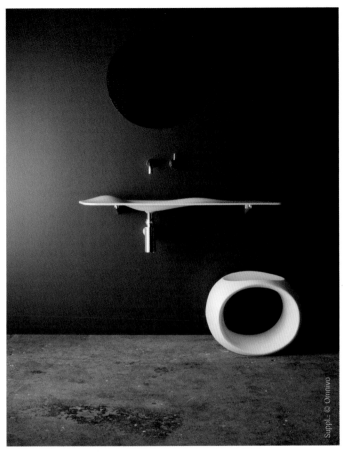

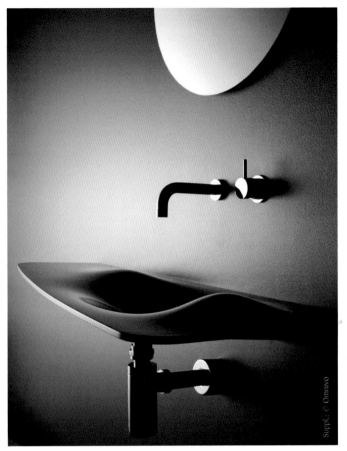

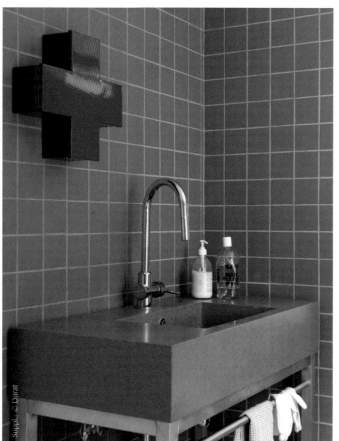

Suppl.: © Durat

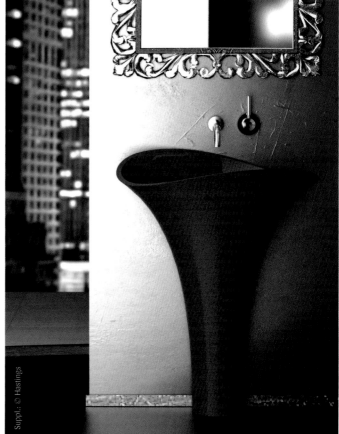

Suppl.: © Hastings

128

Color in bathrooms, as in any other room in the house, is a personal preference, but one that portrays personality. From the wall tile to the vanity countertop, bring color into your bathroom for a unique touch.

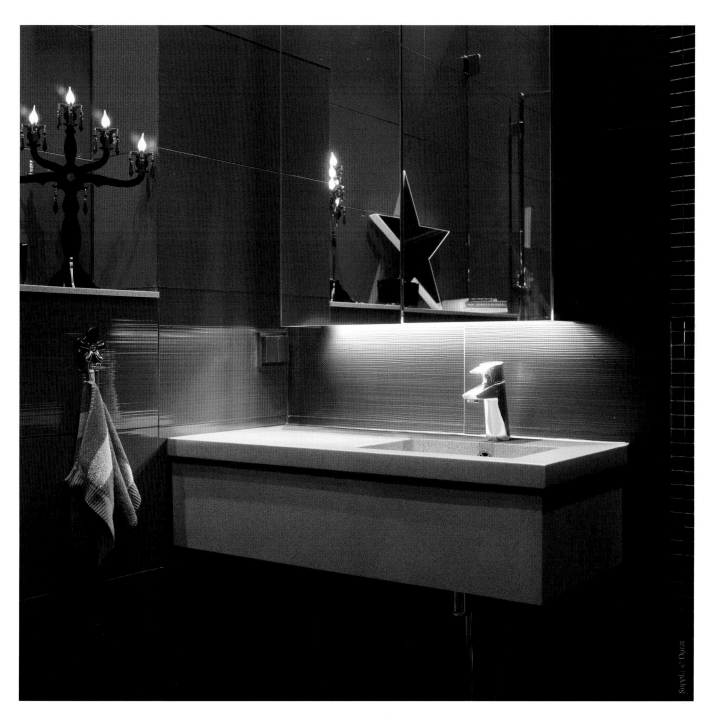

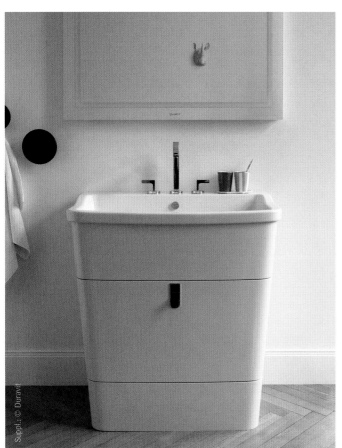

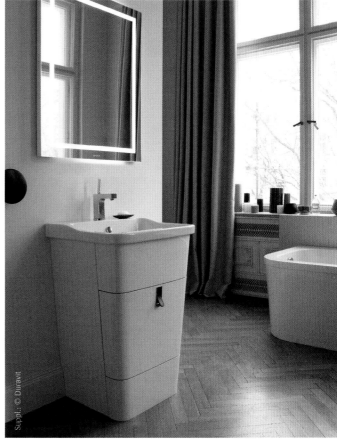

129

Vanities can be accent pieces
of furniture that can fit outside
the bathroom realm, provided
that there is a connection
to the plumbing line.

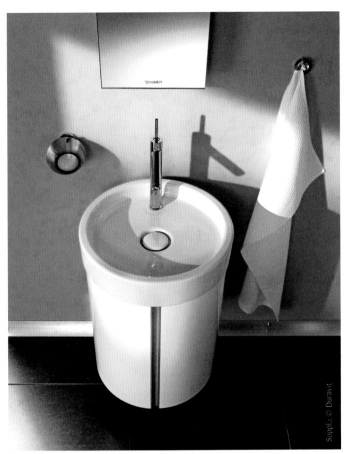

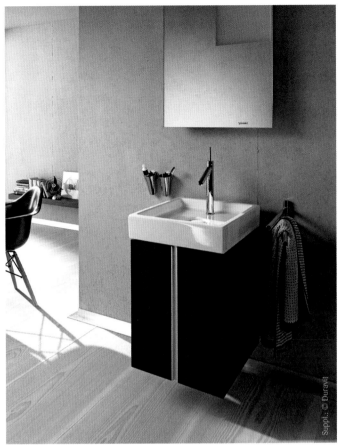

Suppl.: © Duravit

Suppl.: © Duravit

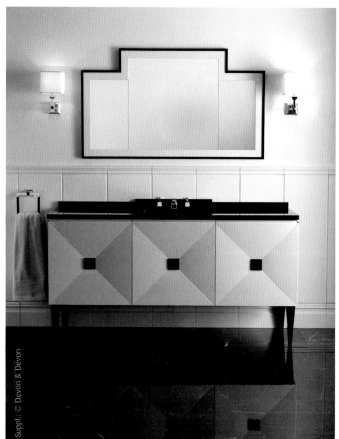

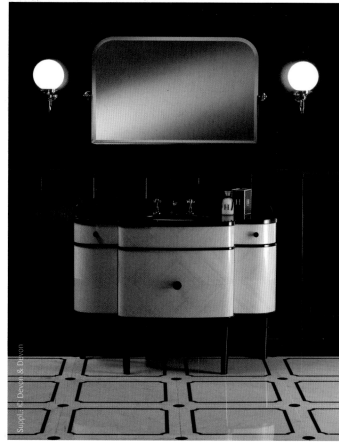

130

Make your vanity the centerpiece of your bathroom or bedroom suite. Vanities inspired by old design eras, such as Victorian, Edwardian or Art Deco, portray an image of flair and artistic appreciation.

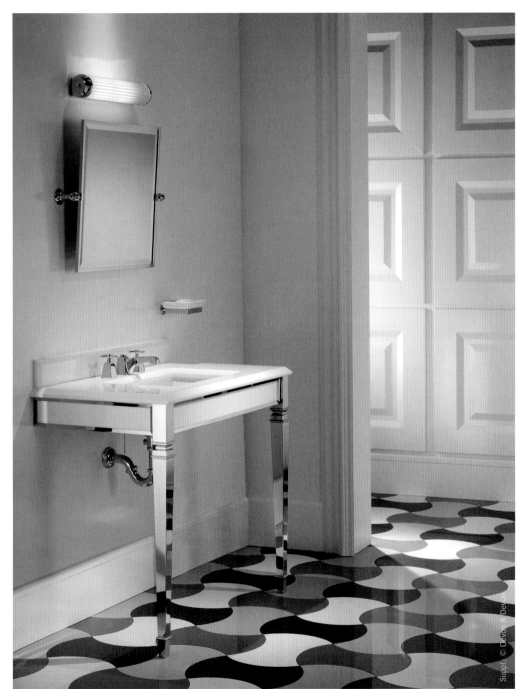

This Art Deco inspired console with chrome-finish aluminum legs, white marble countertop and porcelain basin is perfectly in tune with the playful floor pattern.

Brimming with delicate colors, this bathroom features a Victorian washstand carved in Carrara marble on a frame of polished nickel.

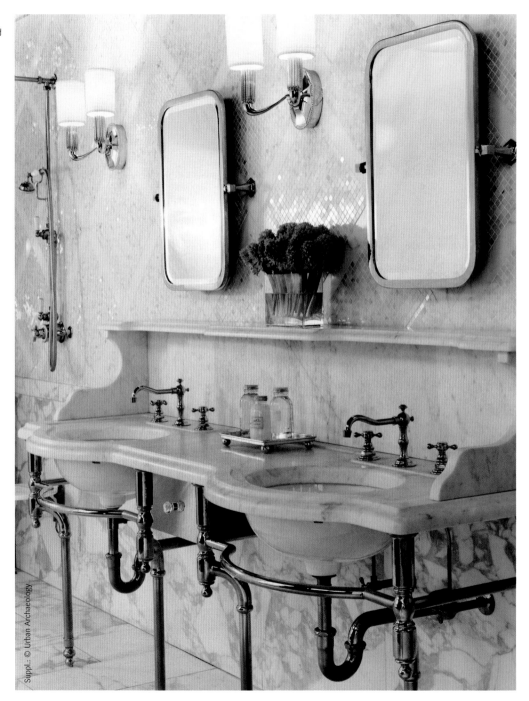

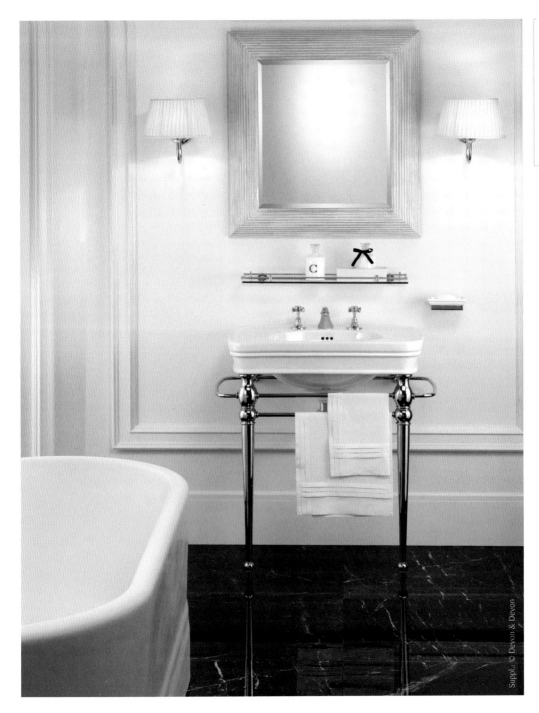

New washstand design has transformed the merely utilitarian console into a statement. There are plenty of options in many styles, whether you are looking for classical elegance or vintage style with flair.

The ceiling-mounted mirrors are handmade tubular structures with a minimal profile in a satin-nickel finish. Frosted-glass panels flanking the mirrors are illuminated by low-voltage, high-brightness LED strips.

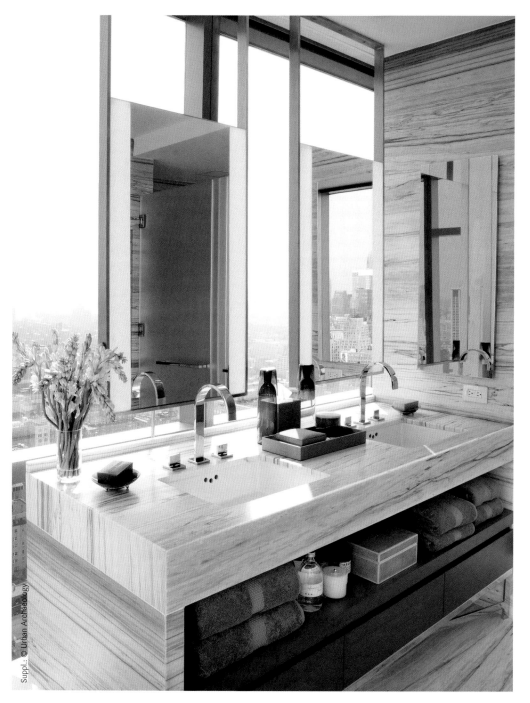

Suppl.: © Urban Archaeology

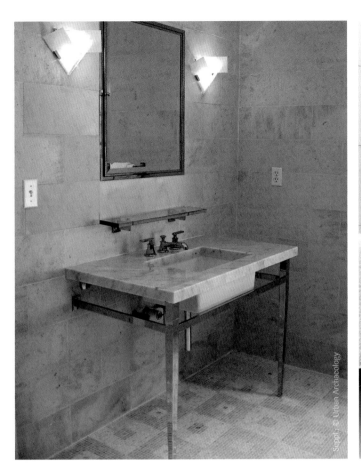

132

Marble, stainless steel
and glass or stone tile make
for a modern, elegant, durable,
and easy to maintain material
combination suitable for
a bathroom environment.

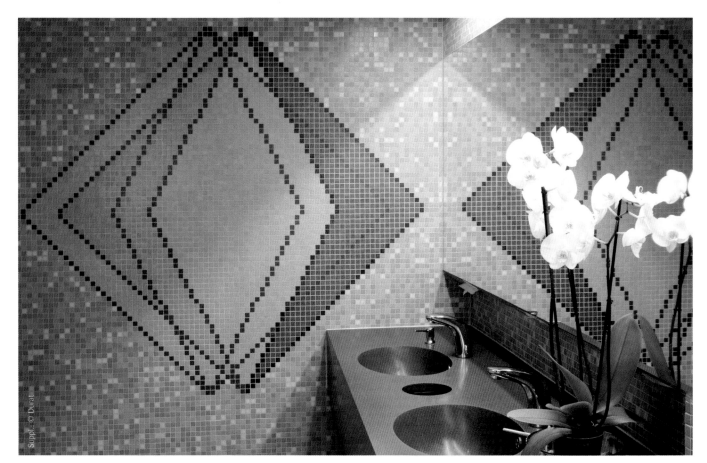

133

Decide if the walls are the backdrop of your bathroom or a focal point. Work out a color scheme based on the major elements like you would do for any other room in your house.

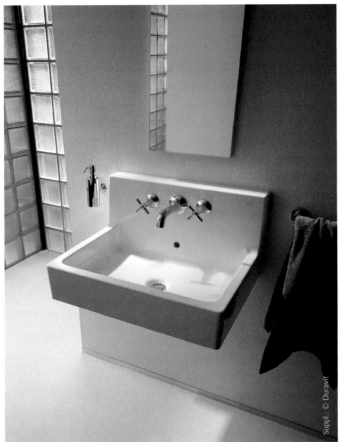

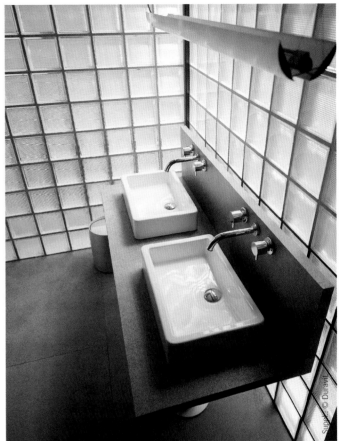

134

Floor-to-ceiling glass-block wall will add a modern dimension to a bathroom. This material transmits light uniformly without compromising privacy, or it can be backlit for stunning effects.

The Muse collection of Oceanside Glasstile™ offers a myriad of versatile blends to choose from with fantastic customizing capabilities.

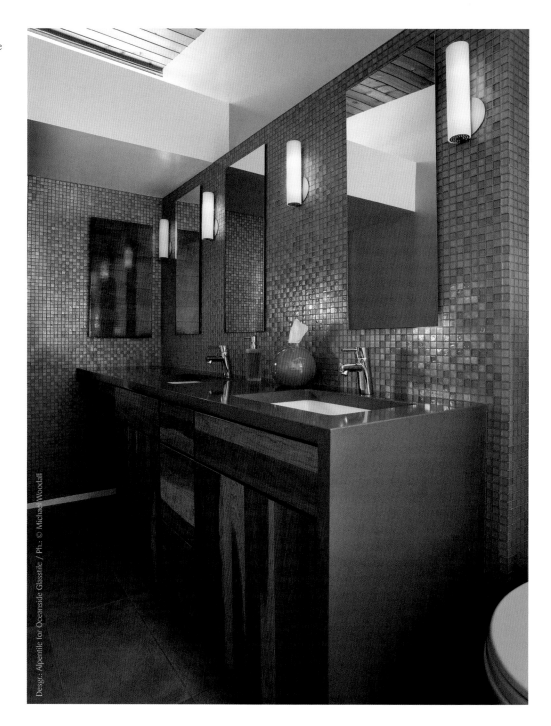

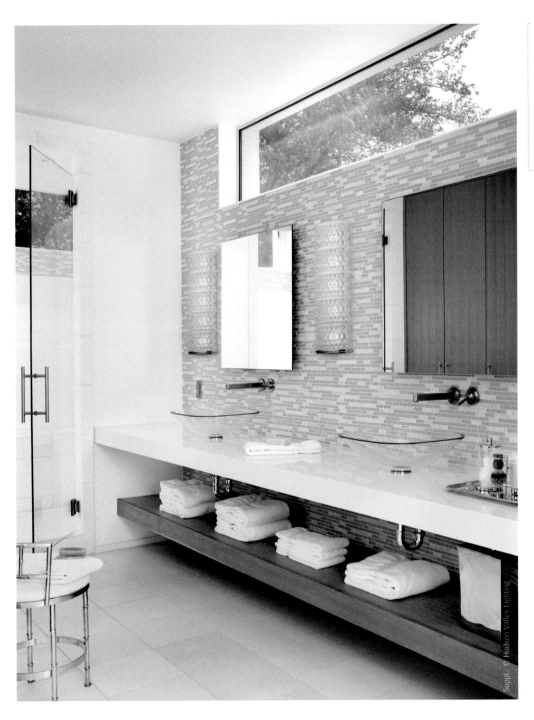

135

The selection of tile colors echo the greenery that can be seen through the transom window. The light brightens the room dominated by pale tones achieving a fresh and natural atmosphere.

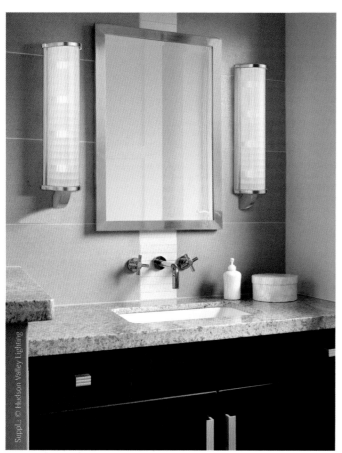

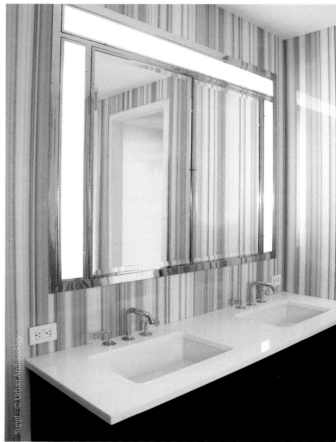

136

Adequate lighting is an
important design element
to set the right mood and to
enhance the aesthetic appeal
of a bathroom as in any room
in a house.

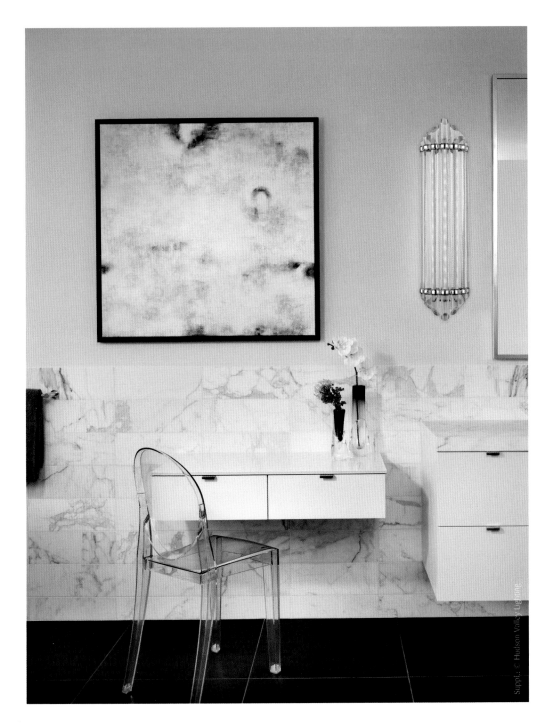

137

Make a strong design statement with a tempered-glass vanity top. Fine ceramic washbasins reinforce the delicate, yet powerful design in line with a minimalistic décor.

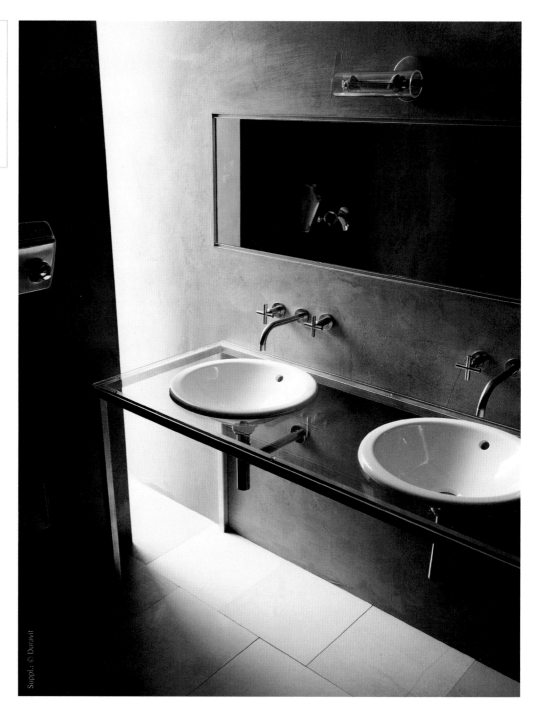

Suppl.: © Duravit

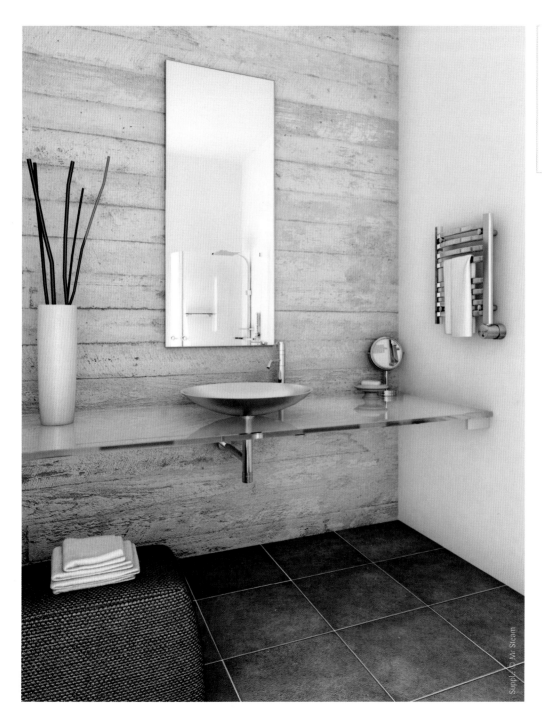

138

A tempered-glass vanity countertop makes a strong design statement. Its subtle green tint complements the warm grays of the tile floor and concrete wall.

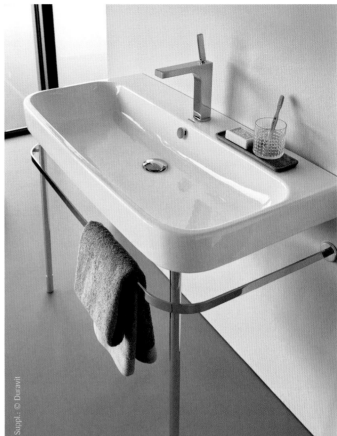

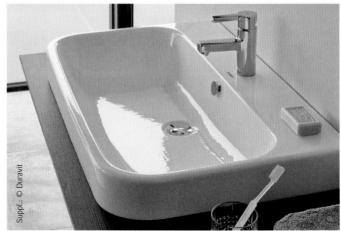

The Delos console with washbasin of Duravit™ has no visible support. This feature produces a floating effect that enhances the simple design of the console.

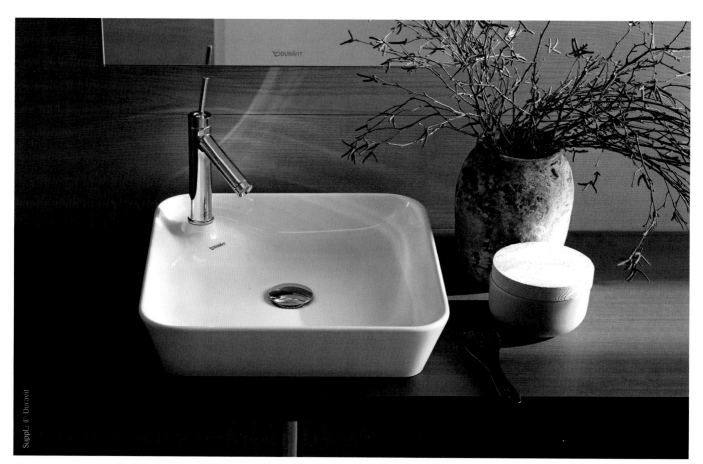

139

Washbasins and faucets don't come in a single package. You need to look at the basin and faucet combinations that better suit your bathroom style.

The Stark 2 line of surface-mounted
ceramic washbasins that designer
Philippe Stark created for Duravit™
features flowing forms inspired
by the movement of water.

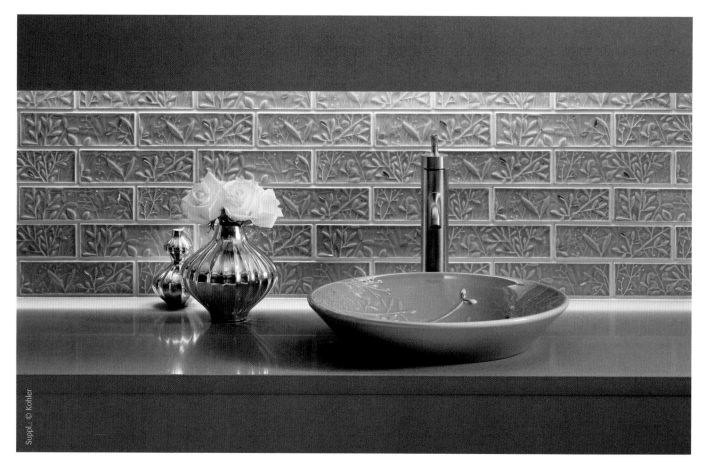

The distinctive design of this bell-shaped vessel sink features a carved floral pattern with gilded accents. This eye-catching item can easily be a focal point in both traditional and modern bathrooms.

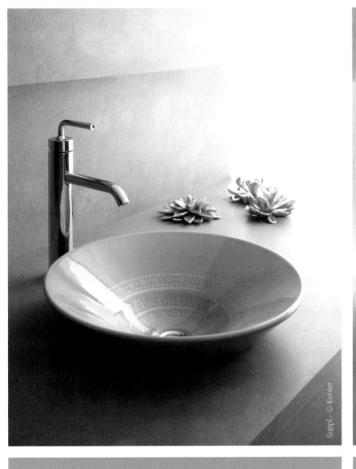

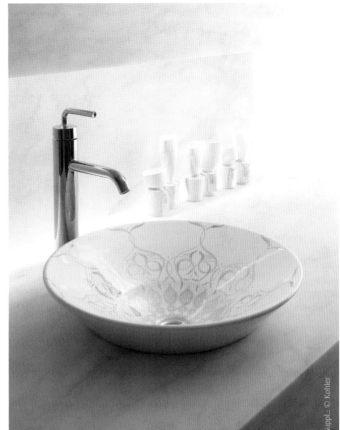

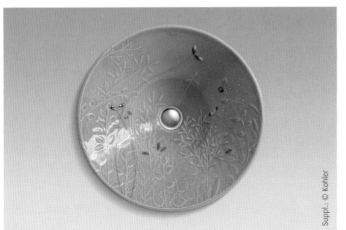

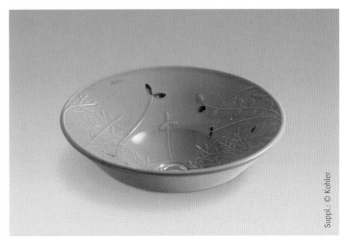

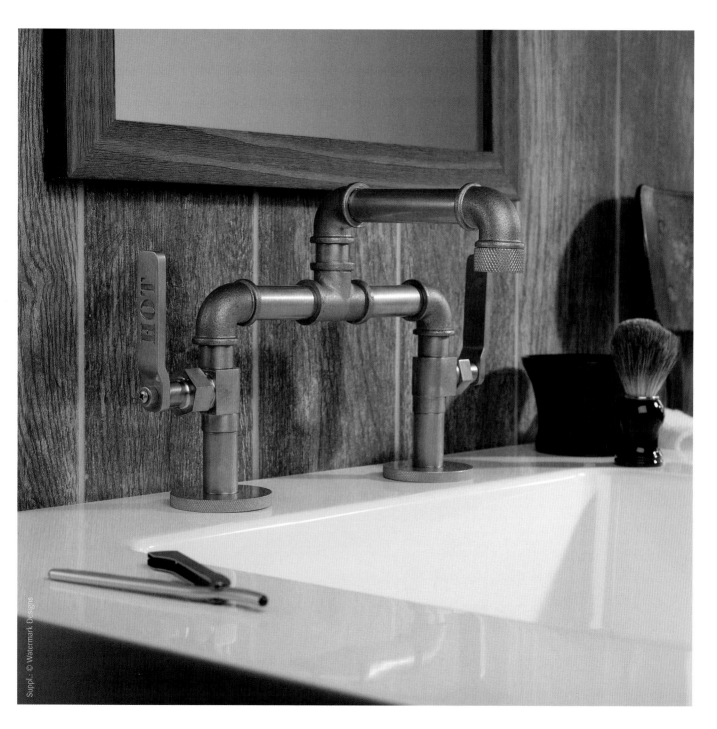

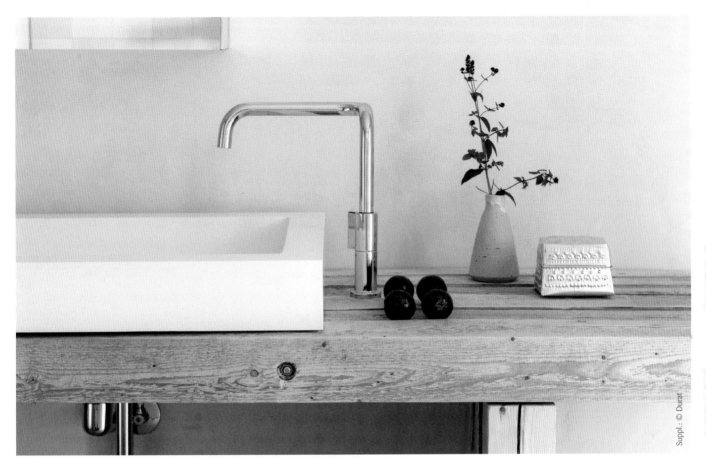

140

Why go by the book when you can mount your basin on just about anything? Chances are that you'll have a harder time taking an old sink down.

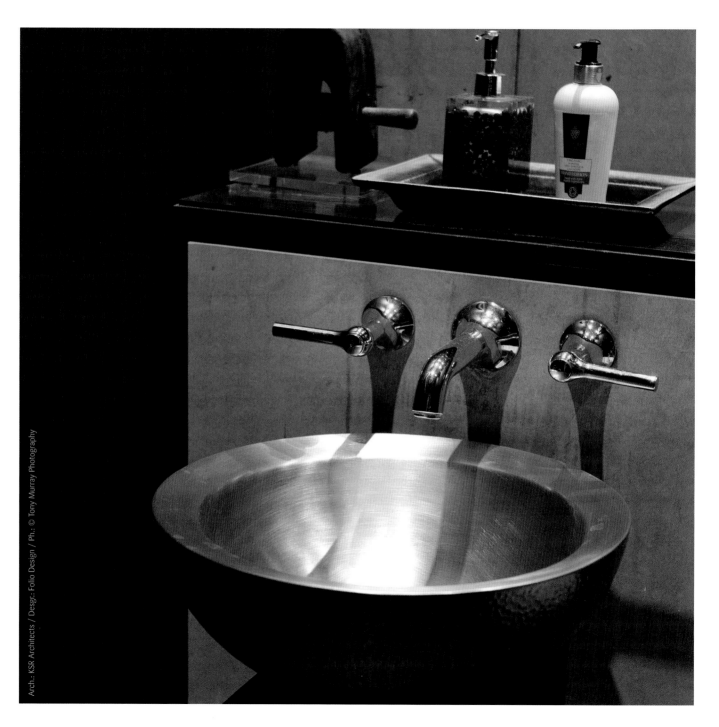

141

You can perk up an old bathroom by simply upgrading the faucets. The difference can be significant. As shown in these images, copper can provide your bathroom with a rustic look without compromising functionality.

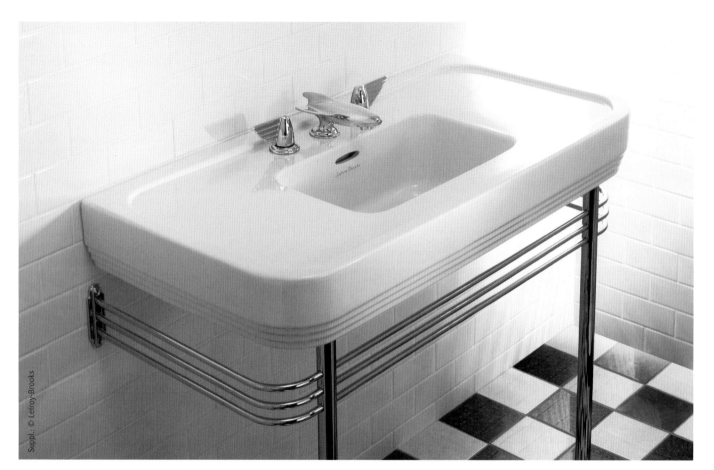

142

A black-and-white marble checkerboard floor adds glamour to any space. In a bathroom, it is enhanced with classic fixtures of different eras in bathroom design.

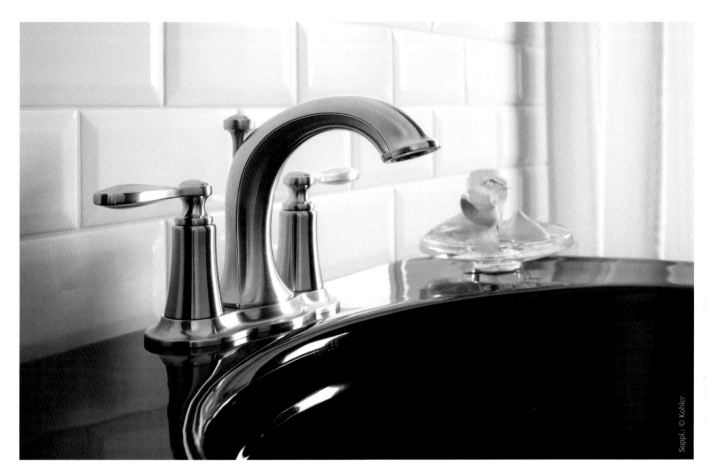

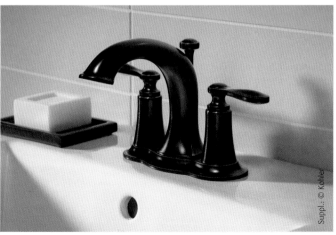

143

The Linwood center set lavatory faucet by Kohler™ is a traditional yet simple design. Available in brushed nickel and in oil-rubbed bronze, the center-set faucet fits any bathroom style.

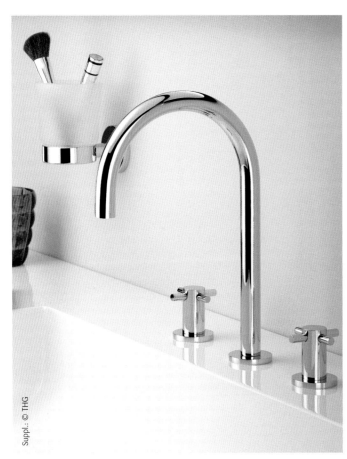

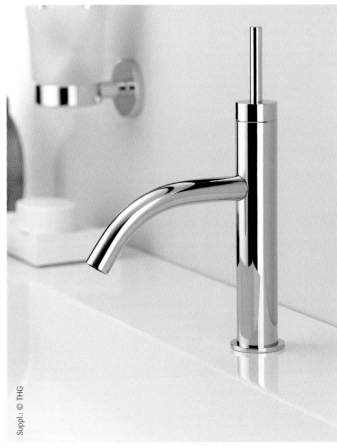

The sleek appeal of this faucet lays in its simple design offering two spout shapes, angled and curved, and the option of cross or lever handles.

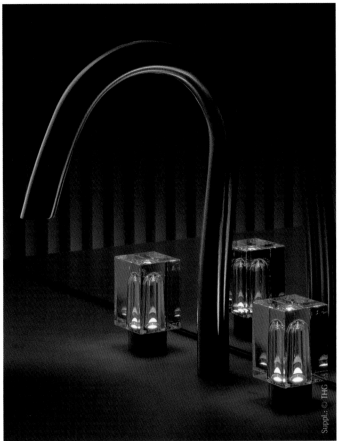

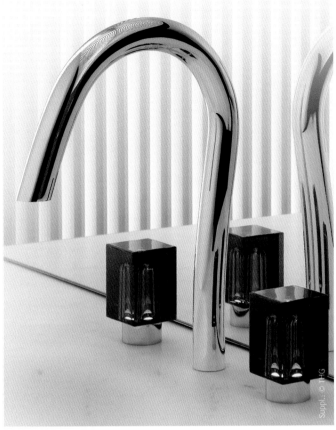

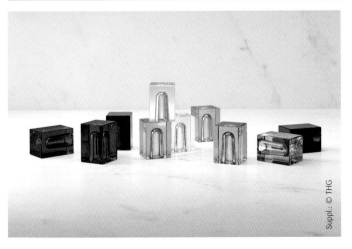

144

This successful series by THG-Paris® incorporates Baccarat cristal handles. Available in aqua, red, champagne and blue as well as in clear crystal, the design is further enhanced with optional LED lights.

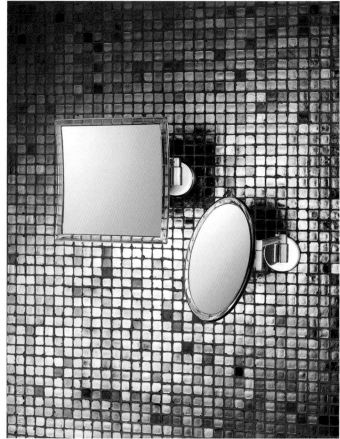

145

Accessories, just like lighting, are often taken for granted, but in fact, they complete the overall look of a bathroom. Choose these small fixtures according to the style of the room.

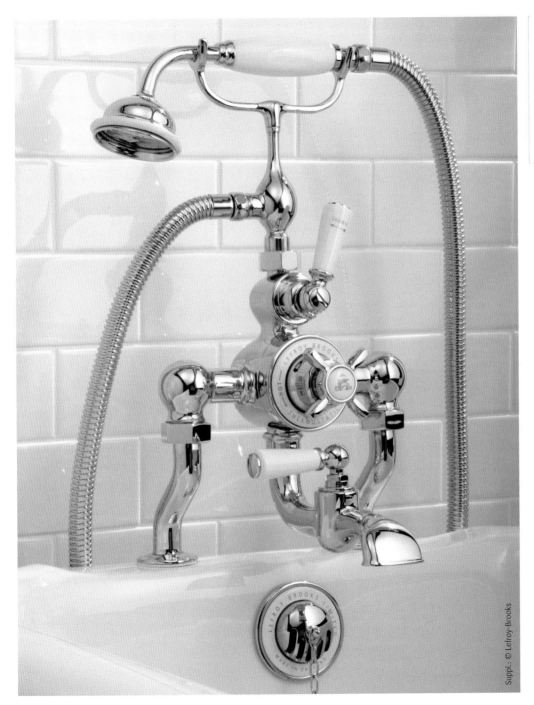

Classical bathroom vanities and tubs are best complemented with retro-style fittings in harmony with an elegant choice of tiles that match ceramic fixtures.

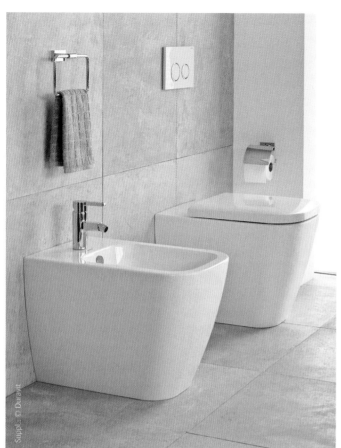

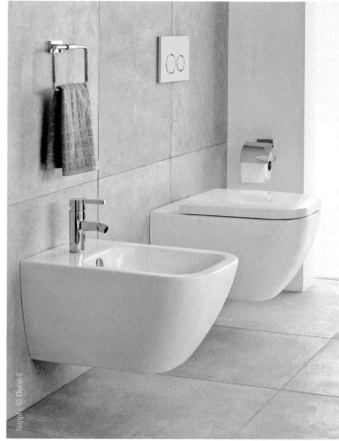

147

Wall-hung toilets are space savers offering an open feel. Their water tanks are generally concealed inside the wall, and since they don't touch the floor, they make the cleaning job much easier.

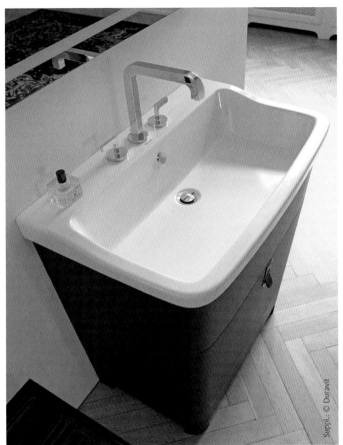

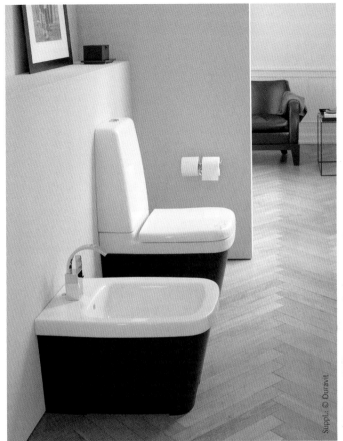

148

The Esplanade line of bathroom fixtures of Duravit™ stands out for its lavish aesthetics that combine oak wood paneling, leather handles, chrome surrounds and ceramic fittings.

149

Wall-hung, concealed tank toilets with wall plate for flushing are the high-end models that manufacturers offer as a minimalist alternative to the common and more cumbersome floor-mount with cistern.

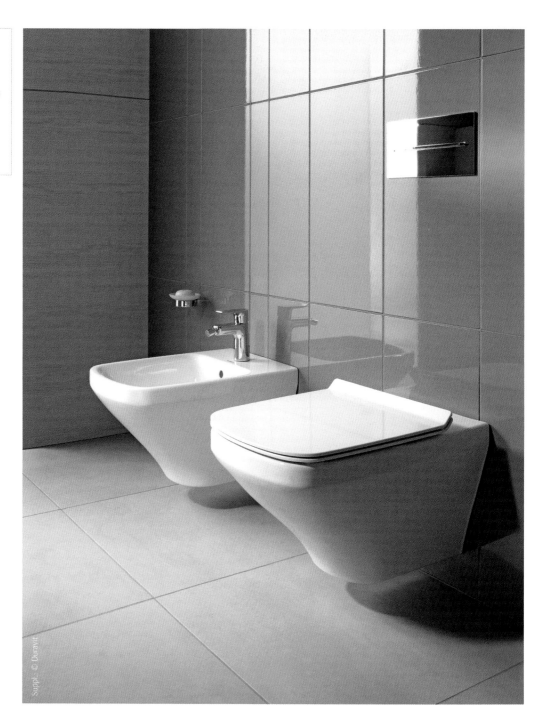

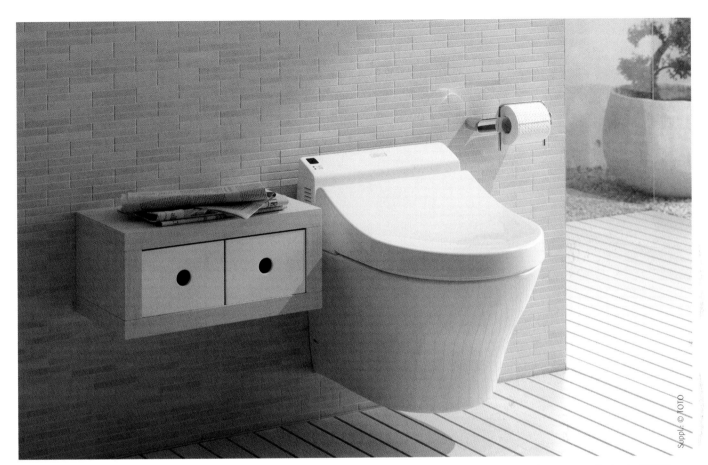

The MH Series of toilets by TOTO™
features a ceramic bowl without
hard-to-reach areas and a special
hygienic finish for an optimum
quality surface.

Suppl.: © TOTO

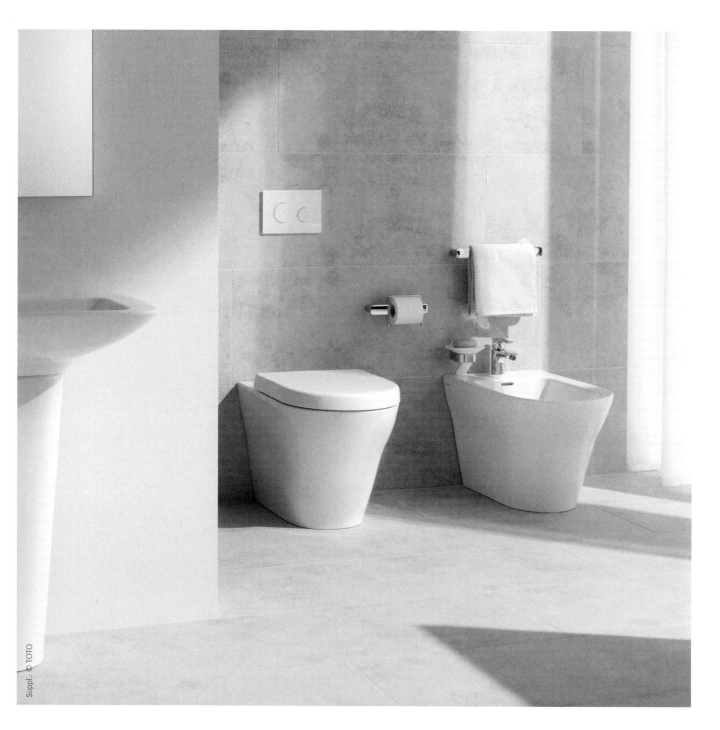

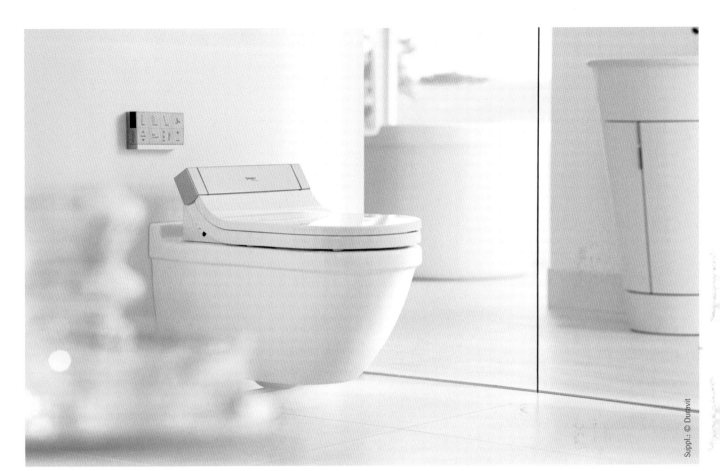

150

Modern-day toilets come with self-closing lids, integrated seat heating, and night-lights offering the ultra-functional form of hygiene.

Wall-hung toilets are supported by a steel frame concealed within the wall cavity. The tank, which also fits in the cavity, is accessible for maintenance through a plate on the wall above the toilet.

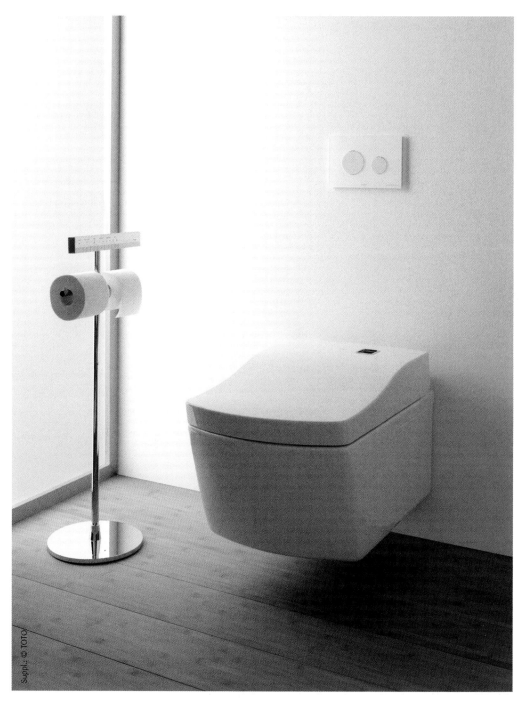

The freestanding towel holders of the Iko line by Boffi™ consist of stainless steel rods and stone bases, bringing a sculptural beauty to any modern bathroom.

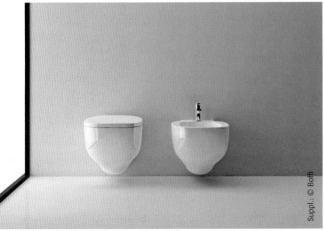

Directory

ARCHITECTS AND DESIGNERS

Anne Sophie Goneau
Montreal, QC, Canada
www.asgoneaudesign.com

Architecture BRIO
Mumbai, India
http://architecturebrio.com

assemblageSTUDIO
Las Vegas, NV, USA
www.assemblagestudio.com

Ben Herzog Architect
Brooklyn, NY, USA
http://herzogarch.com

Besch Design
Chicago. IL, USA
http://beschdesign.com

beth kooby design
Atlanta, GA, USA
www.bethkoobydesign.com

BLOUIN TARDIF
Architecture - Environnement
Montreal QC, Canada
www.btae.ca

C+M STUDIO
Sydney, NSW, Australia
http://cm-studio.com.au

Cassidy Hughes Design
London, UK
www.cassidyhughes.com

E/L STUDIO
New York, NY, USA
www.elstudioarch.com

Finne Architects
Seattle, WA, USA
www.finne.com

Floriana Interiors
San Francisco, CA, USA
www.florianapetersen.com

Folio Design
London, UK
www.foliodesignllp.com

FORMA Design
Washington, DC, USA
http://formaonline.com

Gervais Fortin
Montreal, QC, Canada
www.gervaisfortin.com

Henri Gleinge, ARCHITECTE
Montreal, QC, Canada
www.cleinge.com

Horton & CO
Newcastle, NSW, Australia
www.hortonandco.com.au

Hugh Jefferson Randolph Architects
Austin, TX, USA
www.austinarchitect.com

Janna Levenstein/TOCHA PROJECT
Beverly Hills, CA, USA
http://tochaproject.com

k YODER design
Philadelphia, PA, USA
http://kyoderdesign.com

KSR Architects
London, UK
www.ksrarchitects.com

Keir Townsend
London, UK
www.keirtownsend.com

Liquid Interiors
Hong Kong, S.A.R.
www.liquid-interiors.com

MR. MITCHELL
Melbourne, VIC, Australia
www.mrmitchell.com.au

Mark English Architects
San Francisco, CA, USA
www.markenglisharchitects.com

marinaniLIND
Toronto, ON, Canada
www.marianilind.com

METAFORM architects
Luxembourg
www.metaform.lu

Michael Lee Architects
Manhattan Beach, CA, USA
http://mleearchitects.com

Min | Day
San Francisco, CA, Omaha, NE, USA
www.minday.com

MU Architecture
Montreal, QC, Canada
http://architecture-mu.com

Nicolas Tye Architects
London, UK
www.nicolastyearchitects.co.uk

one d +b architecture
Miami, FL, USA
www.onedbmiami.com

REDO home & design
Franklin, TN, USA
www.redoyourhouse.com

SHED Architecture & Design
Seattle, WA, USA
www.shedbuilt.com

Studio G+S Architects
Berkeley, CA, USA
http://sgsarch.com

Swell Homes
Fremantle, WA, Australia
http://swellhomes.com.au

TACT Architecture
Toronto, ON, Canada
http://tactdesign.ca

TG Studio
London, UK
www.tg-studio.co.uk

Toronto Interior Design Group
Toronto, ON, Canada
http://tidg.ca

WNUK SPURLOCK Architecture
Washington, DC, USA
http://wnukspurlock.com

Z+ Architects
Allendale, NJ, USA
www.zplusarchitects.com

SUPPLIERS

American Standard
Piscataway, NJ, USA
www.americanstandard-us.com

Boffi
Lentate sul Seveso, MB, Italy
www.boffi.com

Céragrès
Montreal, QC, Canada
www.ceragres.ca

Devon&Devon
Florence, FI, Italy
www.devon-devon.com

Durat
Rymättylä, Finland
www.durat.com

Duravit
Hornberg, Germany
www.duravit.com

Hastings Tile & Bath
Ronkonkoma, NY, USA
www.hastingstilebath.com

Hudson Valley Lighting
Newburgh, NY, USA
www.hudsonvalleylighting.com

INDA
Milan, MI, Italy
www.inda.net

KOHLER
Kohler, WI, USA
www.kohler.com

Lefroy Brooks
Hertfordshire, UK
www.lefroybrooks.co.uk

MGS
Gravellona Toce, VB, Italy
www.mgstaps.com

Mr. Steam
Long Island City, NY, USA
www.mrsteam.com

Neutra
Seregno MB, Italy
www.neutradesign.it

Oceanside Glasstile
Carlsbad, CA, USA
www.glasstile.com

OMVIVO
Tullamarine, VIC, Australia
http://omvivo.com

PORCELANOSA Grupo
Castellón, Spain
www.porcelanosa.com

Ramacieri Soligo
Outremont, QC, Canada
www.ramacierisoligo.com

SAMO
Bonavigo, VR, Italy
www.samo.it

Stone Forest
Santa Fe, NM, USA
www.stoneforest.com

THG USA
Coconut Creek, FL, USA
www.thgusa.com

TOTO USA
Morrow, GA, USA
www.totousa.com

Troy Lighting
City of Industry, CA, USA
www.troy-lighting.com

Urban Archaeology
New York, NY, USA
www.urbanarchaeology.com

Watermark Designs
Brooklyn, NY, USA
www.watermark-designs.com